Look Close
Think Far
Art at the
Ackland

Look Close
Think Far
Art at the
Ackland

EDITED BY
PETER NISBET

ACKLAND

Publication of *Look Close, Think Far: Art at the Ackland* has been made possible by The William R. Kenan, Jr. Charitable Trust.

Published by
Ackland Art Museum
The University of North Carolina at Chapel Hill
101 South Columbia Street
Chapel Hill, NC 27514
www.ackland.org
Publication editor: Peter Nisbet
Managing editor: Lauren Turner

Produced by
Paul Holberton Publishing, London
www.paulholberton.com
Design: Laura Parker
Printing: e-Graphic Srl, Verona

ISBN: 978-1-913645-26-7
British Library Catalogue in Publishing Data
A CIP record of this publication is available from the British Library

Library of Congress Control Number: 2022907342

Copyright permissions for illustrations are listed on p. 310.

For full identification of cover images:
Front cover: p. 36
Back cover: p. 240

This edition has been printed on certified FSC® Garda Matt Ultra paper and other certified materials.

Contents

Chancellor's Foreword

The University of North Carolina at Chapel Hill is fortunate to be the home of a distinguished art museum, the Ackland, which serves its students, faculty, staff and community. Every year, 10,000 of Carolina's undergraduate, graduate and professional students receive unique instruction using art at the Ackland. Art offers all of us unique ways of understanding and communicating about the world around us regardless of our connection to Carolina or our chosen field of study. This is also true for the many general visitors from the community, region, state and beyond.

It is an honor to introduce you to this publication—the latest book of highlights from the Ackland's rich, encyclopedic collection. I guarantee that you will find something not to just like, but to love, in this book. I commend director Katie Ziglar and her colleagues, especially deputy director for curatorial affairs, Peter Nisbet, on this accomplishment. I thank the William R. Kenan, Jr. Charitable Trust for the support that has made it possible.

My hope is that you will be moved to visit the Ackland whenever possible and to take advantage of the offerings on its robust website, Ackland.org. Both will be a worthwhile and rewarding experience.

Kevin Guskiewicz
Chancellor
The University of North Carolina at Chapel Hill

Director's Foreword

For several years now "Look Close, Think Far" has been the tagline of the Ackland, informing everything from our dynamic and varied program of special exhibitions to our ambitious interpretation, education, and outreach activities. It applies especially strongly to our permanent collection, the focus of this handsome publication.

Useful as a reference, aide-mémoire, and a nifty Museum calling card, books featuring highlights of museum collections are issued infrequently. So it is with great pleasure that I write to introduce the third iteration of a book about the Ackland Art Museum's collection. The Ackland has over 20,000 artworks, and we are pleased to present even the small percentage represented by 283 works, for they are all from among the best the Museum has. I want to take this opportunity to thank the many, many private donors of artworks and funds to purchase art who have made our entire collection possible. No state funds have ever been used to purchase art for the Ackland.

A quick perusal of this book establishes the high standard of quality that has always marked the Ackland's acquisitions throughout its almost sixty-five-year history. It also hints of areas where the Ackland's holdings are deep and distinguished. I will point out works on paper (drawings, prints, and photographs); European painting; Asian art; modern and contemporary art, including works by artists of color and women; and Southern vernacular art. Another area of particular interest to me where we are making intriguing acquisitions is Islamic art.

I thank my good colleague Peter Nisbet above all the many others who have contributed to this book, for he has been the "driver" of the process and has written an insightful essay on the Ackland's history. I also thank the William R. Kenan, Jr. Charitable Trust for its sponsorship of this wonderful record of the riches of the Ackland—even if it barely scratches the surface! This is but the tip of an iceberg, which should inspire a multitude of visits.

Katie Ziglar
Director
Ackland Art Museum

A Selection from the Collection

Notes for the Browser

Showcasing only one and a half percent of the current total holdings of over 20,000 works of art, the 283 works of art on the following pages have nevertheless been chosen to present an impression of the Ackland's permanent collection that is, in helpful ways, true to its character, representative of its breadth, and indicative of its quality. Although any such selection will have its fair share of the idiosyncratic and the arbitrary, it should be a plausible introduction of the institution, a way of getting to know the Ackland. It is a nice coincidence that the number of selected works in fact closely mirrors the number of works on view at any one time in the Museum's current building.

The works are here not divided into the conventional museum departments ("Asian Art," "Prints, Drawings, and Photographs," "Contemporary Art," and so on), but are merged into one continuous sequence, emphasizing the unity of the collection. A central organizing principle of the project has been to conceive of each two-page opening (with one work per page) as a whole, the carefully selected pairings intended to stimulate visual acuity, reflective thinking, or maybe just a smile. In their buildings, art museums expend great time and effort on the key activity of arranging permanent collection works in sequences and groupings that make some intellectual and aesthetic sense. Maybe the pairings in this volume can reflect some of that kind of activity. The juxtapositions are presented in chronological order, with the quirk that the order begins in the present and extends backwards in time. This undermines any sense of the "evolution" of art across the ages from prehistory to the present, and it mirrors our rootedness in the now as we explore the past and attempt to understand it.

The resulting album is less a compendium of "masterpieces from the collection" or "highlights from the collection," and more an anthology (in the root sense of a bouquet of flowers or beautiful things), a compilation of excerpts. In the end, "a selection from the collection" is surely the best, least complicated designation. May it kindle delight in, curiosity about, and enthusiasm for the full trove of treasures that the Ackland stewards for present and future discovery.

Peter Nisbet

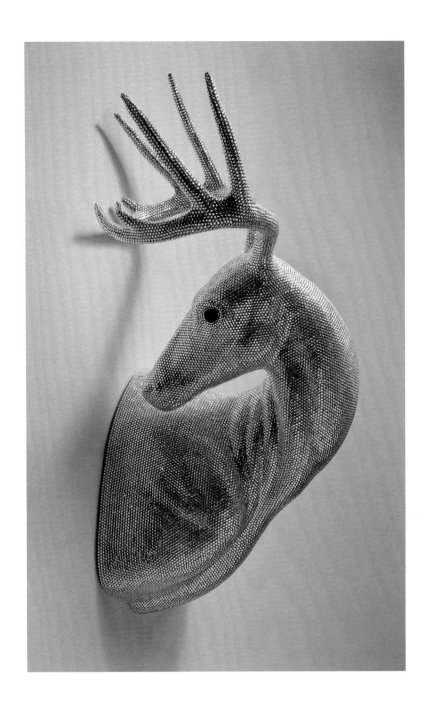

Marc Swanson
American, born 1969
Untitled (Looking Back Buck), 2004
crystals, polyurethane foam, and
adhesive
36 × 18 × 18 in. (91.4 × 45.7 × 45.7 cm)
Ackland Fund, 2012.11

A son of a small-town New England hunter, Marc Swanson spent his twenties immersing himself in San Francisco's gay culture scene. His artistic practice investigates the dualities inherent in these disparate life experiences. Covering modeled deer heads in materials like rhinestones (traditionally viewed as a kitschy decorative element), he creates a number of bejeweled sculptures. These works resemble gaudy hunting trophies, and they complicate the ideas of manliness often associated with such totems. There is also a touching hint of vulnerability in the exposed neck as the head turns back. Mortality emerges as a theme, alongside masculinity. Hanging on a museum wall, the work can invoke the tradition of relief sculpture and may also gently critique the collecting institution's celebration of masterpieces as the successful culmination of the hunt for acquisitions.

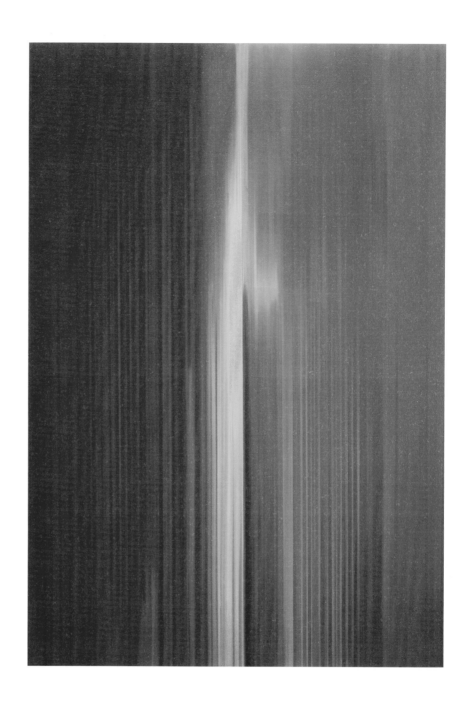

Rachel Howard
British, born 1969
Gluttony, 2002–03
household gloss on canvas
120 × 84 in. (304.8 × 213.4 cm)
Gift of Mr. and Mrs. John L. Townsend III,
2010.45

Gluttony is one in a series of paintings that Rachel Howard created to evoke Christianity's seven deadly sins. In these paintings, she allows household gloss paint to separate into pigment and varnish, applying the two materials separately, and frequently allowing gravity to determine the compositional aspects of the layers. The title's association with transgression lends the formal components a symbolic reading: the high-gloss finish and monumental scale make the work seem both tempting and overwhelming, whereas the vibrant reds and yellows warn of danger. There is an enjoyable tension between the utilitarian, everyday material of household paint and the seemingly profound, existential theme. Together with paintings named for the other six sins, this work was exhibited in 2003 in an exhibition entitled *Guilty*, though the artist averred that this referred at least in part to the "guilty" pleasure of painting.

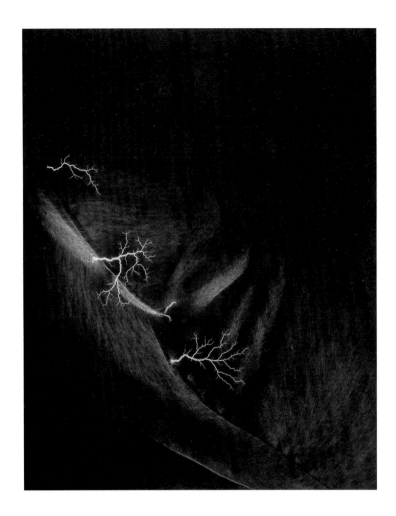

Hiroshi Sugimoto
Japanese, active in the United States,
born 1948
Lightning Fields, no. 176, 2009,
printed 2012
gelatin silver print
sheet: 58¾ × 47 in. (149.2 × 119.4 cm)
Ackland Fund, 2012.17

Sugimoto's elegant, large-scale photograph evokes the raw power of unmediated nature,
combining the macroscopic and the microscopic in an abstract composition that alludes
as much to dendritic nerve endings as to interstellar space. The dramatic effect of light
and dark was achieved by releasing a massive and hazardous electrical charge across a
photographic negative submerged in water. This sophisticated work situates itself in the
traditions of camera-less photography, the aesthetics of chance, and the sublime. The
artist undertook this series following a visit to Lacock Abbey in the United Kingdom, where
William Henry Fox Talbot (1800–1877) experimented with both photographic processes
and static electricity in the mid-nineteenth century.

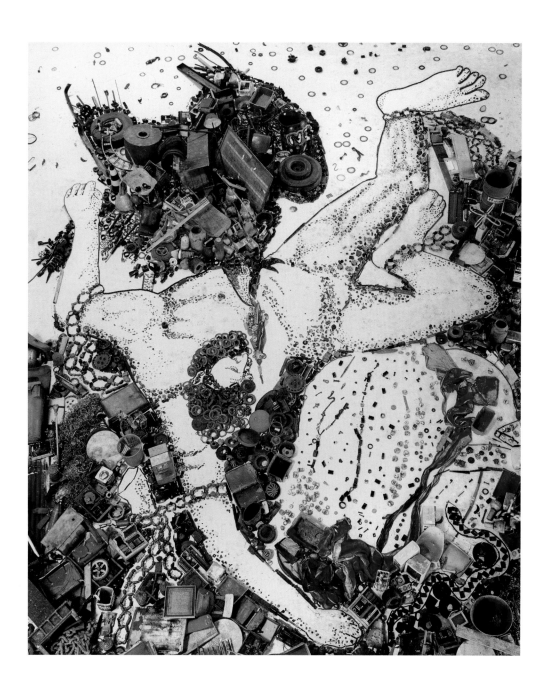

Vik Muniz
American, born in Brazil, born 1961
Prometheo, after Titian,
from *Pictures of Junk*, 2006
chromogenic print
50 × 40 in. (127 × 101.6 cm)
Ackland Fund, 2006.15

Muniz uses photography to create images out of nontraditional materials – from chocolate to peanut butter and jelly, from dirt to toys. This image, from his series *Pictures of Junk*, was made using garbage. The artist arranged domestic and industrial detritus on the floor of a warehouse to match a masterpiece in the European painting tradition, in this case Titian's *Prometheus* (c. 1565, Prado Museum, Madrid). In mythology, this Greek Titan was punished by Zeus for sharing fire with humans. Every day, his liver was eaten by an eagle; every day it grew back. With remarkable skill and powerful irony, Muniz photographs from an elevated gantry and renders Titian's canonical composition in discarded adding machines, crushed soda cans, rusted wire, nuts, bolts, and much else besides. The result wittily plays the putatively eternal value of great art against the ephemerality of everyday possessions.

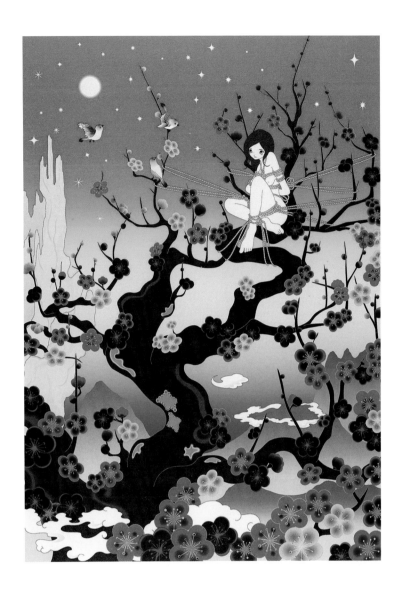

Chiho Aoshima
Japanese, born 1974
Japanese Apricot 2, 2005
offset lithograph
image: 31½ × 22⁵⁄₁₆ in. (80 × 56.7 cm)
Ackland Fund, 2005.28

Aoshima's print represents the fusion of old and new technologies: inspired by traditional Japanese woodblock printmaking, she executes her works using a modern computer imaging software program. The subject matter of this image is also a hybrid, combining conventional depiction of a surreal landscape with a darker theme in the image of the bound young woman, trapped in this seemingly innocent and paradisal nature, whose multiple plum blossom flowers, under the alternative name Japanese apricot, give this print its title. Reflecting the contemporary aesthetics of Japanese comics and animation, Aoshima's work is closely connected to the production of the Kaikai Kiki art collective founded by artist Takashi Murakami.

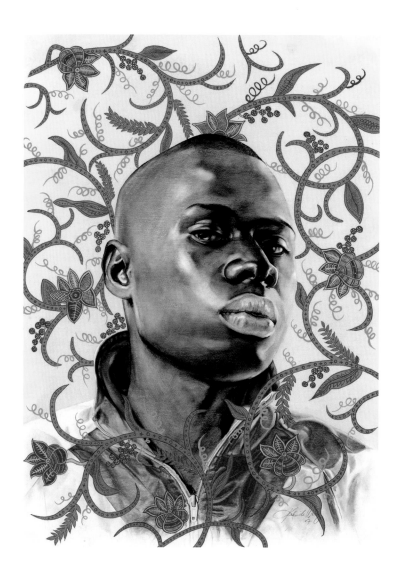

Kehinde Wiley
American, born 1977
Study for Idrissa Ndiaye, 2007
oil wash
sheet: 30 × 23 in. (76.2 × 58.4 cm)
Ackland Fund, 2008.7

Wiley's portraits of young Black men often draw on Renaissance and Baroque art, depicting the men in poses that have historically represented power and majesty in those eras. Through the application of these sixteenth- and seventeenth-century visual codes to his contemporary portraits, Wiley explores issues of social posturing and the construction of modern Black masculinities. Here, another intriguing collision of old and new is in play: the subject, a young man from Senegal, is surrounded by luxuriously curling and colorful vegetal forms inspired by eighteenth-century decoration. The relentlessly flat ornament sets off the assertively three-dimensional rendering of the head. Wiley has selected his subjects from the urban environment, approaching men on the street and inviting them to contribute to his work. Returning to his studio, Wiley photographs and sketches the subject in a particular pose, often of the model's own choosing, leading ultimately to a finished painting in oil.

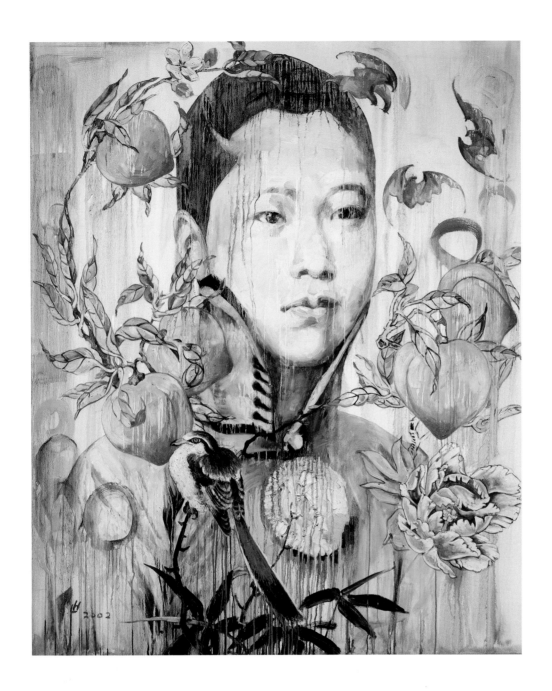

Hung Liu
American, born in China, 1948–2021
Peaches, 2002
oil on canvas
72 × 60 in. (182.9 × 152.4 cm)
Ackland Fund, 2002.7

Peaches is based on a historical photograph of a prostitute that Hung Liu discovered in a Beijing archive in 1991. Bringing a forgotten piece of Chinese history to light has enabled the artist to reclaim both the past and her own identity as a survivor of China's Cultural Revolution and, more recently, as a naturalized American citizen. The peaches and bats (often symbols for happiness) swirling around the woman's head were inspired by an eighteenth-century ceramic plate that the artist studied at the Asian Art Museum in San Francisco. Both the woman and the plate became objects for the pleasure, whether physical or aesthetic, of others, notably Westerners. The drips and flows of paint across the canvas add a melancholy mood of dissolution and loss.

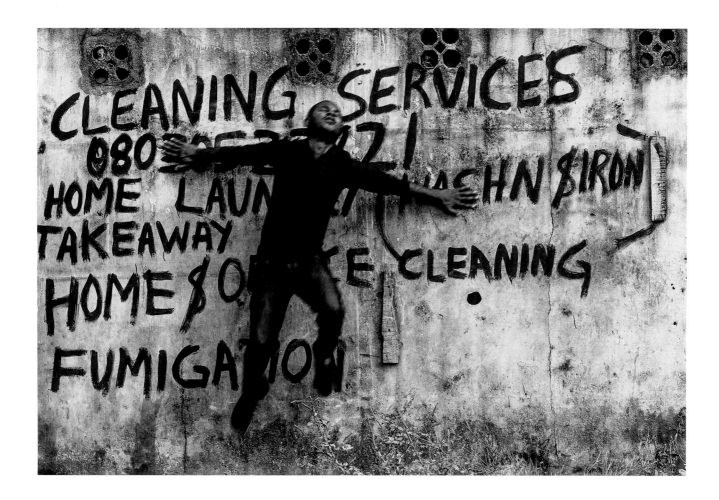

Abraham Oghobase
Nigerian, born 1979
Untitled 2, 2012
gelatin silver print
sheet: 20 × 30⅛ in. (50.8 × 76.5 cm)
Ackland Fund, 2013.26.3

African cities are among the fastest growing in the world. Oghobase explores the dynamism and experiential force of his native hometown, Lagos, the commercial capital of Nigeria, through photographs that emphasize performance. This photograph is one of a series in which the artist himself is shown jumping in a perhaps futile attempt to achieve a momentary liberation from the world of insistent commerce that characterizes the urban milieu. His eyes are closed, his back is turned to the advertising, which promises a different, more everyday kind of cleansing and release. Personal and business messages are juxtaposed in a shallow monochrome space.

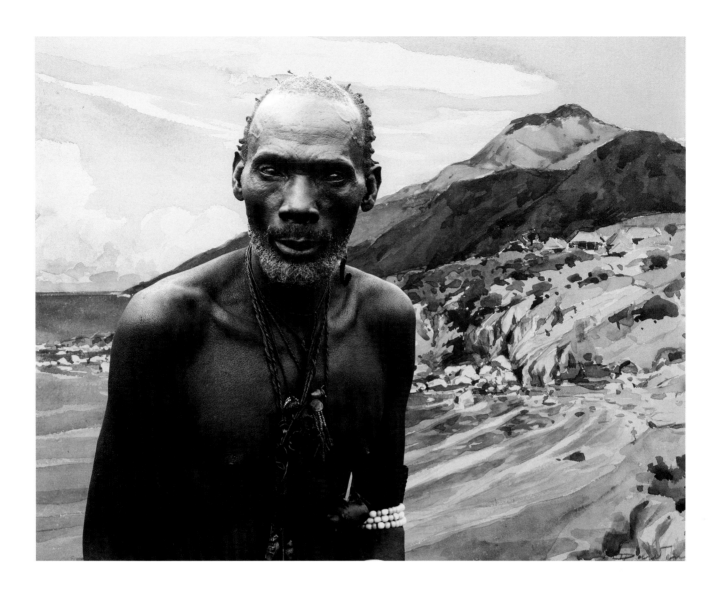

Sammy Baloji
Congolese, born 1978
**Portrait #1, Kalamata, Chief of the Luba,
against a Watercolor by Dardenne,
from *Congo Far West*,** 2011
archival digital photograph on
Hahnemühle paper
frame: 40½ × 51½ in. (102.9 × 130.8 cm)
Ackland Fund, 2016.6

This photograph belongs to the series *Congo Far West*, made by the artist while in residence at the Royal Museum for Central Africa in Tervuren, Belgium. Baloji combines two types of images produced by artists accompanying the 1898–1900 Lémaire Expedition, part of the colonial project to map Congo and collect natural and ethnographic specimens for study and display in Belgium. François Michel took photographs, including this portrait, while Léon Dardenne made landscape watercolors. The overlaying of the images at a large scale alters the viewer's relationship to the subjects. Kalamata is nearly life-size, towering over the shoreline and mountains, and appearing to stand immediately before us. The crisp focus of the black-and-white image contrasts with the fluid strokes of the landscape, posing questions about why the members of the Expedition chose to use these media, and what information viewers (in 1898 and today) expect photography and watercolor to communicate.

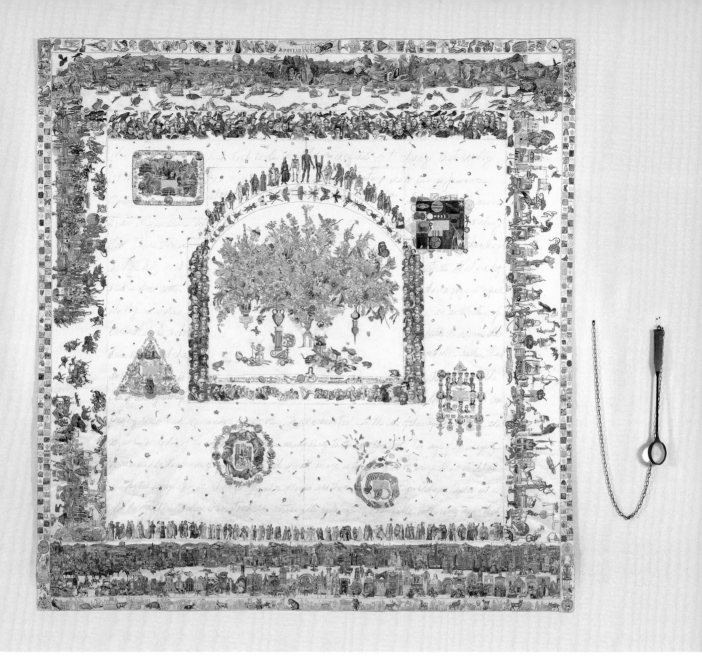

Aldwyth
American, born 1935
The World According to Zell, 1997–2001
collage on Okarawa paper with pencil
inscription and every illustration in
Zell's Popular Encyclopedia (1871),
with magnifying glass
sheet: 79 × 76 in. (200.7 × 193 cm)
Ackland Fund, 2010.41

Aldwyth, who dropped her first name to downplay her gender, created this epic collage over the course of four years, during which she carefully cut all of the wood engravings out of the 1871 edition of *Zell's Popular Encyclopedia* and pieced them together into a new, whimsical, and subversive encyclopedia of her own. Famous buildings have been amassed into new cities, mismatched fish swim below a fantastic landscape, and birds roost on the heads of distinguished historical figures. The collaged elements are pasted over and partly obscure a handwritten text about digital and analog information. An old-fashioned magnifying glass is provided to enhance legibility and encourage scrutiny. Many of the artist's large-scale collages and smaller sculptural objects address questions of cultural authority, dismantling and critiquing publications, institutions, professional expectations, and classifications.

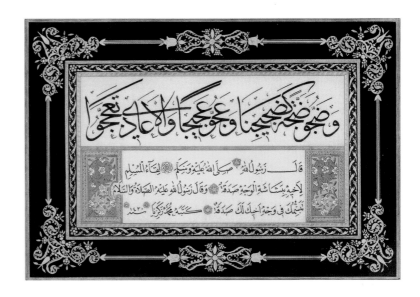

Mohamed Zakariya
American, born 1942
Tongue-Twister Kit'a, late 20th century
ink, color, and gold leaf
9³⁄₈ × 13¹⁵⁄₁₆ in. (23.8 × 35.4 cm)
The William A. Whitaker Foundation Art
Fund, 2002.36

In his contemporary calligraphy, Zakariya aims to infuse his own sensibility into styles of writing and ornament practiced in Turkey under the Ottoman Empire. In the artist's words about this *kit'a* (small piece of calligraphy),

> the top line is a favorite of calligraphers – a visual as well as linguistic tongue-twister that says, "and they raised a loud noise like our noise, and they roared a great roar and the enemy also roared." It is followed by two hadiths (sayings of the Prophet Mohammed): "When a Muslim meets his brother with a cheerful face, it is a kind of charity" and "Smiling to your brother is charity."

The contrast between hostile armies facing each other and friendly individuals greeting each other is mirrored in the contrast between the styles of the inscriptions: the first one bold, agitated, and tangled; the other two neat, orderly, and punctuated by floral ornament.

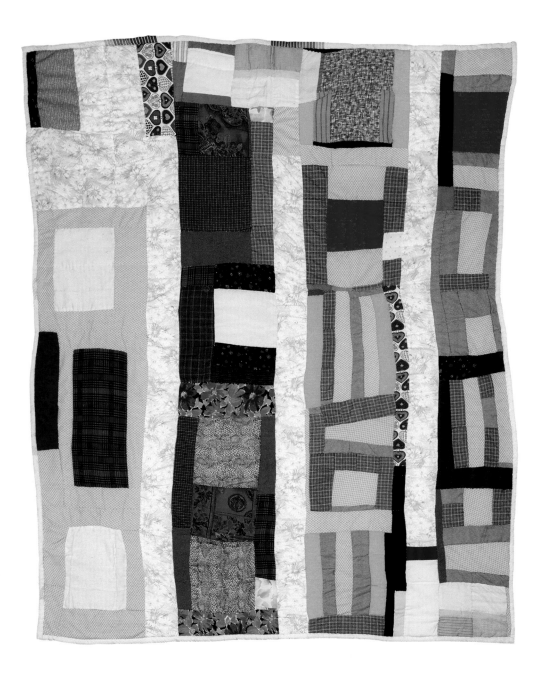

Irene Williams
American, 1920–2015
Quilt (Lazy Gal/Housetop Variation),
2004
found textiles
94 × 79 in. (238.8 × 200.7 cm)
Gift of the Arnett Collection and Ackland
Fund, 2010.52.8

Irene Williams was a member of the famed community of Black quilters centered on Gee's Bend, Alabama. Continuing a tradition that may date back to the nineteenth century, the women of Gee's Bend received national attention during the civil rights era as a cooperative, the Freedom Quilting Bee, and then in the 1990s and beyond as exponents of an aesthetically vibrant and distinctive quilting practice. Williams, who began quilting when she got married at age seventeen, lived in a remote area on the outskirts of town, and developed a personal approach to the various traditional patterns prevalent among the quilters. This example combines the simple vertical strips of the appropriately named "Lazy Gal" pattern with a lively variation on the concentric squares of the "Housetop," creating complex rhythms across the four principal columns of the pictorial surface.

Thornton Dial
American, 1928–2016
New Generation, 2002
wood, cloth, metal, wire, and paint
approximately 69½ × 60 × 17 in.
(176.5 × 152.4 × 43.2 cm)
Gift of the Arnett Collection and
Ackland Fund, 2010.51.1

Dial is perhaps best known for his monumental mixed-media paintings and assemblages. He carefully collects used objects which he believes are imbued with love and labor from the past and arranges them into sculptures that comment on the social and political issues of the day, including the struggles and resilience of African Americans. He produced this two-sided piece after meeting the celebrated quilters of Gee's Bend, Alabama, who, like Dial, use recycled materials. The fabric visible on one side of *New Generation* may allude to the artistic tradition of quilting (typically done by women). The other side, with painted wood, may invoke the tradition of making wood root sculptures (principally made by men). Perhaps the sculpture points toward the generating of new creators produced by this union of male and female.

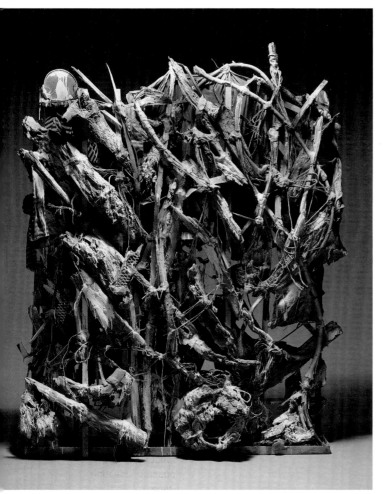
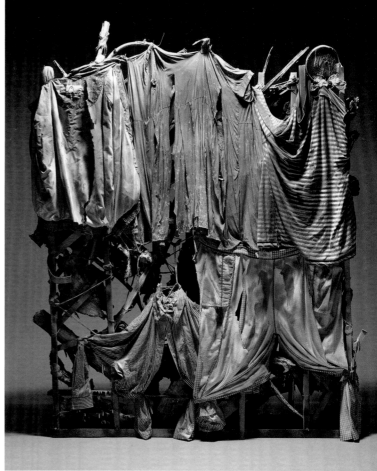

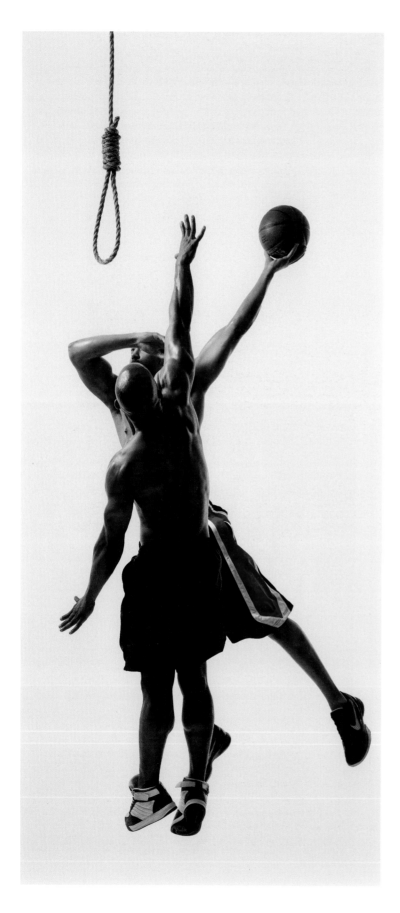

Hank Willis Thomas
American, born 1976
And One, 2011
digital chromogenic print
sheet: 60 × 28½ in. (152.4 × 72.4 cm)
Ackland Fund, 2016.30

Combining conceptual provocation and visual impact, this photograph aligns ways in which Black male bodies have been made a spectacle within dominant American culture. Staging a public show of the lynching of African Americans is here conflated with the exploitation of Black basketball players in professional sports. The title *And One* cites the phrase for a free throw earned after a player is fouled in the process of shooting the ball and making the basket. The implied foul may evoke the larger theme of Black-on-Black violence, a longtime concern of the artist. The two players are certainly opponents, one wearing Nike shoes, the other maybe the AND1 brand perhaps also evoked by the title. In this context, the commercial branding of sports marketing parallels the branding of enslaved peoples as a sign of ownership. Above the Black bodies, in place of the expected hoop and net, Thomas positions a startling and ominous noose.

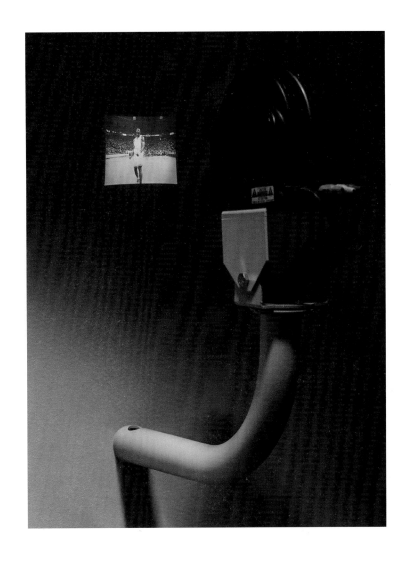

Paul Pfeiffer
American, born 1966
**Fragment of a Crucifixion
(after Francis Bacon)**, 1999
color video installation with projector
and mounting arm
overall: 20 × 5 × 20 in.
(50.8 × 12.7 × 50.8 cm)
4 seconds, looped
Gift of James Keith Brown and Eric
Diefenbach in honor of Carol Folt,
UNC Chancellor 2013–2019, 2019.13

This work uses a commercial video of a basketball game, showing the scene immediately after a player dunks the ball. All other players have been edited out of the scene, as has any specific evidence of the game itself (jersey numbers, advertising). The artist has spoken of this scene of intense but indeterminate emotion in a single figure surrounded by crowds and lights as perhaps an archetypal image of our time.

The artist's title refers to the work of the postwar British expressionist painter, Francis Bacon (1909–1992), and in particular his 1950 canvas showing a wide-mouthed, agonized creature, similarly isolated and emotional, on a cross-like form (Van Abbemuseum, Eindhoven, The Netherlands).

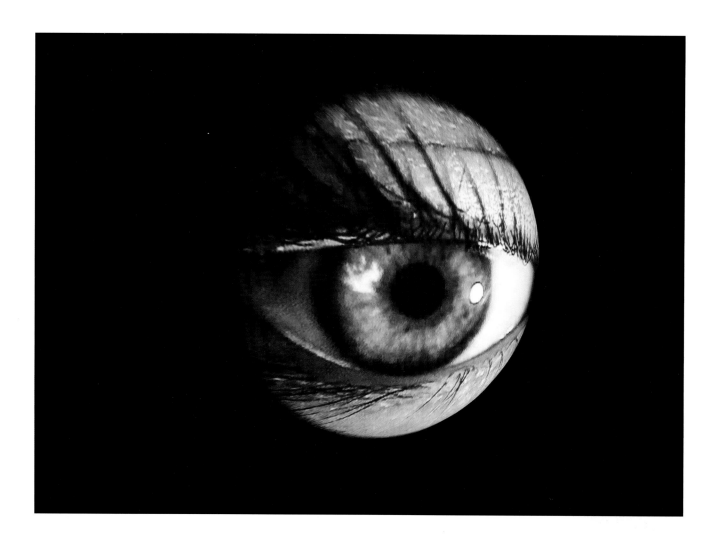

Tony Oursler
American, born 1957
Eye in the Sky 1997, 1997
mixed-media video installation:
projector, DVD, DVD player, 18-inch
fiberglass sphere, acrylic paint,
and tripod light stand
dimensions variable
13 minutes, 25 seconds, looped
Ackland Fund, 2000.11ab

Oursler's work, which combines sculpture, video, and performance, deals with the psychological effects of mass media and the visual processing of information. Watching and being watched became key themes, notably in works like *Eye in the Sky, 1997*. Without a body or face to convey expression, a single eye, belonging to the artist's collaborator, the performance artist Mary N., compulsively watches the rapidly changing channels on a television screen that is reflected in its iris. As the eye consumes endless fragments of weather broadcasts, game shows, and commercials, we imagine what effects popular culture's obsession with television has on our psyches. Like some strange creature from a science-fiction film or surreal dream sequence, Oursler's disembodied eye is a metaphor for the human condition in a media-saturated age.

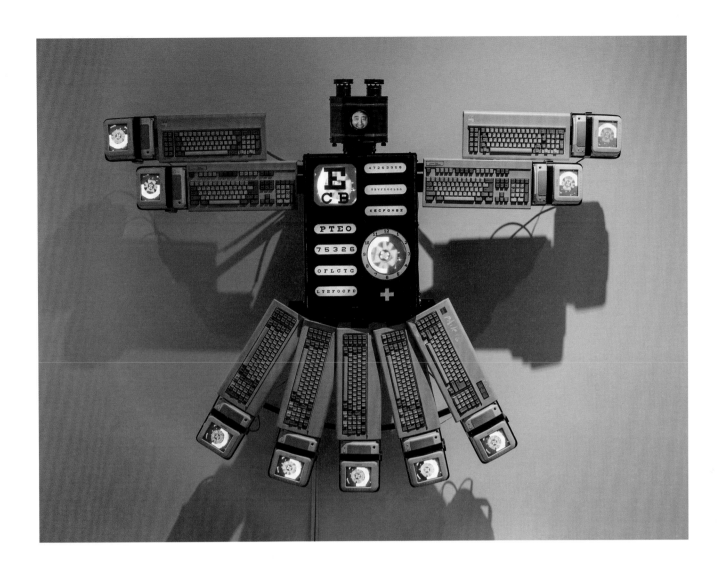

Nam June Paik
South Korean, active in the United
States, 1932–2006
Eagle Eye, 1996
antique slide projector, aluminum,
computer keyboards, eye chart, neon,
nine 5-inch televisions, two 9-inch
televisions, DVD player, and DVD
66¹¹⁄₁₆ × 86⅜ × 24½ in.
(169.4 × 219.4 × 62.2 cm)
20 minutes, 39 seconds, looped
Ackland Fund, 99.8

Paik began his career as a musician and performance artist but is best known for his
pioneering work in video. Paik described works like *Eagle Eye*, however, as collages
of found objects. The inspiration for *Eagle Eye* was an antique eye chart and the work
has an underlying theme of clarity and accuracy of vision, perhaps the vision of the
artist represented in a smiling self-portrait photograph. The combination of outdated
technologies like the slide projector with (then) more current ones like the DVD also
suggests a cycle of innovation and obsolescence. The video on the screens presents a
kaleidoscope of pulsating images programmed and edited with the aid of a computer.
Satellite photographs of Earth and a solar eclipse intermingle with images of American
missiles. Inspired by both the spirit of Zen and the ever-changing dynamics of American
society, Paik juxtaposes opposing aspects of technology that continue to haunt humanity.

Ken Price
American, 1935–2012
The Squeeze, 1995
ceramic and acrylic
19½ × 27½ × 14½ in.
(49.5 × 69.9 × 36.8 cm)
Gift of Linda and Donald Schlenger,
2005.9

Trained and based largely in California, Ken Price was a noteworthy sculptor who spent much of his career exploring the possibilities of clay and ceramics as a medium, with particular attention to inventive form and surface treatment. In *The Squeeze*, the exuberant but slightly ominous biomorphic form comes alive through the luminous opalescence of its colored surface. By 1983, Price had dispensed with using glazes on his ceramics and achieved this effect by painting scores of different layers of acrylic colors on the surface and then wet- and dry-sanding at different rates through those paints. Eruptive surfaces, an enigmatic orifice, and hints of limbs combine to create an unsettling, unclassifiable object.

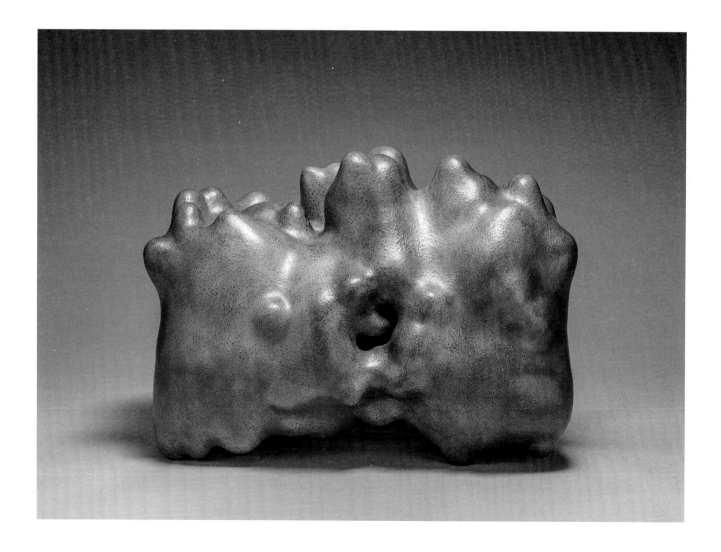

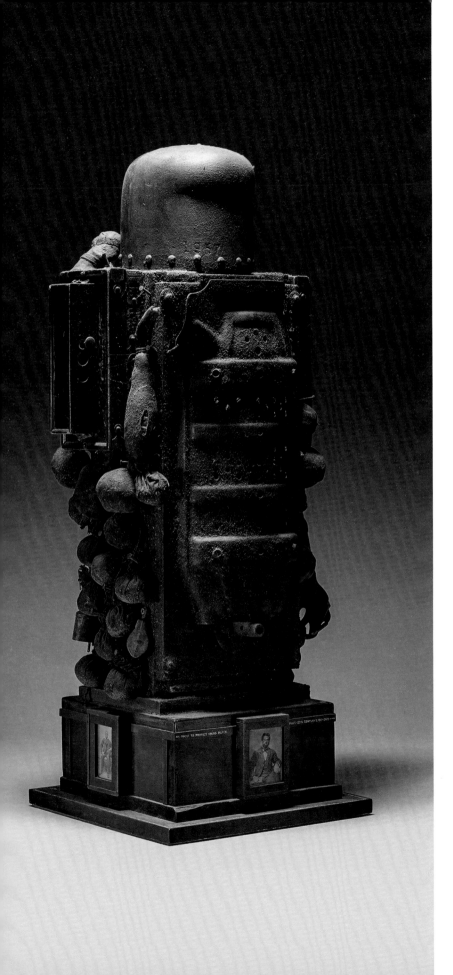

Renée Stout
American, born 1958
Ogun, 1995
wood, metal, and other found materials
34½ × 16¾ × 13½ in. (87.6 × 42.6 × 34.3 cm)
Ackland Fund, 97.6.1

In addition to the technique of assemblage familiar from European and American art since the beginning of the twentieth century, Stout evokes two distinct African cultural traditions in this work. It represents Ogun, the Yoruba (Nigerian) god of iron and war, but it is constructed like the *nkisi* figures of the Kongo culture, objects that accrue power from various additions to the original carving. Similarly, Stout created *Ogun* as an assemblage of various materials with special meaning for her, including parts of her old computer and tintype photographs that (symbolically) represent her male ancestors. The work carries an inscription: "An nkisi to protect young black males. Twentieth century & beyond [arrow]." Stout feels a family connection to Ogun's strong and protective energy, especially as it affects metal and machines. Her grandfathers worked in Pittsburgh steel mills, her father is a mechanic, and she uses power tools herself as a sculptor.

Sebastião Salgado
Brazilian, born 1944
Church Gate Train Station, Bombay, India, from *Migrations: Humanity in Transition*, 1995
gelatin silver print
image: 20⅛ × 30½ in. (51.1 × 77.5 cm)
Ackland Fund, 2004.19.1

Having trained and worked as an economist, Salgado turned to photography in the 1970s, prompted by his professional experiences in Africa. He subsequently joined significant photo agencies, notably Magnum in 1979. Many of his documentary projects focus on global issues affecting humanity, especially the plight of workers in the modern economy. This photograph is from his second series, *Migrations: Humanity in Transition*, which considered population growth and the displacement around the world. Salgado captures the seething mass of humanity at one of the major stations in Bombay (now Mumbai). In a composition firmly anchored in symmetry, geometry, and the central elevated standpoint, blurred forms of individuals ebb and flow to the rhythms of modern urban life. The subtle commentary of the image is enhanced by the ironic force of the brand name "Wills" hovering above platforms and the single solitary standing figure at the left, observing the tumult.

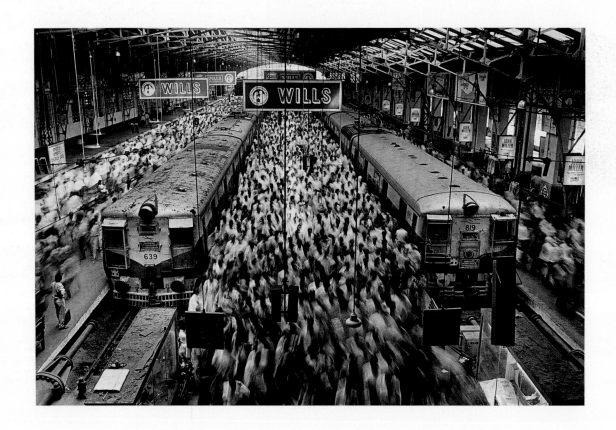

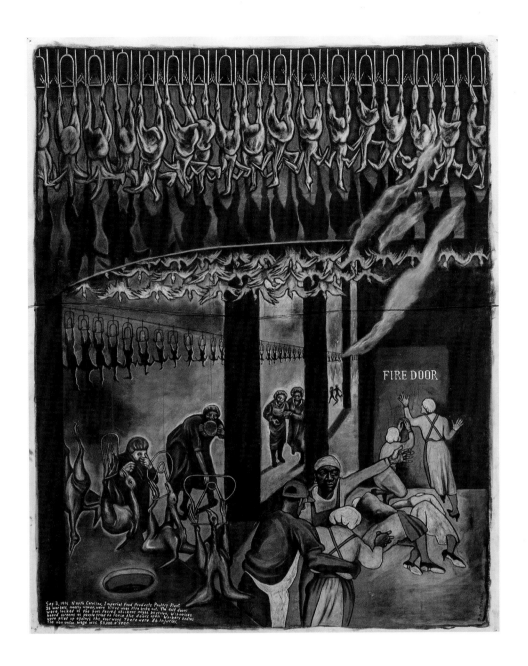

Sue Coe
British, born 1951
Poultry Packing Fire, 1991
pastel, gouache, and graphite
49 × 40 in. (124.4 × 101.6 cm)
Ackland Fund, 96.14

"Sept 3, 1991 North Carolina, Imperial Food Products Poultry Plant
25 workers, mostly women, were killed when fire broke out. The exit doors were locked
as the boss feared chickens might be stolen. Witnesses heard screams as people
tried to force the doors open. Workers bodies were piled up against the doorways.
There were 86 injuries. The non union wage was $11,000 a year."

The drawing's inscription emphasizes several facts about a real disaster in Hamlet, North
Carolina. The imagery vividly conveys the horrors of the event, combining factual details
and artistic license. Dark tones punctuated with red and yellow suggest smoke, fire,
violence, and death. The rows of dead chickens foreshadow the fire's human casualties.
The story aligns closely with two political issues important to Coe: economic inequality and
animal rights. This drawing was part of an exhibition and publication called *Dead Meat*,
focused on the American meatpacking industry.

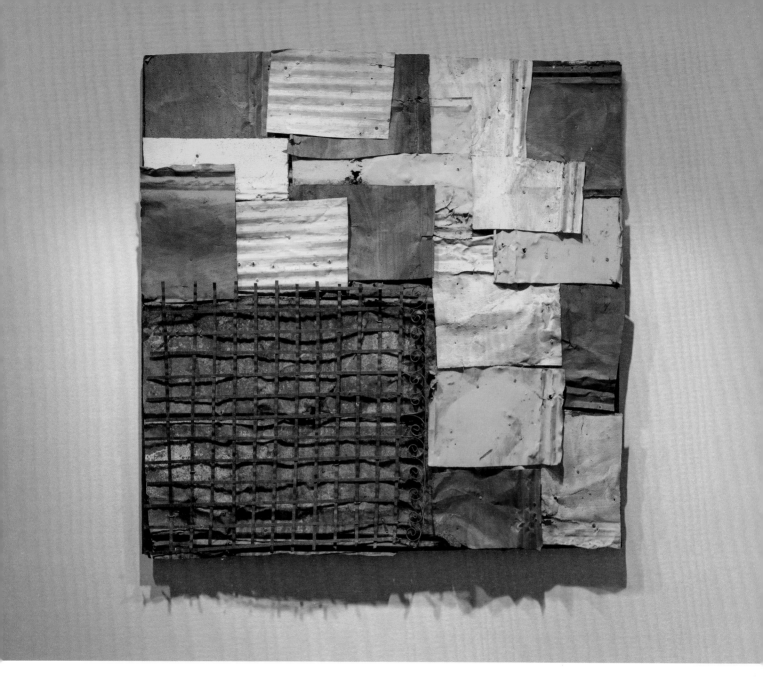

Ronald Lockett
American, 1965–1998
Remembering Sarah Lockett, c. 1997
found metal, wire, wood, and paint
approximately 48 × 48 × 2 in.
(121.9 × 121.9 × 5.1 cm)
Gift of the Arnett Collection and Ackland
Fund, 2010.52.5

Sarah Lockett was Ronald Lockett's beloved great-aunt, the woman who raised him.
He was devastated when she died in 1995 at age 105, and this work is an homage to her.
Its composition of colored squares recalls the patterns of the quilts she was known for
making, and its textures, perhaps, recall the weave of the cloth blocks she used. Whereas
her materials were recycled fabric, Lockett used pieces of recycled roofing metal, which he
trimmed, painted, and attached to a wood support with wire. The metal grille in the lower
left corner reinforces the grid-like pattern of the overall collage – and suggests the form of
a quilt. Around this time, Lockett made collages with cut metal squares about other topics,
notably the bombing of the Alfred P. Murrah Federal Building in Oklahoma City, but in
Remembering Sarah Lockett the structure aligns with its subject in an especially
poignant way.

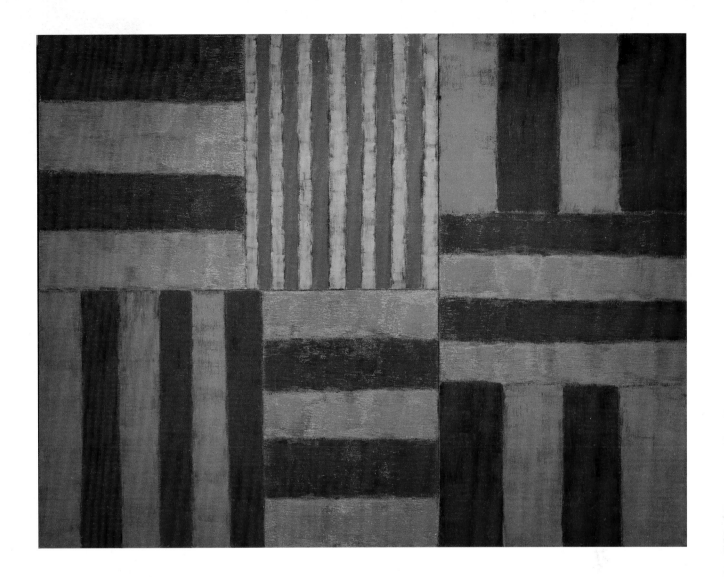

Sean Scully
American, born in Ireland, born 1945
Red Durango, 1991
oil on linen
100 × 130 × 3½ in. (254 × 330.2 × 8.9 cm)
Gift of Mary and Jim Patton to honor
Josie Patton, 2001.29

Over the course of his long career, Scully has developed a vocabulary for the stripe that expresses a wide range of emotions and ideas. Within a seemingly narrow range of formal choices, the artist has produced brilliantly nuanced effects by experimenting with the dimension, color, and composition of the stripe in its vertical, horizontal, and diagonal orientations. By constructing his paintings on a heroic scale in multi-paneled arrangements, he injects a sculptural quality that heightens the work's impact. As an art student in the late 1960s, Scully became acquainted with the paintings of Mark Rothko (1903–1970), whose spirit can be sensed in such works as *Red Durango*. Multiple layers of oil paint; soft, irregular edges; and rich colors that seem to emit light characterize this important work, whose title refers to an area in Mexico rich in minerals and ferrous metals.

Carl Chiarenza
American, born 1935
Untitled 174, 1990
gelatin silver print
60 × 48 in. (152.4 × 121.9 cm)
Ackland Fund, 94.3

Chiarenza has developed a conceptual form of picture-making that derives from a dissatisfaction with landscape and nature photography. Since 1979, his dramatic black-and-white images have been made using models of card, foil, and other materials, constructed in the studio. Rhythms of light and shade combine with pattern, texture, and tone across a relatively shallow space to create compositions that seem unmoored from specificities of time and place. Most prints, such as this one, are identified simply as *Untitled* with a number. Having studied in his native town at the Rochester Institute of Technology with, among others, Minor White, Chiarenza also has had a distinguished career teaching art history and photography. He earned his PhD from Harvard University in 1973 with the institution's first ever dissertation on a living artist, Aaron Siskind.

Kenneth Noland
American, 1924–2010
Doors: One O'Clock Jump, 1989
acrylic on canvas on panel with Plexiglas
80 × 37½ in. (203.2 × 95.3 cm)
Gift of Julie and Lawrence B. Salander,
in honor of Richard B. Gersten, Class of
1970, 2003.34.19

Kenneth Noland achieved considerable fame in
the late 1950s and 1960s with paintings of bold
and simplified forms such as concentric circles,
chevrons, and stripes rendered in vibrantly
contrasting colors often separated by white
borders. Noland's *Doors* series of the late 1980s
extends those investigations, exploring the
space between painting and relief sculpture. In
this example, titled after Count Basie's 1937 jazz
instrumental standard, squeegeed acrylic paint is
built up into tactile surfaces. Protruding Plexiglas
dividers separate the three panels that had been
contiguous when painted, thereby interrupting
the flow and emphasizing the materiality of the
delicately colored medium. The human scale of
the panels, probably cut from a hollow-core door,
resonates with the obviously manual gestures of
paint manipulation to create a work to which the
viewer can relate in terms of the body as well as
the eye.

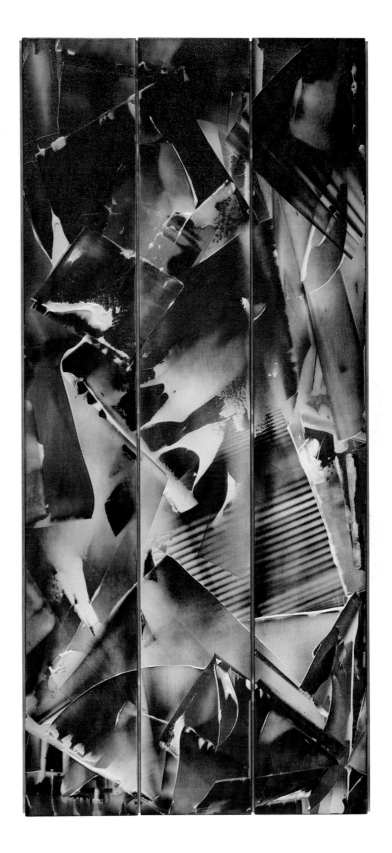

Allan C. Houser
American, Chiricahua Apache, 1914–1994
Next Generation II, 1989
bronze
61 × 92 × 74 in. (154.9 × 233.7 × 188 cm)
Gift of Hugh A. McAllister Jr., MD '66 in
honor of his father Hugh A. McAllister Sr.,
MD '35, 2012.3

Alan C. Houser's monumental abstract sculptures conjure many associations, from ancient rock formations to the human form, evoking universal themes that often transcend physical boundaries. In this work, two linked concave forms, one slightly larger than the other, swirl toward one another, creating one integrated organic mass. Their interplay suggests a human relationship between an elder and a youth, perhaps a parent and a child or a teacher and a student, through which knowledge and traditions pass from one generation to the next.

The notion of transmission was especially integral to Houser's role as an artist and teacher. Centering his work on his Chiricahua Apache heritage, Houser combined his personal vision with the twentieth-century modernist aesthetics of artists like Constantin Brancusi and Henry Moore. His artistic influence, particularly in sculpture, reached thousands of young American Indian artists during his nearly twenty-five-year teaching career.

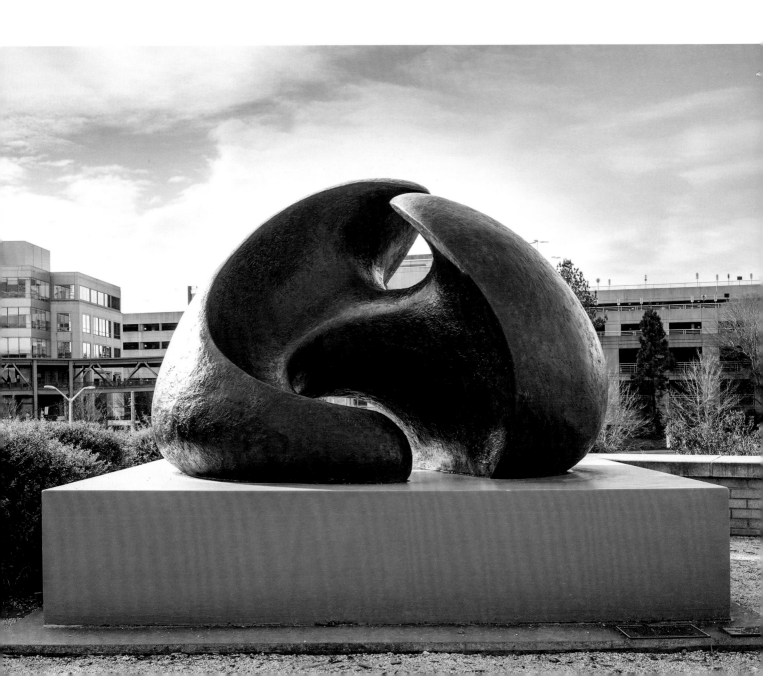

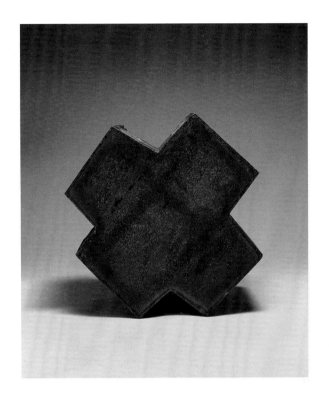

Richard Nonas
American, 1936–2021
**Points North (for John and Irma
Honigmann)**, 1980
steel
15½ × 15 × 8 in. (39.4 × 38.1 × 20.3 cm)
Gift of the Artist, 90.99

Richard Nonas studied anthropology at the University of North Carolina at Chapel Hill from 1961 to 1963. During this time, he developed a close relationship with his professor, John Honigmann, and his wife, to whom this sculpture is dedicated. After publishing his ethnographic research on Native Americans and teaching briefly in New York City, Nonas abandoned the field to become an artist in 1966. He has created sculptures that use industrial materials, modular units, and geometric abstraction to influence people's perceptions of space and environment, establishing a sense of time and place. Many of his large-scale installations in galleries and the outdoors define boundaries, reflecting his fieldwork in the southwestern desert. The cross form and title of this work invoke orientation to the points of the compass, making the sculpture a kind of site-marker, though a phenomenological rather than a geographical one.

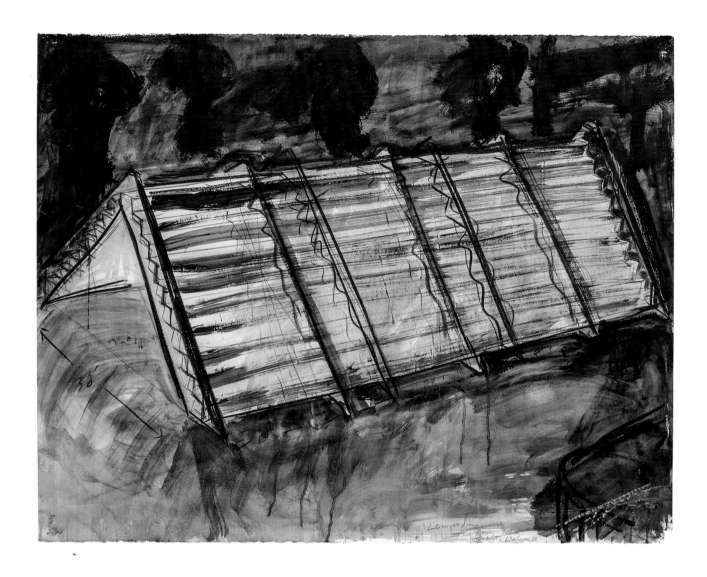

Bruce Nauman
American, born 1941
**Study for Stadium Piece, Late Night
Version**, 1983
graphite, charcoal, black and gray wash,
black and yellow paint
34⁵⁄₁₆ × 50 in. (87.2 × 127 cm)
The Madeleine Johnson Heidrick Fund,
86.3.1

This drawing is a study for an unrealized commission, *Abstract Stadium*, for the University of New Mexico in Albuquerque. The design of back-to-back bleachers subverts the conventional understanding of spectators at a stadium and allows Nauman to explore the psychological and emotional implications of physical environments that underscore the conditions of seeing and being seen. This night view, showing a placement between a structure in the foreground and maybe trees behind, reveals the intense yellow light that the artist proposed for the underside of his inverted V, a ghostly and discomfiting passageway reminiscent of other such disorienting corridors and uncanny spaces that Nauman has made during his career. A more elaborate version of the stadium was eventually completed in the late 1990s on the campus of Western Washington University, in Bellingham.

H. C. Westermann
American, 1922–1981
Vent for a Chicken House, 1967
wood, leather, and metal
$73^{15}/_{16} \times 38\frac{1}{2} \times 18\frac{1}{2}$ in. (187.8 × 97.8 × 47 cm)
National Endowment for the Arts and North
Carolina Art Society Purchase Funds, 74.14.1

Vent for a Chicken House is one of the largest
sculptures by H. C. Westermann, a sculptor known
for melding exquisite craftsmanship with socially
engaged, often surreal messages. He made it for
friends whose new home in an old chicken barn had
a ventilation system that allowed various animals
to enter. Formally, the sculpture refers to domestic
architecture, with its tall walls and gabled roof.
On the wood plank at the top of the roof, the artist
carved a schematic human figure, a star, and a
rocket. On the interior, but visible through openings,
he affixed a plastic relief of a log cabin and a drawing
of a dog. Through this proliferating series of evocative
references, Westermann is surely provoking reflection
on the image and idea of home in the postwar era.

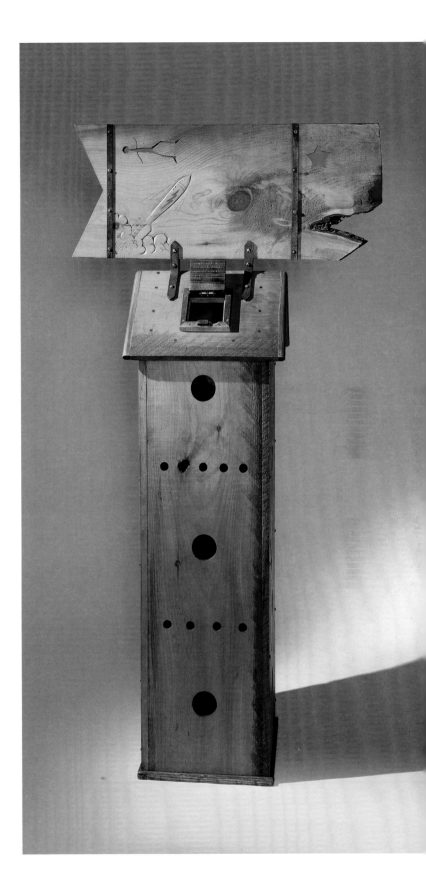

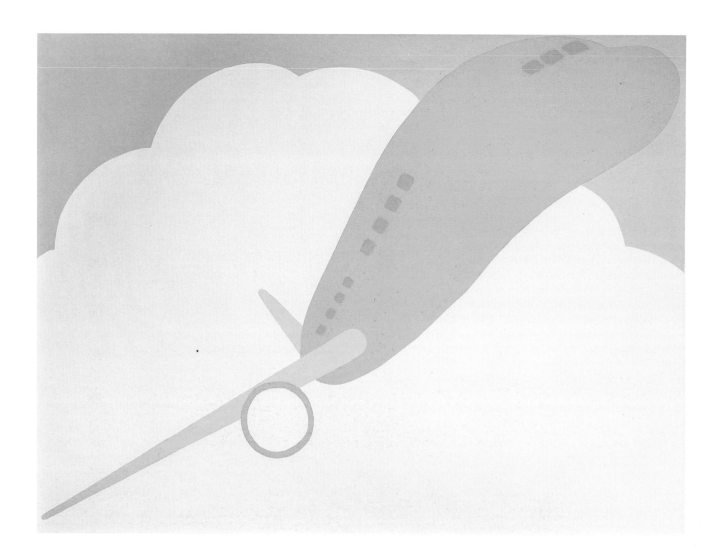

John Wesley
American, 1928–2022
Boeing, 1982
acrylic on canvas
41½ × 55 in. (105.4 × 139.7 cm)
Ackland Fund, 2011.3

Wesley emerged onto the art scene in the early 1960s. His paintings since then have come to be characterized as sharing aspects of Pop Art (such as cartoon imagery and style) and Surrealism, with their invocation of memory, desire, and fantasy. *Boeing* displays all the best characteristics of Wesley's painting: his lyrical, almost rococo colors (his reduced, flat, and unmodulated palette of pink, coral, blue, and white); his taut and balanced composition, rotating around the engine-circle in a remarkably flat picture plane, emphasized by the use of the white framing line to enhance the tension; sensuous (and whimsically erotic) curving contours. The image may initially seem banal and childlike but reveals itself to be both enigmatic and perhaps even autobiographical, as one of Wesley's first jobs was as a technical draftsman, rendering blueprints of advanced aircraft designs into simplified drawings readily understood by those building the plane.

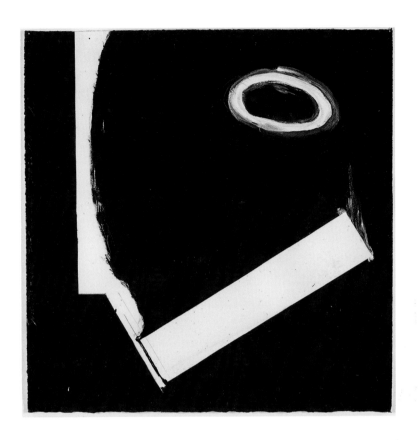

Donald Sultan
American, born 1951
Smokestack-Cigarette-Smoke Ring,
1980
ink, graphite, and spackle
18³⁄₁₆ × 17¹⁵⁄₁₆ in. (46.2 × 45.6 cm)
The Madeleine Johnson Heidrick Fund,
85.35.1

Sultan made this drawing seven years after graduating from the University of North Carolina at Chapel Hill in 1973. In the intervening years, he had studied at the School of the Art Institute of Chicago, moved to New York City, and begun to exhibit paintings and prints that resonated with the post-minimalist hunger for images. A number of his works around 1980 engage with the subject matter of *Smokestack-Cigarette-Smoke Ring*, a trio of associated objects here combined into a forthright still life that, perhaps inadvertently, evokes the profile face, with eye, mouth, and nose. The artist balances the hard-edged industrial architecture against the soft ephemeral smoke, surrounding all the forms with his characteristic black. The use of white spackle gives texture to a few places and reminds the viewer of Sultan's commanding use of linoleum, tar, plaster, and other materials in his paintings.

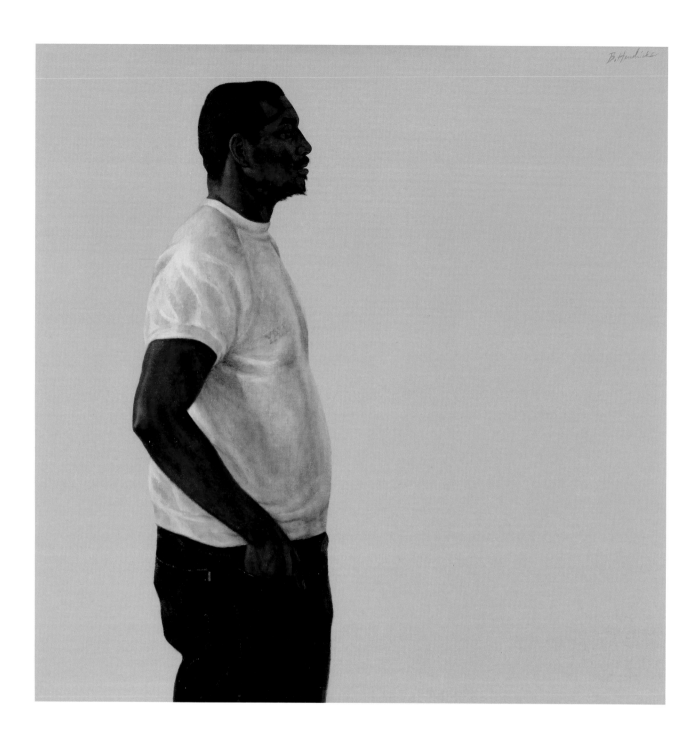

Barkley Hendricks
American, 1945–2017
**New London Niggah/Big Chuck
(Charles Harvey)**, 1975
oil and acrylic on linen canvas
48 × 48 in. (121.9 × 121.9 cm)
Ackland Fund, 2008.6

Hendricks is best known for his bold, life-size portraits of Black people, often from the urban Northeast. As in this example, he takes a sympathetic "everyman" and ennobles the figure by placing the self-confident, proud pose against a strikingly abstract field of blue. Charles Harvey was a friend of the artist who occasionally attended the classes that Hendricks was teaching as professor of art at Connecticut College in New London. The assertiveness of the image is matched by the title's forceful use of a traditional racial slur in a vernacular version sometimes used by African Americans as a gesture of reclamation.

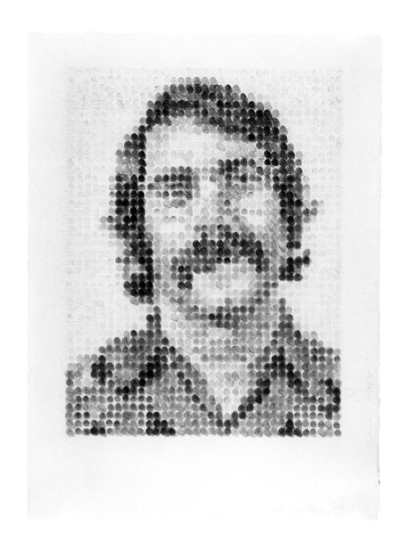

Chuck Close
American, 1940–2021
Robert/Fingerprint, 1978
graphite and stamp pad ink
sheet: 29¾ × 22¼ in. (75.6 × 56.5 cm)
Ackland Fund, 79.6.1

From the 1960s, Close reinvigorated the genre of portraiture. His technique has often been related to photorealism, but he has also deployed a grid-based method driven by system and experiment. *Robert/Fingerprint* epitomizes that kind of portrait. Based on a photograph, the image of Robert is seen as if through a double veil: the lattice structure that Close set up as a framework for the image and the inky fingerprints with which he created it, fingerprints that are in their way symbolic of Close himself. The sitter is obscure, identified later by the artist as Robert Ellson, a friend of his wife from junior high school, who went on to work in finance. At this point, Close wanted to make portraits of anonymous, everyday people. As with many of his other sitters, Robert appears several times in Close's oeuvre, in a range of media.

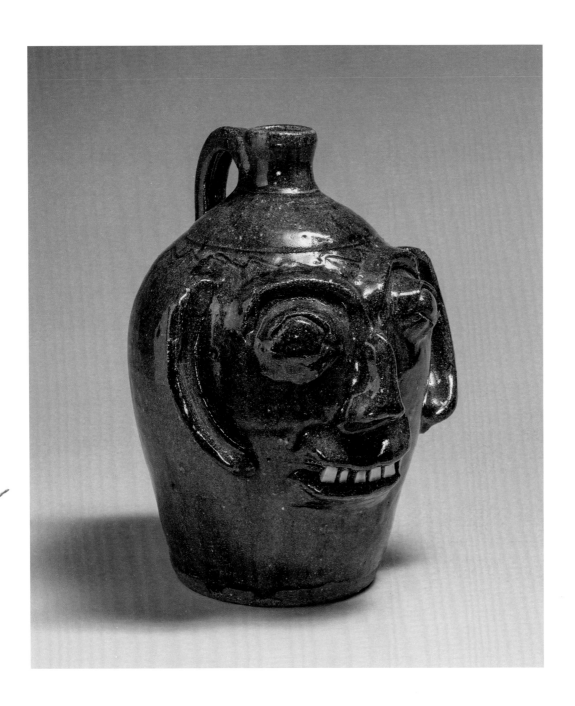

Burlon B. Craig
American, 1914–2002
One-Gallon Face Jug, 1980
alkaline-glazed stoneware
10⅝ × 8¾ × 7¾ in. (27 × 22.2 × 19.7 cm)
Gift of Mr. and Mrs. Charles G. Zug, III,
80.36.2

In the United States, the heritage of the face jug stretches back to African American potters in Edgefield District in South Carolina in the years around the Civil War. In the twentieth century, these jugs became a popular expressive format, notably with the work of Burlon B. Craig. Deeply influenced by the alkaline-glaze stoneware traditions of his native western piedmont of North Carolina, Craig began in the 1970s to expand his repertoire beyond exclusively functional objects. This jug sports a face that is less grotesque and grimacing than some, focusing instead on the balanced rhythms and curves of the facial features and their placement on the well-proportioned body of the jug.

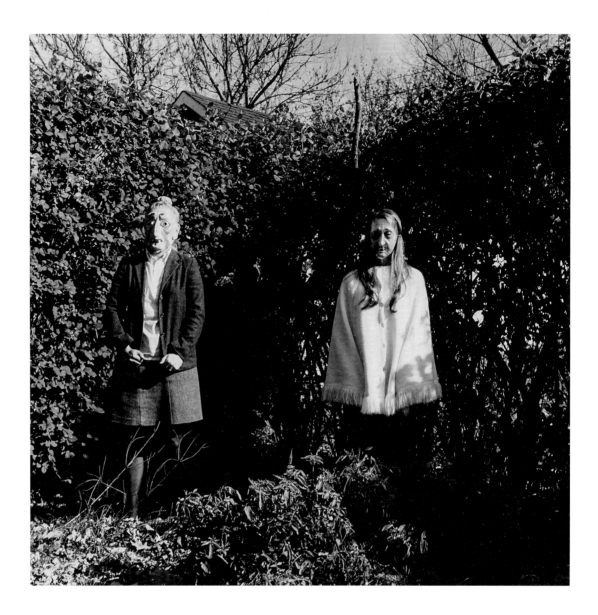

Ralph Eugene Meatyard
American, 1925–1972
Lucybelle Crater and her 20 year old son's legless wife Lucybelle Crater,
1970–72
gelatin silver print
image: 7⅝ × 7⅝ in. (19.4 × 19.4 cm)
The William A. Whitaker Foundation Art Fund, 2014.33

This is a hauntingly mysterious photograph. Two figures stand against suburban bushes, both wearing grotesque masks, one seemingly hovering in the air. One shows hands, the other not. One is dressed in a dark outfit contrasting to a light background, the other in light against dark. The title tells us only that this cryptic double portrait involves two related characters, both named Lucybelle Crater. Interpretation is not much helped by learning that this name connects to a short story by Flannery O'Connor (1925–1964), nor by knowing that this photograph, one of many featuring family and friends enacting such symbolic dramas, forms part of the photographer's posthumously published *The Family Album of Lucybelle Crater*. Meatyard, now recognized as an important visionary artist, was an optician by training and profession, who began in the 1950s to engage with photography, notably using masks and blurs to evoke apparitions and uncanny worlds.

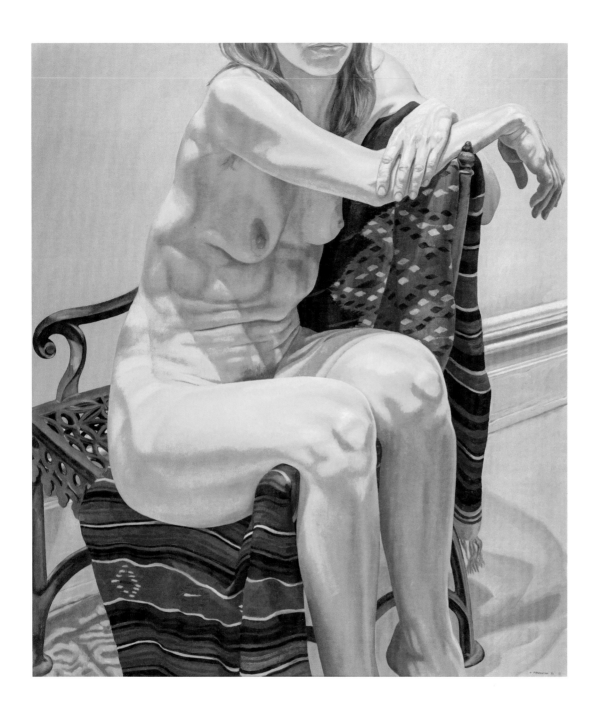

Philip Pearlstein
American, born 1924
Female Model on Chair with Red Indian Rug, 1973
oil on canvas
48⅛ × 42 in. (122.2 × 106.7 cm)
Ackland Fund, 73.12.1

Pearlstein has played a key role in the revitalization of figurative and realist painting in an era when abstraction seemed destined to triumph. However, the artist has consistently avoided narrative and symbolism, presenting his compositions of cropped views of the naked body, furniture, and rugs as still lifes and studies of form, color, and texture. This painting plays on the contrasts among the metal chair, the textile rug, and the human flesh, all set within a spatially complex arrangement of oblique viewpoint, angled spaces, and the carefully choreographed position of limbs. The air of cool detachment prevails both in the model's glimpsed expression and in the handling of the paint.

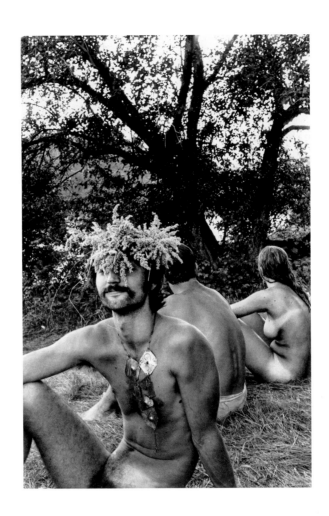

Burk Uzzle
American, born 1938
Woodstock (Nude Man with Flowers on His Head), 1969
gelatin silver print
image: 11⅞ × 7¹⁵⁄₁₆ in. (30.1 × 20.1 cm)
Gift of Charles Weinraub and Emily Kass, 2008.3.18

The North Carolina–born Uzzle produced some of the most iconic images of Woodstock, the seminal music festival held in upstate New York in August 1969. Formerly a staff photographer for newspapers and magazines, Uzzle went on to work as a freelancer with the Magnum photo agency. Not responsible to any editor nor publication, he was free at Woodstock to focus on the crowd rather than the stage. In this seemingly spontaneous but in fact carefully composed composition, the artist found subtle rhymes between the diagonal row of all but naked people and the line of tree trunks, between the angles formed by intersecting limbs and those formed by the branches, and between the arboreal foliage and the flowers worn unselfconsciously by a man with an unfocused gaze. This utopian idyll of harmony between human and nature captures something specific about the late 1960s hippie dream and something timelessly universal.

Robert Morris
American, 1931–2018
Blind Time XIII, 1973
graphite
35⅛ × 46³⁄₁₆ in. (89.2 × 117.3 cm)
Ackland Fund, 79.14.1

A key contributor to many of the important developments in avant-garde art since the 1960s, Morris created an extremely wide-ranging and experimental oeuvre encompassing painting, sculpture, video, performance, and environmental art. *Blind Time XIII* is one of a series of ninety-eight drawings in which the artist explored the role of memory and time in the creative process. In the lower right-hand corner of the sheet, Morris self-reflexively documents how he executed this particular drawing, making certain marks with his hands during a specified amount of time while blindfolded. In this sightless process of creation, the hands of the artist, guided by memory and a preconceived time limit, took over the artistic guidance usually accorded to the eyes. As for much of Morris's work, it is the process and concept that concern the artist, however mysteriously beautiful the finished artwork may be.

Gerhard Richter
German, born 1932
Train Station, Hanover, 1967
offset photolithograph
image: 18⅞ × 23⅛ in. (47.9 × 58.7 cm)
Ackland Fund, 2001.3.2

This haunting image began with a found object, a postcard of the train station in the German city Hanover. Richter manipulated his own photograph of the postcard and then printed the resulting image as an offset photolithograph in two slightly misregistered gray tones. The blur can stand for the unknowability of objective reality, a theme that runs through all of Richter's varied work. One of the most celebrated contemporary artists, he seems equally committed to "realist" and "abstract" styles, relishing ambiguity and mutability. This radical skepticism is surely fed by doubts about the reliability of image-making in the aftermath of World War II and the National Socialist catastrophe. This perspective may resonate in Richter's choice to show a facade that was perhaps already inauthentic when built in a Renaissance revival style in 1879, but then was doubly so when reconstructed in the 1940s, after its destruction by wartime bombing.

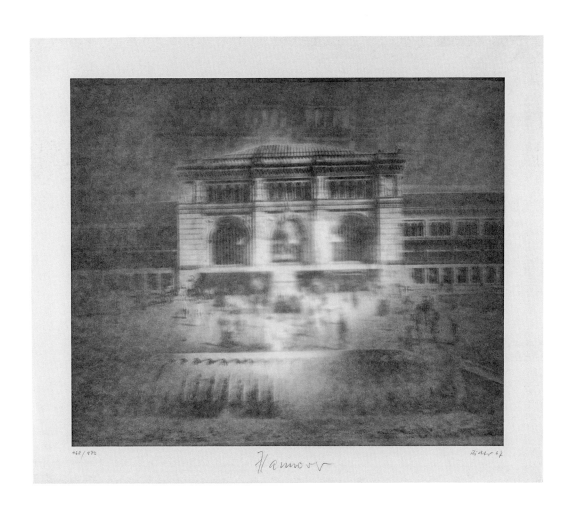

Julian Stanczak
American, born in Poland, 1928–2017
Glare, 1969
acrylic on canvas
50⅛ × 50⅛ in. (127.3 × 127.3 cm)
Ackland Fund, 72.20.1

During the 1960s, in the wake of Abstract Expressionism, a number of artists sought alternative approaches to abstraction. Many turned to studying optical phenomena, the science of color, and the interactions between an image and its viewer. Often employing a precise painting technique, they experimented with geometry and contrasting hues to activate vision. Stanczak had studied in the 1950s at Yale University, where Josef Albers taught his influential courses on geometric abstraction and color theory. His work was featured in the Museum of Modern Art's important 1965 exhibition, *The Responsive Eye*, which effectively defined the Op (short for "optical") Art movement. In the appropriately titled *Glare*, Stanczak employs crisscrossing lines and a diagonal grid to define a circle that floats in the center of the canvas. He derives much of the effect from the fine, hard-edged parallel lines of varying widths, achieved through extensive use of painter's tape.

Jim Nutt
American, born 1938
Study for Cotten Mouth, 1968
crayon and graphite
35¹³⁄₁₆ × 25⅛ in. (91 × 63.8 cm)
Ackland Fund and Gift of Mr. and Mrs.
Irving Shell, 80.18.1

During the 1960s, Nutt exhibited with the Hairy Who, a group of Chicago-based artists who were influenced by the brightly colored and slickly executed images of contemporary comic books, advertisements, and pulp magazines. The brash tones and simplified color palette employed here look to these forms of popular media and perhaps to Japanese woodblock actor portraits, while the grotesque distortion of the physical form recalls other artistic sources such as the early twentieth-century Surrealists. Nutt also distorts conventional language, as the apparently correct title *Cotten Mouth* is an intentional misspelling of "cotton mouth." As a serious medical symptom, "cotton mouth" is considered a marker for underlying disease. The body of the figure seems to have been formed in response to this condition. This drawing is a study for a painting on Plexiglas in which the fiendish grin seen here is backed with real cotton balls.

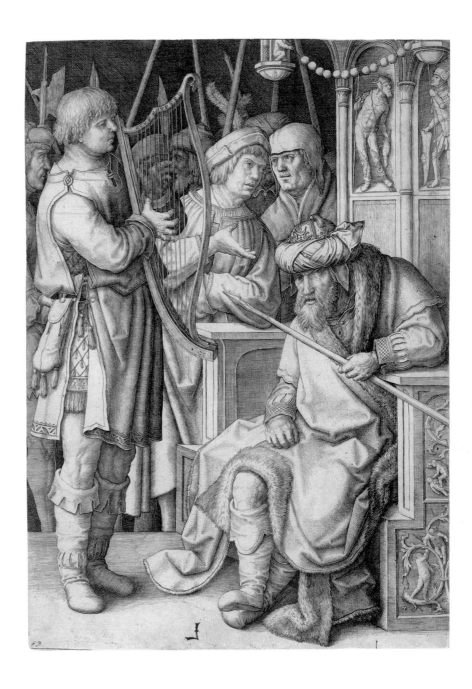

Lucas van Leyden
Netherlandish, c. 1494–1533
David Playing the Harp Before Saul,
c. 1508
engraving
9¹⁵⁄₁₆ × 7³⁄₁₆ in. (25.3 × 18.3 cm)
The William A. Whitaker Foundation
Art Fund, 92.27

David's ability as a warrior, who defeated Goliath with his sling, is familiar and frequently depicted. Less known and rarely represented is David's artistry as a harpist, whose music subdued the evil spirit that plagued King Saul (1 Samuel 18). This engraving dramatizes the tense moment when Saul is still afflicted. Saul's body hunches, his eyes shift, his feet convulse. David's soothing music has yet to heal him.

Lucas was one of the two greatest Northern European printmakers of his time, rivaled only by Dürer. He is particularly recognized for his unorthodox choice of subject matter. In *David Playing the Harp Before Saul*, Lucas not only chose an uncommon subject, but interpreted it in an extraordinary way. He was the first to depict Saul's affliction as an internal conflict, a mental or spiritual disease, rather than the work of a demon as the biblical text suggests.

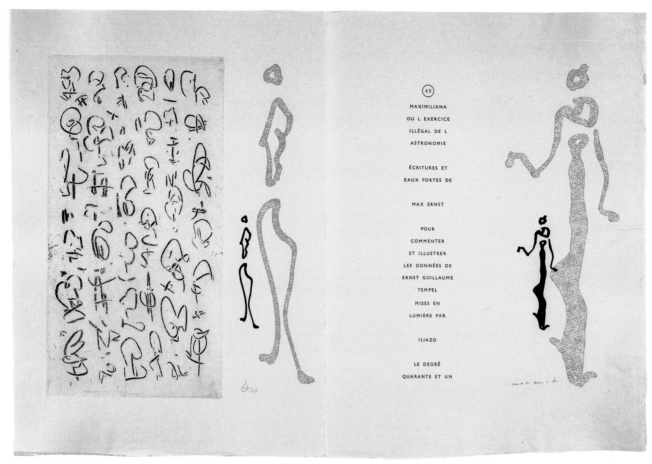

2014.34.9.1

Max Ernst
German, 1891–1976
**Maximiliana, or The Illegal Practice
of Astronomy**, 1964
portfolio of etchings
each sheet (unfolded): 16¼ × 23¹⁵⁄₁₆ in.
(41.3 × 60.8 cm)
Gift of William A. Koehnline,
2014.34.9.1–30

The portfolio from which this sheet comes is a late masterwork by the Franco-German Surrealist Max Ernst, produced in close collaboration with the experimental typographer known as Iliazd (Ilia Zdanevich, 1894–1975). Both artists were fascinated by the life of Ernst Wilhelm Leberecht Tempel (1821–1889), a nineteenth-century amateur astronomer who was never adequately recognized for his unusual record of accomplishment in discovering various deep-sky objects. This publication is named for the sixty-fifth such discovery, an asteroid that Tempel named "Maximiliana," a designation that surely appealed to Max Ernst. Experimental layouts of texts derived from Tempel's writings accompany Ernst's mysterious imagery invoking microcosmic and macrocosmic elements, hieroglyphs, and his characteristic birdlike creatures.

Marcel Duchamp
French, 1887–1968
**From or by Marcel Duchamp
or Rrose Sélavy**, 1966
mixed-media assemblage: red leather
box containing miniature replicas,
photographs, and color reproductions
of eighty works by Marcel Duchamp
closed: 16¹⁵⁄₁₆ × 15³⁄₁₆ × 3⅞ in.
(41.4 × 38.6 × 9.9 cm)
Ackland Fund, 2014.37

This portfolio contains eighty miniature and small-scale reproductions of Duchamp's works, ranging from his avant-garde paintings (such as the famous *Nude Descending a Staircase, No. 2* which scandalized New York at the Armory Show in 1913) to his provocative "ready-mades," such as the 1917 *Fountain*, an inverted urinal signed with the pseudonym "R. Mutt." Its title also incorporates a pseudonym, the artist's provocative feminine alter ego, Rrose Sélavy. Between 1941 and 1968, Duchamp issued more than 300 of these custom-built boxes in seven series with slight variations. The first series incorporated a leather carrying case (hence the common title *Boîte-en-valise*, or "box in a suitcase"). The Ackland's example is from the sixth series, an edition of seventy-five created in 1966. As a work of art in its own right, the compendium summarizes the artist's radical reinvention of art as concept, blurs the distinction between reproduction and original, and comments wittily on the museum's urge to collect.

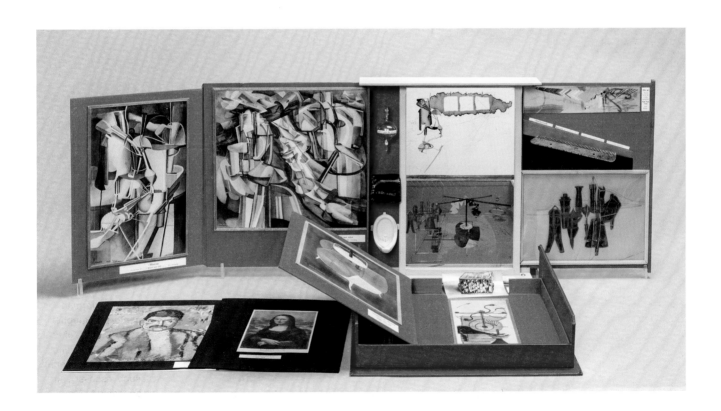

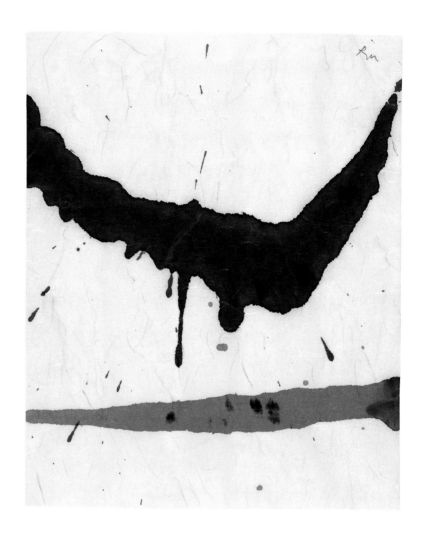

Robert Motherwell
American, 1915–1991
Untitled, from *Lyric Suite*, 1965
black and colored ink on rice paper
sheet: 11 × 9 in. (27.9 × 22.9 cm)
Gift of Carroll and Jeanne Berry,
2008.36.5

Robert Motherwell began the *Lyric Suite* series in 1965 by impulsively purchasing one thousand sheets of Japanese rice paper. The title of the series, *Lyric Suite*, refers to one of Alban Berg's string quartets, to which Motherwell listened while creating his works. The series was an experiment in automatism, where an artist avoids any conscious thought and instead relies on the subconscious when creating art. Using this technique, Motherwell rapidly worked on the series, occasionally finishing up to fifty works each day. A quintessentially open series, it was limited only by the number of sheets that Motherwell had purchased. The series numbered approximately six hundred works when it ended in May 1966 with the sudden death of Motherwell's close friend David Smith. The project was never resumed.

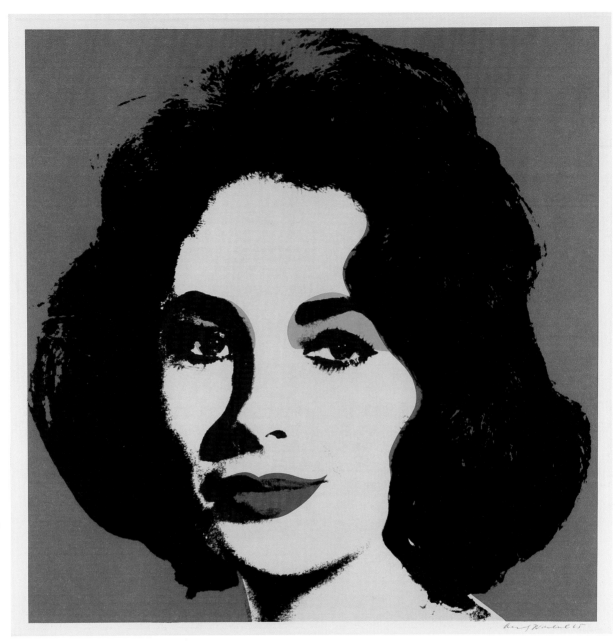

Andy Warhol
American, 1928–1987
Liz, 1964–65
color offset lithograph
image: 21¹⁵⁄₁₆ × 21¹⁵⁄₁₆ in. (55.7 × 55.7 cm)
Gift of Charles Millard, 89.19

Like many of Warhol's portrait subjects, *Liz* is at once instantly recognizable as the movie star Elizabeth Taylor (1932–2011) and as a work by Warhol. The artist's color interventions and the actress's likeness (based on a cropped MGM publicity still) are suggestively misaligned like bad color printing. This aesthetic suggests a disjuncture between the image of fame and the reality of its manufacture. Warhol began the *Liz* series in 1963, not as commissioned portraits but as a meditation on stardom, its power, and its limitations. This print is not a silkscreen, the commercially popular reproductive medium the artist used most frequently, but rather an offset lithograph, produced in a signed edition of about 300 copies at the time of an exhibition at the Leo Castelli Gallery in New York.

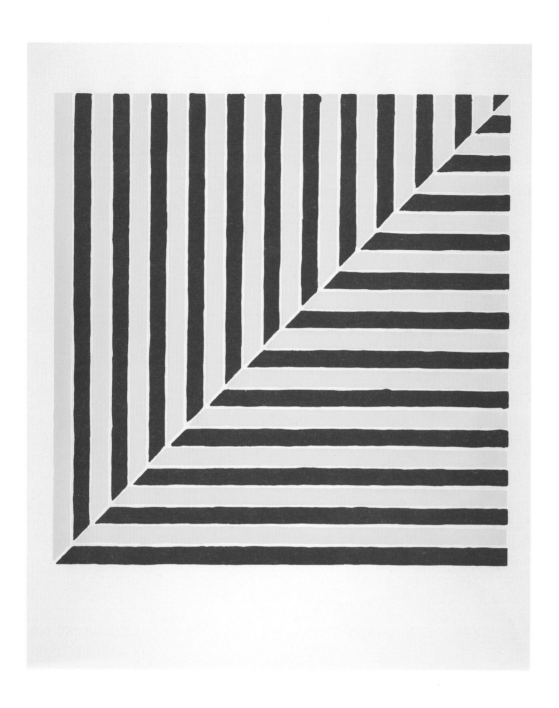

Frank Stella
American, born 1936
Untitled, from *X + X Ten Works by*
Ten Painters, 1964
screenprint
24 × 20$\frac{1}{16}$ in. (61 × 51 cm)
Gift of Mrs. Edith Gregor Halpert, 67.16.2

This screenprint, one sheet from the portfolio *X + X Ten Works by Ten Painters*, published in an edition of 500 in 1964 by the Wadsworth Atheneum in Hartford, Connecticut, is based on one of Frank Stella's series of twelve large-scale paintings with the names of Moroccan cities as titles. Inspired in part by the geometric forms and strong colors of Arabic tiles, these works achieve a vibrant optical intensity that is almost psychedelic. This effect is enhanced by the impression of perspectival depth along the shifted diagonal within the strict confines of the square format. The screenprinting process captures not only the insistent flatness of the surface, but also the textured brushstrokes of the stripes' edges. All together, these features highlight the richness and variety possible within the rubric of "minimalist" art, with which Stella was associated in the 1960s.

Agnes Martin
American, born in Canada, 1912–2004
Untitled, 1961
pen and black ink and graphite
11 × 10⅞ in. (27.9 × 27.6 cm)
Ackland Fund, 80.4.1

The critic Lawrence Alloway once described Martin's depiction of the grid as "halfway between a rectangular system of coordinates and a veil." While the artist's later works deploy much more regular geometries, this early example is among her most eccentric, with lines of variable length creating an asymmetrical field hovering within the confines of the paper. Dots along the upper and lower margins were used to space the vertical lines evenly, while the gaps between the horizontal ones vary more intuitively. This meditative drawing was made when Martin was almost fifty and living in New York, in close contact with members of the younger generation of artists such as Ellsworth Kelly, Jasper Johns, and Robert Rauschenberg.

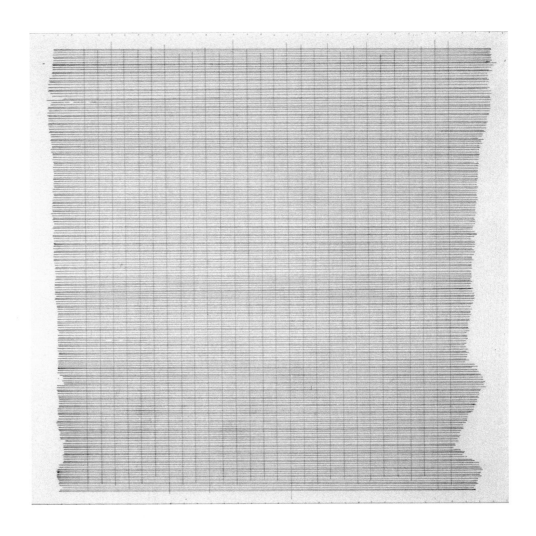

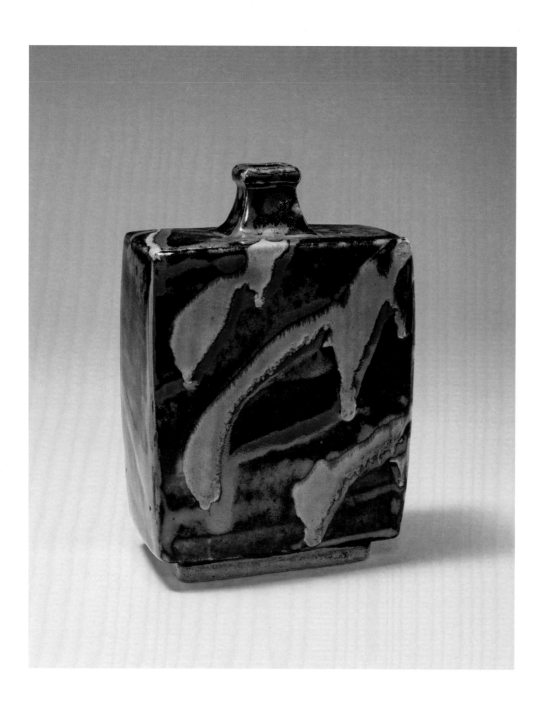

Hamada Shoji
Japanese, 1894–1978
Square Flask, c. 1965
stoneware with wood-ash glaze
8⅞ × 3 × 6 in. (22.5 × 7.6 × 15.2 cm)
Ackland Fund, 2003.21.2

Despite being one of the champions of *mingei*, a term roughly meaning "art of the common folk," Hamada lived an extraordinary life. His career as a potter began in Tokyo but he worked as a ceramicist in St. Ives (United Kingdom) for three years before founding a studio in Mashiko, Japan. He traveled widely, giving ceramic demonstrations and kiln workshops all over the world, including in the United States and Korea. This handmade vase was primarily slab built and then glazed in multiple steps. A combination of iron-rich and copper-based glazes, the last of which was poured directly from a container onto the surface, the vase exemplifies energy and abstraction using the material language of viscosity.

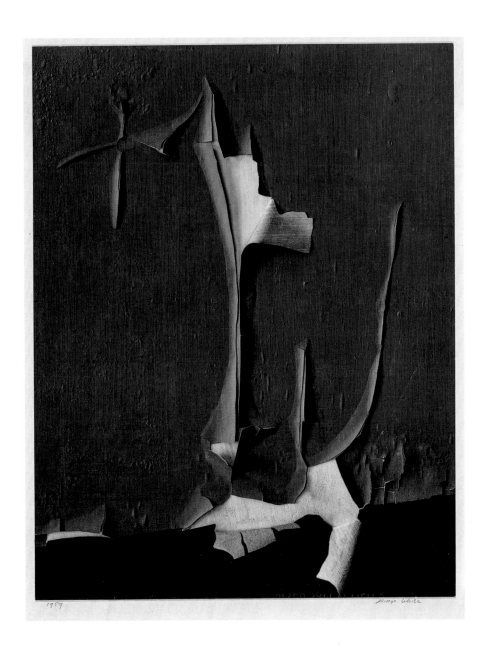

Minor White
American, 1908–1976
Peeled Paint, 1959
gelatin silver print
9⁷⁄₁₆ × 7⁷⁄₁₆ in. (24 × 18.9 cm)
Ackland Fund, 92.2.2

This characteristically contemplative and concentrated image was made while White was teaching photography at the Rochester Institute of Technology in Rochester, New York. This print was once owned by one of White's students there, Carl Chiarenza. The artist here transforms the mundane occurrence of peeling paint into an elegantly grand abstracted composition. He elicits an almost spiritual resonance from the careful calibration of light and shadow in this close-up view, with gray peeling back to reveal white and both hovering above a black void. A landscape also suggests itself, with a dark body of water in the foreground reflecting forms, a central tree and its foliage, with a sunburst at upper left. An influential teacher and founding editor of the distinguished photography journal *Aperture* in 1952, White achieved substantial renown as the leading photographer of his day.

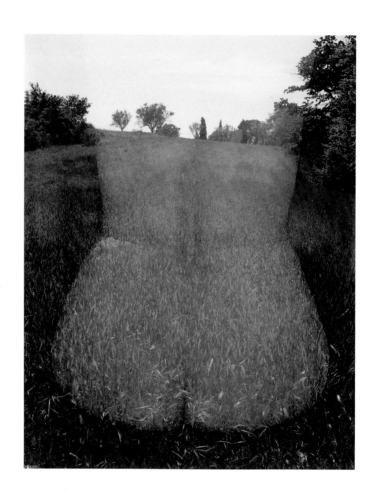

Harry Callahan
American, 1912–1999
Eleanor, Aix-en-Provence, France, 1958
gelatin silver print
image: 6½ × 5⅛ in. (16.5 × 13 cm)
Ackland Fund, 79.24.4

Harry Callahan was an American photographer, renowned for his experimental approach to black-and-white and color photography. Influenced by Ansel Adams, László Moholy-Nagy, and Bauhaus design, Callahan utilized several technical approaches in his work, most notably the double exposure used in this work. Callahan's wife, Eleanor, was one of his main models and muses. Here, a close view of Eleanor's torso is overlaid on a landscape view of Aix-en-Provence, France. The intimate and cropped view abstracts Eleanor's body into a sinuous natural shape, perhaps creating a comparison between the body and the land.

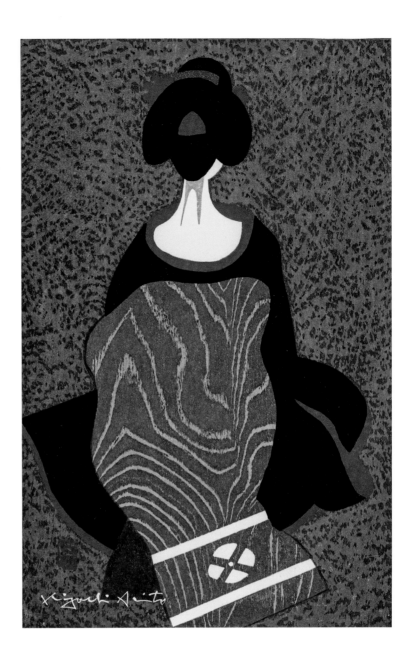

Kiyoshi Saito
Japanese, 1907–1997
Seated Female Figure, c. 1960
color woodcut
image: 15½ × 10⅛ in. (39.3 × 25.7 cm)
Gift of Professor and Mrs. J. Douglas
Eyre, 92.28.1

This print represents a *maiko*, an apprentice geisha, training to become an entertainer skilled in music, dance, and conversation. The woman wears traditional dress, a black kimono and brown *obi* (an elaborate sash) with a white badge that identifies her school. Her neck, an erogenous zone in traditional Japanese culture, is accentuated by a pattern of white and gray makeup.

Artists of the "Creative Print" (*sosaku-hanga*) movement rejected the division of labor in traditional Japanese printmaking, where a skilled wood carver reproduced the delicate lines and watercolor washes of a brush drawing made by the artist. Instead, the artists themselves carved shapes directly into the woodblocks that would be inked to print them, deriving a design from the nature of wood and wood carving. Saito's images are created from masses of black or color ink, and in this print the decorative pattern of the woman's obi references the grain patterns seen in a plank.

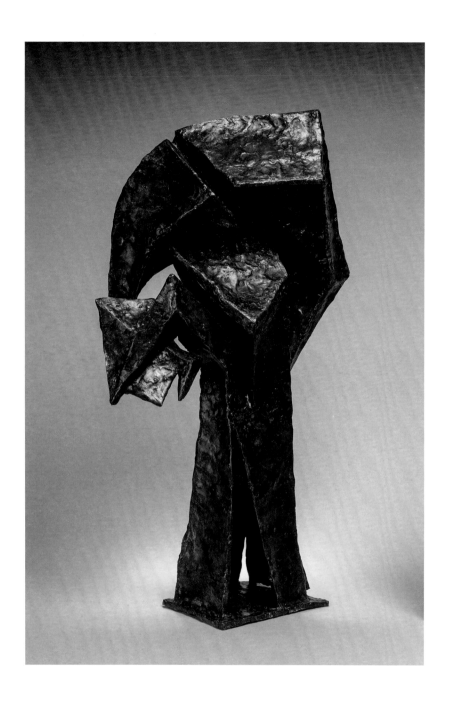

Seymour Lipton
American, 1903–1986
Sentinel #2, c. 1959
bronze on Monel metal
23¾ × 13 × 8½ in. (60.3 × 33 × 21.6 cm)
Gift of Shirley Siegel in memory of her
husband, Sidney H. Siegel, 2008.21

Sentinel #2 typifies the technique that Lipton had developed in his sculpture by the 1950s.
He built his works from sheets of metal, bent, assembled, and finished with an irregular
surface suggesting rock or bone. This mature style coincided with his growing interest in
expressing mythic concepts (influenced by the writings of Carl Jung and Joseph Campbell)
through abstract forms.

Lipton himself analyzed this work in terms of standing figure, armor, and helmet,
but that is only the beginning. *Sentinel #2* takes on radically different appearances as we
view it from different angles, because of the different forms that coexist in it: aggressive
angular shapes, smooth rounded surfaces, and sheltering hollows. Abstract in form, but
with a cargo of figurative allusions, *Sentinel #2* is both a hero facing danger and a steadfast
protector.

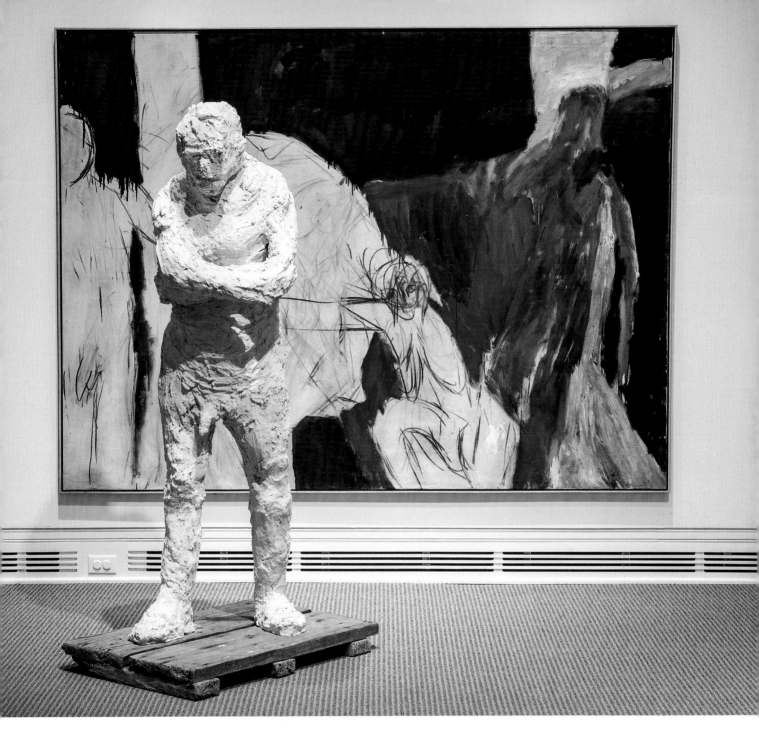

George Segal
American, 1924–2000
The Legend of Lot, 1958
plaster, wood, burlap, chicken wire,
and oil on canvas
installation: 74 × 96 × 66 in.
(188 × 243.8 × 167.6 cm)
The William A. Whitaker Foundation Art
Fund and Gift of The George and Helen
Segal Foundation, Inc., 2009.1

Segal, later celebrated for his environments composed of real objects and plaster figures cast from live models, began his career as an Abstract Expressionist painter. *The Legend of Lot*, an important, transitional piece, forecasts his figure-based installations created to bring art closer to everyday life. This work is based on the biblical story of Lot, who was forced to flee his home in the land of Sodom before its destruction. Segal translates the theme of exile by positioning a sculpture of a man, expressively modeled in plaster, stepping out of a large, boldly defined figurative painting. The artist identified with this tormented figure, which has been interpreted as a self-portrait.

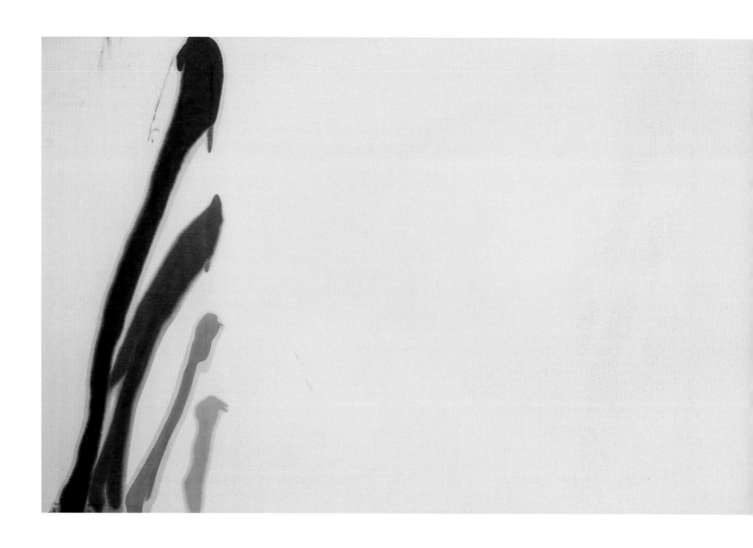

Morris Louis
American, 1912–1962
Theta Beta, from *Unfurleds*, 1960
acrylic resin paint on canvas
104⅝ × 233½ in. (265.7 × 593.1 cm)
Gift of Marcella Louis Brenner, 90.87

The viewer encounters a large, empty expanse of raw canvas, flanked by delicate waves of color cascading down to frame a sea of white space. The fluid acrylic paint, devoid of any suggestion of brushstrokes, soaks into the canvas, creating a quintessentially modern flat picture plane. In the repeated colors and matching angles, the composition gestures to symmetry, but chance effects of touching, dripping, staining, and pooling dominate. The invitation to meditation is both lyrical and sublime.

This painting belongs to a series of about 150 canvases that the artist named *Unfurleds*. Unlike many of his other major series, such as *Veils* (1958–59) or *Stripes* (1961–62), the *Unfurleds* carry no referential or evocative titles beyond one or two Greek letter names. These give an aura both of systematic inventorying of experiments and of classical grandeur.

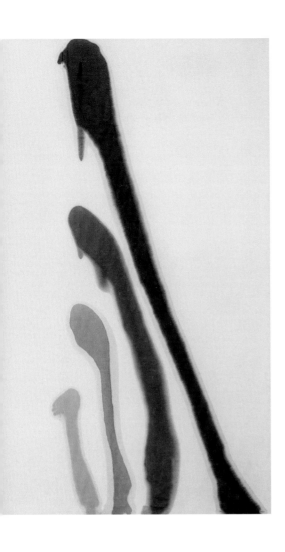

Hans Hofmann
American, born in Germany, 1880–1966
Undulating Expanse, 1955
oil on canvas
48 × 96 in. (121.9 × 243.9 cm)
Ackland Fund, 88.27

In 1950, Hofmann was commissioned to create mosaic murals and plaza paving designs for a new central structure to be constructed as part of an ambitious urban renewal project in Chimbote, Peru. *Undulating Expanse*, with its uncharacteristic horizontal format and almost symmetrical composition, seems ultimately to be derived from sketches for that unrealized project. Some of the formal elements may allude to Indigenous Peruvian art, with a snakelike form perhaps echoing an Aztec feathered serpent and other shapes evoking the sun shining through mountain peaks. However, the painting's title and composition – unified by energized brushstrokes and thick passages of paint – allude to a cosmic rather than earthly terrain. *Undulating Expanse* is a vibrant example of Hofmann's vigorous and expressive abstraction.

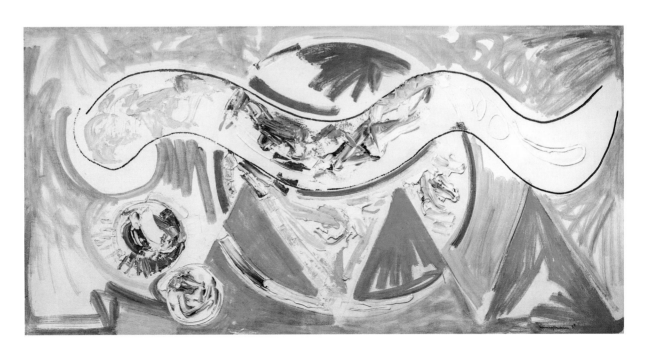

Roberto Sebastian Antonio
Matta Echaurren
Chilean, 1911–2002
Untitled, c. 1954
oil on canvas
24 × 29¹⁄₁₆ in. (60.9 × 73.8 cm)
Gift of Mrs. William H. Fineshriber, Jr.,
72.10.1

In its turbulent composition of lurid greens and red, flame-like forms, this modestly scaled work perhaps suggests the cataclysm of World War II, a subject that haunted the artist. Its nebulous organic forms in a dreamlike atmosphere are characteristic of Matta's interest in fantastic imagery. His training as an architect in his native Santiago, Chile, and subsequent work for the leading French designer Le Corbusier in Paris may be reflected in the ghostly evocation of architecture visible as perhaps the arches of a bridge.

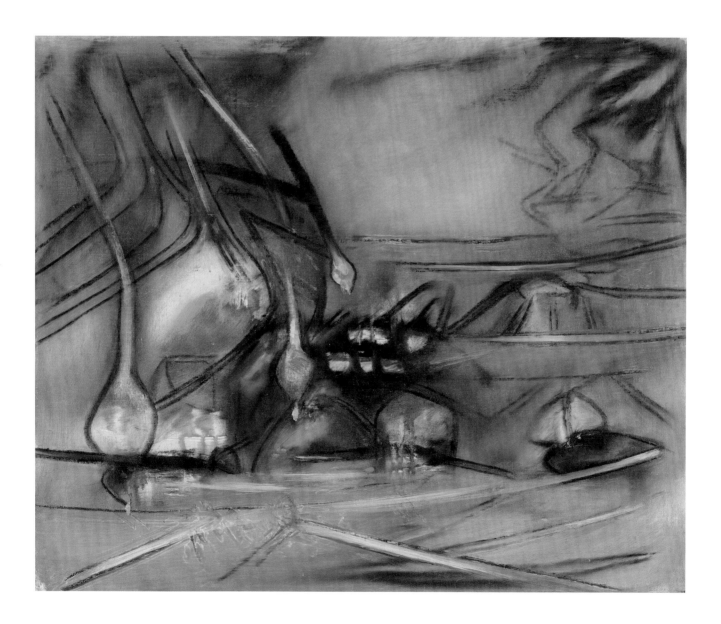

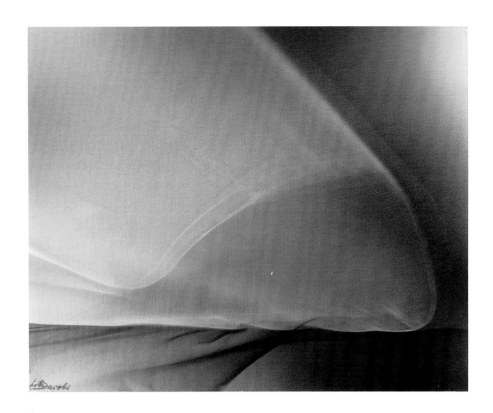

Lotte Jacobi
American, born in Germany, 1896–1990
Photogenic, c. 1950
gelatin silver print
8 × 10 in. (20.3 × 25.4 cm)
Ackland Fund, 2006.5

Having had a distinguished career as a portrait photographer in German avant-garde cultural circles around 1930, Jacobi fled the Nazi regime for New York. She had her first American solo exhibition in 1937, opened her own studio after the war, and was introduced to camera-less photography in 1946. Dissatisfied with the relatively static results of placing objects on sheets of photographic paper and exposing them to light, she began "moving things around." She applied the name "photogenic" (meaning "produced by light") to the unique images created by her process of shifting the light source, the object, or both.

Josef Albers
German-American, 1888–1976
Blue/Yellow/Gray, c. 1943
collage
10$\frac{1}{16}$ × 8$\frac{9}{16}$ in. (25.6 × 21.7 cm)
Gift of John A. Parker in memory of
Robert Curtis Parker, 1938–1986, 91.35

Albers is acknowledged as one of the great teachers and theoreticians of art in the twentieth century. Many distinguished artists studied with him at Yale University after 1950 and, before that, during his sixteen years at the experimental Black Mountain College, near Asheville, North Carolina. This collage was made during his Black Mountain years, but as a demonstration piece for a course held in June–July 1943 at the Lowthorpe School of Landscape Architecture for Women in Groton, Massachusetts. The donor of this work was the school's director from 1930 to 1945, when it was absorbed into the Rhode Island School of Design. Albers used this exquisitely composed collage to illustrate one of his major aesthetic interests, the "interaction of color." Here the two gray shapes, though identical in hue, appear different because of the effect of the surrounding color. The papers show significant wear, reflecting classroom use.

Olavi Sihvonen
American, 1921–1991
Study in Rectangles, 1947
oil on board
frame: 9⅝ × 19¹⁵⁄₁₆ in. (24.4 × 50.6 cm)
The Robert Myers Collection, 2015.10.169

After serving in World War II, Sihvonen attended Black Mountain College, near Asheville in Western North Carolina, a progressive, cooperative school that attracted very distinguished faculty and students. Many became leading figures in the world of avant-garde art and literature after the war. Sihvonen studied with Josef Albers, who had joined the school from Nazi Germany in 1933, its first year. This precise, balanced painting, made during Sihvonen's years at the College, clearly reveals the strong influence of teacher on student. The work layers rectangular forms, plays with translucency, and suggests some movement across its horizontal expanse. Sihvonen went on to a significant career as a painter of geometric, hard-edged abstractions with exuberant colors.

Charles Ephraim Burchfield
American, 1893–1967
Whirling Sunlight (Our Ailanthus), 1946
(later reworked)
watercolor, charcoal, and white chalk on
joined paper mounted on pressboard
38 × 33 in. (96.5 × 83.8 cm)
Gift of the Tyche Foundation, 2010.21

Burchfield was a solitary and visionary poet of nature, whose responses to natural
phenomena were often mystical and intensely personal. Beginning in 1943, he returned to
themes and subjects from earlier in his career, either completing old studies or elaborating
already finished works by adding strips of paper. The present work is a composite, though
an exact determination of the process, the sequence of execution, and the specifics of
any later reworking remain elusive. The work in its current state is an ecstatic rendering of
pulsating sunlight as it dissolves an ailanthus tree into abstract patterns, set off against the
corners of two buildings. Apparently unfinished passages reinforce the sense of dissolution
and experimentation.

Ad Reinhardt
American, 1913–1967
Yellow Painting (Abstraction), 1946
oil on canvas
32 × 40 in. (81.3 × 101.6 cm)
Gift of Litsa Dermatas Tsitsera in honor
of Charles Millard, 2000.20

Throughout his life, Reinhardt remained committed to abstraction, passing through several stylistic phases before reaching his most radical negation, the 1960s black paintings. This 1946 work reflects his deep engagement with Asian art and calligraphy at the time. It was also the moment when the artist, a prolific polemicist, drew a cartoon of a man looking at an abstract painting and saying: "Ha ha, what does this represent?" The painting responds gruffly: "What do *you* represent?" The artist added the commentary: "An abstract painting will react to you if you react to it. It will meet you half-way but no further. It is alive if you are." This sentiment offers a context for experiencing this dynamic painting, with its mixture of gestural lines, rectilinear blocks, loosely brushed passages, and open-ended shapes, all skillfully interlocked and overlayed in a shallow pictorial space dominated by just a few, nonsymbolic colors.

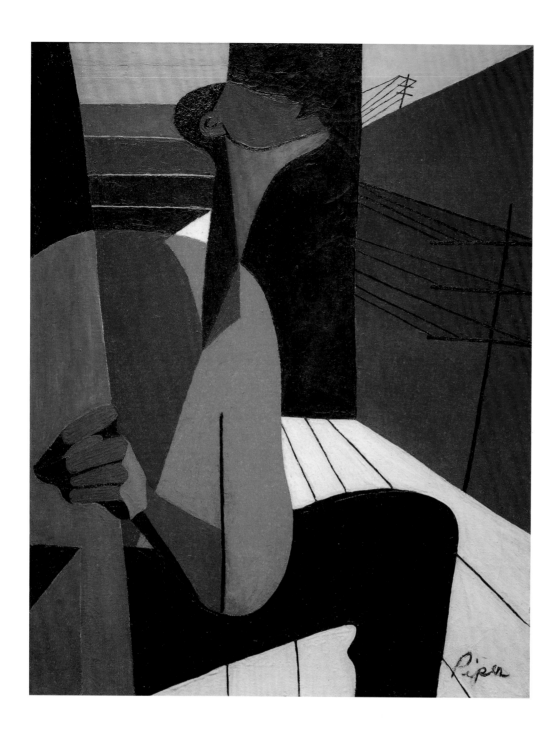

Rose Piper
American, 1917–2005
Slow Down Freight Train, 1946–47
oil on canvas
29⅛ × 23⅛ in. (74 × 58.7 cm)
Ackland Fund, 91.8

Piper's subject is an African American man boarding a freight train as he leaves his home in the rural South to find work in the industrial North. Stepping aboard the train car, he cranes his neck and opens his mouth, evoking both strong emotion (perhaps grief) and action (climbing on and perhaps singing out). Piper's title refers to the blues singer Trixie Smith's recording of "Freight Train Blues," whose music and lyrics express the sorrow of a woman left behind. The context of both painting and song is the Great Migration of the early decades of the twentieth century. *Slow Down Freight Train* belongs to a series of fourteen paintings by Piper inspired by African American folk and blues music.

John Woodrow Wilson
American, 1922–2015
Native Son, 1945
graphite and white heightening
12¼ × 10⅛ in. (31.1 × 25.7 cm)
Ackland Fund, 2006.7.4

Although still a student at the Boston Museum School, by 1945 Wilson had already achieved great success and renown in the art world, with his socially engaged work exhibited and illustrated widely. His themes of human dignity and racial justice were firmly established. This powerful drawing is titled *Native Son*, a reference to the title of Richard Wright's landmark novel about race, poverty, and crime, which had been published five years before. Presumably, Wilson represents the novel's protagonist, Bigger Thomas, who appears not engaged in any dramatic or violent action, but rather in reflective and maybe melancholic contemplation of the era's social and political circumstances. The artist used this drawing for a lithograph printed the same year, and the violent indentation along major contour lines may be the result of tracing the drawing over for transfer to a lithographic stone, but it may also reflect the artist's emotional involvement.

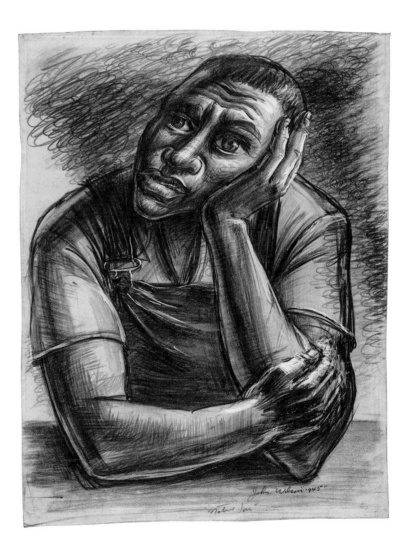

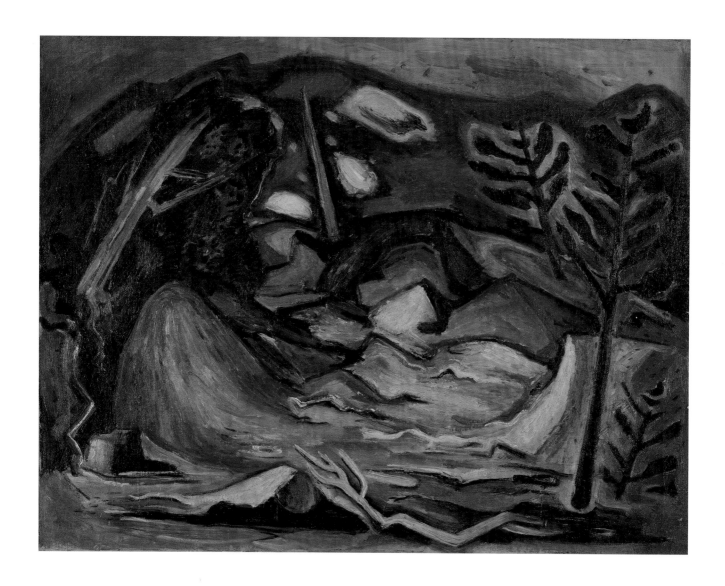

Hale Aspacio Woodruff
American, 1900–1980
Landscape (Mississippi, Soil Erosion),
c. 1944
oil on canvas
26³⁄₁₆ × 33¹⁵⁄₁₆ in. (66.5 × 86.2 cm)
Ackland Fund, 2013.6

Woodruff is now perhaps best known for the murals he painted between 1938 and 1942 at Talladega College, a historically Black institution in Alabama, founded by formerly enslaved people after the Civil War. The paintings dealt with themes related to slavery, including the 1839 Amistad Mutiny, the Underground Railroad, and the history of Talladega College itself. In July 1943, he received a fellowship and grant of $2,400 from the Julius Rosenwald Fund "to pursue individual creativity in art." He traveled through Georgia, Alabama, and Mississippi documenting social and environmental issues in the rural South, before settling in New York at the end of the year. This turbulent landscape of broken trees and eroded soil was probably created in New York in late 1943 or in 1944.

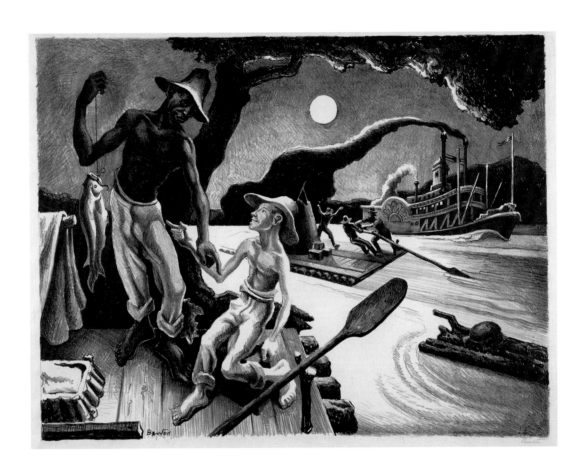

Thomas Hart Benton
American, 1889–1975
Huck Finn, 1936
lithograph
image: 16⅝ × 21¼ in. (42.2 × 54 cm)
Gift of W. P. Jacocks, 58.2.84

Thomas Hart Benton was an American "regionalist" artist known for his innovative murals and works about the rural American Midwest and South. Benton utilized recognizable American stories, legends, and vernacular, such as *Adventures of Huckleberry Finn* by Mark Twain, to create art for everyday people. This lithograph was derived from a series of murals Benton painted at the Missouri State Capitol in 1936.

Huck Finn shows two of Twain's most famous characters, Huck and Jim, floating down the busy Mississippi River on their raft. In the background, a steamboat cuts an imposing figure with billowing smoke and acts as a symbol for mass industrialization, a recurring theme in many of Benton's works. The steamboat forms a direct contrast with the simplicity of the wooden raft and oars that Twain's heroes use on their adventures and the picturesque beauty of the river and forests yet unmarked by technology.

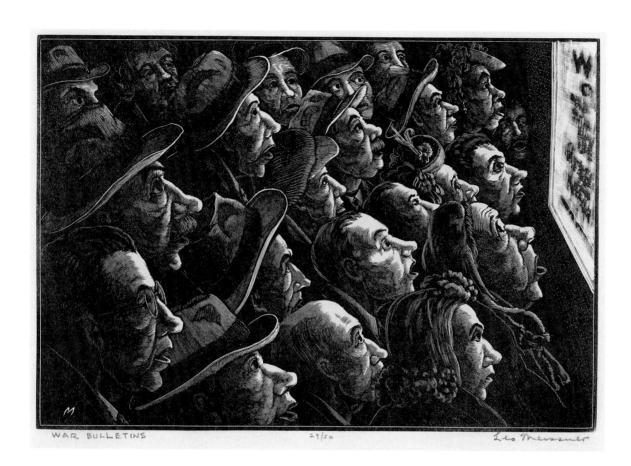

WAR BULLETINS 29/50 Leo Meissner

Leo John Meissner
American, 1895–1977
War Bulletins, c. 1942
wood engraving
image: 6¹⁄₁₆ × 9 in. (15.4 × 22.8 cm)
The Hunter and Cathy Allen Collection,
2013.21.30

This woodblock print is somewhat uncharacteristic for the artist, who is better known
for work less topical or disturbing: landscapes and coastal views (notably of Monhegan
Island, where he summered for some forty years), portraits, and nudes. Meissner made this
compelling print for a competition organized by Artists for Victory, a government-sponsored
group of over 10,000 artists dedicated to producing art in service of the nation's war effort.
It was exhibited in the 1943 exhibition *America in the War*, the same selection of one
hundred prints presented simultaneously in twenty-six museums across the country. The
prospectus for the exhibition had announced, "The artist who today interprets the emotions
and experiences of the American people serves not only a cultural, but a patriotic purpose."
Meissner shows a crowd of attentive, concerned people, their mouths uniformly open
(perhaps in shock) and their profiles illuminated by the public bulletin announcing news
about the war.

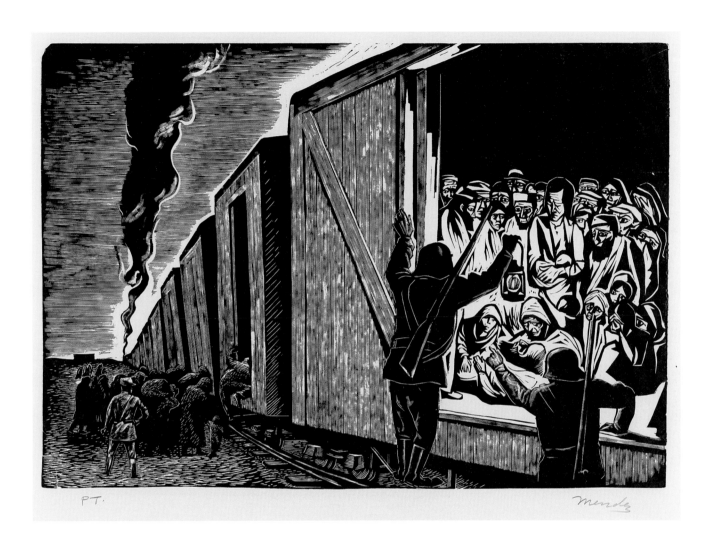

Leopoldo Méndez
Mexican, 1902–1968
Deportation to Death (Death Train),
1942, perhaps printed later
linocut
image: 13¹³⁄₁₆ × 20³⁄₁₆ in. (35.1 × 51.3 cm)
Ackland Fund, 2010.48

Méndez was a founder of the Taller de Gráfica Popular (People's Graphic Workshop) in Mexico in 1937. The group, which still exists, is devoted to making prints to advance politically and socially radical causes. Méndez's linocut may well be the first published print related to the Holocaust and the Nazi death camps. It was illustrated as one of the Taller's contributions to the 1943 anti-fascist volume, *The Black Book of Nazi Terror in Europe*, a documentation of German atrocities produced by a group of German left-wing exiles in Mexico. The stark and expressive linocut shows German soldiers loading and inspecting crowded train cars of Jews about to be deported on a seemingly endless train waiting to depart. The lantern illuminates an infant held tight, a recumbent old man comforted, women weeping. A child is among those being forced to board the next car.

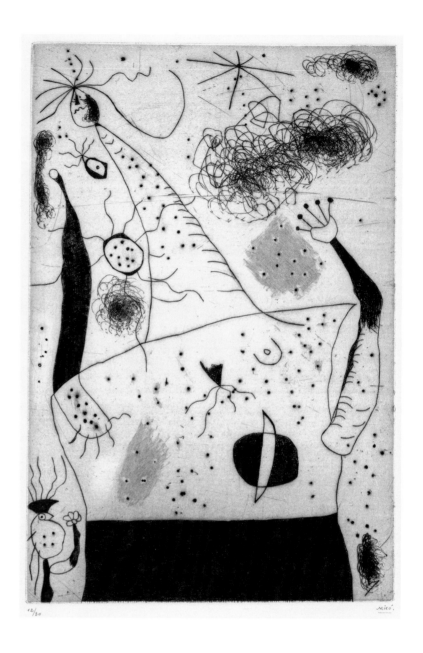

Joan Miró
Spanish, 1893–1983
The Giantess, 1938
etching and aquatint
image: 13¹¹⁄₁₆ × 9⅜ in. (34.8 × 23.8 cm)
Ackland Fund, 2011.9

In Miró's work from the 1930s, wandering lines evoke the art of a toddler, and yet they produce shapes that might have come from a biology textbook. Those hairy or wormlike shapes come together to form the body of a gigantic woman. She towers above, in a sky of clouds and stars, but the black rectangle of her lower body anchors her firmly to the earth. Her expression reads as anger, uncertainty, or determination, but she bends her faraway head toward the tiny figure who offers her an outstretched hand – or a bouquet.

Constellation or landscape, mother-goddess or motherland? With his native Spain torn by civil war, Miró may be expressing some of the feelings that had inspired another Spaniard, Pablo Picasso, a year earlier. But instead of *Guernica*'s mourning, Miró gives us struggle amid chaos, an ambiguous message combining ferocity and humor, even hope.

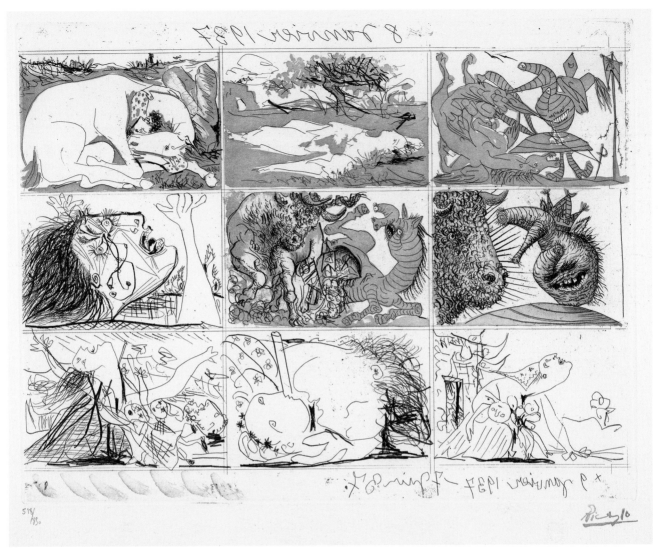

2011.22.4.2

Pablo Picasso
Spanish, 1881–1973
Dream and Lie of Franco, 1937
two prints: etching with aquatint
each plate: 12⅜ × 16⅝ in. (31.4 × 42.2 cm)
The William A. Whitaker Foundation
Art Fund, 2011.22.4.1–2

In late 1936, Fascist insurgents attacking the Spanish Republican government proclaimed Francisco Franco as their leader. In response to the turmoil in his native Spain, Picasso made a series of two prints with an accompanying prose poem, attacking the would-be dictator. While the first takes the form of a raucous comic strip satirizing Franco as an obscene potato-head, the second (shown here) moves from satire to tragedy. The nine scenes, read from upper right (as the print reverses the artist's composition), show Franco devouring his own dead horse; two panels of deaths caused by war and two of Franco battling a bull, the symbol of Spain; and four scenes prompted by the Fascist air raid on the town of Guernica, images that relate to Picasso's monumental 1937 painting protesting that atrocity. Issued in a large edition of 850, the prints and poem were sold to benefit the government forces.

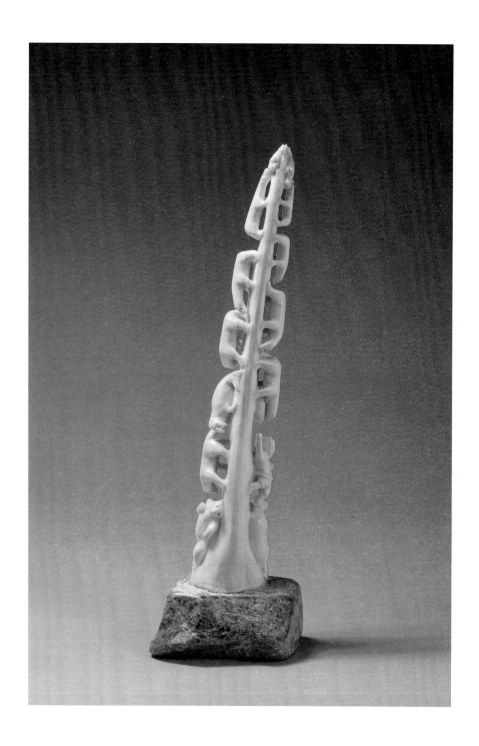

Unidentified artist
Canadian, Inuit, Northwest Territories
Totem, mid-20th century
carved walrus tusk
13$\frac{7}{16}$ × 4$\frac{5}{8}$ × 3$\frac{1}{2}$ in. (34.1 × 11.8 × 8.9 cm)
Gift of the H. G. Jones Collection of Inuit
Art, 92.12.2

Carved from a curving walrus tusk and mounted on rough-hewn stone, this "totem" or totem-like object presents an accumulation of polar bear, walrus, seal, bear, and fox figures, along with one gesticulating – or maybe dancing – human, in what seems like a celebration of natural abundance. Probably made in the mid-twentieth century by an Inuit artist based on Baffin Island in Canada's Northwest Territories, now Nunavut, this sculpture was not intended for pragmatic or ritual use, but rather designed for sale to traders.

attributed to the Teague Family
American, 20th century
Grave Marker for James R. Teague, 1938
salt-glazed stoneware
height: 17¾ in. (45.1 cm); diameter: 7¼ in.
(18.4 cm)
Gift of Charles G. Zug, III, 84.42.1

The Teague family has been making pottery in the Seagrove area of North Carolina since the early nineteenth century. One of its members was probably responsible for this handsome, subtly rounded grave marker for one James R. Teague, who died, according to the inscription on the top, in 1938 at the age of fifty-four years, five months, and twenty-four days. Such a stoneware grave marker provided a durable memorial at a fraction of the cost of carved stone. This example was originally from the cemetery of the Union Grove Church in Randolph County, which declined its return when it appeared on the art market.

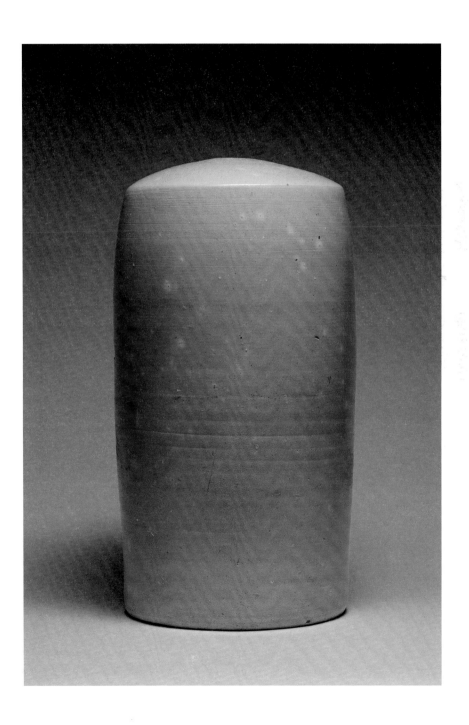

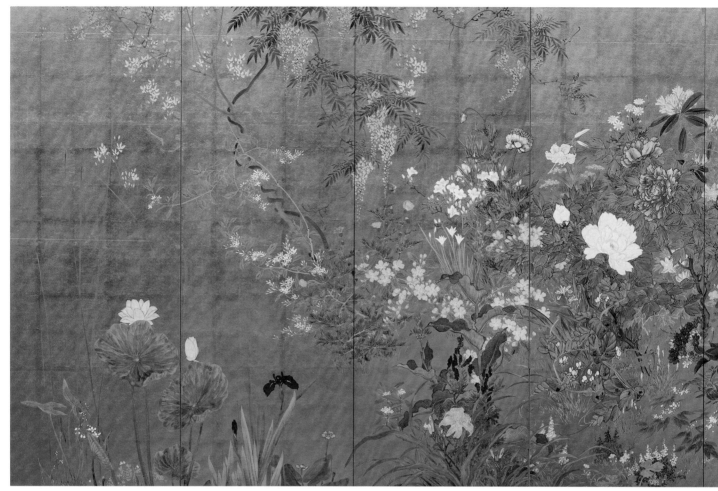

2016.11.2.2

Kajino Genzan
Japanese, 1868–1939
Flowers of the Four Seasons, 1920s
pair of six-panel screens: ink, pigment,
and *gofun* (white powdered shell)
with gold leaf, mounted on screen
with lacquer frame
each screen: 66¹¹⁄₁₆ × 147⅜ in.
(169.4 × 374.4 cm)
Gift of the William E. Shipp Estate and
Mrs. Joseph Palmer Knapp, by exchange,
2016.11.2.1–2

"One Hundred Flowers of the Four Seasons" is a popular theme throughout East Asian
art. In Genzan's pair of screens, the traditional subject matter, which begins with spring
on the rightmost panel of the right screen (shown here), is rendered modern through
the heightened naturalism and the depiction of imported flowers, such as sunflowers.
The pictorially dense composition includes some fifty varieties across both screens,
set against a gold background with little or no indication of the ground on which they
grow. Based in Kyoto, Genzan fulfilled many commissions for branches of the Japanese
Imperial Family, though this work would have been displayed in the home of a wealthy
merchant or businessman.

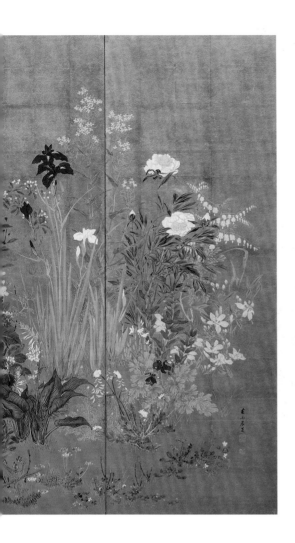

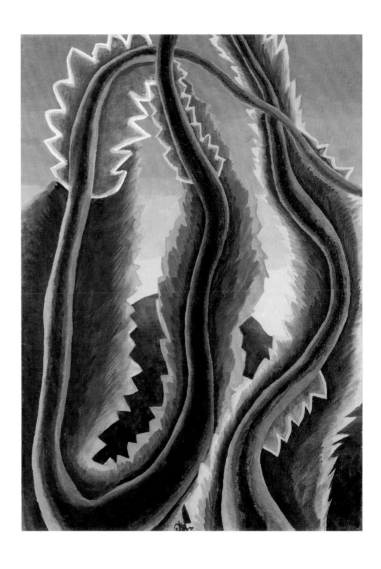

Arthur G. Dove
American, 1880–1946
Tree Forms, 1932
oil on canvas
28¹⁄₁₆ × 20¹⁄₁₆ in. (71.3 × 51 cm)
Ackland Fund, 65.25.1

Arthur G. Dove was among the earliest proponents of modern art in America and experimented with avant-garde compositional and stylistic techniques to capture the essence of landscape through abstraction. In *Tree Forms*, the artist expressed his emotional response to nature by transforming tree trunks and foliage into non-representational forms and colors. Characterized by undulating gray and brown tendrils that overlay sawtooth green and orange shapes, the biomorphic elements sway and pulsate with vibrant energy. Behind, Dove suggests a mountain with a simple gray mound, the sky darkening gradually toward the top of the picture plane. The artist's innovative depiction of nature had the early support of Alfred Stieglitz, a photographer and advocate of contemporary art. Dove exhibited at Stieglitz's galleries on a regular basis for over thirty years.

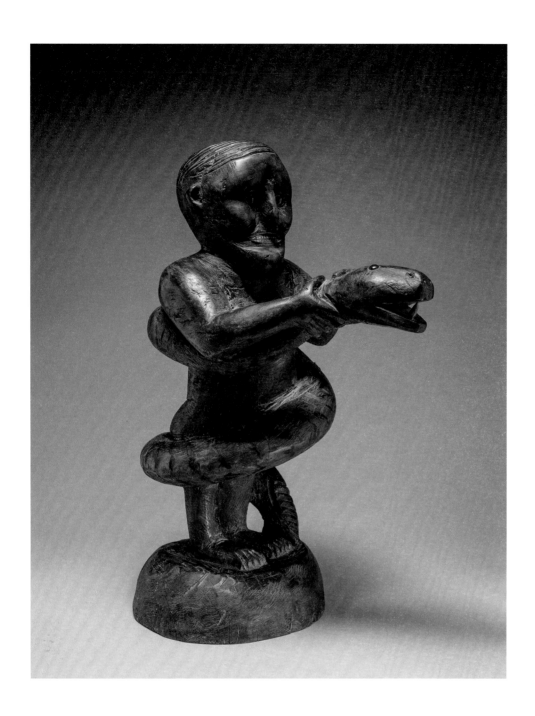

Edgar Alexander McKillop
American, 1879–1950
Man with a Snake, 1926–33
black walnut with glass eyes, bone
teeth, and painted bone fang
21¹³⁄₁₆ × 10¼ × 15⅛ in.
(55.4 × 26 × 38.4 cm)
Ackland Fund, 79.7.1

McKillop often used the local black walnut of his native region, the mountains of rural Western North Carolina, to carve his expressive, often humorous creatures. This sculpture of a naked man holding the head of an oversize snake encircling his body calls to mind the "serpent-handling" rite of a small number of Christian churches in Appalachia. Drawing on several passages in the Bible that describe the faithful as immune to venom, practitioners see the ritual as evidence of salvation. There are surely also thematic echoes of Adam and the snake in the Garden of Eden. The man's wide-eyed and open-mouthed expression matches the snake, not only in expressivity, but also in the shared materials of glass and bone.

Osei Bonsu
Ghanaian, Asante, 1900—1977
Ntan Drum, 1930s?
painted wood
45 × 18 × 23 in. (114.3 × 45.7 × 58.4 cm)
Ackland Fund, 2000.6

Osei Bonsu, who was chief carver to several Asante rulers, learned to carve from his father, who was both a drummer and an artist. Bonsu's works are characterized by proverbs and animal supports, seen in this drum in the images adorning the drum's exterior and in the lion at its base.

Volunteer organizations of Asante musicians, called *ntan*, used this type of drum – whose form and design they borrowed from the neighboring Fante culture – in social and festive community gatherings that were especially popular between the 1920s and 1950s. Whereas in earlier times Asante performances were controlled by elites, ntan performances were open to broader segments of the population.

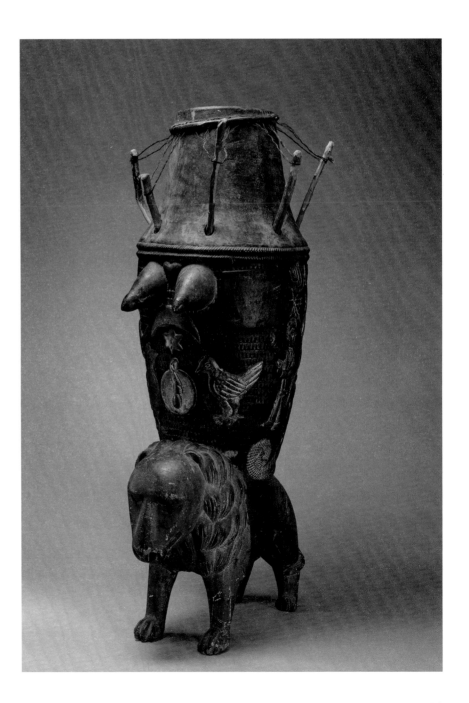

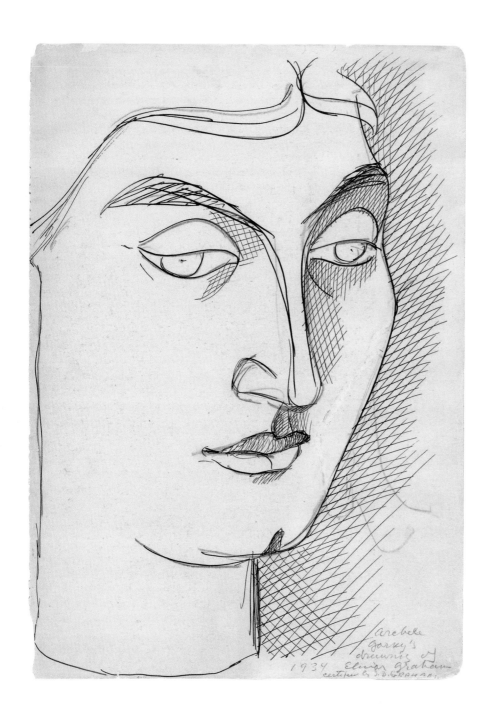

Arshile Gorky
American, born in Armenia, 1904–1948
Elinor Graham, 1934
pen and black ink over graphite
14½ × 10⅜ in. (36.8 × 26.4 cm)
Gift of the Ackland Associates, 88.22

Elinor Graham was the third wife of John D. Graham, a multifaceted painter, writer, and collector who was a central figure among avant-garde artists in New York in the 1920s to the 1940s. One of the artists whom he helped to gain recognition was Arshile Gorky, who drew this portrait of Elinor in the year she divorced Graham. Gorky casts the subject's likeness as a classical sculpture bust in modernist form. The artificial break at the base of the neck alludes to the ancient portrait convention just as the monumental style recalls Pablo Picasso's "classical" phase from the early 1920s. This sheet is one of a number of drawings in a linear style that Gorky made of friends and patrons in the 1930s.

Edward Steichen
American, born in Luxembourg,
1879–1973
**Fashion Model in White Evening Dress,
with a Bust of Nefertiti**, 1935
vintage gelatin silver print
9⅛ × 7½ in. (23.2 × 19.1 cm)
Gift of the Ackland Associates, 84.4.1

Edward Steichen began his photographic career with portraits and landscapes self-consciously "artistic" in appearance, moving to the world of commercial photography in the early 1920s. This change in career emphasis was accompanied by a gradual change in style: his earlier, blurred, impressionistic photographs were succeeded by elegant, sharply focused images like this one, fashion pictures and celebrity portraits that appeared in the pages of *Vogue* and *Vanity Fair* during the 1920s and 1930s.

Juxtaposing the reproduction of a famous Egyptian sculpture with a white model posed with gestures adapted from ancient Egyptian painting, Steichen compares the modern Western ideal beauty with that of the "other." The model's pose both appropriates and commercializes ancient Egyptian art for a modern, Western audience.

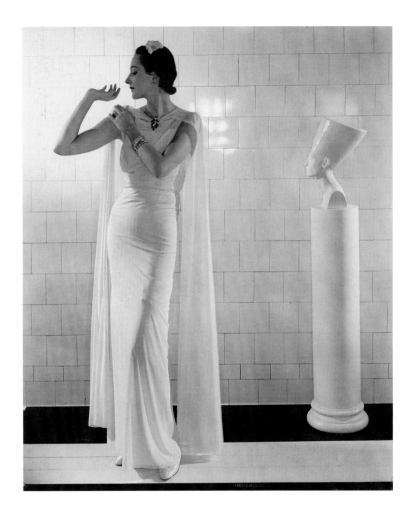

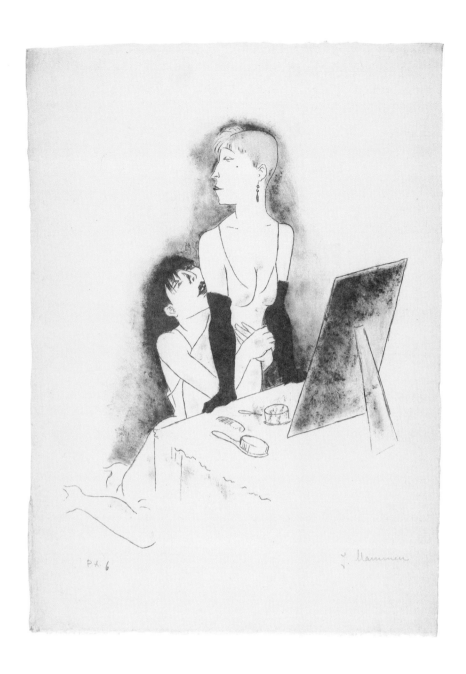

Jeanne Mammen
German, 1890–1976
Jealousy, no. 2 in *Songs of Bilitis*,
1930–32
lithograph in black and yellow
21¾ × 15⅞ in. (55.2 × 40.3 cm)
Ackland Fund, 2009.7

In 1930, Mammen was commissioned by the Berlin art dealer Wolfgang Gurlitt (1888–1965) to create nine lithographs to accompany the *Songs of Bilitis*, a collection of highly erotic prose poems by Pierre Louÿs (1870–1925), first published in 1894. Louÿs's text was purported to be a translation from the ancient Greek, recounting the life and experiences of a lover of Sappho. Mammen transported this antique setting into contemporary Berlin, producing images of same-sex intimacy that seem aimed less at the voyeuristic male gaze and more at a sympathetic female audience. Mammen became well known in the interwar period for her depictions of modern women, fashion, and café society. For either economic or political reasons, the planned book was never published and only a few proof impressions, including this sheet, survived World War II.

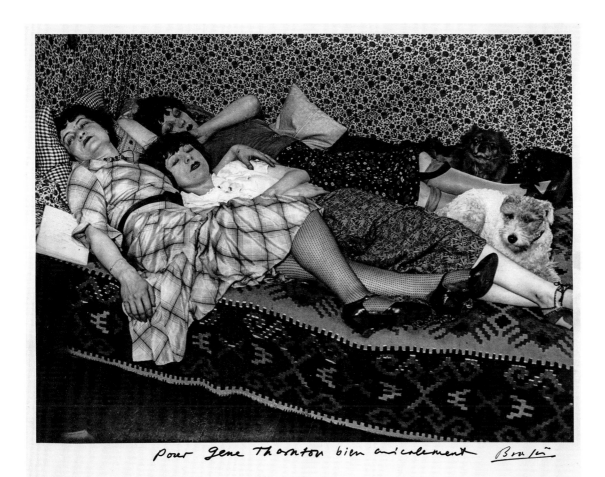

Pour Gene Thornton bien amicalement Brassaï

Brassai
Hungarian, active in France, 1899–1984
Kiki with Her friends Thérèse Treize de Caro and Lily, c. 1932
gelatin silver print
sheet: 10¼ × 11⅞ in. (26 × 30.2 cm)
Gift of Gene Thornton, 2007.15.1

This photograph is dominated by a riot of contrasting patterns from which emerge the figures not only of the three ostensible subjects, but also of two attendant dogs. While apparently an intimate moment (women sleeping, stockings rolled down, book cast aside in reverie), this scene is more likely staged. The "Kiki" of the title (probably the woman in the middle) was the chosen name of Alice Prin, a famous French singer, wit, actress, and artists' model for whom posing was a common routine. An erotic muse to a number of Parisian artists of the period, she appeared several times in Brassai's photographs of nighttime Paris, its bohemian life, and demimonde. This photograph bears a dedication to the author and *The New York Times* photography critic Gene Thornton.

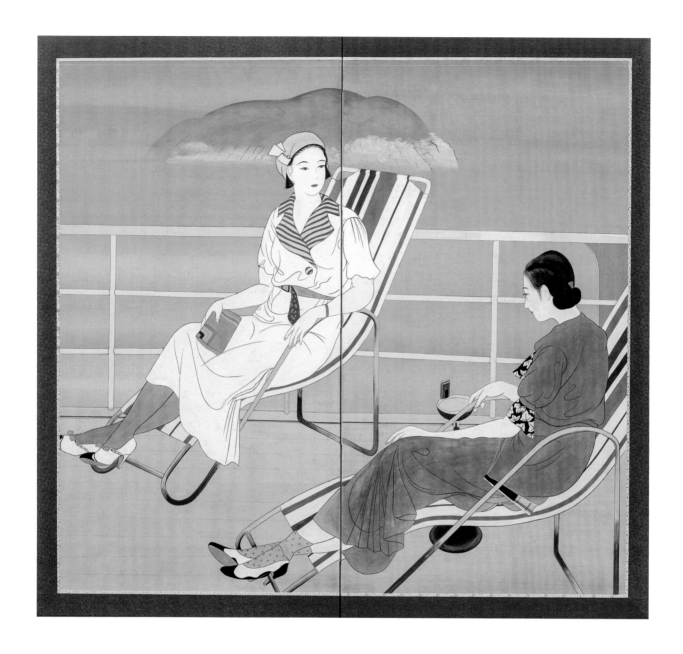

Unidentified artist
Japanese
Beauties Aboard a Ship, c. 1930
screen: colored pigment on paper
61 × 66½ in. (154.9 × 168.9 cm)
Gift of Mrs. Joseph Palmer Knapp, by
exchange, 2016.16.2

Two women relax on the deck of an ocean liner (or possibly the terrace of a seaside resort). Screens like this were commissioned as portraits – this one may show two sisters. From the clothes they wear to the chairs they sit in (a type of furniture unheard of in traditional Japan), almost nothing suggests Japanese culture. They are *modan* (modern), a word the Japanese language had borrowed from English to emphasize the break from national tradition.

With minimal changes this image could be a European or American travel poster. Yet ironically the culture that Japan has absorbed in this screen painting had itself been influenced for almost a century by a fascination with Japanese art and design. Posters and fashion illustrations derived their flat color and graceful contours from Japanese prints, and the light, spare structures that Westerners admired in Japanese architecture helped inspire furniture like the tubular steel chairs.

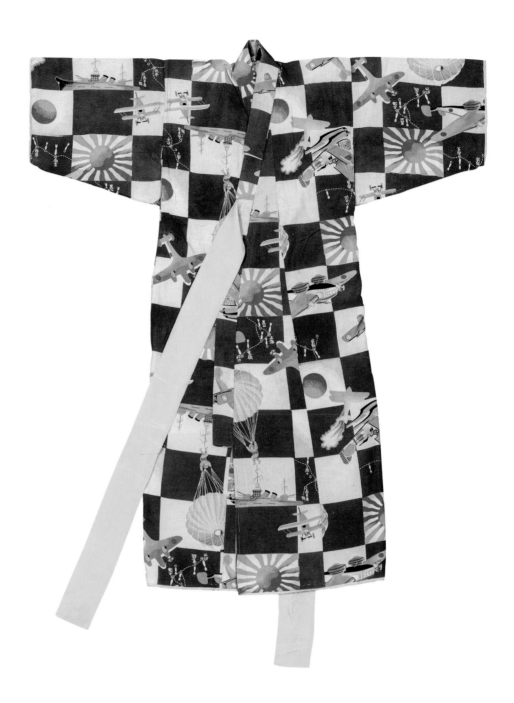

Unidentified artist
Japanese
Boy's Haregi Decorated with Bombers,
Maps, Paratroopers, and Imperial Flags,
1930s
printed artificial silk
34$\frac{1}{16}$ × 31$\frac{5}{16}$ in. (86.5 × 79.5 cm)
Gift of Jacqueline M. and Edward G.
Atkins, 2016.21.3

This kimono for special occasions reflects the Japanese predilection in the early twentieth century for incorporating imagery of modernity such as consumer goods and modern technology into textile design and decoration. A special subset of this practice deployed war motifs aligned with the militaristic nationalism resurgent in Japan in the 1930s. This garment combines airplanes of various types, battleships, Imperial Japanese flags, and schematic bombing maps. One plane appears to have been shot down, with its pilot parachuting down. Set in a lively grid, in which blue may allude to the water and white to the sky, this is a visually vibrant, celebratory composition. Although it contains no historically specific references, it may have been made after the 1937 outbreak of hostilities between Japan and China. The boy who wore it may well then have gone on to fight for Japan in World War II.

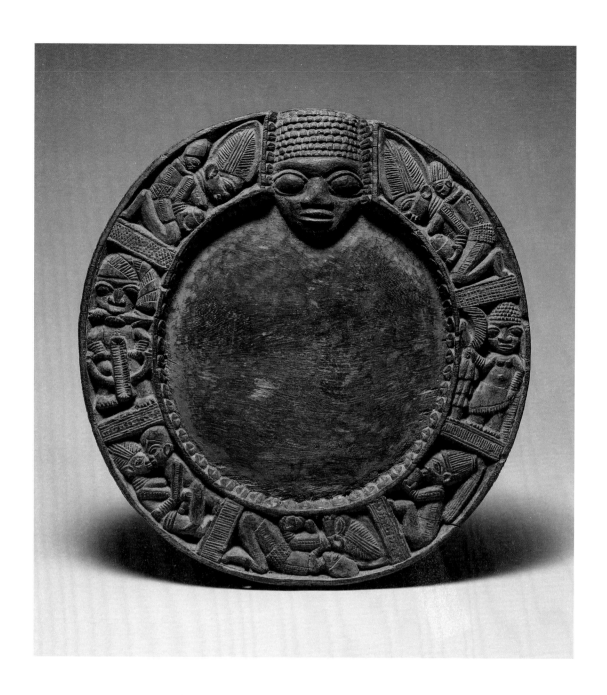

attributed to Areogun of Osi-Ilorin
Nigerian, Ekiti Region, Yoruba culture,
c. 1880–1956
Divination Tray, 1930s
carved wood
17$\frac{11}{16}$ × 17$\frac{3}{8}$ × 1$\frac{9}{16}$ in. (45 × 44.2 × 4 cm)
Ackland Fund, 97.1

The artist of this tray, Areogun, is known only by his praise name, shortened from *areogunbunna*, meaning "one who gets money with the tools of Ogun and spends it liberally." Ogun is the Yoruba god of iron, blacksmiths, hunters, warriors, and carvers. Areogun's facility with the carver's tools is clearly in evidence here: in seven compact frames encircling the open space at the center, human figures represent desirable things in public and private life – political power, for example, or family relationships. At the top appears the face of Eshu, the god who mediates between human and divine worlds. The imagery alludes to the tray's function in Ifa divination, in which clients consult a diviner for advice about how to solve problems they are facing. Ifa originated in Nigera and is practiced in West Africa and in North and South America.

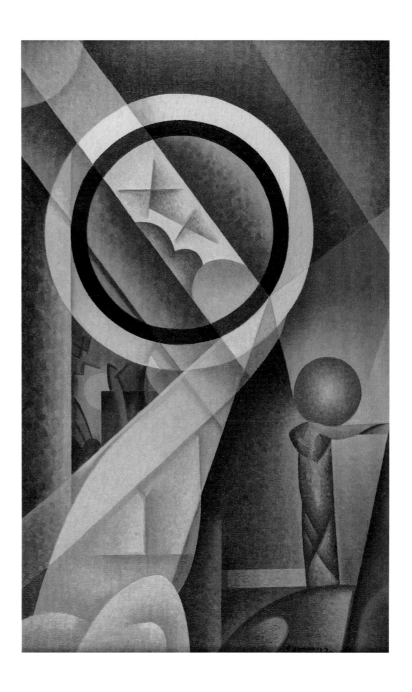

Raymond Jonson
American, 1891–1982
Abstract Naught, from *The Digits*, 1930
oil, maybe with tempera, on canvas
24 × 15 in. (61 × 38.1 cm)
Ackland Fund, 2012.20

Jonson was one of many artists transformed by experiencing the New Mexico landscape. He moved to Santa Fe from Chicago in 1924 and continued a painting career already deeply influenced by seeing the experiments of the legendary Armory Show in 1913, reading the writings of Vassily Kandinsky about abstraction and spirituality, and working with the mystical painter and set designer Nicholas Roerich. By the late 1920s, he was working in series. *Abstract Naught* is the final canvas in a set of ten, *The Digits*. Vestiges of landscape and the stylized human figure are subsumed into a lyrical and dramatic composition of cubistically inflected forms, dominated by a single hue. Numbers were a neutral subject, suitable for a methodical investigation of form, as was the alphabet, the subject of Jonson's subsequent series. Later in the 1930s, Jonson painted murals for the Works Progress Administration and cofounded the influential Transcendental Painting Group.

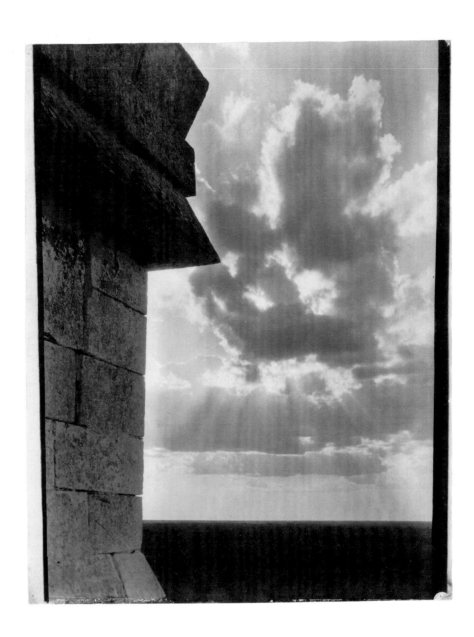

Laura Gilpin
American, 1891–1979
Sunburst, the Castillo, Chichén Itzá,
1932
vintage gelatin silver print
image: 14 × 11 in. (35.6 × 27.9 cm)
The William A. Whitaker Foundation Art
Fund, 2015.3.3

Laura Gilpin, one of the only female landscape photographers of her time, developed a career spanning seven decades with a specific focus on the American Southwest. Unlike her contemporaries in landscape photography, Gilpin did not isolate the land from civilization with uninhabited picturesque explorations. She understood humans as inseparable from their environment and therefore committed to showing the mark humans made upon the land.

The Castillo is a well-known pyramid in Chichén Itzá, the site of an ancient Mayan city in Mexico. The pyramid has four sides corresponding to the cardinal directions, with a total of 365 steps. It was designed so that, during the spring and autumn equinoxes, the shape of a snake is sent slithering down its steps by the shadows cast by the sun. Gilpin, however, concentrates instead on the contrast among the vertical human-made structure (shown in a close-up detail of the structure's upper elements), the distant, dark horizon, and the dramatic effects of sunbeams through the clouds.

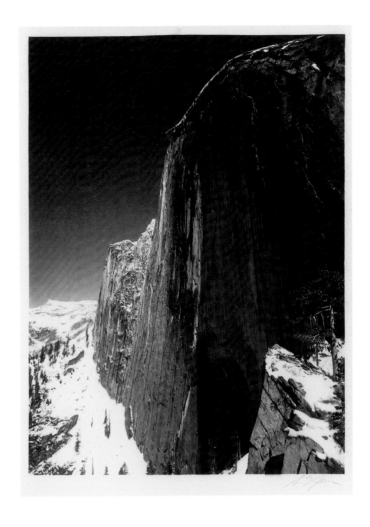

Ansel Adams
American, 1902–1984
**Monolith: The Face of Half-Dome,
Yosemite, from *Parmelian Prints of the
High Sierras*,** 1927
vintage gelatin silver "parmelian" print
image: 8 × 6 in. (20.3 × 15.2 cm)
The William A. Whitaker Foundation Art
Fund, 2017.2.1

This dramatic view of Yosemite Valley's most iconic landmark demonstrates Ansel Adams's expressive approach to photography. Rather than recording the scene the way it appeared objectively, he sought to capture it on film the way he envisioned it internally, what he called a "visualization," using effects such as sharp focus, deep contrast, and tone. He considered *Monolith* to be his first "visualization." According to Adams, he waited for the sun to strike the sheer granite cliff, then used a red filter to darken the sky so that it appeared almost black. This work showcases Adams's mastery of photography in both technical and theoretical terms.

Adams began visiting Yosemite as a teenager, forming a lifelong attachment to the park, which served as his inspiration. His representations of Yosemite and the western landscape as a largely uninhabited wilderness featured prominently in his work and made him synonymous in the American psyche with the notion of the untamed West.

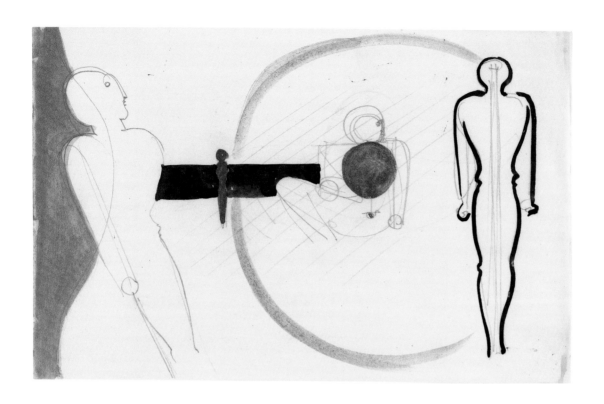

Oskar Schlemmer
German, 1888–1943
Composition with Figures and Circle,
1939–40
graphite with black and metallic
watercolors
5½ × 8¹¹⁄₁₆ in. (14 × 22.1 cm)
The William A. Whitaker Foundation Art
Fund, 70.4.1

Schlemmer was a leading light on the faculty of the Bauhaus, Germany's experimental and influential art and design school between the wars. He taught a wide range of subjects that mirrored his own creative activity: sculpture, mural painting, metalwork, and theater design. Employment as a teacher came to an end when the National Socialists came to power in 1933. His art was declared "degenerate." By 1940, he was supporting himself with work in a lacquer factory and private mural commissions. This sketch surely relates to such a commission. It deploys Schlemmer's characteristic friezelike array of idealized and rigidly posed human figures set into a geometrical framework. Frontal and profile forms in varying scales evoke a utopian vision, perhaps of a family group. Similar projects in Schlemmer's oeuvre were partially executed in wire relief, combining linear perfection with planar color, and that was perhaps the intention here too.

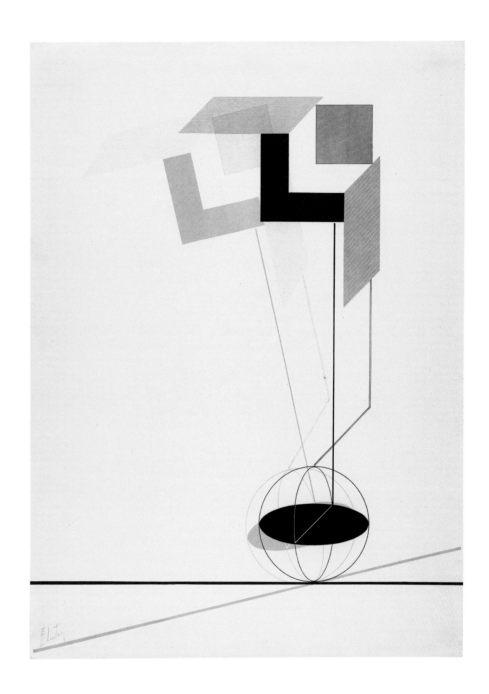

El Lissitzky
Russian, 1890–1941
Untitled, from the portfolio *Proun*, 1923
lithograph in black and brown
23¾ × 17⁵⁄₁₆ in. (60.3 × 43.9 cm)
Ackland Fund, 59.3.2

In the aftermath of World War I, the Russian Revolutions of 1917, and the radical abstract painting of his mentor, Kazimir Malevich, the Russian-Jewish artist Lissitzky coined "Proun" as an evocative neologism for his nonobjective art. The artist himself never provided a derivation for this word. Though scholarship has identified it as an acronym from the Russian words "For the establishment of the new," it was to him a symbol whose full meaning would only become clear in the future, as would the full implications of his utopian art. While in Germany in the early 1920s, Lissitzky produced a largely monochrome portfolio of elegant lithographs with the overall title *Proun*, some of which demonstrated his mastery of spatially complex architectures, while others played with texture and collage. This sheet, with its witty allusion to a shifting figure posed on a ball and a wire, evokes balance and dynamic motion.

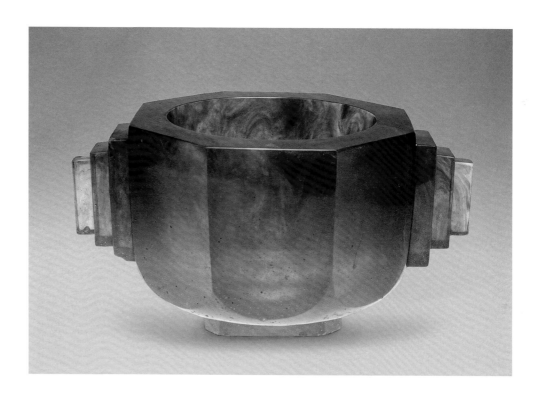

François-Emile Decorchemont
French, 1880–1971, company active
1902–14, 1919–71
Bowl, c. 1927–30
pâte-de-cristal
5⅜ × 7½ × 11 in. (13.6 × 19.1 × 27.9 cm)
Gift of Dorothy and S. K. Heninger, Jr.
and the William A. Whitaker Foundation
Art Fund, 96.1.1

Decorchement became famous for his glass objects, made in the pâte-de-verre technique in which a malleable paste made from crushed-glass colored and metallic oxides is cast in heated molds. The craftsman invented his own variant, pâte-de-cristal, which has an especially translucent, crystalline aspect. This sophisticated bowl, with its stepped geometries and sleek form, exemplifies the modernistic style art deco, a style that took its name from the *Exposition Internationale des Art Décoratifs et Industriels Modernes*, held in Paris in 1925. In his later years, Decorchement devoted himself to the art of stained-glass windows for churches.

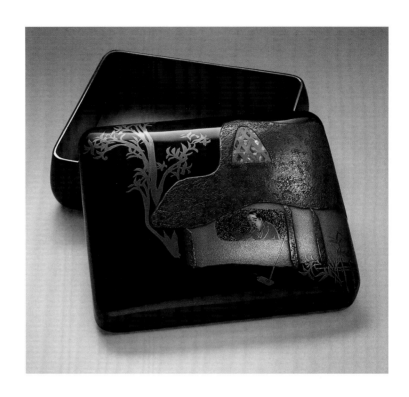

Kamisaka Sekka
Japanese, 1866–1942
Cigarette Box, 1920s
lacquer with inlaid decoration in
pewter, abalone, silver, and gold
overall: $4^{15}/_{16} \times 5^{15}/_{16} \times 2$ in.
(12.5 × 15.1 × 5.1 cm)
Ackland Fund, 93.2ab

This lacquer box combines a self-consciously rustic theme with luxury materials. The lid depicts a farmer sitting in his hut, with pewter used for the straw roof, mother-of-pearl and gold for the grill in the roof front, silver for the hoe, and gold for the rest of the structure. As part of its campaign to modernize Japanese traditions in art and design, in 1901 the government sent Sekka on a six-month tour of Europe, to visit the Glasgow International Exhibition and to study ornamental design. Strongly influenced by art nouveau, he returned to Kyoto and established himself as a highly influential teacher, artist, organizer, and designer, working on projects as various as ship and train interiors, gardens, paintings, and woodblock illustrations for books. All his work combines traditional Japanese aesthetics with modern design trends.

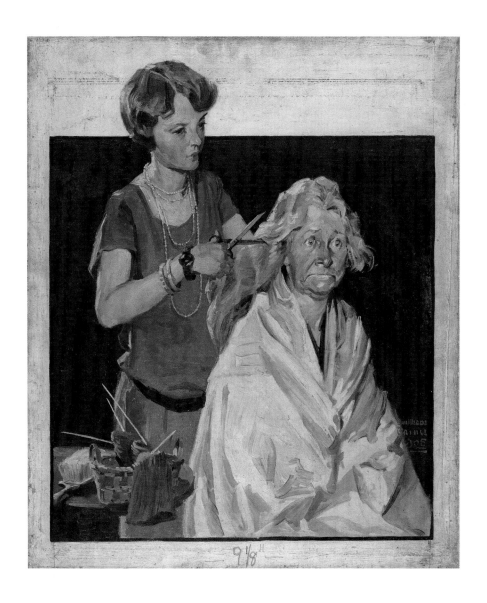

William Meade Prince
American, 1893–1951
Hair Bob, cover illustration for
***The Country Gentleman**, 1925
oil on canvas
25⅛ × 21¹⁄₁₆ in. (63.8 × 53.5 cm)
Gift of Mrs. William Meade Prince
(William Meade Prince Collection),
62.27.9

A prolific illustrator in the first half of the twentieth century, Prince grew up in Chapel Hill, North Carolina, and moved back there in 1930. After studying art in New York, he went on to supply cover images and story illustrations for such magazines as *Collier's*, *Redbook*, and *The Saturday Evening Post*. This painting was used as the cover for the May 9, 1925, edition of *The County Gentleman*, an agricultural magazine which, like the *Post*, was published by the Curtis Publishing Company. Typical of Prince's gently humorous depiction of expressive characters, the image shows the modern young girl, with a sleek black watch and conveniently short hair in the fashionable "bob" of the 1920s, beginning to give her somewhat perplexed grandmother the same updated look. Whether or not to "bob" one's hair was energetically debated at the time. Prince often depicted such mild generational contrasts, tensions, and incongruities.

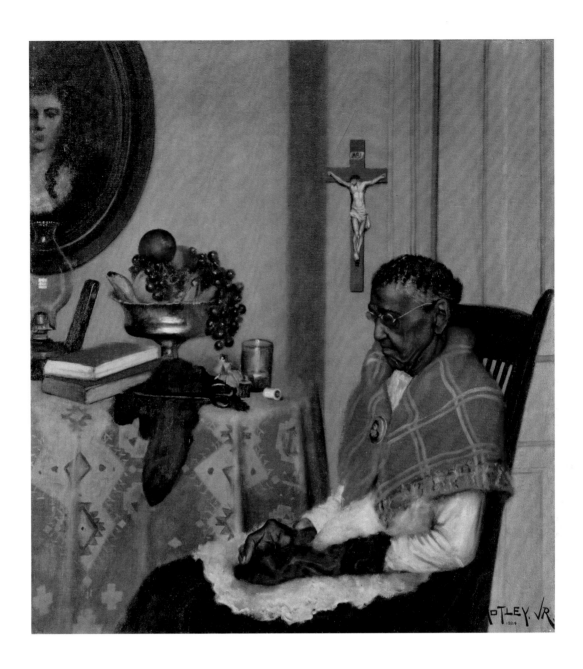

Archibald John Motley Jr.
American, 1891–1981
Mending Socks, 1924
oil on canvas
43⅞ × 40 in. (111.4 × 101.6 cm)
Burton Emmett Collection, 58.1.2801

In addition to his well-known scenes of jazz age nightlife in Chicago, Archibald John Motley Jr. also painted portraits. *Mending Socks* is a portrait of Emily Motley, his grandmother, who sits sewing amid an array of objects carefully organized to represent her life and values, tracing, from left to right, a time line of her life. The oval portrait at the upper left was a gift to Mrs. Motley from the woman who owned her when she was enslaved, given upon her emancipation. During those early years, she learned to read (referenced by the books). The well-appointed table signifies her marriage, family, and middle-class status. In old age, at the picture's right, her enduring values are in evidence: the mending in her lap a sign of her industriousness and her dedication to caring for her family, and the crucifix beside her head, her faith.

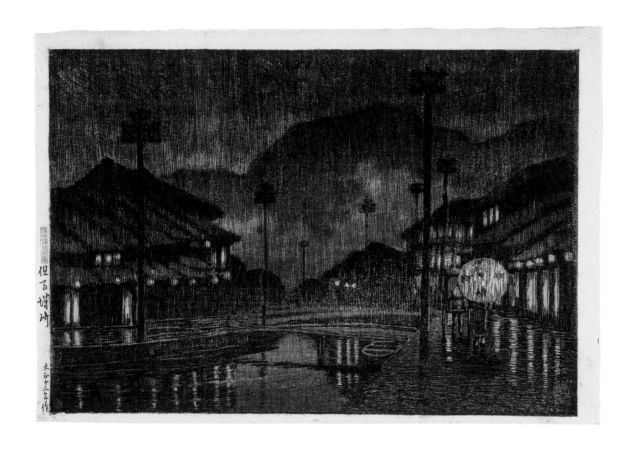

Kawase Hasui
Japanese, 1883–1957
Kinosaki, Tajima, from *Souvenirs of Travel*, 1924
color woodblock print
sheet: 10⅛ × 15¼ in. (25.7 × 38.7 cm)
Gift of W. A. Whitaker, 60.14.15

Hasui was one of the chief artists of the "new print" (*shin-hanga*) movement, depicting the landscape of modern Japan: note the electric poles here. Shin-hanga artists rendered landscape and figures according to Western conventions of perspective and anatomy but followed traditional methods of print production. Skilled craftsmen reproduced the artist's drawing on wooden printing blocks, using fine black outlines that enclosed fields of flat or delicately shaded color. The resulting print looks like a precise drawing in ink, colored with watercolor washes.

But here Hasui breaks from the traditional technique: this image reveals that it was printed from woodblocks. There are no black contour lines – forms are defined by different shades of color printed from different blocks. Highlights are made by lines gouged out of the blocks printed in dark blue or black. The result is a striking impression of night and rain, punctuated by golden light from windows.

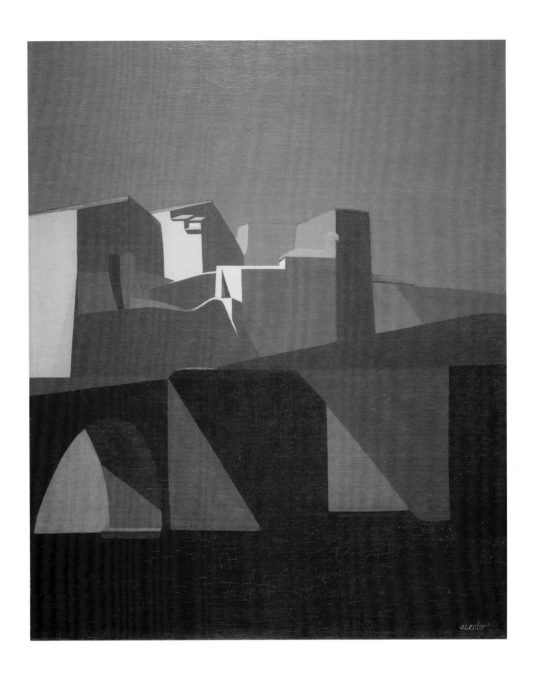

Amédée Ozenfant
French, 1886–1966
Sisteron, between 1919 and 1928
oil on canvas
28⅝ × 23½ in. (72.7 × 59.7 cm)
The William A. Whitaker Foundation Art
Fund, 72.29.1

Ozenfant was the coinventor of a style he called Purism. The quintessential Purist painting is the still life: bottles, glasses, and the occasional guitar, arranged and stylized to form a harmonious composition, completely controlled by the artist. Painting a view of Sisteron, a riverside town in southern France that he had visited in 1914, Ozenfant was faced with the challenge of a preexisting subject. Over a decade, he produced at least nine subtle variations based on a single postcard view. Eliminating a mountainous background, they give us river, sky, and clustered buildings between, and they simplify the complex architecture of the town to create a clean pattern of sunlight and shadow. Purist paintings have been described as crystalline, but crystals can include flaws. Ozenfant's variations from strict geometry acknowledge an old town: walls lean and stone weathers. The result blends geometric structure, natural irregularity, and perhaps memories of sunlight from years earlier.

Charles Demuth
American, 1883–1935
**Study for Poster Portrait: Wallace
Stevens**, 1925–26
graphite and colored pencil
8¼ × 6⅜ in. (21 × 16.2 cm)
Ackland Fund, 76.50.1

This is a study for one of Charles Demuth's symbolic "poster portraits" of artist and writer friends. Rejecting the traditional figural form of portraiture, Demuth relies on objects and words alluding to the subject's life and career rather than physical likeness. In this work, he evokes the poet and playwright Wallace Stevens (1879–1955) through an inkstand and quills, paper, and a mask set against an abstract grid. A member of New York's avant-garde, Demuth believed that art could express psychological and spiritual states by using a modern visual vocabulary.

Stevens was a successful Hartford insurance executive who secretly wrote in his spare time. The duality between the executive and the poet is implied by the two quills and the secrecy of his writing is symbolized by the mask. The grid likely refers to Stevens's literary theme of creating order and harmony through poetry, as well as his ordered life as an insurance agent.

Max Beckmann
German, 1884–1950
Georg Swarzenski, c. 1921
black crayon and traces of graphite on
yellow prepared paper
16⅚6 × 12½ in. (41.5 × 31.7 cm)
Ackland Fund, 84.12.1

With strong contours and a minimum of shading, Beckmann gives sculptural presence to the head, near life-size, of his friend Georg Swarzenski. The museum director sits sideways in his chair and turns to look across its back rail. He gazes around the rimless lens of his pince-nez to focus on the artist (and viewer): a scholar, turning from his desk, to greet us.

Yet his other eye is distorted by the pince-nez. The modeled roundness of his head contrasts with clashing patterns of shading that render his jacket as a flat surface. In foreground and background, diagonal strokes defining the chair and wall pin him between them, and the paper's yellow coating is a glaring contrast to the delicate pencil lines that Beckmann has drawn on it. The artist has maintained a skillful equilibrium between his calm observation of Swarzenski's face and the tension pervading the drawing as a whole.

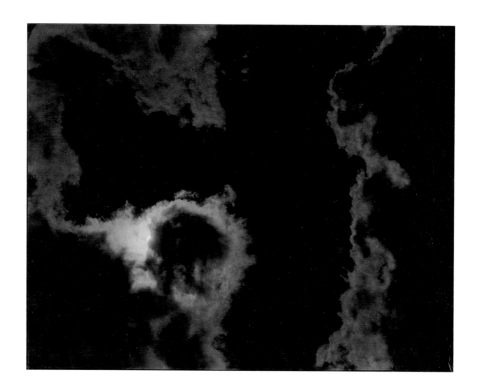

Alfred Stieglitz
American, 1864–1946
Portrait of Georgia, No. 3,
from *Songs of the Sky*, 1923
gelatin silver print
4 × 5 in. (10.2 × 12.7 cm)
Ackland Fund, 80.32.1

From 1922 to 1934, Stieglitz created a series called *Songs of the Sky* at Lake George in New York. Using the sky, and specifically the clouds, as his almost abstract motif, he created disorienting images that offer a grounding sense of scale or obvious up or down in their composition. The photographs are intended to evoke the artist's emotions through analogues in natural forms. The series of over 200 photographs also bore the title *Equivalents*. The personal content of this image, as separate from what is actually depicted, is underscored by the title, which refers to Stieglitz's longtime muse, lover, and wife, the artist Georgia O'Keeffe (1887–1986). This photograph can be seen as belonging to the very extensive series of representational portraits of O'Keeffe that Stieglitz made over the course of their long relationship.

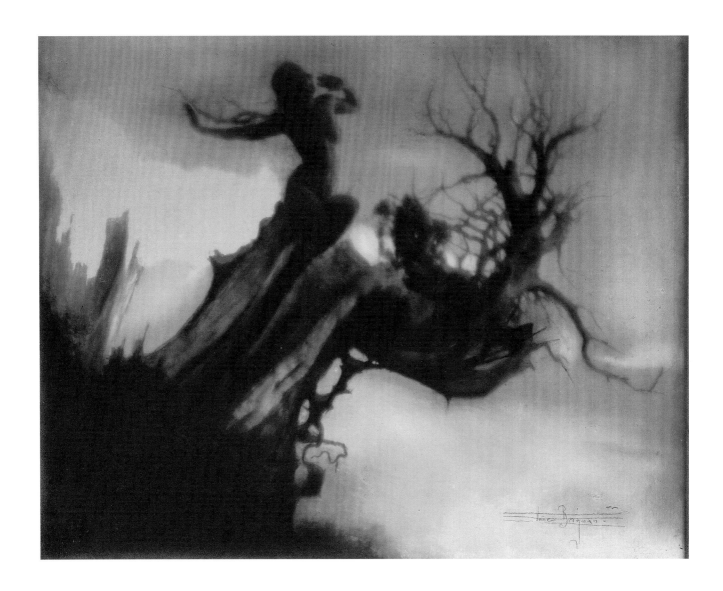

Anne W. Brigman
American, 1869–1950
The Storm Tree, 1912
gelatin silver print on original mount
image: 7⁹⁄₁₆ × 9¹¹⁄₁₆ in. (19.2 × 24.6 cm)
Ackland Fund, 2006.4

Living in California, Brigman belonged to the Photo-Secession, a prestigious group of artists based in New York City who sought to advance photography to the status of fine art during the first decades of the twentieth century. She achieved widespread recognition early in her career for photographs of nude women fused with the rugged landscape of the American West. In *The Storm Tree*, a woman emerges from the bark of a gnarled and grotesque ancient tree, referred to by the artist as a "dragon tree." As though in flight, the woman rides the preternatural creature with outstretched arms and arched torso, gazing upward into the formless ether. The soft focus and dramatic shadows, achieved through manipulation of the negative and typical of the Pictorialist movement, create an eerie, otherworldly atmosphere for this hybrid figure, formed from the mystical convergence of a human with nature.

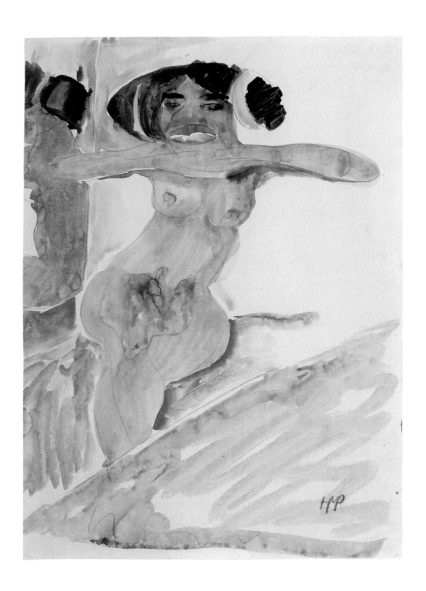

Max Pechstein
German, 1881–1955
Nelly, c. 1910
watercolor over graphite
17⅝ × 13⅛ in. (44.7 × 33.4 cm)
Ackland Fund, 65.17.1

"Nelly," a cabaret dancer and circus performer, became acquainted with a group of young artists in Dresden who called themselves "The Bridge." Fascinated by African and South Pacific cultures, these men hoped to emulate the "primitive" art they saw in the Dresden Ethnographic Museum. One portrayed Nelly in watercolor that flows through her pictured body like a stream: naked, posed in what may be a dance movement. She is seen as a force of nature.

This picture would have shocked viewers in 1910. Today it shocks by a disturbing similarity to the racist caricature common then – and later – in America. How did Pechstein see Nelly: friend, model, African specimen? In a photograph, dancing with the fiancée of Pechstein's friend Erich Heckel, Nelly does not seem an outsider. Another portrayal by Pechstein – a true portrait – exaggerates her features no more than his depictions of European faces do. However, her last name remains unknown to us.

Max Weber
American, 1881–1961
Composition with Three Figures, 1910
watercolor and gouache on brown (kraft) paper
47 × 23 in. (119.4 × 58.4 cm)
Ackland Fund, 60.4.1

Max Weber was among the first American artists to introduce European modernism to the United States. He lived in Paris from 1905 to 1908, and through his friendships with artists Henri Matisse, Henri Rousseau, Pablo Picasso, and others, Weber experienced the radical and innovative approaches to artistic representation unfolding at the time. He was particularly influenced by Picasso's experiments with cubism and shared in his interest in African and Oceanic art. Following Weber's return to New York City in 1909, he developed his own cubist style, producing works like *Composition with Three Figures* that reveal the artist's early geometric engagement with the human form. Pressed tightly together within the picture's frame, the nude figures sit in sleepy, melancholic poses with their eyes closed. Simple, sculptural shapes, both angular and rounded, denote features and limbs while hatching and touches of color produce form. The underlying pattern of uniform horizontal lines, which Weber likely achieved by executing the drawing against a corrugated surface, produces a textural matrix that simultaneously draws attention to and competes with the two-dimensionality of the surface.

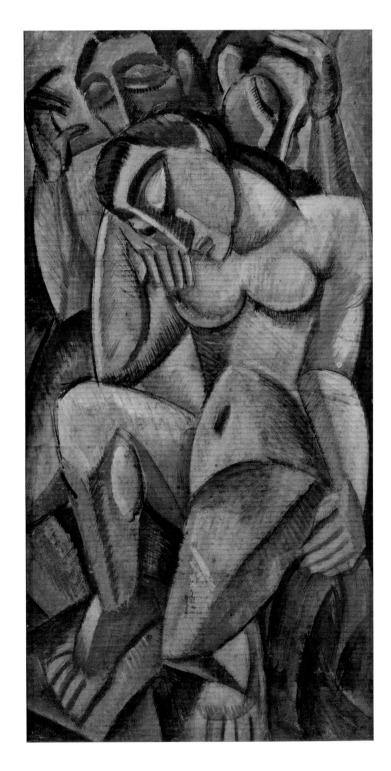

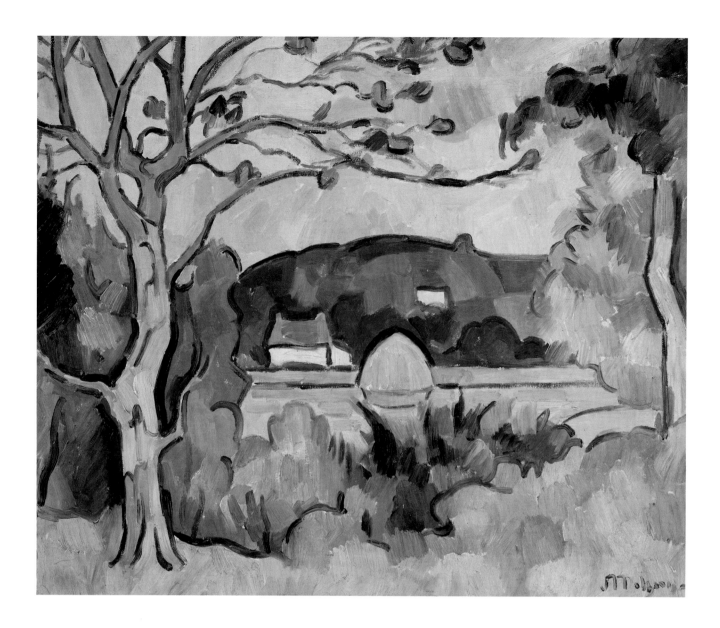

Jean Metzinger
French, 1883–1956
Landscape, 1904
oil on canvas
21¼ × 25⅝ in. (54 × 65.1 cm)
Ackland Fund, 60.26.1

By 1903, aged twenty, Metzinger had established himself with a version of Impressionism, featuring mosaiclike surfaces of bright colored dots, and he was still devoted to that style as late as 1907. Here, in contrast, we see broad patches of subtly modulated color with black linear accents, and simplified forms echoing each other, like the tree branches and the hillside below. In form and color, the painting strongly resembles the work of Paul Cézanne, a striking anomaly that Metzinger did not repeat.

What happened? Cézanne's work was famous among young artists through hearsay, but seldom seen in public. But an exhibition in 1904 included paintings by both Metzinger and Cézanne, a striking opportunity for the much younger Metzinger. Here it seems as if he were digesting the experience of Cézanne, pondering a possible alternative to his current style. A few years later, he would commit himself to a different alternative: not "Cézanneism," but cubism.

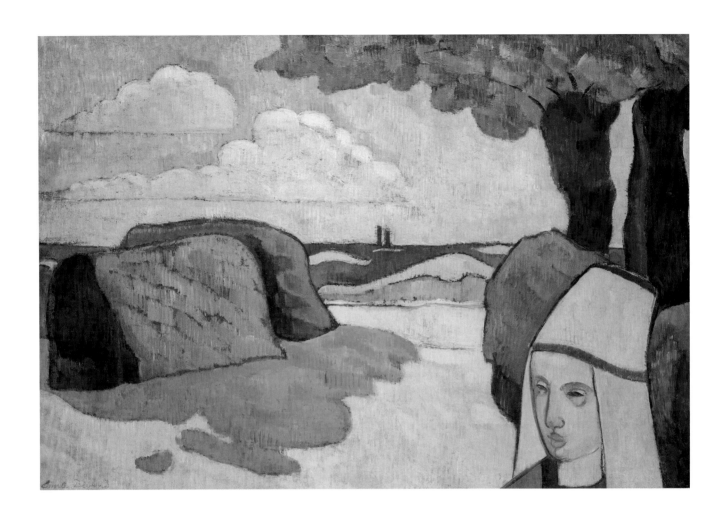

Émile Bernard
French, 1868–1941
The Wave, 1892
oil on pulpwood board, mounted on canvas
22¾ × 33⁹⁄₁₆ in. (57.8 × 85.2 cm)
Ackland Fund, 71.29.1

In the late 1880s, Bernard and his friend Paul Gauguin worked extensively in Brittany, a region where the clothing and customs of peasant society recalled the Middle Ages more than modern Europe. The reddish mounds in this coastal scene are seaweed, gathered by women on the shore for fertilizer or animal fodder. Bernard may have been responding to an 1889 painting of the seaweed harvest by Gauguin, but he reduces the scene to its basic elements: sea, beach, seaweed, and a woman's face in the foreground. Her headdress echoes the contour of the seaweed stack behind her, linking her to the harvest.

Moving beyond Impressionism, Bernard sought visual equivalents for the idea of a cloud, tree, or wave, rather than the accidental effects of light and shadow on surfaces. The painting combines jewellike colors, black outlines, simple shapes, and rhythmic patterns that recall stained-glass windows, folk art, and ornamental designs.

Louis Comfort Tiffany
American, 1848–1933
(company in New York, 1892–1931)
Water Lily Vase, c. 1900
glass
height: 16⅞ in. (42.8 cm);
diameter: 9¹³⁄₁₆ in. (25 cm)
Gift of Dorothy and S. K. Heninger, Jr. and
the William A. Whitaker Foundation Art Fund,
93.14.3

This transparent yellow vase with delicate bluish-gray water lily pads connected through a net of interwoven vines is indicative of Louis Comfort Tiffany's mastery over glass. The soft curves of the vase, the loose waves of vines, and the lightly iridized color of the vase show Tiffany's lifelong fascination with forms from the natural world, and inspiration from them.

Tiffany was an acclaimed and prolific artist whose work spanned numerous decorative art media from glass and metalwork to interior design. Tiffany opened his glass factory in Corona, New York, in 1893 and experimented with new methods of glass manufacturing. That same year, he invented "Favrile" glass, a term taken from the Old English word fabrile, meaning handwrought. This method blended different colors together in their molten state, creating subtle shading and texture effects. Favrile glass became renowned for its iridescence and vibrant colors.

Namikawa Sosuke
Japanese, 1847–1910
Vase with Spring Flowers, c. 1895
cloisonné enamel vase with wired, wireless,
and "few wire" elements against gradient
ground, with some cloisons of silver and gold
height: 22 in. (55.9 cm); diameter: (32.5 cm)
The William A. Whitaker Foundation Art Fund
and Partial Gift of Susan Tosk in honor of
Eugene Tosk, 2017.6

Cloisonné is a technique for decorating metal
surfaces. It uses thin flattened wires to demarcate
shapes that are then filled with variously colored
vitreous enamels. Late nineteenth-century
Japan saw extraordinary technical and aesthetic
advances in the practice. Namikawa was one of the
most notable practitioners, known for inventing a
method that used acid and increasingly viscous
enamels to minimize or avoid the wire lines visibly
separating color areas. The resulting painterly
effect is splendidly evident in this large vase, with
its atmospheric gradations of blue and lustrous
floral arrangements. Surely designed for a wealthy
collector (and likely a Western one) and not
intended for use, it would rather have been put
out as a very self-evidently expensive art piece to
be discussed and admired. A frequent exhibitor at
international expositions of the period, Namikawa
was designated an Imperial Court Artist by the
Emperor Meiji in 1896.

Unidentified artist
South African, Mfengu culture,
early 20th century
Collar, early 20th century
glass beads, fiber, leather, and mother-
of-pearl buttons
circumference: 14 in. (35.6 cm); strand
length: 4¹/₁₆ in. (10.3 cm)
Gift of Norma Canelas Roth and William
Roth, 2017.17

The Mfengu peoples fled the Zulu kingdom in the mid-nineteenth century and migrated
south, becoming integrated into Xhosa-speaking cultures. Like many other groups of the
Southeast Cape region of South Africa, the Mfengu developed highly refined beadwork,
using the freely available beads imported from Europe. The variations in the beadwork in
the different rows of this fine collar give a subtle dynamism to its visual effect and the color
palette is typical of the softer shades that seem to have been preferred by the Mfengu
by the turn of the twentieth century. The mother-of-pearl buttons may be modern-day
equivalents to cowrie or ostrich eggshell. Collar necklaces of this type would be worn
by either men or women on important occasions such as weddings or significant tribal
dances.

Unidentified artist
Iranian, Qajar dynasty
Dervish Cap, 19th century
wool and thread
height: 8¾ in. (22.2 cm);
diameter: 8 in. (20.4 cm)
Ackland Fund, 2020.2.1

This man's cap would have been worn by a member of a Dervish sect in Persia (present-day Iran), a follower of one of Islam's mystical and ascetic traditions. The sturdy but elegant form in humble wool felt is decorated with contrasting embroidered lines of Islamic texts set among shapes that evoke architectural forms. These texts may have been embroidered by the Dervish himself as a meditative ritual. Four inscriptions encircle the cap, crossing over the decorative shapes in broadly horizontal bands. They reflect the dominant Shiite piety that imbued Dervish orders at this time, setting Mohammed's cousin and son-in-law Ali as the rightful successor to the prophet. From top to bottom, they include a common Arabic formula praising God; a quatrain from the fourteenth-century Persian poet Hafez extolling the virtues of Ali; an Arabic formula about Ali; and a Persian saying about the difficulty of renouncing the world.

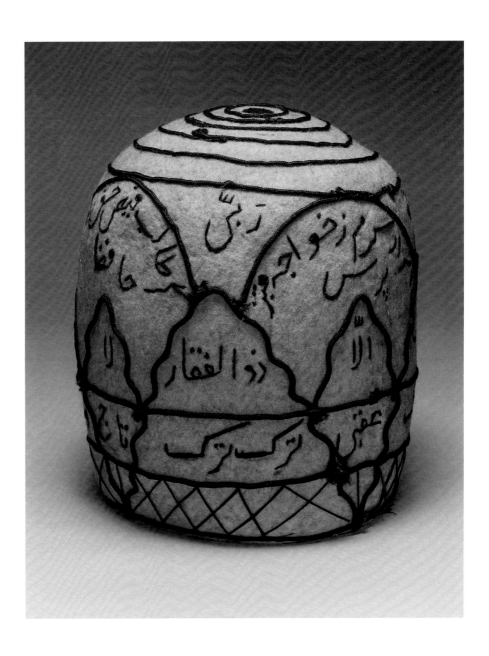

C. W. Moses
American, active late 19th to early
20th century
**Miss Myrtie Peek, Champion Long
Distance and Roman Standing Lady
Rider of the World**, late 1880s or early
1890s
cabinet card photograph
card: 4³⁄₁₆ × 6⁷⁄₁₆ in. (10.6 × 16.4 cm)
Ackland Fund, 2019.33.28

During the late nineteenth century, mass-produced, inexpensive cabinet cards were very popular for portraits, celebrity marketing, product advertising, and photographic trickery. This example, one of a series from the studio of "C. W. Moses, Photo. artist" in DuBois, Pennsylvania, shows three views of Myrtie Peek, identified on the back as "Champion Long Distance and Roman Standing Lady Rider of the World." Peek, who died of pneumonia in 1899 at the age of thirty-one, had a notable career as an equestrian, including performing so-called "Roman riding." Allegedly derived from the spectacles of ancient Rome, this feat involved riding two horses at the same time, standing with one foot on each mount. The photograph shows Peek in her jockey uniform at right, in her Roman riding outfit at left, and in fashionable clothing at center, all against one common background, a curiously modern triple exposure documenting Peek's three social and professional identities.

Unidentified artist
American
Mugshot of Estelle Behee, 1900
gelatin silver print mounted on
lithographed and inscribed card
card: 3 × 4⅞ in. (7.6 × 12.4 cm)
Gift of Mark Sloan and Michelle Van
Parys, 2014.29.36

The juxtaposition of a frontal and a profile view has long been the hallmark of the police mugshot. Also seen in mid-nineteenth-century attempts to document racial characteristics scientifically, this double-image format appears to offer a neutral document of visual evidence, reinforced by the written record (on the back of the card) of the subject's physical features (height, weight, distinguishing marks). This card, which shows signs of both use and age, was not produced by a police agency, but by the McGuire & White Detective Agency of Chicago, Illinois, which noted, among other things, that twenty-five-year-old Estelle Behee had been arrested in New York for shoplifting on December 14, 1900, was 5 feet, 4⅛ inches tall, and weighed 116 pounds.

Pierre Bonnard
French, 1867–1947
La Revue Blanche, 1894
lithograph
31⅞ × 24⅝ in. (81 × 62.5 cm)
UNC Art Department Collection, 57.3.4

An elegant woman stands in front of a shop. As the guttersnipe beside her rudely points out, she has just bought a copy of an avant-garde literary magazine. Its issues crowd the shopwindow, and a top-hatted man bends over to peer at them. Its title, *La revue blanche* (*The White Review*) runs across the figures in irregular lettering – the *a* of *la* seems to twine around the woman's body. She has an air of sophistication, and her half-hidden face looks seductively at us. Insiders familiar with the magazine would recognize her as Misia Natanson, wife of the editor and muse to the group of artists and writers associated with it, including the designer of the poster.

Bonnard's simplifications, influenced by Japanese art, permit visual trickery. The man's shiny top hat and voluminous overcoat become a pointy-eared animal (a bat?) ogling the woman. Everything suggests desirability and mystery.

Alfred Gilbert
British, 1854–1934
Nina Cust, 1894
pigment on plaster
20¹⁵⁄₁₆ × 17¹³⁄₁₆ × 12 in.
(53.2 × 45.3 × 30.5 cm)
Ackland Fund, 80.44.1

An elegant portrait of the aristocratic British writer and sculptor Nina Cust (1867–1955), this sculpture is also a study in contrasts. Its black base orients us to see Cust face-to-face, but her body turns away and her downcast eyes avoid our gaze. If we move to one side and her body faces us, her head turns away but shows off a beautiful profile. The smooth modeling of her face recalls ancient Greek sculpture, and her coiffure and headband may derive from Greek art. But Gilbert renders it, and her dress, as rough, irregular surfaces that suggest the sculptor's fingers modeling wet clay rather than imitating hair or cloth. These deliberately "unfinished" areas echo those in marble sculptures left deliberately unfinished by Michelangelo Buonarroti – and Michelangelo's famous *Pietà* (which Gilbert surely encountered during the years he lived in Rome) might also have inspired the quiet melancholy of Cust's expression.

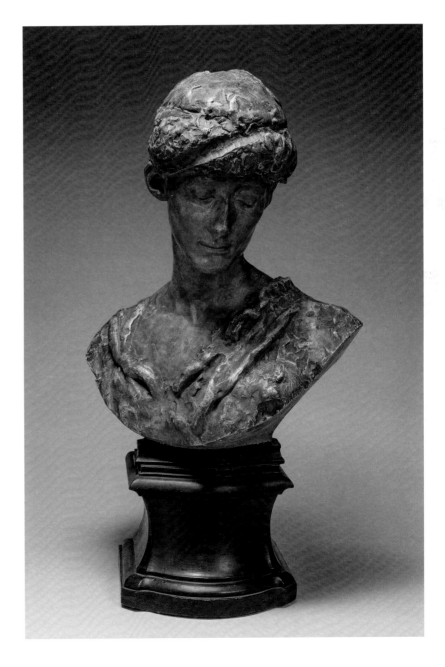

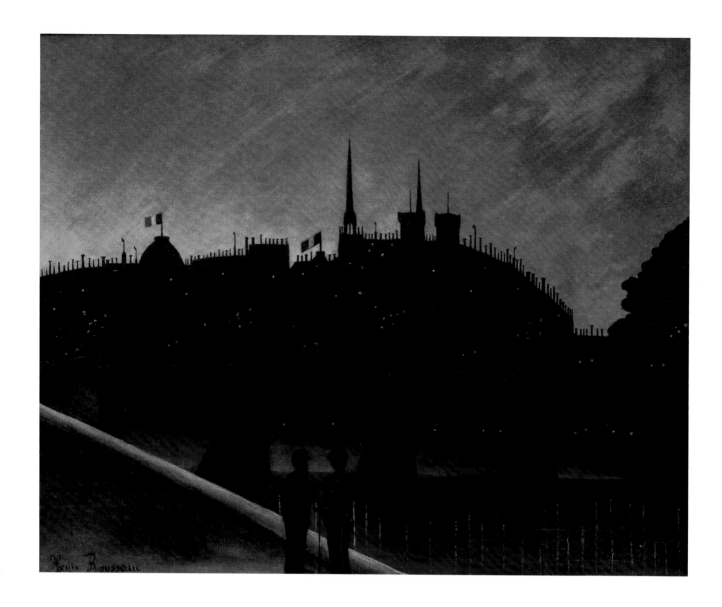

Henri Rousseau
French, 1844–1910
View of the Île de la Cité, Paris, c. 1893
oil on canvas
31⅞ × 39⁹⁄₁₆ in. (81 × 100.5 cm)
Ackland Fund, purchased in honor of
Joseph C. Sloane, alumni distinguished
professor and first director of the Ackland
Art Museum, 77.38.1

On February 1, 1868, there was a large fire at the omnibus depot on the rue d'Ulm in
Paris. Although Henri Rousseau did not witness the fire firsthand, he reimagined it in this
painting, which features the recognizable dome of the Tribunal de Commerce, the spire
of the Sainte-Chapelle, and the towers and spire of Notre-Dame. The painting was likely
exhibited at the 9th Salon des Indépendants in 1893 under another title: *View of the Ile
Saint-Louis during the Night of the Fire at the Bus Depot, Quai de L'Estrapade*.

A self-taught painter, Rousseau spent much of his adult life in the service of the
city's toll-collecting agency and was known as "le douanier Rousseau" (customs-officer
Rousseau). His simplified outlines and flat colors were a coincidental – rather than
intentional – parallel to the self-conscious "primitive" painting that Paul Gauguin and his
followers were producing at this time.

Edgar Degas
French, 1834–1917
Twilight in the Pyrenees, c. 1890–93
color monotype
11¾ × 15¹¹⁄₁₆ in. (29.8 × 39.8 cm)
Ackland Fund, 71.21.1

In 1892, a friend asked Degas about his recent landscapes, a new subject for the painter:

> "What kind are they? Vague things?"
> "Perhaps."
> "Reflections of your soul?"
> "Reflections of my eyesight. We painters do not use such pretentious language."

But there was more to it than a reflection of Degas's eyesight. He had made this landscape and others in the studio of a friend, a few weeks after a trip to the Pyrenees. To reconstruct a memory – perhaps a glimpse of mountains from a train window – he put colors on a metal plate, adding, wiping away, and moving the pigments on the smooth metal until shapes and colors matched his mental image. Then he transferred it to paper in a printing press. The process, known as monotype, gives freedom to manipulate the composition at will, and adds a bit of accident as the press squeezes colors against the paper.

Jean-Léon Gérôme
French, 1824–1904
La Fontaine and Molière, c. 1890
oil on canvas
11 1/16 × 7 15/16 in. (28.1 × 20.2 cm)
Ackland Fund, 84.22.1

In 1890, when the Impressionists had only begun
to achieve widespread recognition, Gérôme had
been famous for half a century, acclaimed for
his depiction of past eras in minute detail. Here,
sometime in the 1650s, the poet La Fontaine,
best known for his adaptations of Aesop's Fables,
greets the dramatist Molière, who looks up from
his work (he was notorious for working to the last
minute on plays that were already in rehearsal).
These two men had always been ranked among the
foremost writers of the "great century" when France
dominated the cultural landscape of Europe.
In Gérôme's time, they had reached particular
prominence as writers for the people rather than for
royal or aristocratic patrons.

 For a middle-class picture-buyer hoping to
show off his intellectual credentials but not too
sure of his own taste, Gérôme's literary subject
and obvious technical skill would have made this
painting an appealing choice.

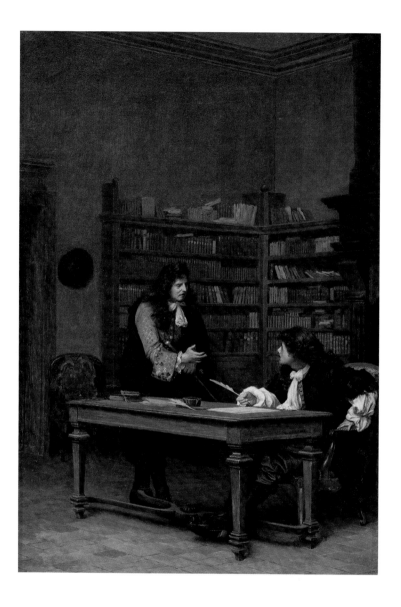

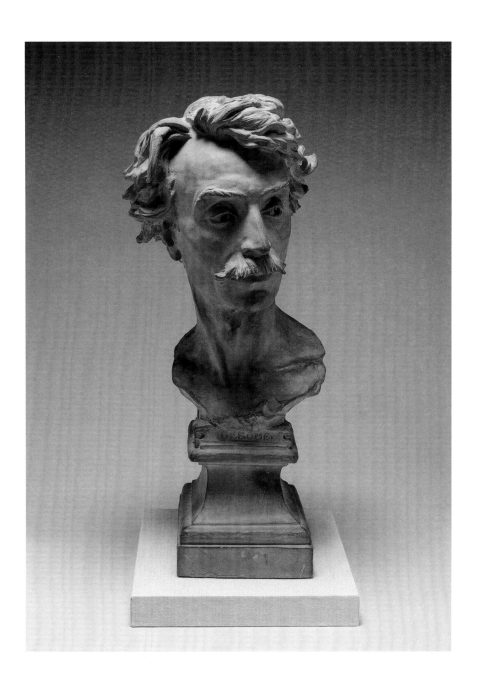

Jean-Baptiste Carpeaux
French, 1827–1875
Jean-Léon Gérôme, modeled in 1871,
cast in 1873
terracotta
22½ × 9⁷⁄₁₆ × 9 ⅜ in. (57.2 × 24 × 23.8 cm)
Ackland Fund, 80.45.1

Carpeaux modeled this portrait of fellow French artist Jean-Léon Gérôme in 1871, while both lived in London as political exiles immediately following the collapse of the Second Empire. Carpeaux's sensitive modeling of Gérôme's features — his heavy eyelids, prominent nose, dense mustache, and thick, tousled hair — captures the sitter's likeness, but Carpeaux's positioning of the head, its fixed gaze, and the seeming unfinished lower edges of the bust enliven the portrait, imparting Gérôme's character and spirit. First presented in bronze at the Paris Salon of 1872, the portrait bust was so admired that Carpeaux produced numerous copies in bronze, plaster, and, less frequently, terracotta, as seen here. Gérôme, who was widely celebrated for his meticulously rendered depictions of the classical world and the Near East, must have approved of Carpeaux's work, as he was among those who ordered a copy.

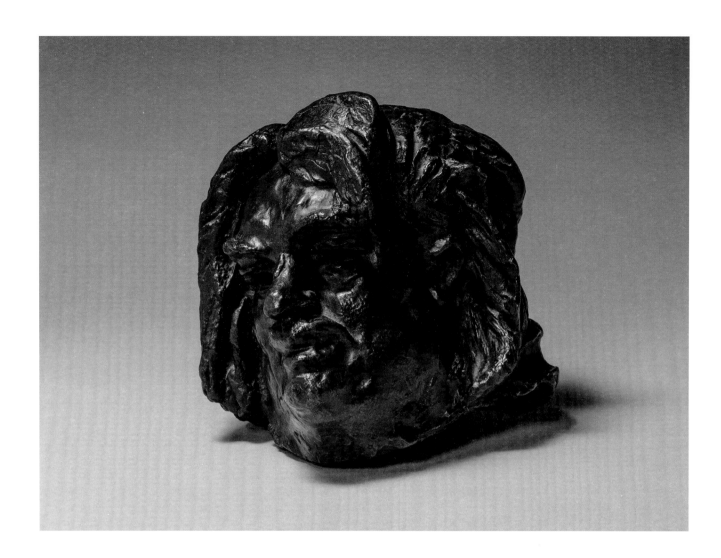

Auguste Rodin
French, 1840–1917
Head of Balzac, 1897
bronze
7 × 6½ × 6 in. (17.8 × 16.5 × 15.2 cm)
Ackland Fund, 63.27.1

In 1891, Rodin was commissioned to create a public monument to Honoré de Balzac (1799–1850), the critically acclaimed and very popular French novelist and playwright. The final full-length sculpture was completed in 1898 but rejected by the patron. In the course of fulfilling this commission, the sculptor made numerous studies, including many for the head. Such studies were later often cast separately in bronze. This aggressively articulated version of the head comes from a stage when the studies were less related to any realistic depiction of the writer's physiognomy and more to the conception of genius. With the deep-set eyes, agitated brow, and tumultuous hair, Rodin concentrated on the evocation of creative power and vigorous personality. As the artist said, "I think of his intense labor, of the difficulty of his life, of his incessant battles, and of his great courage. I would express all that."

George Minne
Belgian, 1866–1941
Wounded Boy II, 1898
bronze
10½ × 4³⁄₁₆ × 4 in. (26.7 × 10.6 × 10.2 cm)
Ackland Fund, 84.3.1

Minne, arguably the most talented Belgian sculptor
of the late nineteenth and early twentieth century,
specialized in small-scale figurative works. Focused
on emotions and the interior life, he created a
number of moving portrayals of wounded figures.
In this example, the physical awkwardness of
the adolescent's stance is counterpoised to the
litheness of the figure, while the simplicity of
the legs' pose contrasts to the complicatedly
interlocking position of the arms. The poignancy
of the motif is enhanced by the gesture of the boy
kissing his wound. The mood is one of solitary,
almost melancholic contemplation.

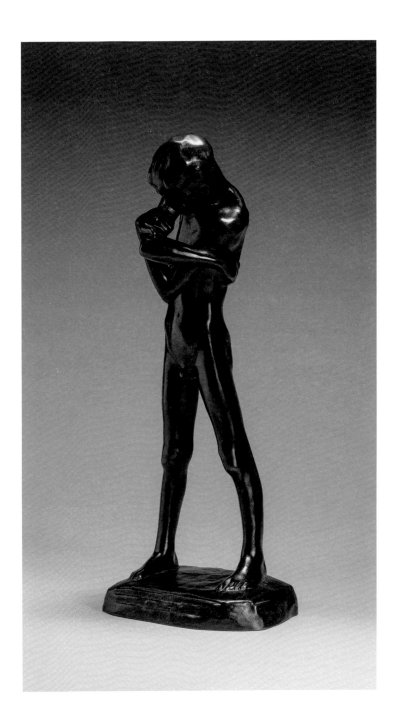

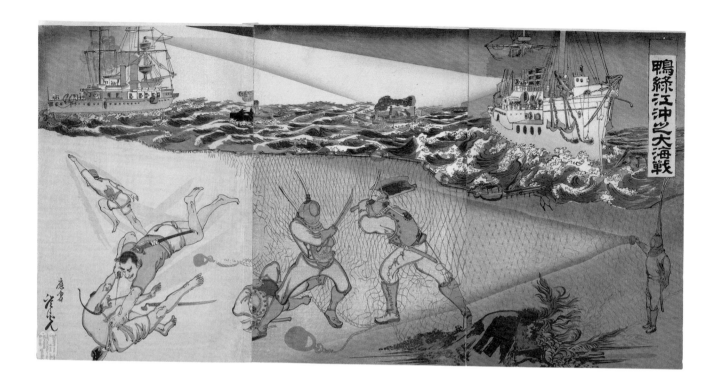

Kobayashi Toshimitsu
Japanese, active 1877–1904
The Great Naval Battle of the Yalu River,
1894
triptych of polychrome woodblock prints
(*nishiki-e*)
overall: 14 × 27⁹⁄₁₆ in. (35.5 × 70 cm)
The Gene and Susan Roberts Collection,
2015.11.110

Guided by modern spotlights, rival armored steamships prepare for battle as free swimming and air-supplied soldiers engage in hand-to hand combat underwater. Illuminated by the waterproof electric lantern held by a diver at the right, the men fight with traditional Japanese weapons, including a katana blade and axe. This triptych is one of many that features the largest naval conflict of the First Sino-Japanese War. Known as the Battle of the Yalu River, it took place on September 17, 1894, and constituted a decisive victory for the Japanese against Chinese forces.

Senső-e, or Japanese war prints, challenged artists to report the dramatic and terrifying spectacles of modern warfare using traditional woodblock printmaking techniques. The dearth of photographs from the front lines often meant artists recycled or reimagined elements from earlier designs to present contemporary, and at times inaccurate, visual accounts to eager audiences.

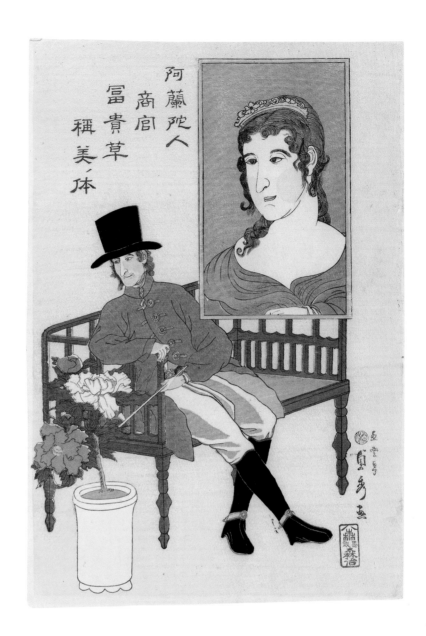

阿
蘭
陀
人

商
宿

冨
貴
草

稱
美
ノ
体

Utagawa Sadahide
Japanese, 1807–1873
Dutch Merchant Admiring Flowers, 1861
color woodblock print
14¼ × 10⅛ in. (36.2 × 25.7 cm)
The Gene and Susan Roberts Collection,
2020.11.15

The United States–Japan Treaty of Amity and Commerce came into effect in 1859, opening Japan to an unprecedented influx of foreigners and foreign trade. Shortly afterward, the Netherlands, Russia, England, and France concluded similar treaties, so that the foreign presence became known as "the peoples of five nations." Yokohama became the major port where facilities for merchants were established; it was there that Japan encountered the West most closely. Many Japanese artists quickly began producing woodblock prints that responded to the novel ships, buildings, habits, and purported characteristics of the newcomers, offering imaginative interpretations for local audiences. This image by Sadahide shows a merchant, identifiable as Dutch by his stereotypical outfit. The trader is seen admiring the boxwood flowers and reaching out to them with a suggestively placed long pipe. Their beauty is perhaps prompting him to think wistfully of his absent wife, shown in the portrait hovering over the scene.

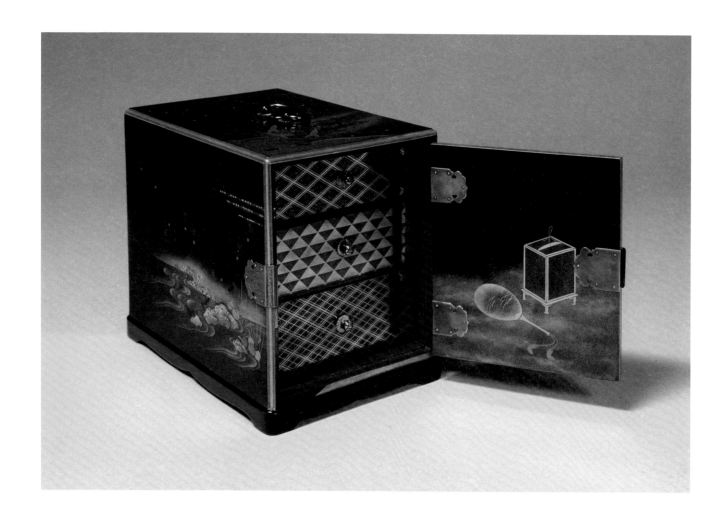

Unidentified artist
Japanese, Meiji period
Small Chest, late 19th century
lacquer over wooden base with gold,
silver, and metal decoration, inlays of
abalone, gold, and silver, *nashiji* (pear
skin) interior, red negoro lacquer, and
cast and engraved silver elements
6 × 7¼ × 5 in. (15.2 × 18.4 × 12.7 cm)
Gift of the William E. Shipp Estate, by
exchange, 2016.11.1a–d

Small chests of this type, known as *kodansu*, were usually used to store personal items like jewelry, combs, or small packets of incense. The scene depicted on this chest, which stretches onto nearly every one of its surfaces, is a traditional Japanese summertime scene of riverside fireflies. Next to the fan on the inside of the hinged door is a firefly cage. The process of creating a lacquer piece like this takes several years and involves drying and seasoning wood, the application of numerous layers of lacquer, inlays, and polishing. This richly worked example deploys a typically wide variety of materials and techniques.

Unidentified artist
Indian and Swiss
Watch and Compass, late 19th century
brass, enamel, silver overlay, and glass
2¹⁵⁄₁₆ × 1⅞ × ⅝ in. (7.4 × 4.8 × 1.6 cm)
Ackland Fund, selected by the Ackland
Associates, 96.3.2

This elegant piece of late nineteenth-century consumer technology brings together
multiple cultural aspects in a hybrid object that can stand as a symbol of international
modernity. A pocket watch with a compass in the stem, it carries inscriptions in Urdu on
its face indicating it was made in Switzerland for a Muslim purchaser, named as Sheikh
Hadji Rahim Bakhsh, a Shiite gem merchant from Ludhiana, a market town in Punjab,
India. The star and crescent on the face may be a trademark of the Indian workshop where
the decorations in calligraphy were inscribed. Additional inscriptions in Arabic calligraphy
on the face and case of the watch repeat Islamic invocations and prayers, including the
al-shehada (the profession of faith). The functionality of the watch/compass combination
serves to assist the owner in observing the Muslim requirement to pray at least five times a
day, facing Mecca.

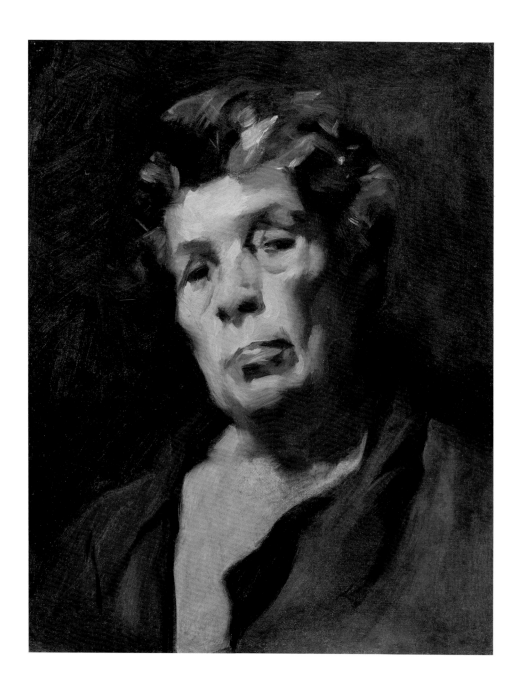

John Singer Sargent, American,
1856–1925
after Diego Velázquez, Spanish
1599–1660
Head of Aesop, 1879
oil on canvas
18¼ × 14⅝ in. (46.4 × 37.2 cm)
Ackland Fund, 75.16.1

Sargent is best known as a society portrait painter who worked in London, Paris, Boston, and New York during the late nineteenth and early twentieth centuries. This painting comes from early in his career, as he was concluding his training. He copied the head of the ancient writer Aesop after a well-known full-length painting by Diego Velázquez (1599–1660), which he saw in the Prado Museum in Madrid during a trip to Spain in 1879. His teacher, the French portraitist Carolus-Duran, had encouraged him to learn from the Prado's extensive collection of Velázquez paintings. While he was there, Sargent registered with the museum for permission to copy paintings in the galleries, studying the techniques of some of the most famous European painters, especially Velázquez, but also including Titian and Peter Paul Rubens. Sargent kept the *Head of Aesop* until his death.

Jean Jacques Henner
French, 1829–1905
Solitude, c. 1892
oil on canvas
18⁷⁄₁₆ × 13¼ in. (46.9 × 33.6 cm)
W.W. Fuller Collection, 48.1.2

While Jean Jacques Henner painted some historical compositions, genre scenes, and landscapes, the theme to which he returned many times was the mysterious female portrait in misty light of which *Solitude* is an excellent example. The elusive quality of this figure derives from the fact that Henner avoided clear outlines in his composition. The woman's profile does not have a sharp contour line; her auburn hair seems to merge with the dark background. Nor is it clear where exactly the low-cut neckline of the dress ends. This effect is partially achieved through very subtle gradations of color and enhanced by clearly visible broad brushstrokes. This painting may be an autograph replica of an unidentified and unlocated painting exhibited by Henner in 1892 under the title *Poveretta* (*The Poor Girl*).

Anthony Frederick Augustus Sandys
British, 1832–1904
Sir William Anderson Rose, 1875
pastel on tan paper
sheet: 26¹⁵⁄₁₆ × 20¾ in. (68.5 × 52.7 cm)
Ackland Fund, 83.24.1

Sir William Anderson Rose's penetrating gaze toward the viewer reflects his family motto, "Constant and true," included here beneath his coat of arms. These characteristics surely contributed to Rose's distinguished career, including his time as Lord Mayor of London (1862–63), as a member of Parliament (1862–65), and his appointment as colonel of the Royal London Militia from 1870 until his death. Rather than portray Rose in his military regalia, Sandys shows him as a gentleman, wearing a velvet-collared tan coat, tie, and pocket handkerchief. He appears before a Japanese textile featuring clouds and stylized cranes in decorative circles, a reference to the contemporary enthusiasm for Asian aesthetics. Sandys's extreme naturalism and precise attention to detail as well as his close association with artist Dante Gabriel Rossetti place him within the circle of the Pre-Raphaelite Brotherhood, a small group of artists who sought to evoke the spirit of the early Renaissance. Since Sandys never officially became a member of the group, his work is often overlooked despite his distinction as one of the most gifted portraitists of the Victorian era.

Emma Sandys
British, 1843–1877
Mary Emma Jones, 1874
oil on board
20 × 15¼ in. (50.8 × 38.7 cm)
Gift of Lauren M. Sanford in honor of
Professor Mary D. Sheriff, 2018.41

Very little is known of Emma Sandys's life. She was born in Norwich, where she lived until her death at age thirty-four, and was trained in painting by her father and her older brother Frederick. The latter introduced her to Pre-Raphaelitism, which greatly influenced her choice of subject matter and style. During the 1860s and 1870s, she exhibited her work at local galleries in Norwich and in London at both the Society of Lady Artists and the Royal Academy.

Like her brother, Sandys specialized in portraiture and depictions of figures in literary and fantastical roles. In this portrait, the artist presents her sister-in-law Mary Emma Jones as a historical beauty, dressed in medieval-inspired clothing. Appearing before a stylized screen of green leaves and branches, she gazes pensively out of the picture plane, adding to the picture's romantic sentiment. Sandys's precise brushwork and meticulous detailing place this painting among her most confident and sophisticated works.

William H. Mumler
American, 1832–1884
**Mrs. W. H. Mumler, Clairvoyant
Physician**, 1870s
carte-de-visite albumen print
card: 4⅛ × 2½ in. (10.5 × 6.3 cm)
Ackland Fund, 2014.24

Mumler claims to have recorded his first spirit photograph in spring 1861. This launched his career in this widely popular field, part of the larger Spiritualist movement, a religious philosophy popular following the Civil War that emphasized the belief that departed souls can interact with the living. Plagued by accusations of photographic fraud, Mumler eventually set up shop in his mother-in-law's house in Boston and promoted his wife as a "clairvoyant physician." This carte-de-visite advertises her services, with text on its reverse specifying the indistinct form behind her to be Declaration of Independence signer Dr. Benjamin Rush (1745–1813).

From life not enlarged La Contadina Julia Margaret Cameron

Julia Margaret Cameron
British, 1815–1879
La Contadina, 1866
albumen print from a collodion negative,
on original mount
image: 15¾ × 12¼ in. (40 × 31.1 cm)
Gift of the Tyche Foundation, 2010.13

Julia Margaret Cameron began photographing at the age of forty-eight, when her daughter gave her a camera, a few years before she made this albumen print. Particularly noted for her portraits in her brief but intense career, she also made elaborately staged tableaux for works of literature (such as her friend Alfred Lord Tennyson's *Idylls of the King*), as well as more theatrical individual portraits in costume but without an artificial setting, such as *La Contadina*, a title that translates as *The Peasant Girl*.

 The model for this photograph was Mary Emily (May) Prinsep (1853–1931), the artist's niece and a young lady whose social standing was far removed from the Italian peasantry suggested by the artist's chosen Italian title. Cameron often enlisted her friends and family in her portraits but was not interested in establishing a commercial studio.

GALERIE CONTEMPORAINE

126, boul. Magenta. — Paris. *Phot. Goupil et Cie.* Cliché NADAR, 51, rue d'Anjou-St-Honoré.

VIOLLET-LE-DUC

Né à Paris, le 27 Janvier 1814.

Nadar (Gaspard Félix Tournachon)
French, 1820–1910
Eugène Emmanuel Viollet-le-Duc, 1878
Woodburytype
image: 9¹⁄₁₆ × 7⅛ in. (23 × 18.1 cm)
Gift of Charles Millard, 2019.26.112

The most famous portrait photographer in nineteenth-century France was surely Gaspard Félix Tournachon, who went by the name Nadar. This portrait of Viollet-le-Duc (1814–1879), the most famous architect of the period, was published in an installment of the periodical *Galerie Contemporaine. Littéraire, Artistique*. This compilation aimed at providing a panorama of the most illustrious cultural figures, photographed by the leading photographers of the day. It employed the Woodburytype process, one of the first photomechanical processes to replicate successfully the delicate halftones of photography. Nadar portrays Viollet-le-Duc in a beautifully lit and natural, but dignified pose.

Eugène Emmanuel Viollet-le-Duc (designer)
French, 1814–1879
Ciborium, designed 1852, manufactured later
vermeil, with gilded bronze foot, semi-
precious stones including jasper, chrysoprase,
moonstone, agate, opal, garnet, citrine,
amethyst, and turquoise
height: 13¼ in. (33.7 cm);
diameter: 6⁵⁄₁₆ in. (16 cm)
The Elisabeth Holmes Lee Fund, 2017.33ab

Viollet-le-Duc is perhaps best known as an
architect and writer who worked extensively on
the restoration of major French architectural
monuments, including many cathedrals and
churches. He also designed church furnishings in
a neo-Gothic style to align with his architectural
ideals. This elegant and richly decorated ciborium,
a vessel used to hold the bread for celebrating
the Eucharist in Christian churches, was initially
designed in 1852. The present example shows
slight variations from that design and was probably
manufactured in the 1880s by the firm of the
goldsmith Placide-Benoît-Marie Poussielgue-
Rusand (1824–1889), who had purchased the
business of Viollet-le-Duc's longtime collaborator
Louis Bachelet (active 1851–1867). For many years,
it was used by the convent of the Poor Clares in
Mazamet, near Albi, France, which existed from
1887 to 2015.

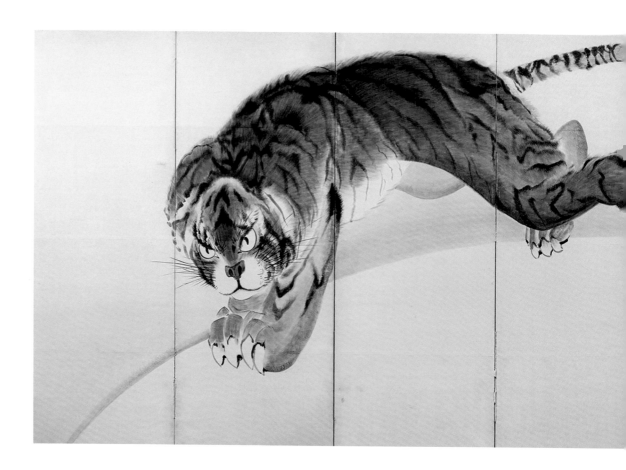

Unidentified artist
Japanese, Tokugawa period
Tiger and Bamboo, 1861–63
six-panel screen: ink on paper
screen: 67¾ × 147½ in. (172.1 × 374.6 cm)
Gift of Rosemarie and Leighton Longhi,
93.21

With a penetrating and determined stare, a massive tiger leaps gracefully across five of
the six panels in this screen by an artist of the Nagasaki School. The dynamic composition
is based on a famous eighteenth-century painting by Nagasawa Rosetsu (1754–1799), a
celebrated artist whose imaginative imagery places him within the "Lineage of Eccentrics,"
a small group of Edo-era painters who defied convention. Rosetsu's original sliding panels
belonged to an ensemble of forty-three works commissioned by a temple in Kushimoto.
The tiger and bamboo, a traditional theme in Chinese art, would have been paired with a
depiction of a dragon among swirling clouds. Together the two animals, one terrestrial and
the other mythological, represent opposite principles in nature — the tiger as the west and
the wind and the dragon as the east and the water — as well as the Taoist principle of the
yin (tiger) and the yang (dragon).

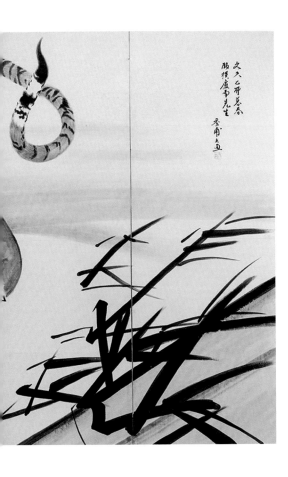

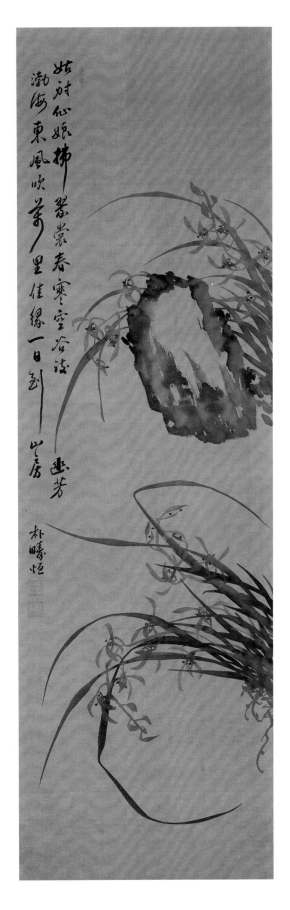

Su Hang Pak
Korean, 19th century
Orchids and Rock with Calligraphy,
19th century
hanging scroll: ink on paper
image: 51⅝ × 16 in. (131.1 × 40.6 cm);
overall: 21⁹⁄₁₆ × 21¹⁵⁄₁₆ in. (204.7 × 55.8 cm)
Gift of Ruth and Sherman Lee, 91.105

According to the calligraphic inscription on this
Korean scroll, the artist wanted to evoke the
scent of the orchids that grow in a sacred site in
China where immortal fairy women reside. While
this work references a Chinese story and bears
a resemblance to northern Chinese painting, the
placement of the flowers and decorative treatment
of their overlaid stems are distinctly Korean. This
subject matter, the somewhat abstract sprays
of orchids and floating rocks, and the execution
entirely in black ink are very typical of scholarly or
literati painting.

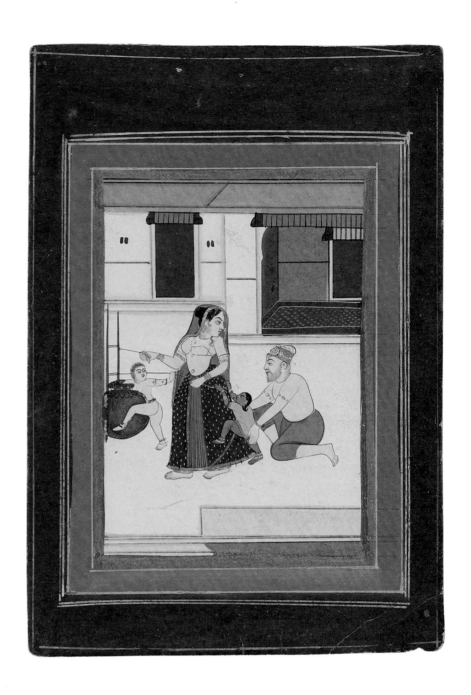

Unidentified artist
Indian, Rajasthan, Jaipur
Krishna and His Brother Stealing Butter,
19th century
gouache
sheet: 10⅝ × 7½ in. (27 × 19.1 cm)
Burton Emmett Collection, 58.1.579

Stories relating to the life and deeds of Krishna, the eighth and principal human incarnation of the Hindu deity Vishnu, have been the subject of devotional literature, music, and art in India for centuries. As a child, Krishna was cared for by foster parents in a remote Indian cow-herding village called Brindaban and was much loved by his friends and the community for his mischievous antics. This image shows the blue-skinned Krishna, who had a great love for butter, distracting his foster mother Yashoda while her son reaches into the churn to steal some. Such coming-of-age narratives were popular in the northern Rajput kingdoms in Rajasthan where sects devoted to Krishna were particularly abundant. Once part of a larger volume, this sheet's vivid, yet limited palette, linear outlining, and red border are characteristic elements of court miniature painting in the region.

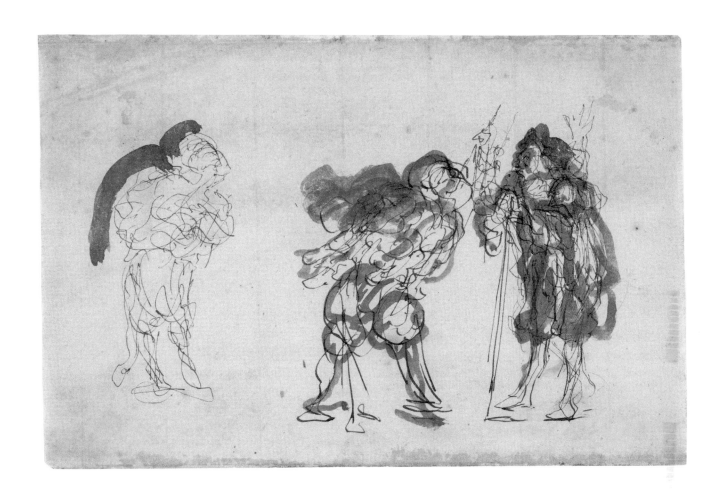

Honoré Daumier
French, 1808–1879
Scene from a Play by Molière, c. 1865–79
pen and gray ink and gray wash
5 × 7¹¹⁄₁₆ in. (12.7 × 19.5 cm)
Ackland Fund, 64.7.4

Daumier made this small drawing of three figures in animated poses sometime during a period of about fifteen years, late in his life, after he stopped publishing satirical prints due to changes in the French political climate. It was originally one of a pair of drawings; the companion drawing, now in a private collection, bears an inscription that explains the subject matter and the early history of the pair. The figures represent characters from a play by Molière (Jean-Baptist Poquelin, 1622–1673), another famous French satirist whose work may have appealed to Daumier. The drawings' first owner was the late nineteenth-century French art critic Arsène Alexandre, who published a book on Daumier's life and art in 1888.

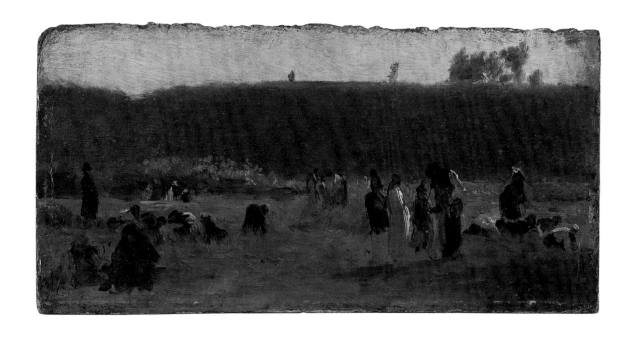

Eastman Johnson
American, 1824–1906
Cranberry Pickers, c. 1876–79
oil on board
3¾ × 7¹¹⁄₁₆ in. (9.6 × 19.6 cm)
Gift of Mr. and Mrs. Norman Hirschl,
72.51.1

Johnson began spending summers on Nantucket, an island in Massachusetts, in 1870. This modest painting is probably the earliest of at least eighteen studies that resulted in a grand composition of 1880 (Timken Museum of Art, San Diego). This very summary sketch, surely made on-site, lacks geographic detail (such as known buildings on the skyline) and narrative details (such as a standing woman greeting a child carrying a baby) that characterize later stages in the evolution of the composition. Here, Johnson quickly captures the multigenerational activity of cranberry picking, evoking harmony and community. Late afternoon light shines from the right, picking out details in the shadowy scene. Although the top-hatted male figure at left may suggest patriarchal dominance, he is ultimately integrated into the rhythm of people standing and kneeling, chatting and picking. Nantucket's cranberry industry, only some two decades old, played a key role in the island's economy.

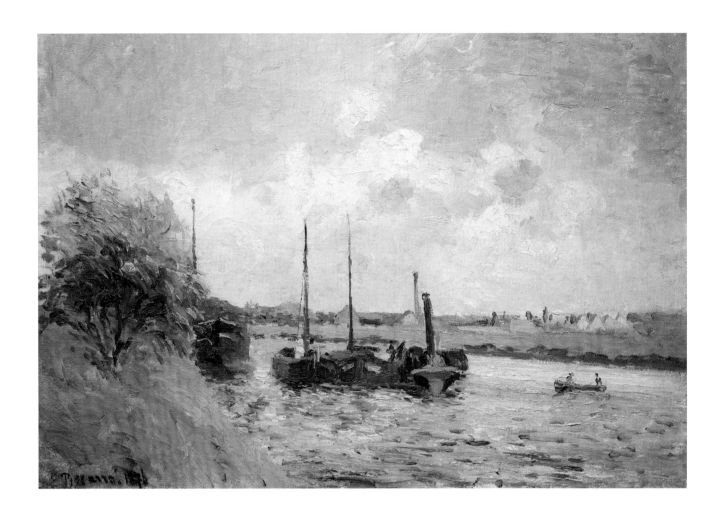

Camille Pissarro
French, 1830–1903
The Banks of the Oise, Near Pontoise,
1876
oil on canvas
14¹⁵⁄₁₆ × 21⅞ in. (38 × 55.5 cm)
Ackland Fund, 65.28.1

A sunny day, a river bank, bright color – we are so used to Impressionist paintings like this that it is hard to see why they repelled viewers in the 1870s. But they offered a strikingly new way to look at the world, and it was easier to see what had been lost than what had been gained. The Impressionists gave up detail, surface texture, and, above all, solidity: the difference between light and shadow mattered more than the difference between stone and steam. We see light and atmosphere, but we don't *feel* earth or water as we might in earlier paintings.

Moreover, the scene is no romantic rendezvous or tourist spot. For viewers in 1876, sailing barges and a steam tug were no more picturesque than a cement mixer would be today. The masts and the tug's smokestack echo a factory chimney in the distance. This is a working river.

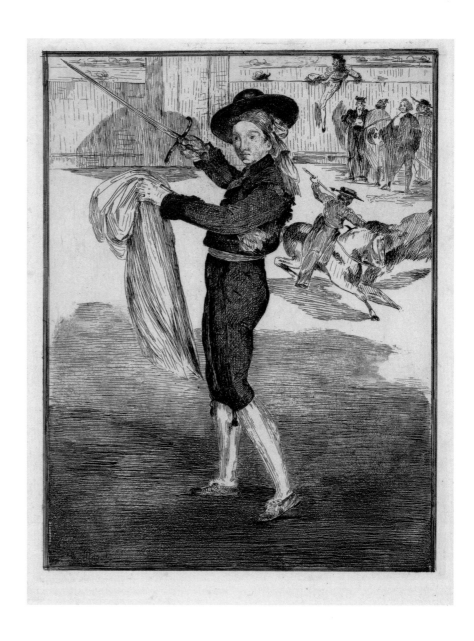

Édouard Manet
French, 1832–1883
Victorine Meurent Dressed as a Bullfighter, 1862
etching and aquatint
image: 12 × 9⅜ in. (30.5 × 23.8 cm)
Ackland Fund, 2008.10

In 1862, Manet painted the model Victorine Meurent as a bullfighter, and in this etching he re-created the composition. In both, the carefully rendered figure differs strikingly from the sketchy figures in the background. The contrast evokes the photographic portraits of the time, where the sitter is posed against a painted backdrop. But by using a female model in a male role and making obvious the different handling of the background figures, Manet also parodies the traditional way of composing a "serious" painting: carefully selected models costumed and posed together within a dramatic composition.

Manet particularly admired the Spanish painter Francisco de Goya. The background figures quote from three etchings in Goya's 1816 series *Tauromaquia* (*Bullfighting*), and the etched version makes this homage even more obvious. The combination of etched line and granular aquatint shading echoes the older artist's etching style, and its dark border is a frank borrowing from the *Tauromaquia*.

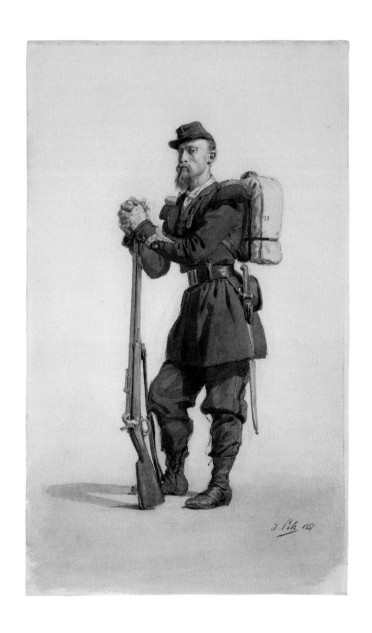

Isidore Pils
French, 1813/15–1875
Study of a Soldier, 1857
watercolor and gouache with graphite underdrawing
12⅝ × 19⅝ in. (32.1 × 49.8 cm)
Gift of Robert Myers in honor of Dr. Richard Thomas Myers, M.D., 2004.24.2

Pils made this drawing just after the end of the Crimean War (1853–56), in which France, together with the Ottoman Empire and the United Kingdom, fought against Russia. Just before the outbreak of that war, Pils had begun painting military subjects, and he received several commissions for scenes depicting the French army's actions. This drawing is not one of the preparatory studies for those commissions, but rather a finished work of art, signed and dated. The uniformed man stands, turns his head slightly to engage the viewer's gaze, and leans on the butt of his rifle. Pils describes specific features of the man, his clothing, and his weapons (his red hair, for example, the gold trim, and the sheen of the sword hilt), and conveys a sense of the soldier's determination through the set of his jaw and his grip on the gun's muzzle.

Gustave Courbet
French, 1819–1877
Roe Deer in the Snow, 1868
oil on canvas
31⅞ × 39⅛ in. (81 × 99.4 cm)
Ackland Fund, 62.1.1

Courbet was the self-appointed champion of the mid-nineteenth-century movement in French painting that renounced historical, religious, and classical subjects in favor of the actual and the mundane. Coming from the Franche-Comté, a mountainous, forested region on the Swiss border, he delighted in playing the role of the earthy provincial. His letters often express a joy in hunting, and his winter landscapes usually contain some reference to it. These landscapes were not painted outdoors but constructed in the studio. His depictions of deer were based on stuffed specimens. But whether derived from sketchbook notes or simply from memory, this painting conveys the visceral experience of the outdoors. Thick paint spread with a palette knife renders snow in layers of white spread over blue or gray. Viewers may feel that they have been walking all day, boots wet, and now at last are glimpsing a couple of deer. This is a hunter's landscape.

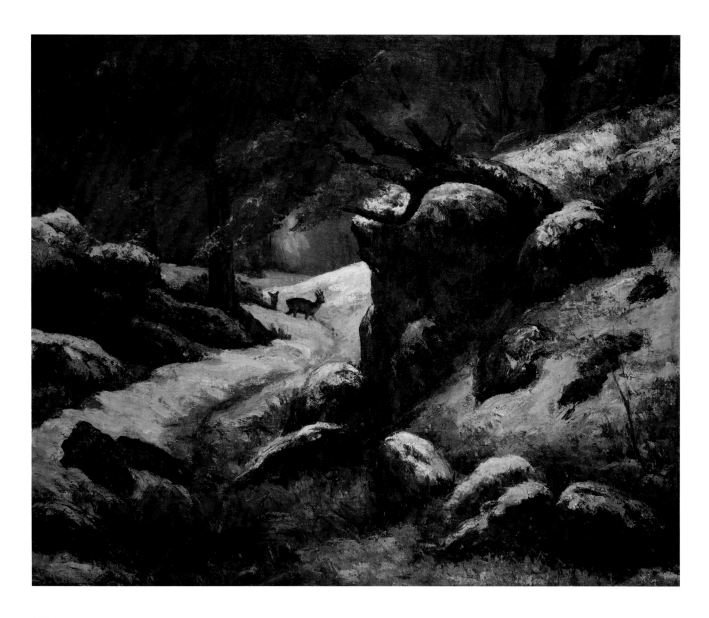

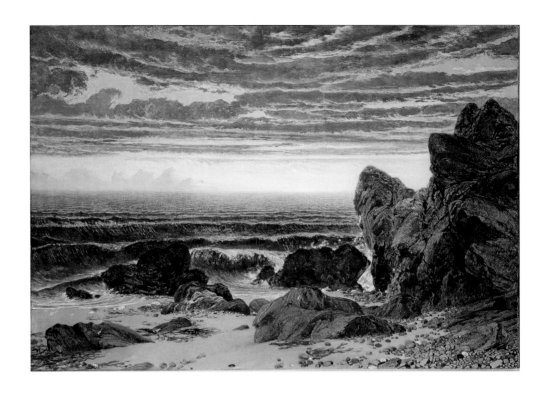

William Bell Scott
British, 1811–1890
**Incoming Tide on the
Northumberland Coast**, 1861
oil on canvas
13 × 19 in. (33 × 48.3 cm)
Ackland Fund, 79.74.1

Scott was associated with a group of British artists who called themselves Pre-Raphaelites, looking for inspiration to the fifteenth-century artists who preceded the famous painter Raphael. The critic John Ruskin described their work as an "earnest effort to paint nature as in a looking-glass." Although Scott disliked Ruskin and felt no compulsion to work directly from nature, he himself wrote of "observing and recording, however slightly and transiently, the multitudinous aspects of life." This almost hallucinatory painting combines an attention to the effects of light with a painstaking focus on detail and intense color. It can remind the viewer of a fifteenth-century Netherlandish painting. But no fifteenth-century painter would have considered an empty shore to be worthy of a finished picture. The idea that rocks and clouds are as important as saints or kings derives from a new scientific attitude toward nature, typical of the nineteenth century.

Unidentified artist
Japanese
Brush Holder, 19th century
Hirado porcelain with underglaze
cobalt blue decoration
height: 5⅛ in. (13 cm);
diameter: 5 in. (12.7 cm)
Transferred from Louis Round Wilson
Library, Willie P. Mangum Collection,
84.19.19

A facility with brushwork and aqueous cobalt pigment defines the lively painting on this blazing white porcelain brush holder, one of a pair. Waves crest to refreshing sprays, sensually evoking air as crisp as the white porcelain is clean. The forms of the rolling waves are echoed in the curvilinear carved base. The surfaces of both the fine-grained porcelain body and the uniformly transparent glaze are so smooth and shiny that they are reflective. Hirado became an important center for the production of porcelain due to several factors, including the discovery in the 1630s of large amounts of kaolin clay (a crucial ingredient), the presence nearby of potters from Korea, and interregional maritime trade in East Asia.

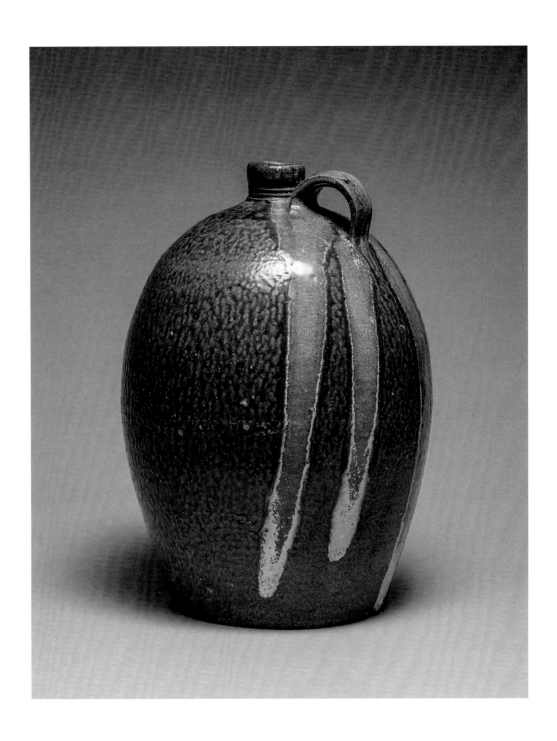

Daniel Seagle
American, c. 1805–1867
Four-Gallon Jug, c. 1850
alkaline-glazed stoneware
height: 16½ in. (41.9 cm);
diameter: 11½ in. (29.2 cm)
Ackland Fund, 82.19.2

By 1850, the Catawba Valley in Western North Carolina had become the major center in America for high-fired stoneware with alkaline glazes. There potters of German descent used the alkaline glaze, which had originated in China some two thousand years before and then resurfaced in South Carolina about 1810. From there, it spread widely across neighboring states. In the mid-nineteenth century, Seagle was the leading potter in this tradition, producing wares that transcended functionality in their perfection of form and surface, with bold, carefully turned forms, neatly balanced rims and handles, and rich, flowing glazes. As in this case, he occasionally applied broken glass which would then melt and flow as chance dictated in beautiful rivulets.

André Adolphe-Eugène Disdéri
French, 1819–1889
**Unidentified Women, maybe the
Levasseur Sisters**, 1862
albumen print
7⅝ × 9⅜ in. (19.4 × 23.8 cm)
Ackland Fund, 2005.35.2

In the mid-nineteenth century, Disdéri was largely responsible for the invention and popularization of so-called carte-de-visite photographs, cheaply made and mass-produced portrait images. He devised a system by which eight exposures could be made on one glass negative, printed in a single operation, and then cut and glued onto visiting card–size mounts. By the late 1850s, collecting and exchanging such cartes-de-visite was an established fashionable practice. This uncut proof sheet, with its minor modifications of pose, setting, and lighting, offers an affecting view of the similarities and differences between the two sitters, reputedly the Levasseur sisters.

Toyohara Chikanobu
Japanese, 1838–1912
Tokyo Playhouse Board Game, 1891
polychrome woodblock print
overall: 35⅜ × 27⁷⁄₁₆ in. (89.9 × 69.7 cm)
Transferred from Louis Round Wilson
Library, Rare Book Collection, Bequest of
Susan Gray Akers, 85.1.13

This rare print is actually a board for a children's game of chance, not unlike chutes
and ladders, based on the Kabuki plays produced by a famous theater in Tokyo. Each
rectangle identifies a play and the actors featured, and also has instructions for how to
move depending on your dice roll. The goal is to reach the rectangle at the upper center.
Many famous actors of the period appear, depicted in their most iconic and popular roles,
including the three most famous: Ichikawa Danjuro IX (1838–1903), Ichikawa Sadanji I
(1842–1904), and Onoe Kikugoro V (1844–1903). Although steeped in theatrical and cultural
tradition, the game reflects its origins in the era of rapid modernization, with the extensive
use of the recently introduced chemical aniline red pigment and surprising details, such as
the actor at the lower margin of the final rectangle holding a Western-style handbag in his
mouth.

Charles Marville
French, 1816–1879
Rue de Carmes, 1865–69
albumen print from wet collodion
negative, on original lithographed mount
image: 13 × 10¹¹⁄₁₆ in. (33 × 27.1 cm)
The William A. Whitaker Foundation
Art Fund, 2010.49.1

Although he also worked to document modern amenities of nineteenth-century Paris
such as lighting fixtures and public toilets, Marville is perhaps still best known for his very
extensive series of photographs of "Old Paris." This was an official project undertaken in the
1860s to document the parts of medieval Paris that were to be destroyed and transformed
by the impending modernization plans of Baron Haussmann (1809–1891), prefect of the
Seine. This characteristic photograph, animated by strongly contrasting shadows and
sunlight, shows a narrow, cobblestoned street in the 5th arrondissement, running from
near the Panthéon down toward the river Seine. The eye is led into depth by the trickle of
water running down the central gutter. In the far distance stands the newly built spire of
Notre-Dame Cathedral, completed in 1859 as part of a restoration project undertaken by
Eugène Emmanuel Viollet-le-Duc.

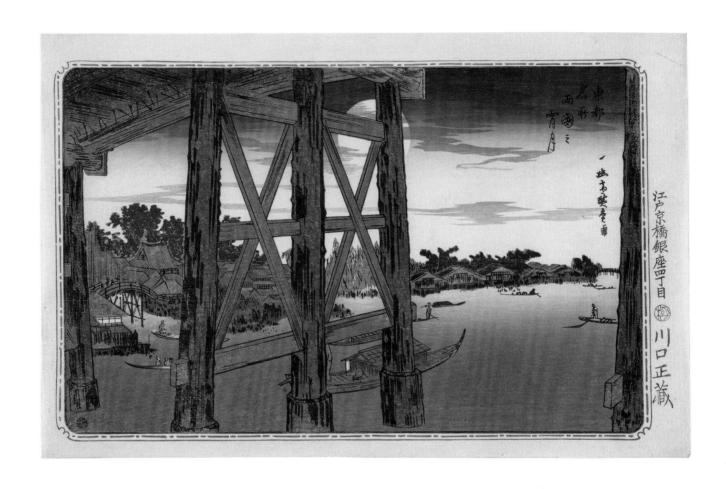

Unidentified artist
Japanese, mid-20th century
after Ando Hiroshige
Japanese, 1797–1858
Evening Moon at Ryōgoku Bridge,
c. 1946–57
color woodblock print
9¹¹⁄₁₆ × 15⅜ in. (24.6 × 39.1 cm)
Gift of Barbara B. Jensen in memory of
The Rev. Dr. and Mrs. T.T. Brumbaugh,
2000.5.5

This striking facsimile print reprises a famous image from Andō Hiroshige's (1797–1858)
first major landscape series *Famous Places in the Eastern Capital* using the same
traditional color woodblock printmaking technique as the 1831 original. The image depicts
the Fukagawa district in Edo (modern Tokyo) through the beams of the Ryōgoku Bridge,
which crossed Edo's Sumida River. Hiroshige's severe cropping of the scene as well as
his emphasis on the structure's massive posts and struts presents an unexpected and
fractured view of the landscape. Such depictions of modern daily life and urbanized
landscapes, first popularized in ukiyo-e prints ("floating world pictures"), experienced
a renaissance during the early twentieth century under the guidance of print publisher
Watanabe Shōzaburō (1885–1962).

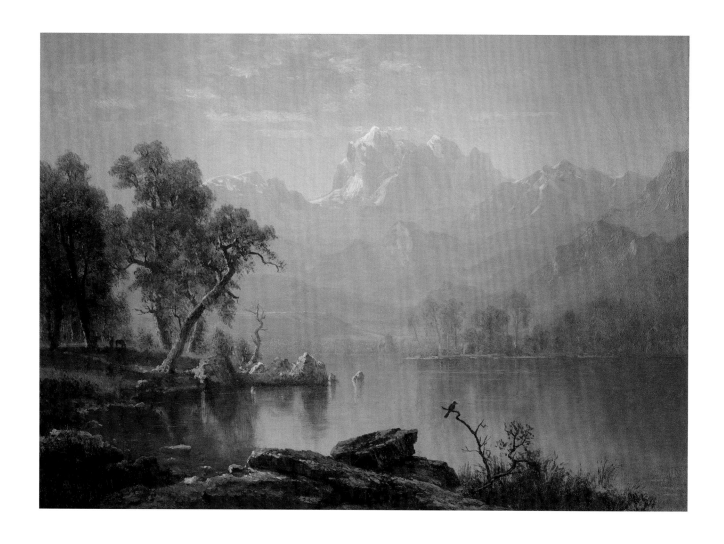

Albert Bierstadt
American, 1830–1902
Wind River, Nebraska Territory, 1861
oil on board
9 × 12¾ in. (22.9 × 32.4 cm)
The Hugh A. McAllister Jr., M.D.
Collection, 2019.15.2

In *Wind River, Nebraska Territory*, Bierstadt portrays the American West as an idyllic frontier wilderness, complete with snowcapped mountains, verdant trees, and a pristine lake. Deer graze on shaded grass along the water's edge while a solitary kingfisher perches on a branch in the foreground, an everlasting witness to an unspoiled landscape. Meriwether Lewis and William Clark's famous expedition to the Pacific Northwest from 1804 to 1806 initiated a series of exploratory excursions by scientists, government officials, entrepreneurs, and artists that continued into the mid-nineteenth century. Bierstadt's own involvement with Colonel Frederick W. Lander's survey expedition through Wyoming and the Rocky Mountains in 1859 marked the first of his journeys westward. In numerous field sketches, Bierstadt documented topographical surroundings that he later transformed into finished paintings in his East Coast studio.

Jasper Francis Cropsey
American, 1823–1900
Landscape with Mountains at Sunset,
c. 1850
oil on paper
diameter: 5¼ in. (13.3 cm)
Ackland Fund, 85.19.1

This painting is an autumn scene, probably somewhere along the Hudson River. Cropsey is known to have made six series of paintings of the Four Seasons, two of which were round in format, like this one. It is possible that the Ackland's painting originally had companion scenes depicting winter, spring, and summer.

In a small frame (the painting is just over five inches in diameter), Cropsey conveys a sense of vast distance that evokes the majesty of nature and, by contrast, the insignificance of humans. He layers landforms (the cliff at the lower right, the river beyond it, the opposite bank, the mountains at the horizon). He contrasts the intense, fiery red foliage in the foreground with the paler, rosy pinks in the sky. The human figures walking along the cliff are tiny, but the pair beyond them in the boat are miniscule by comparison.

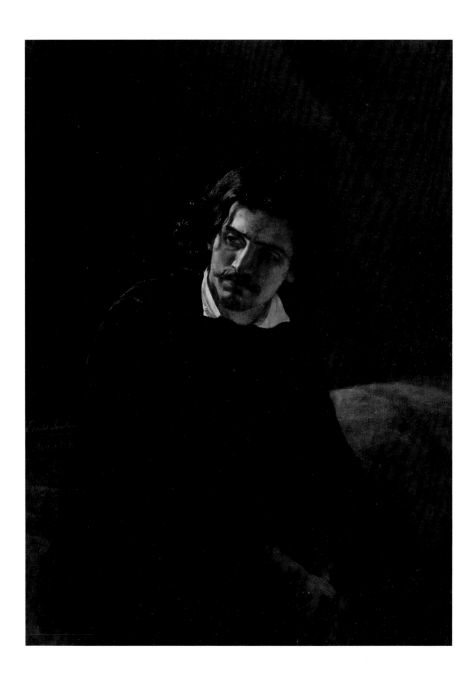

Elisabeth Baumann
Danish, 1819–1881
Italy, 1859
oil on canvas
38¼ × 28 in. (97.2 × 71.1 cm)
Gift of Ruth and Sherman Lee, 2003.35.1

In 1859, Italy did not exist as a nation. It was a mosaic of territories, some dominated by foreign powers. A movement for a liberated, united Italy, the Risorgimento, was repeatedly suppressed by those in power; its supporters could be exiled, imprisoned, or executed. Here a young man sits in a dark, confined space – light from a high window falls on his bed. *Libertà*, written on the wall above, is barely legible. It is not hard to recognize him as a political prisoner.

 An ethnic German, Elisabeth Baumann worked in Italy, but her birthplace was Poland, another fragmented and disempowered country. She would have had reason enough to sympathize with national aspirations. There are two ways to read the painting's title, literally: "This is what it is like in Italy right now, young men imprisoned for their political beliefs"; or symbolically: "This is the spirit of Italy itself, imprisoned yet defiant."

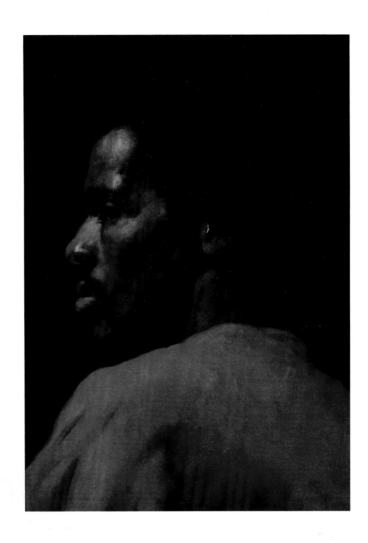

Léon Bonnat
French, 1833–1922
Head of a Model, c. 1857
oil on paper, mounted on canvas
17¹/₁₆ × 12½ in. (43.3 × 31.8 cm)
Ackland Fund, 77.47.1

Leon Bonnat's *Head of a Model* is a tour-de-force study of light and color. Depicted in profile against a dark background, a Black man looks over his left shoulder, the pupil of his eye trained on something beyond the picture plane. Light illuminates the figure from the upper left, producing a dramatic interplay of light and shadow. White highlights on the forehead, nose, and cheekbone contrast with the deep tones of the figure's skin, portrayed with nuanced variations of brown, red, and gray-green, with each color's intensity enhanced by the figure's brilliant red shirt.

While depictions of people of African descent were seen in European art as early as the Renaissance and indeed before, the abolition of slavery in France in 1848, which resulted in an expansion of the city's Black population, as well as artist travel to the northern parts of Africa, contributed to more representations of Black men and women in nineteenth-century European art. Bonnat was among the most fashionable painters in France during the late 1800s and may have created this sketch to be used in a larger painting, although there is no finished composition currently known.

John Murray
British, active in India, 1809–1898
King's Turret, Fort at Agra, c. 1855–58
waxed paper negative,
with additions in ink
14⁷⁄₁₆ × 17 in. (36.7 × 43.2 cm)
Gift of Clara T. and Gilbert J. Yager,
88.25

Murray took up photography while in India as a medical doctor serving in the army of the East India Company. Stationed in Agra, near the Taj Mahal, he developed a strong interest in documenting the local Mughal architecture. Murray worked with a large-format wooden camera and often used waxed paper negatives, such as this one. Unlike glass negatives, they did not require immediate development. This view shows the Musamman Burj, an octagonal tower at Agra Fort, built in the 1630s and formerly named the King's Turret. The panorama stretches from the turret, with a lone figure looking out, across a walled moat, to the Yamuna River beyond. The correct exposure for the building could, with the available emulsions, result in difficulties depicting the sky, a problem solved by blacking out the negative's sky with India ink, resulting in a crisp white in the final print.

Anna Atkins
British, 1799–1871
Lastroea Oreopteris, c. 1851–54
cyanotype
image: 14⅝₁₆ × 10½ in. (36.4 × 26.7 cm)
Gift of Charles Millard, 91.204

Anna Atkins was a pioneer in photography who was primarily interested in the new medium's value as a tool for accurately recording the natural world. Atkins received a scientific education, an opportunity seldom given to women in her time, from her father, leading to her interest in the subject.

Atkins seized on photography's commercial and educational value with her *Photographs of British Algae: Cyanotype Impressions* (1843), the first publication to include photographic images. This book employs the cyanotype as an alternative to the hand-drawn illustrations traditionally found in botanical indexes. Cyanotypes, or blueprints, are made by placing an object on a piece of paper coated with a light-sensitive solution, which is then exposed to the sun. The areas touched directly by ultraviolet rays undergo a chemical reaction, resulting in a brilliant dye known as Prussian blue. The shaded portions of the paper will remain white, creating a positive image of the object, in this case, a type of fern.

VACUUM SUGAR APPARATUS. HECKMANN.

Claude Marie Ferrier
French, 1811–1889
Vacuum Sugar Apparatus, 1851
salted paper print
image: 8½ × 6⅛ in. (21.6 × 15.6 cm)
Ackland Fund, 2011.35.6

Ferrier was commissioned, perhaps by Queen Victoria's husband, Prince Albert, to photograph the entries at the Exhibition of the Works of Industry of All Nations, the so-called "Great Exhibition" held at London's Crystal Palace in 1851. The photographs were published in 1852 within the four-volume *Reports by the Juries*, over one hundred copies of which were given as gifts to foreign governments and notable participants.

The vacuum sugar apparatus was invented to crystallize sugar without heating it to boiling, since overheating turned potential sugar crystals into treacle. In a vacuum chamber heated by high-pressure steam, evaporation could be achieved at lower temperatures. Three such devices were displayed at the exhibition. All were praised by the jurors for their "magnitude, perfection of workmanship, and the excellence of arrangement," qualities well captured in this crisp and imposing image of the Prussian submission.

William Henry Fox Talbot
British, 1800–1877
Lacock Abbey, c. 1845
salted paper print from paper negative
image: 7¼ × 8⅞ in. (18.4 × 22.5 cm)
Ackland Fund, 2012.21.2

William Henry Fox Talbot created and popularized two major early photographic processes: his calotype process produced paper negatives, and his salted paper printing process created positive images from those negatives. This work is an example of his salted paper printing, which appears to hold the image within the fibers of the paper, unlike other processes, in which silver salts are suspended in a layer of material like gelatin or albumen that rests on top of the paper.

Lacock Abbey was Talbot's home and the central base for his photographic work and experimentation with the medium. The abbey and the surrounding landscapes were often his subjects. Talbot created photographic images as early as 1835 but was still having difficulty producing stable prints in the early 1840s. His success in getting consistent results was marked by the production of a photographic album, *The Pencil of Nature*, which featured this work and was published in installments from 1844 to 1846.

David Octavius Hill, British, 1802–1870
Robert Adamson, British, 1821–1848
The Nasmyth Tomb, Greyfriars Churchyard, 1844
salted paper print from calotype negative
image: 7¹⁵⁄₁₆ × 5¹³⁄₁₆ in. (20.2 × 14.8 cm)
Ackland Fund, 2009.2.1

Hill, a painter, and Adamson, an engineer, were pioneers in the development of photography. They used calotypes, the first photographic process to deploy a negative to produce multiple positive images. This picturesque work, one of several they made in a graveyard in Edinburgh, Scotland, shows two men observing the carved stonework and inscriptions of the Nasmyth Tomb. One points; the other seems poised to make notes. The division between the living and the dead is here complicated by the tree that has grown up through the memorial stone to overshadow the composition. In a sense, this image metaphorically portrays several generations of one family. Indeed, Hill and Adamson became famous for their work in more traditional forms of portraiture.

John Frederick Lewis
British, 1805–1876
Court of the Lions, the Alhambra, 1834
graphite, watercolor, and gouache on
gray paper
11 × 15 in. (27.9 × 38.1 cm)
Ackland Fund, 75.14.1

The subject of Lewis's drawing is a courtyard in the Alhambra, the famous medieval Islamic fortress and palace in Granada, Spain. Lewis devoted the vast majority of the space in this drawing to the distinctive architectural details of the fountain, columns, capitals, and arches of the Court of the Lions, using only graphite (and the paper's gray surface) to convey the building's appearance. With incidental figures – four conversing humans and two playing dogs – and touches of watercolor to suggest light, reflections, and sky, he captures a sense of the place's atmosphere.

Lewis traveled to Granada in 1833 and produced a series of drawings of the Alhambra's architecture, which were made into lithographs and published in 1835 as *Sketches and Drawings, of the Alhambra, Made during a Residence in Granada, in the Years 1833–4*.

Edward Lear
British, 1812–1888
**The Cliffs at Tivoli with the Temples of
Vesta and the Sibyl**, c. 1838
black colored pencil and gouache on blue
wove paper
image: 16⁷⁄₁₆ × 9¹⁵⁄₁₆ in. (41.8 × 25.2 cm)
Ackland Fund, 75.12.1

Perched high above the dense forest and rocky cliffs at
Tivoli, the ancient Temples of Vesta and Sibyl dominate
the cloudy skyline. The spectacular site, located
some twenty miles east of Rome, became a popular
destination among seventeenth- and eighteenth-
century artists and Grand Tour sightseers. British
landscape painter Edward Lear, often remembered
for his eccentric children's limericks, depicted this
scene during his first trip to Italy. Lear contrasted the
uniformity of the temples and ruins of the ancient
acropolis, which he depicted with precise drawing,
against the sublime variation of nature, portrayed
with dark outlines, scribbled shadows, and swaths
of white gouache. To increase the height of the cliffs,
the artist added a narrow strip of paper at the bottom
of the sheet that features a fence-lined path winding
dramatically into the dark ravine below.

Fujiwara Nobuyoshi
Japanese, 1800–1856
Figures Viewing Cherry Blossoms
(detail), c. 1800–40
hand scroll: color on paper
overall scroll: 11⁵⁄₁₆ × 343¼ in.
(28.8 × 871.8 cm)
Ackland Fund, 84.39.1

In Japan, the blooming of the cherry trees marks the beginning of the spring season. In the class-bound society of the Edo period, an occasion like the Cherry Blossom Festival offered a rare opportunity for members of different classes to mingle. This lively scroll by a little-known artist adept at both figures and landscape illustrates the annual gathering to view the cherry blossoms on the eastern bank of the Sumida River on the very edge of the capital city. Hand scrolls like this were designed to be read from right to left. Unrolling the scroll at one end and rolling it up at the other, the viewer could follow a crowd of people enjoying a festival atmosphere as they stroll along a street lined with temporary booths selling refreshments.

Alexandre-Gabriel Decamps
French, 1803–1860
The Flight into Egypt, 1850s
oil on canvas
23⅝ × 31⁵⁄₁₆ in. (60 × 80.3 cm)
Ackland Fund, 64.25.1

As early as 1828, Decamps was one of the first major artists to travel extensively in North Africa and the Middle East. These journeys provided a great deal of material for his prolific output of paintings, drawings, and prints. His "orientalism" focused on everyday scenes rather than the fantastic or heroic and became the basis for his immense popularity. He often painted biblical subjects set in landscapes inspired by his travels. His later works, such as this broadly executed sketch, show a great interest in light effects, with relatively subdued color. Here, the figures of the Holy Family on their escape to Egypt appear small against the sweeping vista. A figure resting by the road in the right foreground, although not part of the narrative, almost attracts more attention, but the focus of interest is clearly the dramatic setting sun contrasted with shadowed landscape.

Eugène Delacroix
French, 1798–1863
Cleopatra and the Peasant, 1838
oil on canvas
38½ × 50 in. (97.8 × 127 cm)
Ackland Fund, 59.15.1

Defeated by the Romans, the Egyptian queen Cleopatra committed suicide by having a poisonous snake smuggled into the house where she was held prisoner. This incident was the basis for a moving scene in Shakespeare's play *Antony and Cleopatra*, where a clownish peasant bringing the snake confronts the melancholy queen, brooding over the death of her lover Antony.

Shakespeare's imagined meeting, in turn, inspired Delacroix. He could have placed it in an elaborate palace. Instead, we have minimal scenery: an elaborate throne in "Egyptian" style against a bare, dark background. The contrast summarizes Cleopatra's plight – she is both a queen and a prisoner.

Like a movie close-up, the painting focuses on the emotions of queen and peasant, each gazing at the basket he holds – and its snake. The "foolish" peasant holds his deadly gift with care and tenderness; Cleopatra might be looking forward to her reunion with her dead lover.

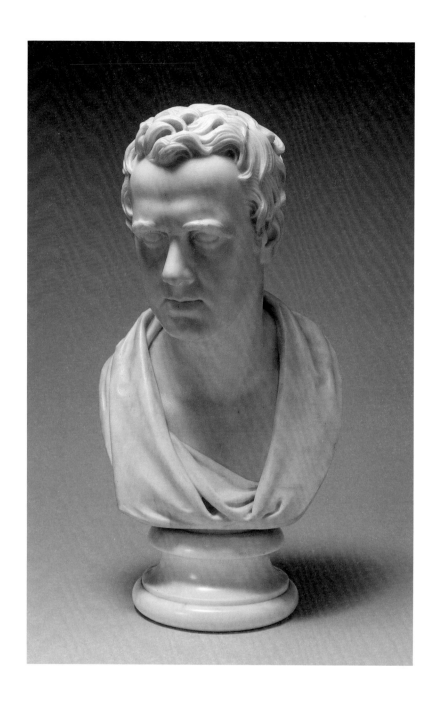

Francis Leggatt Chantrey
British, 1781–1841
Francis Horner, 1820
marble
23½ × 11¾ × 10½ in. (59.7 × 29.8 × 26.7 cm)
Ackland Fund, 86.16

Francis Horner (1778–1817) was an economist and a member of the House of Commons. Chantrey sculpted this portrait bust in connection with a commission for a full-length marble statue of Horner that was erected in Westminster Abbey in 1823. Although the full-length statue shows Horner wearing nineteenth-century clothing, the Ackland's bust shows him draped in what resembles ancient Roman senatorial dress, perhaps an allusion to his political life. At the time he made this bust, Chantrey was developing his reputation as a portraitist of important political and literary figures, including King George III. He considered it a point of pride that he attained professional success as an artist without formal training in official art institutions. When he died, he left a bequest with which the Royal Academy of Arts was to buy great works of British art; they are now at Tate Britain in London.

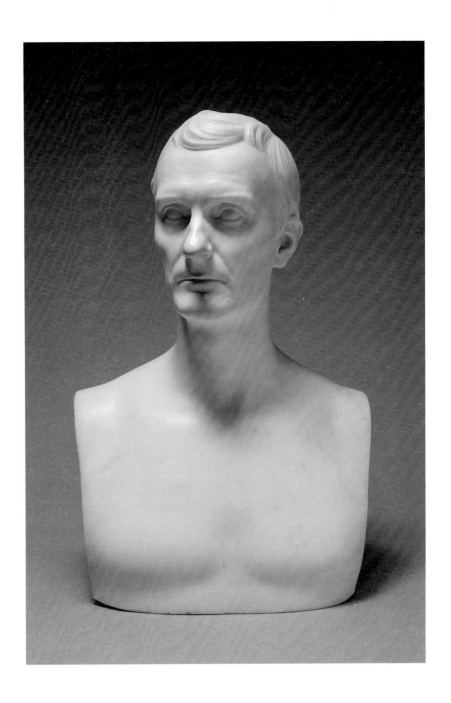

Hiram Powers
American, 1805–1873
Duff Green, 1834–37
marble
22¾ × 14½ × 8¾ in. (57.8 × 36.8 × 22.2
cm)
Transferred from the Art Department
Collection, 56.3.1

Before he gained fame for his marble *Greek Slave* (1841–43), Powers spent several years in Washington, DC, carving busts of leading politicians and diplomats in a style that evoked the portrait sculpture of ancient Rome. One sitter was Duff Green (1791–1875), who served in the War of 1812 and in the so-called Indian Campaign. He also participated in Missouri politics. From 1835 to 1838, Green edited a radically partisan newspaper, devoted to free trade and states' rights. Later, he was a supporter of the Confederacy. Although modelled in the mid–1830s, the final portait in marble was not ready to be delivered until 1853, long after Powers had moved to Florence in 1837. In a letter to the sitter, the artist explained the delay as arising from his need both to find adequately skilled assistants in Florence and to accept a plethora of new commissions to establish himself financially.

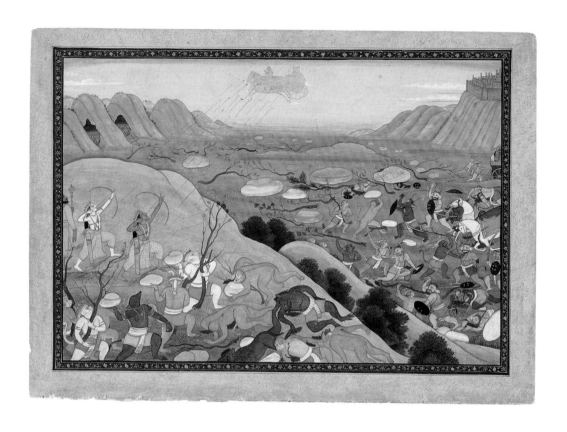

Unidentified artist

Indian, Punjab Hills, Kangra

The Battle between the Monkeys and the Demon Army of Ravanna, c. 1800

opaque watercolor and gold

image: 8⅝ × 12⁹⁄₁₆ in. (21.9 × 31.9 cm)

Gift of Clara T. and Gilbert J. Yager, 91.71

This lively scene depicts a battle from the Sanskrit epic the *Ramayana* or "Rama's Journey" between the virtuous Rama, a blue-skinned avatar of the god Vishnu, and Ravana, the demon-king of Lanka who had kidnapped Rama's wife, Sita. At left, Rama and his brother Lakshmana shoot arrows at the invisible airborne chariot of their opponent's son. Across the corpse-strewn battlefield, Rama's army of bears and monkeys fight Ravana's monstrous forces with rocks and branches. The golden palace of Lanka can be seen at upper right. The tradition of incorporating multiple narrative moments is reflected in the view of the monkey army gathering in the caves at left and the defeated chariot departing at right. The story has enjoyed enormous popularity over many centuries; this illustration comes from a set made in Kangra, a princely state in the Punjab Hills in north India, around 1800.

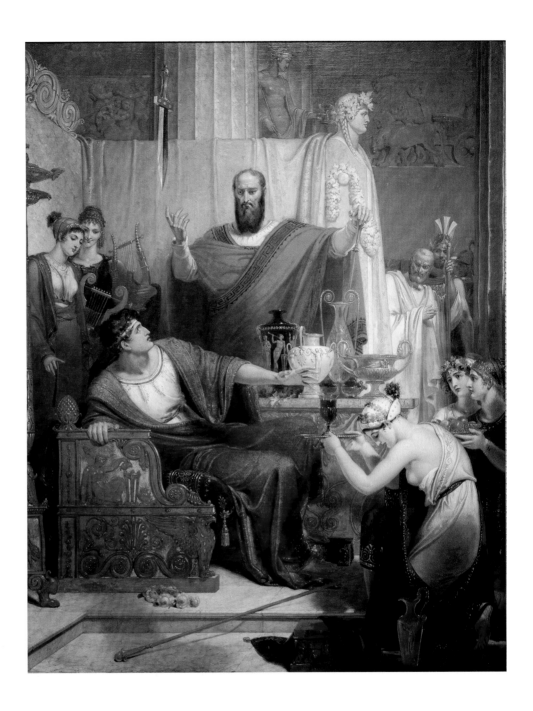

Richard Westall
British, 1765–1836
The Sword of Damocles, 1812
oil on canvas
51³⁄₁₆ × 40⁹⁄₁₆ × 3¼ in. (130 × 103 × 8.3 cm)
Ackland Fund, 79.10.1

Dionysius, ruler of the ancient Greek city of Syracuse, overheard the young man Damocles envying his wealth and power. "If you think I am so fortunate," he said, "try changing places with me for a day." Feasting in the palace, Damocles was terrified to see a sharp sword above him, hanging by a single hair. Dionysius, who had seized power by violence and lived in fear of assassination, was demonstrating the insecurity of his own life.

Westall made this painting for Thomas Hope, a wealthy collector of ancient artifacts. It belongs to a long artistic tradition – to delight the eye with precious objects and yet hint that they are ultimately meaningless. Dionysius's left hand hovers over a profusion of ornate vessels but his right hand points to the sword, hanging in front of an austere Doric column. Rather than a tyrant haunted by fear, he resembles a wise philosopher-king.

45

Y esto tambien.

Francisco de Goya
Spanish, 1746–1828
I Saw This Too, from *The Disasters of War*, c. 1815, published 1863
etching
image: 5¼ × 7½ in. (13.3 × 19.1 cm)
The William A. Whitaker Foundation
Art Fund, 2004.15.3

In this scene, women carry children, household belongings, and farm animals across a dark landscape beneath a dark sky. The three women in the foreground are modeled more fully than those in the background, who are represented with minimal marks. The effect is of a dramatic scene enveloped in ominous shadow. *I Saw This Too* is one of over eighty etchings that form Goya's series *The Disasters of War*.

Goya's subject in this series was the violence, aftermath, and political significance of the Peninsular War (1808–14), in which Napoleon's forces occupied the Iberian Peninsula. His take on the scenes depicted was visually and psychologically dark, frequently showing the war's most brutal moments.

The Disasters of War etchings were made between 1810 and 1820, but remained unpublished until 1863, long after Goya's death, because they were so politically charged. This print comes from that first edition.

Louis-Léopold Boilly
French, 1761–1845
The Flood, 1808
pen and black ink and gray wash, brush
and brown ink and brown wash, traces of
black crayon
image: 12⁷⁄₁₆ × 9¼ in. (31.6 × 23.5 cm)
Ackland Fund, 60.9.3

The uniforms of the soldiers in this drawing and the style of the architecture in the distance suggest a particular setting for Boilly's scene. In 1806–07, there were floods across Northern Europe, including areas that were under the control of Napoleon's forces.

Within the framework of these historic floods, Boilly presents a fictionalized and highly dramatic story of heroic rescue. Soldiers evacuate a large family from their home, one guiding the bow of a boat on and around which family members cluster, another carrying one of the young women. Grandparents, parents, children, and babies gesture and make expressions of emotions ranging from terror to shock to relief.

This drawing was originally one of a pair. The pendant depicted the moment before, as soldiers arrived to save the family. Drawings with this degree of finish were often made into prints or paintings, but none that match this composition has been found.

A KICK-UP AT A HAZARD TABLE!

Thomas Rowlandson
British, 1756/57–1827
A Kick-Up at a Hazard Table, 1790
etching and aquatint, hand-colored
13⅜ × 19 in. (34 × 48.2 cm)
Ackland Fund, 81.37.2

Tempers flare and pistols are drawn during a game of hazards (modern-day craps). The stout officer on the right is not happy about losing to the scrawny gentleman on the left. Two gamers at the back join the fray wielding makeshift weapons. Others cower or fall over themselves in their haste to flee. It is a kick-up indeed!

The potential for violence may be one of the hazards of gambling, but Rowlandson's print is comic, not cautionary. With considerable graphic skill and not a little gusto, Rowlandson quickly captures the physical quirks and exaggerated emotions of the motley group gathered around the gaming table. Rowlandson humorously introduces us to the excitements of gambling, which he, an inveterate gambler, knew well. *A Kick-Up at a Hazard Table* demonstrates why Rowlandson is regarded as one of the great social observers and caricaturists of the eighteenth century.

Thomas Lawrence
British, 1769–1830
Portrait of a Gentleman, 1795
black and red chalk
9¾ × 7¹³⁄₁₆ in. (24.8 × 19.8 cm)
Ackland Fund, 83.4.1

In this fully realized portrait drawing, Lawrence reveals more than his sitter's physical characteristics and dress. Lawrence's particular genius as a portraitist was his ability to capture his sitters' expressions, attitudes, and personalities, bringing them vividly to life. Lawrence often asked his sitters to talk while posing so that he could capture the animated expressions that made his portraits "speaking likenesses." It was this ability to create lively likenesses through a turn of the head, arch of an eyebrow, set of a mouth, that contributed to Lawrence's preeminence as a portraitist in early nineteenth-century England.

Many of Lawrence's "paper portraits" were preparatory to painted portraits, but others were produced as finished works of art in themselves. Most of these independent works are thought to represent close friends or family members. This may be the case with the Ackland's drawing, whose subject has yet to be identified.

School of the East India Company
Indian, near Calcutta
Bristlegrass, c. 1780–1800
opaque watercolor
19 × 13¾ in. (48.3 × 34.9 cm)
Bequest of Gilbert J. Yager, 2007.8.4

Against a plain white background, a single stalk of the common grass plant known as "Bristlegrass" (a grass of the tribe Paniceae, probably a species of *Setaria*) curls elegantly, its delicate blades framing the steeply arched flower head. Seemingly pasted like a botanical specimen upon a page, this image conforms to the European tradition of scientific illustration. It is possible that this drawing was created by a British artist working in India, which was then largely controlled by the East India Company. However, the British also established art schools in India, most notably in Calcutta, where native artists were trained in Western techniques and styles. It is equally likely, therefore, that the producer of the watercolor was an Indian artist. Although the style is intensely realistic, the work's lyrical lines and carefully rendered details recall Indian miniature painting.

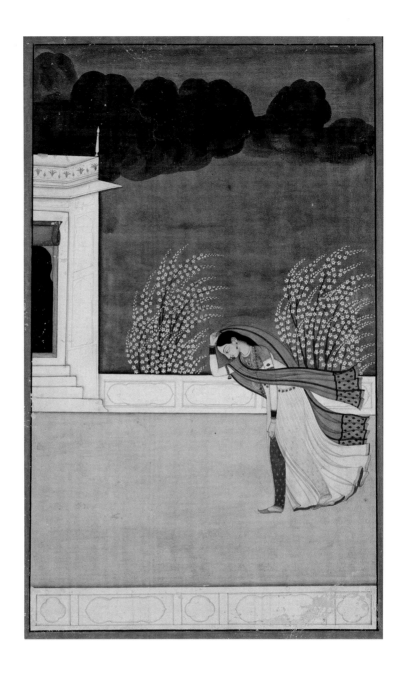

Unidentified artist
Indian, Punjab Hills
Woman in a Windstorm, c. 1780
opaque watercolor and gold
9½ × 6¼ in. (24.1 × 15.9 cm)
Gift of Clara T. and Gilbert J. Yager,
82.20.1

The painter of this Indian miniature took great care to represent the intricate details and patterns of tangible surfaces such as architectural ornaments, flowers, and the young woman's beautiful clothes. In addition, he skillfully conveys the translucency of the orange veil and white dress. At the dress's hem, for example, we see not only the form of the woman's foot, but also the different hues of the outside and inside of the hem's border. With the finest strokes of glittering gold, he suggests the flash of lightning in the storm clouds.

Depictions of lovely young women braving fierce natural elements are common in Indian visual arts and poetry. Such imagery may refer to romantic heroines who, among other brave deeds, face all hazards while hastening toward their waiting lovers. This painting was probably kept together with others in an album belonging to a ruler.

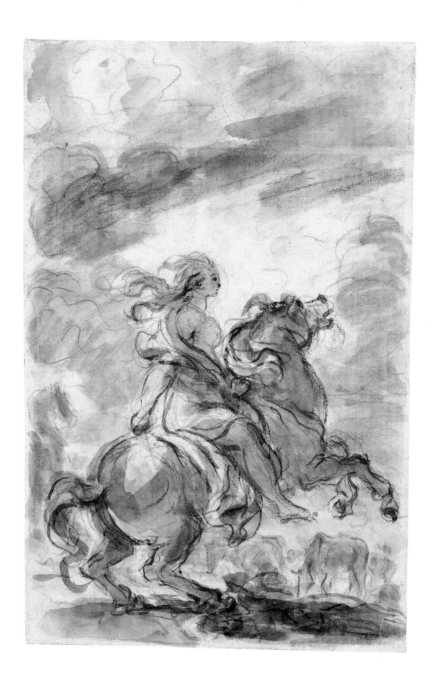

Jean-Honoré Fragonard
French, 1732–1806
Angelica Selects a Mount, Illustration for Ariosto's *Orlando Furioso*, Canto XI, Verse 12, 1780s
black chalk with brown ink, brown and gray wash
15¹¹⁄₁₆ × 10½ in. (39.9 × 26.7 cm)
The William A. Whitaker Foundation Art Fund, 76.18.1

Orlando Furioso (1516), Ariosto's epic poem of romance, enchantment, and daring exploits, is filled with thrilling episodes. The episode illustrated here is not among them. Angelica, having escaped the devouring jaws of the monster, Orc, and the amorous advances of her rescuer, Ruggiero, picks a horse and heads for home.

Fragonard invests this minor moment with the passion that characterizes the poem as a whole. The sharp diagonal of the rearing horse, the exuberant application of chalk and wash, and the flickering play of lights and darks convey excitement. Fragonard has transformed a narrative pause into a scene of high drama.

Angelica Selects a Mount is one of 179 drawings by Fragonard dedicated to *Orlando Furioso*. There is no evidence that the drawings were commissioned. Fragonard likely produced them for his own pleasure.

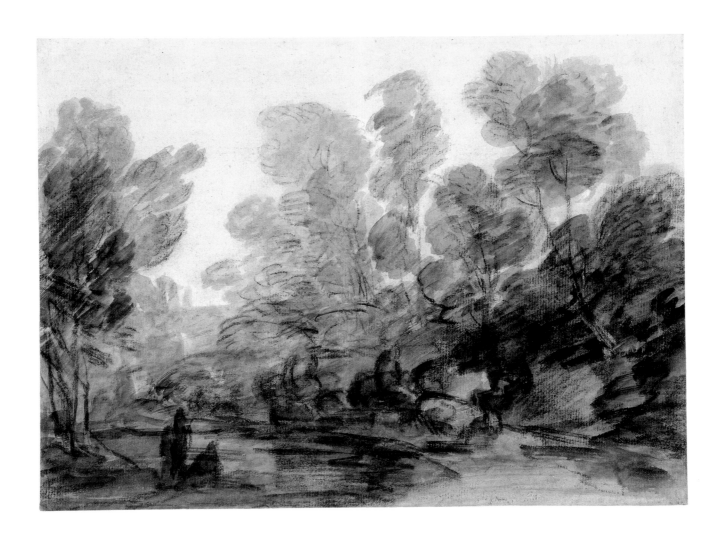

Thomas Gainsborough
British, 1727–1788
**Wooded Landscape with Herdsmen
and Cattle**, c. 1780s
black and brown and white chalk,
gray wash
8⅜ × 11⅞ in. (21.3 × 30.2 cm)
The William A. Whitaker Foundation
Art Fund, 2008.4

It is early evening. In the hazy half-light, cattle and herdsmen troop past a pool of water, watched by three figures on the other side. This tranquil scene is typical of some thousand landscape drawings Gainsborough made over the course of his career. Portraits were Gainsborough's business, the source of his income and fame, but landscapes were his pleasure and lifelong passion.

While Gainsborough made many excursions into the countryside and sketched from nature, his landscapes are not topographical. Over and again, he returned to the same motifs present in the Ackland's drawing: wooded settings, cattle and herdsmen, rustic figures, pools of water, shimmering light filtered through trees. These quickly, but surely sketched landscapes were much admired by the artist's contemporaries. They were not for sale, however. As Gainsborough wrote, he made them for "quietness and ease" as a respite from the stresses of "the cursed face Business."

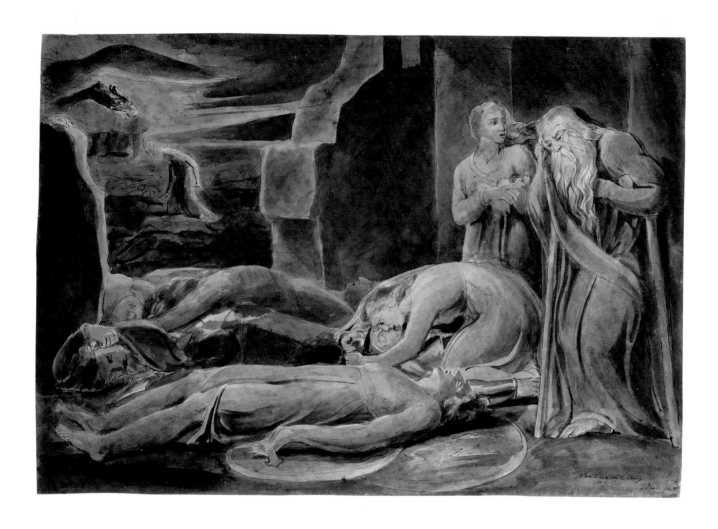

William Blake
British, 1757–1827
A Breach in a City, the Morning after the Battle, 1784?
pen and black ink, and watercolor
12¹⁵⁄₁₆ × 18¹³⁄₁₆ in. (32.8 × 47.8 cm)
Ackland Fund, 62.16.1

In a barren landscape blanketed with bodies and suffused in a sulfur-tinged haze, survivors mourn their dead. It is the bleak aftermath of a devastating battle. Blake's *A Breach in a City* is as evocative and moving as the poetry for which he is best known.

A Breach is an indictment of war and the suffering it causes. To make his case, Blake rejected descriptive specificity in favor of a spare and simplified style. He exploits broad areas of monochrome wash, long fluid lines, and attenuated forms for their expressive and emotional power.

The present work is one of a series of watercolor compositions by Blake that explore the consequences of war. The series may have been inspired by current events, including the American Revolutionary War, but there is no indication of that here. The drawing's generalized forms and setting raise it above the topical to the timeless and universal.

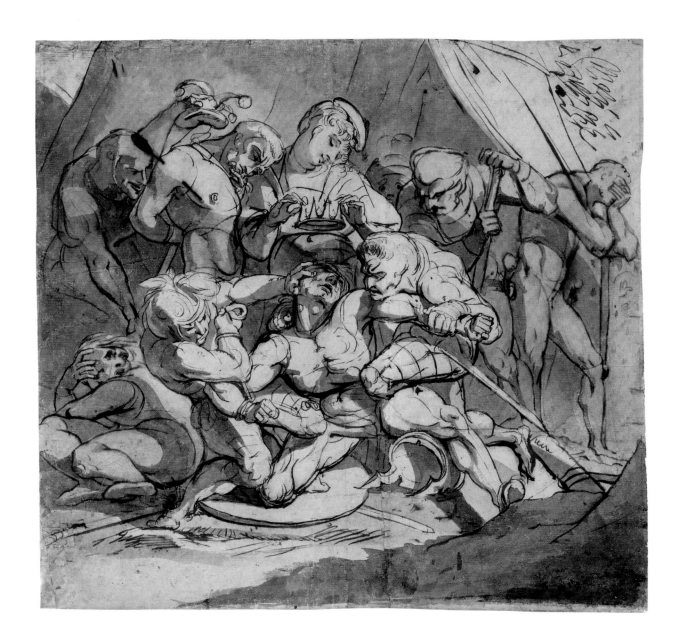

Henry Fuseli
Swiss, active in England, 1741–1825
**Queen Margaret Crowning York with
a Paper Crown, from Shakespeare's
Henry VI Part 3 (Act 1, Scene 4)**, c. 1771
pen and brush with iron gall ink, gray and
brown wash, over graphite
17⅜ × 19³⁄₁₆ in. (44.2 × 48.7 cm)
Ackland Fund, 60.9.1

The persecution of a powerless man by a pitiless woman is a leitmotif in Fuseli's art. In
Shakespeare's *Henry VI*, Fuseli found a poignant example of the theme. After capturing the
Duke of York, who claimed his right to her crown, Queen Margaret shackles and humiliates
him – the paper crown – before killing him. In the drawing's center, York succumbs to
his tormentors. The jeering jester on the left, whose proffered foolscap adds to York's
abasement, and the despondent man on the right are Fuseli's inventions, designed to
intensify the pathos of York's plight.

Emotions – fury, anguish, despair – are vividly expressed through Fuseli's energetic
pen strokes, dramatic swaths of wash, and contorted figures. The crown and battle tent
are the only details that tie the composition to its narrative source. Fuseli achieves what he
called "poetic timelessness." He compellingly conveys a sense of universal suffering and
cruelty.

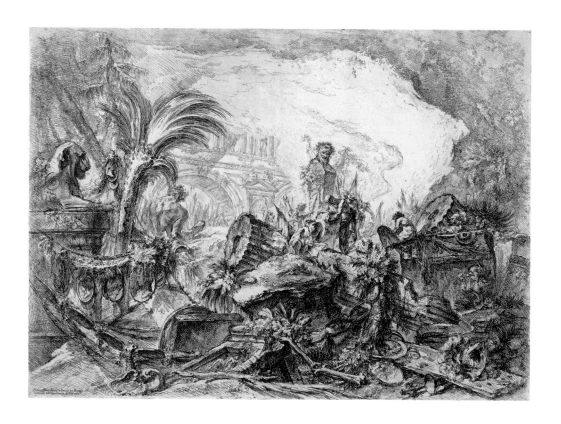

Giovanni Battista Piranesi
Italian, 1720–1778
The Triumphal Arch, from *Grotteschi*,
1750
drypoint and etching
image: 15⁷⁄₁₆ × 21⁹⁄₁₆ in. (39.2 × 54.8 cm)
Ackland Fund, 76.31.2

A "caprice of ruins" is one way to characterize *The Triumphal Arch*, with its bewildering accumulation of architectural and sculptural fragments, old bones, overgrown vegetation, discarded military paraphernalia, and ghostly arch. It is a caprice, certainly, but it is not capricious on Piranesi's part. *The Triumphal Arch* reflects his calculated cultivation of the eighteenth century's fascination with ruins and their ability to astonish and amaze. Piranesi's unusual "worm's eye" viewpoint enhances the impression of awesome size. His jarring juxtapositions of extremes – dark/light, large/small, near/far – create a dreamlike effect that defies reason and evokes wonder.

The *Triumphal Arch*, one of four architectural fantasies designed by Piranesi with the collective title *Grotteschi*, continues to astonish viewers by what it reveals of Piranesi's ingenuity and virtuosity as a printmaker. It also continues to mystify. Despite many attempts, *The Triumphal Arch* and its fellow *Grotteschi* have so far eluded any convincing interpretation.

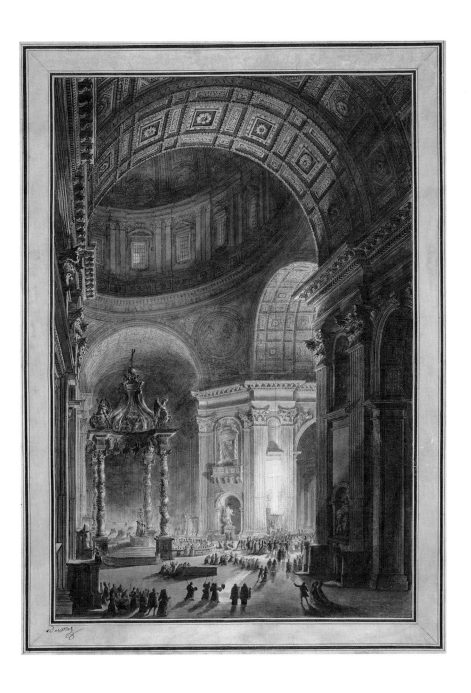

Francesco Piranesi, Italian, c. 1756–1810
after Louis-Jean Desprez, French,
1743–1804
**Interior View of Saint Peter's in the Light
of the Great Illuminated Cross**, 1787
watercolor over etching
sheet: 32 × 23¼ in. (81.3 × 59.1 cm)
Gift of Carol Selle, 2003.11

Eighteenth-century tourists to Rome expected to be amazed by the architectural marvels
there. Saint Peter's was among those marvels, its breathtaking immensity equal to the
monuments of antiquity. The basilica was especially spectacular and attracted many
visitors during the week before Easter when a colossal cross illuminated with 628 oil lamps
was suspended from the dome.

 Interior View of Saint Peter's is one of a series of hand-colored etchings of celebrated
sites in Italy on which the painter Louis-Jean Desprez and the printmaker Francesco
Piranesi, son of Giovanni Battista, collaborated to capitalize on the tourist trade. By staging
the scene at night and choosing an elevated viewpoint, they effectively dramatized what
was already a stunning sight. Within the cavernous gloom, the cross dissolves into a
spectral glow and the figures are diminished to ant-like insignificance.

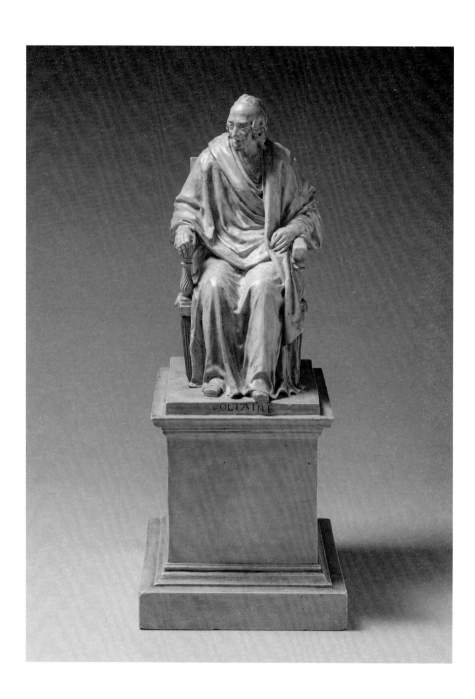

Jean-Antoine Houdon
French, 1741–1828
Voltaire, dated 1778, probably made
between 1779 and 1793
painted plaster and wood
14 × 5¾ × 7⅞ in. (35.5 × 14.6 × 20 cm)
Ackland Fund, 75.15.1

The sculptor and the subject of this small sculpture were both important figures of the
Enlightenment in France. During the 1770s and 1780s, Houdon sculpted portraits of
numerous prominent figures, including Denis Diderot, Jean-Jacques Rousseau, Benjamin
Franklin, George Washington, Thomas Jefferson, and, of course, Voltaire (the nom de
plume of François-Marie Arouet, 1694–1778) – the influential writer, philosopher, and critic.

Houdon made many versions of Voltaire's portrait, large and small, bust-length, seated
(as here), and standing, for numerous patrons, and in a variety of media, including bronze,
marble, terracotta, plaster (like the Ackland's), and even papier-mâché. Houdon based
Voltaire's head on a life mask he made before the writer's death in 1778, and the hands from
casts that were taken after his death.

The Ackland's small portrait has been covered with an opaque colored coating to make
the plaster resemble terracotta.

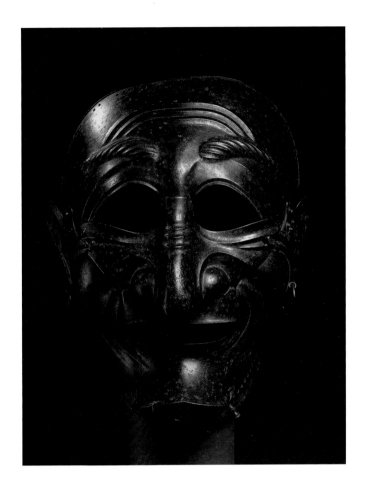

Myochin Munefasa
Japanese, 18th century
Full-Face Mask, late 18th century
forged russet iron with traces of black
lacquer
8⅞ × 7⅜ × 5⁵⁄₁₆ in. (22.6 × 18.8 × 13.5 cm)
Gift of the Tyche Foundation, 2010.25

This fine example of a Japanese full armor mask with a laughing expression carries on the chin plate the name of its maker, a member of an extensive and distinguished family of armorers which flourished from the fourteenth to the nineteenth century. There would have been a throat guard of lacquered leather or iron scales attached by silk cords through the holes visible under this chin plate. A cord passed through the rings on the lower cheeks would have held the helmet on the head. Such a helmet would often have been adorned with decorative elements, most commonly with mustaches made of horsehair.

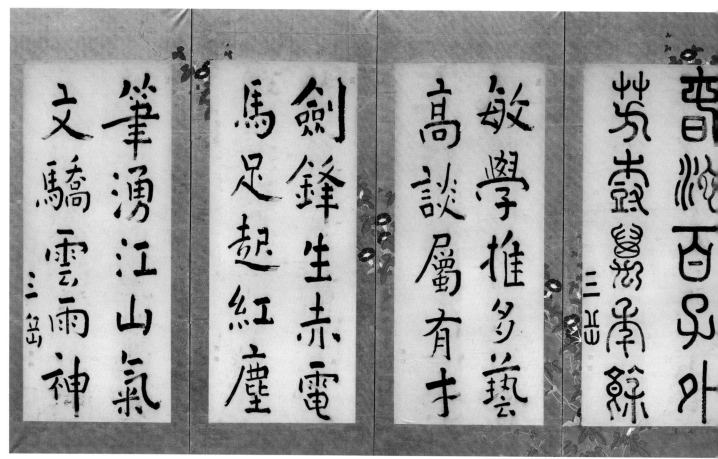

2008.15.1

Ike no Taiga
Japanese, 1723–1776
Calligraphy in Four Script Styles,
mid-1760s
pair of six-fold screens: ink on paper;
borders of gold paper painted with
design of morning glories
each: 68¼ × 171½ in. (173.4 × 435.6 cm)
Gift of the Tyche Foundation in honor of
the 50th Anniversary of the Ackland Art
Museum, 2008.15.1–2

Taiga was one of the most versatile, virtuosic, and, by the time of his death, celebrated painters in eighteenth-century Japan. Prolific as a landscapist, he was also a highly talented master of calligraphy, especially as influenced by the Chinese tradition. This pair of six-fold screens uses four script styles ("seal," "regular," "official," and "running;" illustrated here are "seal" and "regular") to render four poems. Three panels are devoted to each style, and each panel contains two lines from poems composed by Chinese poets of the Tang dynasty (618–907).

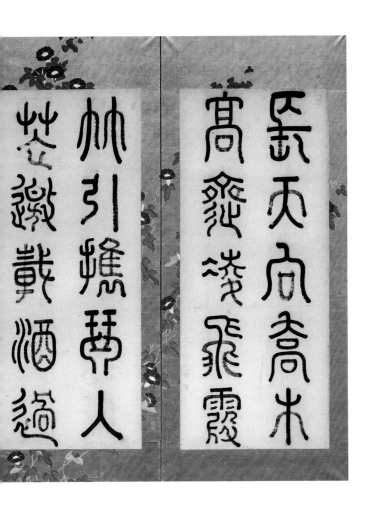

attributed to Shamsuddin Asaf Jahi
Indian, Deccan, active 1724–1748
Panel of Calligraphy, c. 1730
paper appliqué and white opaque
watercolor on dark blue paper
5⅜ × 9³⁄₁₆ in. (13.7 × 23.3 cm)
Gift of Charles Millard, 91.75

The large calligraphic white letters across the paper's
dark blue surface are made from pieces of cut paper,
a technique requiring considerable dexterity. They
read, in Persian: "God! Bless Muhammad, and the
family of Muhammad." Surrounding this inscription
and filling the page are scrolling vines and flowers
painted in opaque watercolor. Two more, smaller
inscriptions appear along the upper and lower
borders, at the center. At the top, the word "he" refers
to Allah. At the bottom is the artist's signature: "Panel
of calligraphy by Shamsuddin [servant of] Asaf Jah."

Shamsuddin was a calligrapher at the court of
Hyderabad in India who worked for the ruler Nizam
ul-Mulk, called Asaf Jah (ruled 1724–48), the founder
of a dynasty that ruled for more than two centuries.

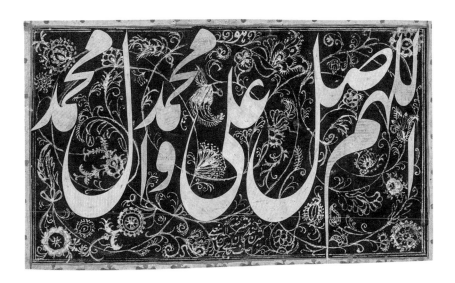

Unidentified artist
Chinese, Qing dynasty
Stem Cup, c. 1723–35
porcelain with incised design under
yellow glaze
height: 4⅛ in. (10.5 cm);
diameter: 6³⁄₁₆ in. (15.7 cm)
Gift of Eunice and Herbert Shatzman
in honor of Sherman Lee, 97.27

A trumpet-shaped stem supports a perfectly circular bowl in this refined object, a wine cup for ritual and display. White porcelain covered by a thin layer of transparent glaze lies underneath a lemon-yellow glaze, combining to create a warm glow. The soft yellow color was one of many monochrome glazes that was perfected by the Qing dynasty (1644–1911) imperial kilns at Jingdezhen during the eighteenth century, a period of military and cultural flourishing known as the High Qing period. The yellow glaze darkens to reveal finely incised motifs encircling the exterior surface, from stylized cloud-forms to decorated lotus sprays. Conventionalized as an ornamental set, the eight distinct symbols located on the prominent and widest section of the bowl are the Eight Buddhist Treasures: lotus, banner, parasol, conch, pair of fishes, wheel, endless knot, and vase.

Unidentified artist
Chinese, Qing dynasty, Qianlong period
Vomit Pot, c. 1750
porcelain with underglaze cobalt blue
decoration
3⅜ × 6⁵⁄₁₆ × 4¹⁵⁄₁₆ in. (8.6 × 16 × 12.5 cm)
Gift of Richard D. Pardue in honor of
Dr. Christiaan J. A. Jörg, 2012.18.1

A single C-shaped handle elegantly invites handling the brightly glazed container to which
it is attached. A sprig of peony blossoms winds around the outer surface of this pot, its
outlines painted in delicately balanced shades of blue. Three more sprays of peonies adorn
the rim. Peonies connote prosperity but, in this case, their association with abundance
has, perhaps, an additional layer of meaning. This pot's function was to collect excess food
for overly ambitious eaters, referenced more pointedly in its name (vomit pot, *spruugpot*
in Dutch). This piece was recovered from the *Geldermalsen*, a Dutch East India Company
ship that sank in 1752. Its cargo, including about 500 such pots, was salvaged in 1985.

Conversation Chinoise.

Antoine Aveline
French, 1691–1743
**Conversation Chinoise, no. 5,
from *Cinquième Livre de Figures et
Ornemens Chinois***, 1736
hand-colored etching
image: 9⅛ × 6⅞ in. (23.2 × 17.5 cm)
Ackland Fund, 63.43.8

This exuberant composition, one plate from a series of forty-two ornamental designs (published in six sets of seven), well exemplifies the playful extravagances of rococo designs inspired by an enthusiasm for all things Chinese that swept across Europe in the early decades of the eighteenth century. Two figures, perhaps one European and one Chinese, are seated in a landscape, with the former seemingly admiring the latter's exaggerated parasol. Surrounding them are dynamic, swirling shells and arabesques, a dreamlike setting in which proper relationships of scale and perspective seem canceled. A mythical bird emerges from one curve; a massive plant and vase loom implausibly over the couple. Everything seems topped by organic flourishes. Such compositions traded on the fantasies of the exotic and alien that characterized the European reception of "the Orient" in this era.

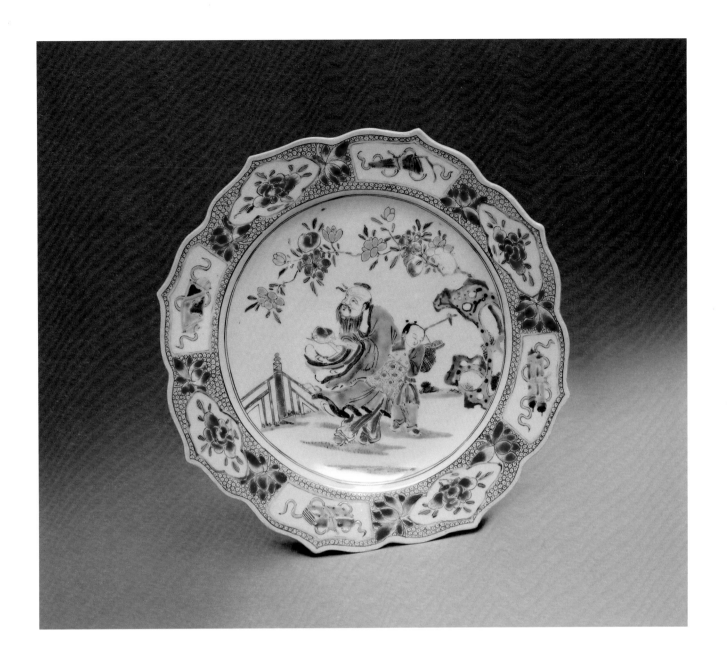

Unidentified artist
Chinese, Qing dynasty, Qianlong period
Plate with Scalloped Rim, c. 1740–45
porcelain with underglaze painting and
overglaze enamel decoration
diameter: 11 in. (27.9 cm); height 1½ in.
(3.8 cm)
Gift of Richard D. Pardue, 2014.39.7

This elegant plate with scalloped edges is replete with symbols of immortality and longevity. The figure painted in the center of the plate probably represents Zhongli Quan, one of the Taoist Eight Immortals. He used to be a general during the Han dynasty (206 BCE–220 CE), but he eventually retired into the mountains and attained immortality. The peaches in his hand and on the flowering branch above his head are symbols of longevity in East Asian art. Beside the immortal stands a servant carrying a basket filled with mushrooms, also a symbol for immortality. Because of the extensive use of pink enamels that began around 1720, Chinese plates of this type made for foreign markets are designated "famille rose" (pink family), a term coined in the mid-nineteenth century by a Frenchman attempting to classify the vast array of Asian export ceramics.

Fukae Roshu
Japanese, c. 1699–1757
Autumn Flowers with Deer, early to
mid-18th century
hanging scroll: color on paper
image: 47⅝ × 19⅝ in. (121 × 49.8 cm);
overall: 83¹¹⁄₁₆ × 25⅝ in. (212.6 × 65.1 cm)
Ackland Fund, 84.7.1

This charming depiction of a deer among autumn
flowers is one of only about two dozen paintings by
Rushu that are known. Rushu was a master of the so-
called "rimpa" school of painting, a decorative style that
emphasizes vivid color, adventurous washes, and subtle
but daring compositions. Here leaves and flowers rise
diagonally up the scroll in a series of rhythmical curves,
ending with the flourish of the artist's red signature seal.
Another series of echoing curves delineates the deer,
probably derived from a monochrome ink drawing by
Tawaraya Sotatsu (c. 1600–1640).

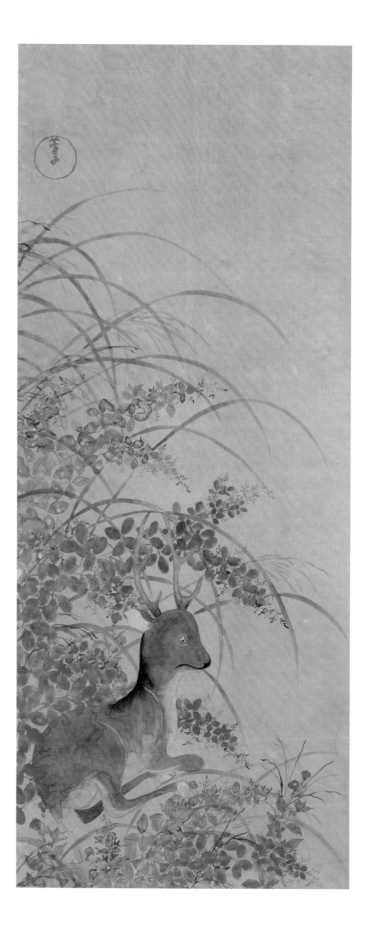

Yun Bing
Chinese, active c. 1720–90
Peonies and Rock, mid- to late 18th
century
hanging scroll: ink and color on paper
image: 46⅝ × 21³⁄₁₆ in. (118.4 × 53.8);
overall: 87½ × 32⅜ in. (222.3 × 82.2 cm)
Ackland Fund, 88.20

On the left of this painting, an inscription identifies the
painter as Yun Bing, a member of a distinguished family
of artists and one of the few women painters from the
imperial period whose works survive. Another inscription
identifies the subject as peonies, known as the "king of
flowers" and, during the Qing dynasty (1644–1911), the
carriers of veiled meanings of dissent and resistance to
Manchu rule. Five blooming peonies grow from a rugged
rock. The painting techniques reinforce the contrast
between flowers and setting. The so-called "boneless"
brushstroke, identifiable by the use of ink wash and
swift strokes without outlines, renders the bamboo
leaves at the bottom of the composition, the quivering
form of the rocks near the middle, and brown branches
near the top right. The second type of brushstroke is
meticulous, characterized by articulated outlines visible
in the peonies' petals and the veins defining their leaves.

Giovanni Battista Tiepolo
Italian, 1696–1770
Walking Man, before 1762
pen with brown ink and brown wash
over black chalk
image: 7⁹⁄₁₆ × 5 in. (19.2 × 12.7 cm)
Ackland Fund, 71.32.1

A balding man descends a slope while gesturing with his right hand. Is he talking to himself? Making a point to an unseen companion? *Walking Man* has the freshness and spontaneity of a figure caught unaware and recorded quickly on paper. This is not a sketch from life, however, but a creation of Tiepolo's imagination.

 Walking Man belongs to a group of drawings titled *Sole Figure Vestite* (*Single Costumed Figures*) that depict older men seen from the back or with their faces turned away. The anonymous figures are individualized through their gestures, poses, and exotic dress. Few of the drawings can be associated with paintings. Tiepolo seems to have made them for his own pleasure. Tiepolo's theatrical flair – expressive gesture, distinctive pose, and shimmering light, the qualities that also distinguish him as a fresco painter – is wonderfully at play in this small graphic gem.

Nicolas Lancret
French, 1690–1743
Reclining Man, mid-1720s
red chalk
4¼ × 6 in. (10.8 × 15.2 cm)
Ackland Fund, 62.5.1

Reclining Man is a working drawing of a gentleman at leisure. It is a preparatory study for one of the many fashionable figures enjoying themselves in the artist's painting *Gallant Party in the Open Air* (Gulbenkian Foundation, Lisbon). Lancret is best known as a prolific painter of fêtes galantes, scenes that depict the pleasant pastimes – dancing, picnicking, chatting, and flirting – of the elite. Executed in Lancret's preferred medium of red chalk, the Ackland's drawing displays all the artist's skill as a draftsman. Short, dark, parallel strokes establish the ground plane and suggest the play of light and shadow. Longer, more lightly sketched lines place the pose and pick out details of dress, hair, and gesture. Although *Reclining Man* was made to serve a finished painting, it is as accomplished and satisfying as an independent work in its own right.

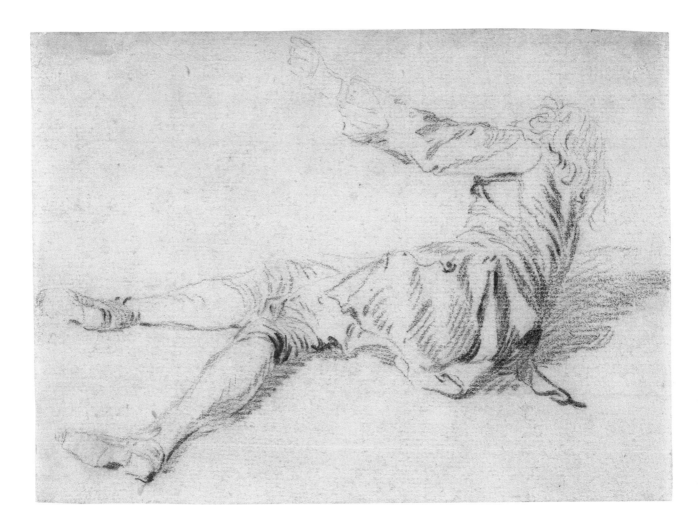

William Hogarth
British, 1697–1764

A Harlot's Progress, Plate 1:
An Innocent Young Girl Just Arriv'd from
the Country in a Wagon to an Inn
in London…, 1732
etching and engraving
image: 12½ × 15⁵⁄₁₆ in. (31.8 × 38.9 cm)
The William A. Whitaker Foundation
Art Fund, 92.6.1

Moll, a naive country girl, has just arrived in London, where she is greeted by a motherly old woman. What might seem an auspicious beginning for Moll is, in fact, the beginning of her end. *An Innocent Young Girl* is the first in a series of engravings called *A Harlot's Progress*, which narrates in graphic detail Moll's coercion into prostitution, imprisonment, and death. Convinced that art had the power to change society, Hogarth issued the narrative sequence to bring the problem of prostitution to public attention. *A Harlot's Progress* is the first of several "modern moral subjects" that brought Hogarth artistic and commercial success.

 An Innocent Young Girl combines real and fictional figures. The old woman is "Mother Needham," a notorious brothel-keeper. The gentleman with a cane in the doorway is Captain Charteris, a well-known seducer. Poor Moll's fate is sealed.

Jacopo Amigoni
Italian, 1682/85–1752
Venus Disarming Cupid, 1730s or 1740s
oil on canvas
29¹⁵⁄₁₆ × 25¹⁄₁₆ in. (76 × 63.7 cm)
Ackland Fund, 86.47

In this charming painting, the goddess Venus seems to toy with her son Cupid, having taken away the arrow with which he had inadvertently scratched her. As told in Ovid's *Metamorphoses*, this wound then caused her to fall in love with the mortal Adonis, who was later killed by wild beasts. With its playful mood and jewellike tones of pink and gray, *Venus Disarming Cupid* gives no hint of the tragedy to come. The delicacy of the figures and the soft rendering of the flesh are typical of the decorative style that gained Amigoni success in London, where he lived for a decade. The painting, whose small size implies private enjoyment, was originally owned by the artist's friend the castrato singer Carlo Broschi (1702–1782), known as Farinelli. Might there have been a suggestion of a parallel between the removal of Cupid's instrument and the singer's castrated state?

Johann Joachim Kändler
German, 1706–1775
for Meissen Porcelain Manufactory,
German, active from 1710 to the present
Apollo, from a *Bath of Apollo*
centerpiece, c. 1748
porcelain with clear glaze
21³⁄₁₆ × 12 × 8½ in. (53.8 × 30.5 × 21.6 cm)
Gift of the William E. Shipp Estate,
by exchange, 2012.7

European collectors were wild about Chinese porcelain. They admired porcelain for its durability, lightness, and luminosity, and they avidly imported it in various forms, functional and decorative. But although they labored to identify the formula for making true porcelain themselves, their efforts were unsuccessful until about 1710, when the Meissen Porcelain Manufactory was established in Germany.

The Ackland's elegant figure of the classical god Apollo comes from the Meissen factory. It is one part of a banquet centerpiece composed of several figures, representing Apollo at his bath surrounded by attending nymphs. In order to assemble the full spectacle, servants used the letters marked on the pieces' bases (the Ackland's Apollo shows the letters *H* and *I/J*) to place each component properly. Before the technology for producing true porcelain was available in Europe, elaborate table displays like this one had been made of sculpted sugar, a similarly radiant and resplendent medium.

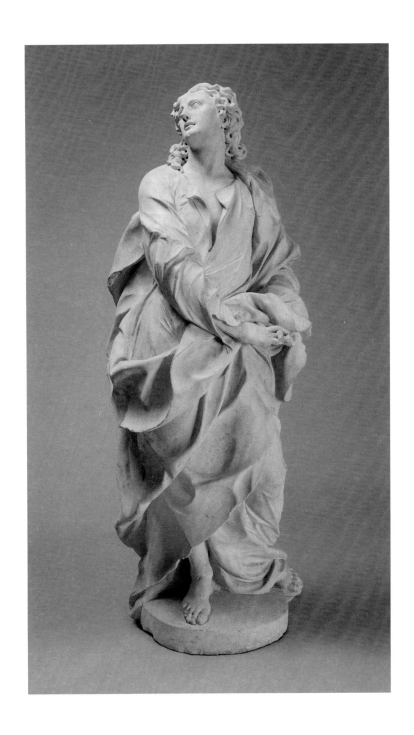

Unidentified artist
Italian, early 18th century
Saint John the Evangelist, c. 1720
limestone
60¼ × 22½ × 14 in. (153 × 57.2 × 35.6 cm)
The William A. Whitaker Foundation
Art Fund, 82.35.1

Although the name of the sculptor who carved this figure is unknown, its subject and its original function are clearer. The robe, long hair, and beardless face are typical of representations of Saint John the Evangelist, the youngest of the apostles of Jesus. The turning pose, upturned face, and dramatically swirling drapery are appropriate for a scene of Jesus's Crucifixion, in which John stood at the foot of the cross, looking upward at Jesus. If this sculpture was part of a Crucifixion scene, it was likely accompanied by a similarly sized figure of Mary that stood on the other side of the cross. The central image of Jesus might also have been a sculpture or another type of representation. Judging by the nearly life size of John, the complete figure group would have been an impressive sight.

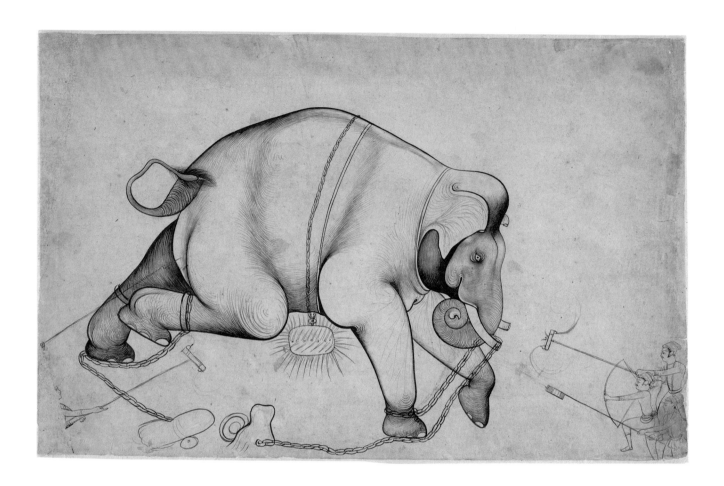

Unidentified artist
Indian, Rajasthan
Enraged Elephant, c. 1710
ink
10½ × 16¹¹⁄₁₆ in. (26.7 × 42.4 cm)
Gift of Clara T. and Gilbert J. Yager, 87.43

Elephants play a hugely important role in Indian history and culture. Admired for their majestic might, they could symbolize royal power and serve military purposes on the battlefield. Courts could be entertained by elephant fights. They appear often in paintings. Probably made in Sawar, an area within the Ajmer district of Rajasthan in northwest India, this lively drawing might even be a portrait of a specific beast. Male elephants become frenzied during their so-called mast season, marked by a discharge from glands in the temples and by aggressive behavior. This energetic animal, with a taut contour and powerful shading, pulls on its chains as three miniscule keepers attempt to subdue it with weapons.

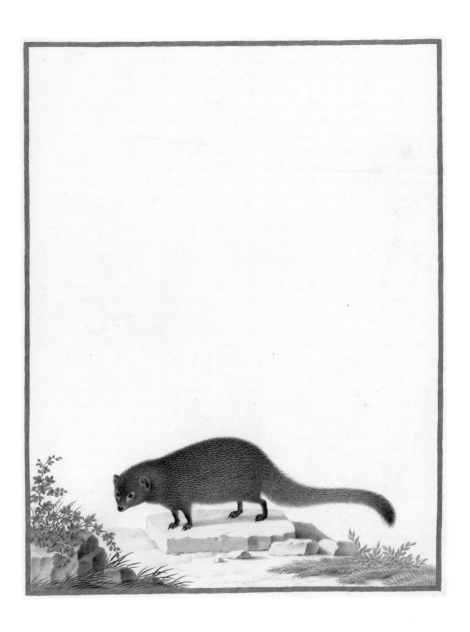

attributed to Jean Joubert
French, active c. 1643–1707
Mongoose, c. 1688
watercolor and gouache on prepared paper
sheet: 9³⁄₁₆ × 7⁵⁄₁₆ in. (23.3 × 18.6 cm)
Ackland Fund, 79.40.1

One of the ways in which the royal palace at Versailles represented King Louis XIV's dominion over his realm was with a menagerie in the grounds, housing animals from distant parts of the world with which France was in contact. In addition to possessing such animals, the king also commissioned artists to depict them in paintings like this one, documenting the mongoose, native to India, North Africa, and southern Spain. The small carnivorous mammal is presented almost as a living sculpture, posed on a stone slab. Scattered rocks and plants suggest a landscape setting, though the blank expanse of most of the background emphasizes how much the creature is presented as a specimen. Although royal patronage of this specific sheet is not established, it closely resembles works in the very extensive portfolios of plant and animal drawings that gathered the production of artists such as Nicolas Robert (1614–1685) and Joubert himself.

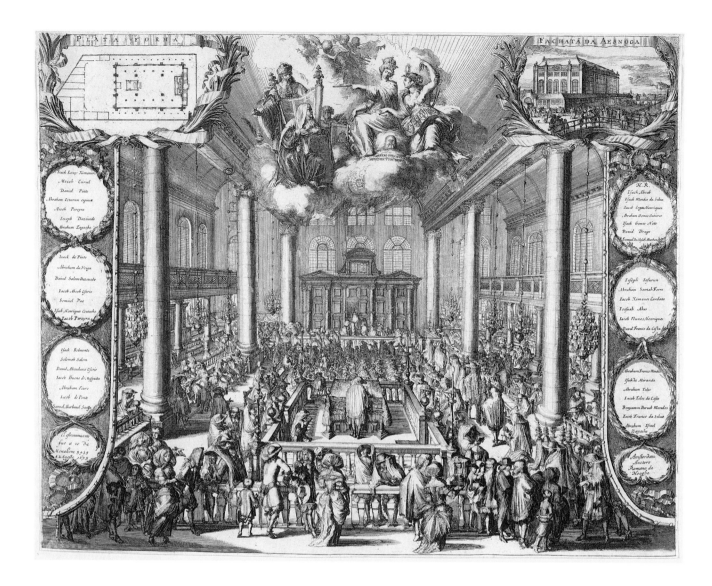

Romeyn de Hooghe
Dutch, 1645–1708
The Dedication of the Portuguese Synagogue in Amsterdam, 1675
etching
15¼ × 19⅝ in. (38.7 × 49.8 cm)
Gift of Leena and Sheldon Peck, 2015.22

In 1675, the new Portuguese synagogue in Amsterdam was consecrated. This large etching, made to commemorate that event, presents the synagogue's interior, including many architectural details and many congregants, most of whom attend to the service, though a few turn to engage the viewer's eye. In addition to the visual grandeur of the building, de Hooghe shows other kinds of information about its construction and importance. Insets at upper left and right corners show the synagogue's floor plan and a view of its exterior. Along the sides are lists of names of people who funded the building, managed its construction, and presided over its opening. At the upper center, hovering over the scene below, is a group of figures symbolizing religious tolerance in the Dutch Republic. For descendants of the Jews who came to Amsterdam from Portugal after the Spanish Inquisition, this message of freedom of worship was important to emphasize.

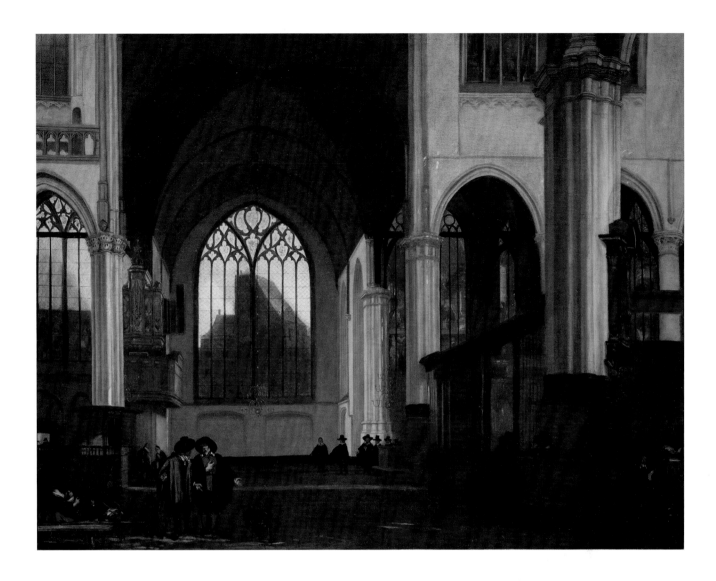

Emanuel de Witte
Dutch, c. 1617–1692
**The Interior of the Oude Kerk,
Amsterdam**, c. 1660
oil on canvas
32⁵⁄₁₆ × 41¼ in. (82.1 × 104.8 cm)
Ackland Fund, 73.31.1

Within the immense interior of the Oude Kerk, Amsterdam, Dutch citizens go quietly about their business. They chat, nap, nurse, and stroll. By contrast, the interior is animated. A rushing perspective leads rapidly from one massive column to another, halting abruptly at the back window through which a dark building looms. Arches open tantalizing views into other spaces that entice exploration. Warm light filters through windows, gently caresses columns and walls, and falls in bright patches on the floor.

De Witte, who specialized in church interiors, was particularly fond of the Oude Kerk and portrayed it many times. The Ackland's version, which depicts the nave, north aisle, and transept of the church, gives the impression of authenticity, but it is not an exact portrait. Like most accomplished portrait painters, de Witte made artful changes, modifying some elements and eliminating others, so to emphasize his favorite subject's best features and distinctive personality.

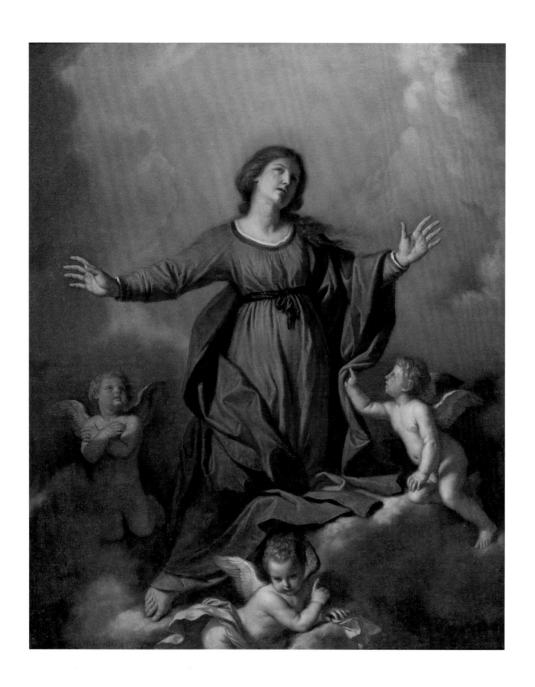

Guercino
Italian, 1591–1666
The Assumption of the Virgin, 1655
oil on canvas
45⅞ × 37½ in. (116.6 × 95.2 cm)
Ackland Fund, 82.12.1

The subject of Mary's corporeal assumption into heaven was popular in religious art. Frequently artists treated the Assumption dramatically, depicting the apostles around Mary's empty tomb looking up in astonishment as she rises above them. Guercino freed the theme from its narrative context, transforming it into an enduring devotional image.

Mary kneels on a bank of clouds, her eyes turned heavenward and her arms outstretched in a reverential attitude. Three putti accompany Mary. Two look up at her with adoration. A third looks down and points to Mary, directing worshippers' attention to her. Mary is foiled against a heavenly glow that forms a halo around her. Guercino uses no earth tones, only celestial hues. His gemlike colors — sapphire rose and lapis lazuli blue — suggest both the heavenly setting of the Assumption and its preciousness as an object of devotion. This small *Assumption* was likely commissioned for an altarpiece in a private chapel.

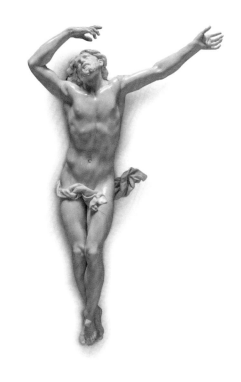

Unidentified artist
German or Netherlandish
The Repentant Thief, last quarter of the
17th century
ivory
9½ × 6½ × 2¼ in. (24.1 × 16.5 × 5.7 cm)
The William A. Whitaker Foundation
Art Fund, 87.9

According to the Gospel of Luke, two thieves were crucified on either side of Jesus. The one on his left rebuked him. The one on his right recognized him and repented. This delicately sculpted figure most likely represents the Repentant Thief. Originally he would have been affixed to a cross with a nail through the hole in his feet and bindings around his arms. Almost certainly, he would have formed part of a tableau of ivory figures representing the Crucifixion.

In the seventeenth century, ivory sculptures like the Ackland's were highly prized by wealthy connoisseurs for the preciousness of the medium and the virtuosity with which it was sculpted. A rare commodity, ivory was fragile and fractured easily if not worked with expertise. *The Repentant Thief* was likely commissioned for a private chapel, where its costly material and fine carving greatly enhanced its value as a devotional object.

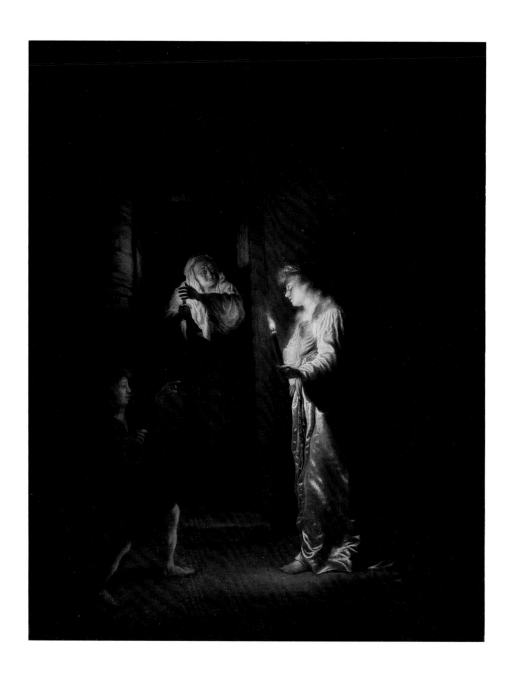

Salomon Koninck
Dutch, 1609–1656
Ceres Mocked by Stellio, c. 1650
oil on wood panel
29¾ × 23⁷⁄₁₆ in. (75.5 × 59.6 cm)
Gift of Mr. and Mrs. Norman Hirschl,
63.36.1

The story of Ceres and Stellio is told in Ovid's *Metamorphoses*. While searching for her daughter, Ceres becomes thirsty and requests water from an old woman. As the goddess greedily gulps the water, Stellio, a rude boy, mocks her for it. To punish his impudence, Ceres transforms Stellio into a lizard. Koninck omits crucial elements from Ovid's tale. He depicts Stellio's taunt, but not its cause (Ceres's gulps) or its outcome (Stellio's metamorphosis). While Koninck may dilute the drama, he concentrates on dramatic effects. The play of light and dark takes center stage, enlivening the subdued composition and spotlighting key components. Candlelight illuminates the young goddess's polite deference to the old woman. Darkness casts the disrespectful boy in a negative light. Candlelight highlights Ceres's smooth face and satiny gown. Shadow softens the old woman's wrinkles and coarse cotton. Koninck's stagy light effects emphasize Ceres's exemplary courtesy and his painterly virtuosity.

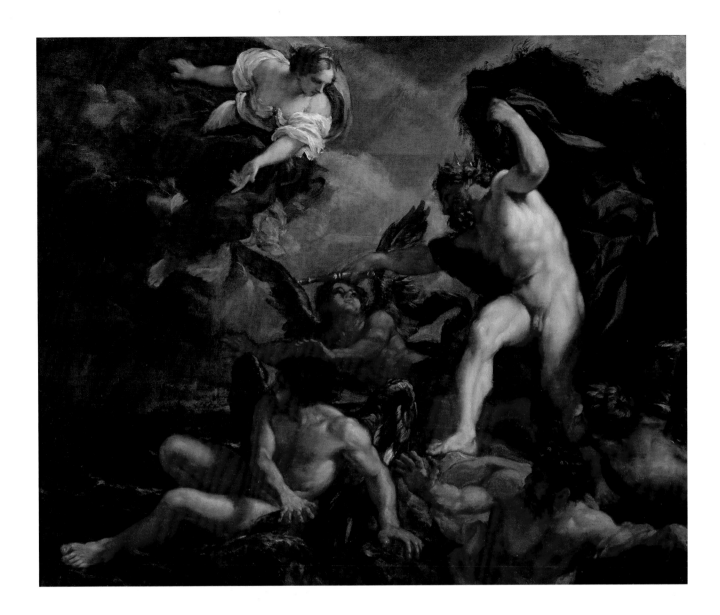

Carlo Maratti
Italian, 1625–1713
**Juno Beseeching Aeolus to Release
the Winds against the Trojan Fleet**,
c. 1654–56
oil on canvas
24⅜ × 30 in. (61.9 × 76.2 cm)
Gift of Mrs. Joseph Palmer Knapp, by
exchange, 2009.10

As told in Virgil's *Aeneid*, the goddess Juno asks Aeolus, king of the winds, to destroy Aeneas's Trojan fleet by unleashing the winds against it. Maratti condenses the lengthy narrative into one dramatic scene: Juno makes her request; Aeolus issues his command; the winds burst outward, churning the waters with their force. Aeneas's endangered fleet is in the distance. The explosive moment is captured by Maratti in a tightly controlled composition.

The airborne Juno faces the earthbound Aeolus across a compositional diagonal. Dressed in cool blues and whites, Juno is self-contained, calm, and collected. Nude Aeolus is all action. Around his open, twisting form, the four winds spiral like a vortex.

This modestly sized painting likely served as a study for a larger work. It is rapidly executed with vigorous brushstrokes. Evidence of compositional changes suggests it is a work in progress.

Soga Shoko
Japanese, active mid-17th century
Three Friends: Plum, Pine, and Bamboo,
17th century
pair of eight-panel screens: ink and
gold wash on paper
each: 67^{15}⁄$_{16}$ × 193^{15}⁄$_{16}$ in. (172.6 × 492.6 cm)
Ackland Fund, 87.11.1–2

87.11.1

The trio "plum, pine, and bamboo" is a traditional Chinese theme favored among poets and painters in Japan. The "three friends" are emblematic of ideal human qualities, representing endurance of spirit, longevity, and resilience in the face of difficulty. In Buddhism, they reflect the belief that one can remain unaffected by change through meditation. On the left-hand screen (illustrated here), the arching stalks of bamboo display their flexibility, while the robust trunk of the plum tree, whose branches extend through the composition in a graceful curve terminating in delicate blossoms, can represent fortitude and renewal.

95.10.1

Kano Tsunenobu
Japanese, 1636–1713
The Seven Sages in the Bamboo Grove,
late 17th to early 18th century
pair of six-panel screens: black ink on paper
each: 62¾ × 133¹¹⁄₁₆ in. (159.4 × 339.6 cm)
Gift of The Gregg Family Trust, 95.10.1–2

The Kano school, an influential school of painters in Japan
that lasted from the fifteenth to the nineteenth century,
often took on subjects of Chinese origin. Here Tsunenobu,
the second-generation head of a branch of the Kano school
in Edo (now Tokyo), presents the "seven sages of the bamboo
grove," a group of men of high education and position
who lived in China during the early Six Dynasties period
(220–589). Turning away from the strict formalities of the
Confucian government, these men retired to the countryside,
immersing themselves in philosophical discussions and
elegant pastimes, enhanced by wine. This pair of screens
shows the men enjoying Confucianism's four noble pastimes:
calligraphy, painting, music, and go (a game similar to chess).
The three on the right-hand screen (illustrated here) play
go while accompanied by an attendant holding an opened
umbrella and packages.

Kano Sansetsu
Japanese, 1589–1651
The Ten Snow Incidents, late 16th
to mid-17th century
six-panel screen: ink on paper
screen: 66¹⁵⁄₁₆ × 149½ in.
(170.1 × 379.7 cm)
Ackland Fund, 91.17

Sansetsu was a major artist of the Kano school in the early Edo period. He often painted works on Chinese themes, in this case the traditional subject known as "the Ten Snow Incidents." On this screen, the left half of what would have been a pair, there are five of these scenes, concentrated in the first two panels: a poor man who could not afford lamp oil but became learned through studying by light reflected from the snow; a gathering of scholars including one who composed a long poem in honor of snow, avoiding all clichés; a man crossing a bridge on a donkey (in the original story, in a blizzard); a captive in a cave who survived by eating snow; and a provincial governor giving a poet the honor of visiting him, even in bad weather. Dominating and unifying the composition are the expanses of atmosphere and snow-covered mountains.

Salomon van Ruysdael
Dutch, c. 1602–1670
River Landscape with Fishermen, 1643
oil on panel
20½ × 32¾ in. (50.8 × 83.2 cm)
The William A. Whitaker Foundation
Art Fund, 2002.15

It is a pleasant day on the river. A light breeze gently swells the sails of a vessel heading to shore. Fishermen in a small boat moored along the bank attend to their nets. Ferrymen row their passengers across placid waters. Ruysdael's *River Landscape* could not be more serene or less eventful. But that, for the artist's Dutch patrons, was precisely the point. Scenes in which working folk go quietly about their business affirmed the peace and stable economy of their recently formed homeland after years of war with Spain. The ordinary was extraordinary, worthy of celebration in paint.

Ruysdael was a pioneer in the development of naturalistic landscape painting in the seventeenth century. River scenes like the Ackland's were his specialty. He excelled, as here, in conveying the freshness of "on the spot" recording of drifting clouds, shifting light patterns, and watery reflections, although the scene was certainly composed in his studio.

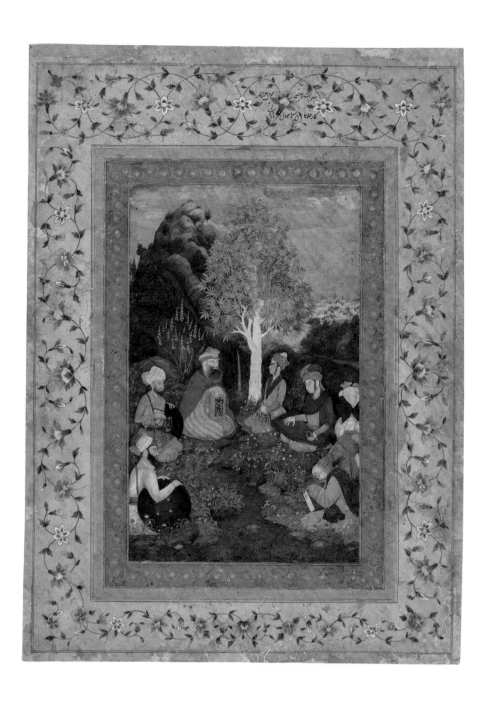

Jalal Quli

Indian, Mughal, active 1630–1660

Scholars and Musicians beneath a Tree, Possibly Prince Dara Shikoh and Mullah Shah, Accompanied by Five Retainers, in Kashmir, c. 1640–50

opaque watercolor and gold on paper mounted on an 18th-century album page

mount: 17⅝ × 12¹⁵⁄₁₆ in. (44.8 × 32.9 cm)

Gift of the Tyche Foundation. 2009.21

This exquisite image, deriving from Persian prototypes featuring a holy man in the wilderness and a ruler seeking counsel, depicts a meeting between Prince Dara Shikoh (1615–1659), eldest son of Shah Jahan (reigned 1628–58), and one of the most prominent Sufi teachers of a Sunni Islamic sect which was famous for its meditational techniques and liberal beliefs. At the age of twenty-five, Dara was initiated into the order by mullah Shah Badakhshi, who became his spiritual mentor. The scene probably shows the mullah holding a volume of sacred biographies written by the prince. Appropriately, the stream seems to emanate from the mullah, the fount of sacred knowledge, and divides him from the profane world of the prince. Furthermore, the background associates the rocky landscape with the mystic, and the Mughal city to the right with the worldly rulers.

Salvator Rosa
Italian, 1615–1673
Two Worshipping Figures, Preliminary Studies for *Jonah Preaching to the Ninevites*, c. 1659
pen and iron gall ink
image: 4⅝ × 4 in. (11.8 × 10.2 cm)
Ackland Fund, 79.33.1

Rosa made the drawings on the front and back of this sheet as preparatory studies for a painting of the biblical subject *Jonah Preaching to the Ninevites*, bought in 1661 by King Frederick III of Denmark. In that subject from the Book of Jonah, the people of Nineveh fervently repent when the prophet warns that God will destroy their city. In Rosa's drawings, we see him experimenting with the most effective ways to convey the people's heartfelt emotions. The man in the upper right corner of the front side (or recto) tilts his head so that we barely see his face; nevertheless, his posture, his gesture, and Rosa's rapid pen strokes communicate his anguish. On the same side of the sheet, Rosa depicts a prostrate man twice, working out the right position of the body and configuration of facial features.

Jacques de Gheyn II
Dutch, 1565–1629
**Portrait of a Young Man Writing
(The Artist's Son)**, c. 1605–10
black chalk
sheet: 6½ × 5¹¹⁄₁₆ in. (16.5 × 14.4 cm)
The Peck Collection, 2017.1.36

This charmingly informal drawing depicts the artist's then-teenage son, Jacques de Gheyn III (1596–1641), who was noted for his remarkable artistic talent at an early age. On the sheet on the table, the father has playfully "signed" the drawing using the hand of his son who shares his name. Both drawing and sitter are thus his creations. The extensive hatching and shading seem to reinforce the variety of techniques that students must master, though they are executed in black chalk, whereas the boy at the table works with pen and ink, made clear from his writing utensils and inkwell. The abbreviation "in" (for "inventor") appears after the signature, a common practice at the time. In this context, with the otherwise blank sheet, it appears to pun on the centrality of the imaginative process for artistic creation, an activity with which the young artist with his head resting on his hand appears to be deeply engaged.

Rembrandt van Rijn
Dutch, 1606–1669
Studies of a Woman and Two Children,
c. 1640
pen and brown ink
sheet: 5⅜ × 5³⁄₁₆ in. (13.6 × 13.2 cm)
The Peck Collection, 2017.1.64

Although many of the children Rembrandt represented, like this infant and toddler, were demonstrably not his own since they date to different times, he drew a large number of such sketches attentively from life, recording the endearing aspects of children. His keen eye and quick pen captured their distinctive postures and expressions with remarkably concise lines, as well as their relationships to the woman (if both figures are indeed the same person) attending them, who in this case is likely an older nurse rather than their mother. This is one of the small handful of exceptional sketches bearing an annotation in Rembrandt's own hand. In order to clarify the odd covering of the infant on the left, he wrote: "a small child with an old jacket on his head" (*een kindeken met een oudt jack op sijn hoofdken*). Rembrandt frequently made drawings like this as studies that he kept in his studio, and the note was likely a reminder to himself.

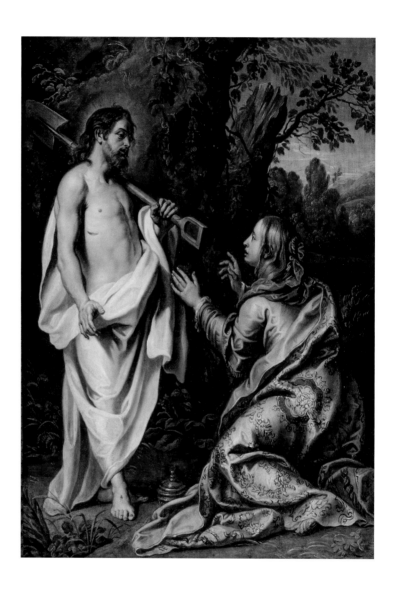

Gerard Seghers
Flemish, 1591–1651
Do Not Touch Me (Noli Me Tangere),
c. 1630–40
oil on panel
17⅜ × 12½ in. (44.1 × 31.8 cm)
Gift of the Tyche Foundation, 2010.7

The story of Mary Magdalene's encounter with Jesus after the Crucifixion is recounted in the Gospel of John. At first Mary Magdalene mistook Jesus for a gardener. When she recognized him, she instinctively reached out, but Jesus prevented her with the words "Touch me not (Noli me tangere), for I am not yet ascended to my father."

The small size and limited palette of the Ackland's painting did not impede Seghers from conveying persuasively the pathos of Mary's prohibited touch. Touch and sight are central to his telling of the story. Seghers emphasizes expressive hands: Mary's hand temptingly close to Jesus's robe and Jesus's gentle gesture of restraint. The gaze between Mary and Jesus is intense. Sight substitutes for touch. As viewers, we share Mary's experience. Seghers's sumptuously painted textures – embroidered robe, soft flesh, silken hair – tantalize, but we can only touch them with our eyes.

Vicente Carducho
Italian, active in Spain, c. 1576–1638
The Stigmatization of Saint Francis,
c. 1610–30
oil on canvas
64¼ × 47 in. (163.2 × 119.4 cm)
The William A. Whitaker Foundation
Art Fund, 95.3

In his *Life of Saint Francis of Assisi* (1263), Saint Bonaventure recounts the miracle of the stigmata, the wounds of the crucified Jesus. One morning while praying on a mountainside, Saint Francis had a vision of a winged seraph with an image of the Crucifixion. The vision "left in his heart a marvelous ardor and imprinted on his body marks that were no less marvelous."

Carducho brings Francis's ardent response to his vision vividly to life, giving the miracle an immediacy that belies its distance in time. The roughness of Francis's robe and the softness of his flesh suggest his tangible presence. Francis holds his hands outward, enlisting viewers as eyewitnesses to the marvelous marks. Carducho appeals to viewers' senses of touch and sight so as to engage their emotions.

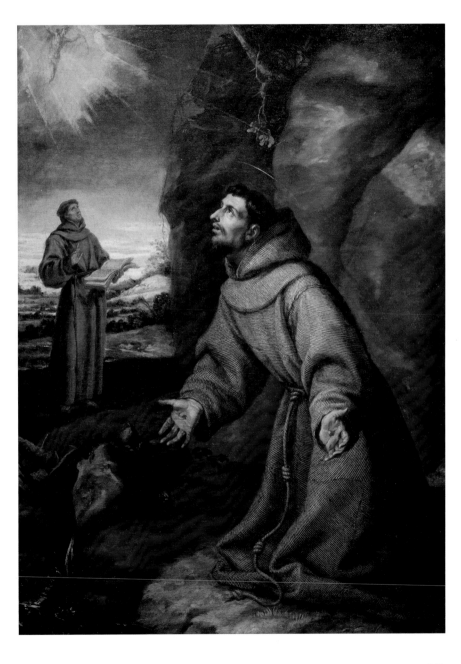

Jusepe de Ribera
Spanish, active in Italy,
baptized 1591–1652
The Penitent Saint Peter, 1621
etching with engraving
12⁷⁄₁₆ × 9⁹⁄₁₆ in. (31.6 × 24.3 cm)
The William A. Whitaker Foundation
Art Fund, 2008.13

Alone in the wilderness, Saint Peter kneels with his hands clasped and his eyes turned heavenward as he begs forgiveness for his sins, notably his denial that he was a follower of Christ. The theme of Peter's remorseful penitence was popular in Catholic Europe in the late sixteenth and seventeenth centuries. This popularity coincided with the church's vigorous defense of penitence as a sacrament and a means to salvation, in response to Protestant skepticism. Ribera's etching of Saint Peter, remorseful and repentant, effectively and movingly offered Catholic faithful confirmation of the importance of penitence through Peter's exemplary act of contrition.

Ribera was not a professional printmaker, but he was an inventive one. He was among the first to exploit etching's potential to rival the effects of oil painting. His *Penitent Saint Peter* displays his masterful use of line to create a rich range of darks and lights, giving this small print visual and emotional power.

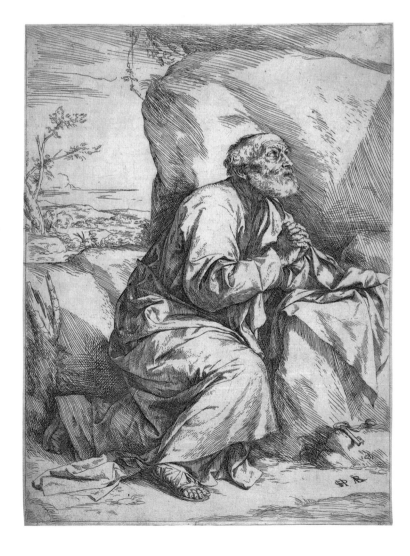

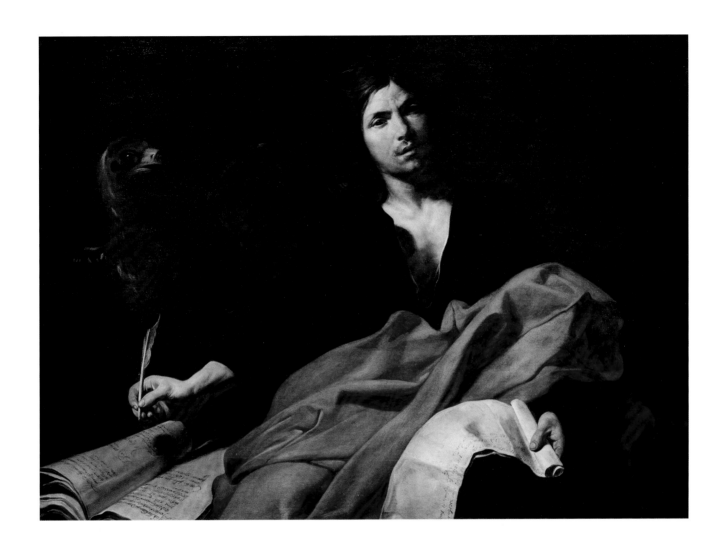

Valentin de Boulogne
French, 1591–1632
Saint John the Evangelist, c. 1622–23
oil on canvas
canvas: 38⅝⁄₁₆ × 52¹⁵⁄₁₆ in. (97.3 × 134.5 cm)
The William A. Whitaker Foundation
Art Fund, 63.4.1

Valentin's art was deeply affected by the Italian painter Michelangelo Merisi da Caravaggio, who deployed dramatic contrasts of light and shadow (or chiaroscuro) to spectacular effect. Here, Valentin's principal figure is Saint John the Evangelist, but it could be argued that light and shadow play the most important role in the story. The entire scene seems to emerge from a murky background. But for the faint reflections on a few of the eagle's feathers and the slightly brighter ones on its beak and eye, we might not even see him. John's dark robe and tousled hair blend in places into the shadows. The brightest light in the scene falls on John's face and neck, his hands, the scroll, book, and pen, alerting us that they are key components of the narrative: John is deep in thought, writing his Gospel. Could the intense spotlight shining in his eyes, making him squint, be divine inspiration?

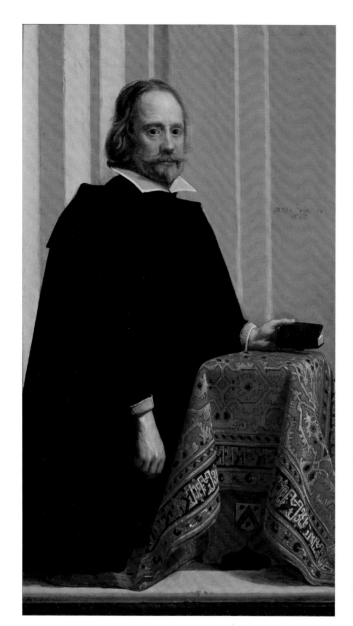
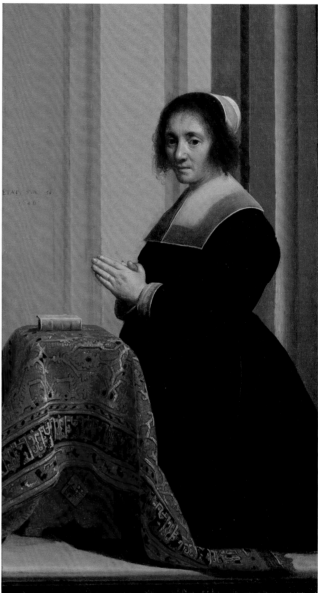

Jacob van Oost the Elder
Flemish, 1601–1671
Everard Tristram, 1646
oil on wood panel
22⅝ × 13 1/16 in. (57.5 × 33.2 cm)
Wilhelmine Bezoete Tristram, 1646
oil on wood panel
22 11/16 × 13⅛ in. (57.6 × 33.3 cm)
Gift of the John Motley Morehead
Foundation, 65.4.1–2

In this portrait pair, a man and a woman kneeling at devotional stands stare sternly outward. Apparently we have interrupted their prayers. The coats of arms on the stands identify the couple as Everard Tristram and his wife Wilhelmine Bezoete. The inscriptions behind them give their ages as fifty-four.

Van Oost reveals more than these facts about the couple. Their respectability and piety is evident from the sobriety of their dress and their poses at prayer. In fact, the portraits likely served as the left and right wings of a triptych flanking a central devotional image. The pair was also prosperous. Only the wealthy could afford the carpets draped over the prayer stands. Islamic carpets, luxury goods, were often included in portraits to reflect high social and economic status. Piety and prosperity were not considered contradictory at this time, when success was seen as one sign of God's favor.

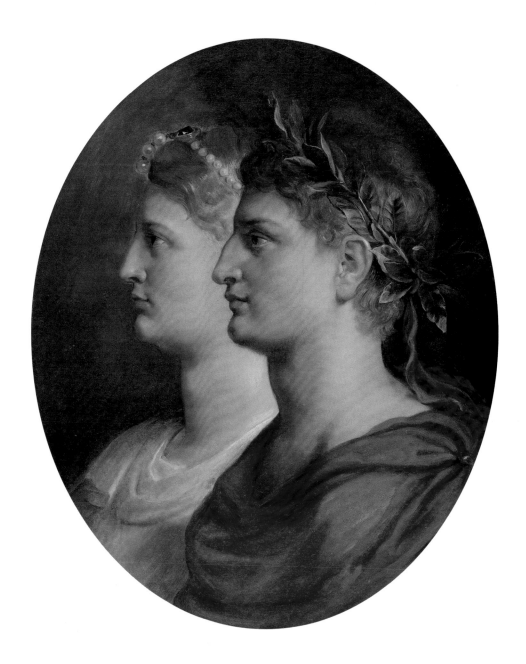

Peter Paul Rubens
Flemish, 1577–1640
Germanicus and Agrippina, c. 1615
oil transferred to Masonite panel
27¹¹⁄₁₆ × 22⅝ in. (70.3 × 57.5 cm)
Ackland Fund, 59.8.3

Rubens based this painting on an ancient Roman gem that belonged to the Duke of Mantua, who was his patron while the artist traveled in Italy. In the gem and in Rubens's painting, a Roman couple face left, their placement staggered so that we can see both profiles. Rubens, who was renowned for his astonishing ability to imitate the appearance of the human body, translates the Roman relief sculpture back into flesh and blood, reversing, in effect, the process the gem carver used to represent living bodies in hard, cold stone.

Rubens painted another version of this subject, now in the National Gallery of Art in Washington, DC In it, he reverses the positions of the figures so that Agrippina appears in front of her husband. The Ackland's painting is more traditional in this respect.

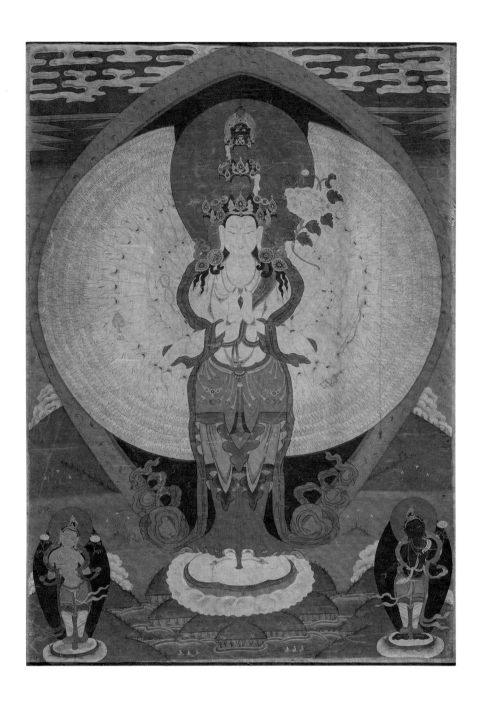

Unidentified artist
Tibetan or Nepalese
**Eleven-Faced, Thousand-Armed
Avalokiteshvara**, early 17th century
tangka: color on cotton
29⅞ × 21 in. (75.9 × 53.3 cm)
Gift of Ruth and Sherman Lee, 99.13.4

Avalokiteshvara, the most merciful and beloved bodhisattva in Mahayana Buddhism, is believed to have vowed to listen to all prayers and not to seek enlightenment until all mankind achieves nirvana. This *tangka* (portable painting) dates from around the rule of the powerful Fifth Dalai Lama, the first Dalai Lama to assume both spiritual and temporal control of Tibet. He was recognized as a reincarnation of Avalokiteshvara, called Chenrezi in Tibetan. With an eye at the center of each hand, the thousand arms in this depiction symbolize the bodhisattva's limitless potential for compassionate outreach and his powerful ability to see and help all beings achieve enlightenment. The bodhisattva's eleven heads also represent his extraordinary vision, corresponding to the four cardinal directions and the midpoints between, as well as the center, zenith, and nadir.

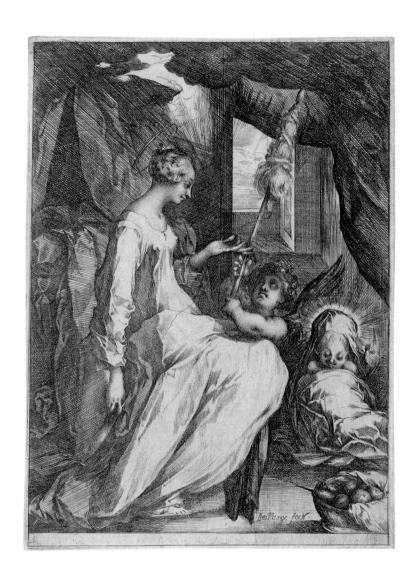

Jacques Bellange
French, c. 1575–1616
**The Virgin and Child with Distaff
and an Angel**, c. 1615
etching and engraving
sheet: 10¹⁄₁₆ × 7⅝ in. (25.5 × 19.4 cm)
The William A. Whitaker Foundation
Art Fund, 2006.22.3

Bellange's image of Mary, the infant Jesus, and a baby angel presents the holy Christian figures in a domestic setting. The angel holds up a distaff and, on close inspection, we notice that Bellange has etched a fine thread extending from the fiber wound around the distaff, through Mary's dainty fingers, to the spindle suspended at her side, grasped gracefully in two fingers of her other hand. At her feet lies a basket of her finished work. If Mary's occupation is meant to show her virtuous modesty, her figure is meant to show her courtly elegance. Her extremely elongated proportions, small head, and willowy posture are those of an idealized, Mannerist lady. Bellange and other artists associated with this style often deliberately diverged from naturalistic norms. In this case, doing so allows Bellange to present Mary in the guise of a refined lady of a European court like that of the Duke of Lorraine, where Bellange worked.

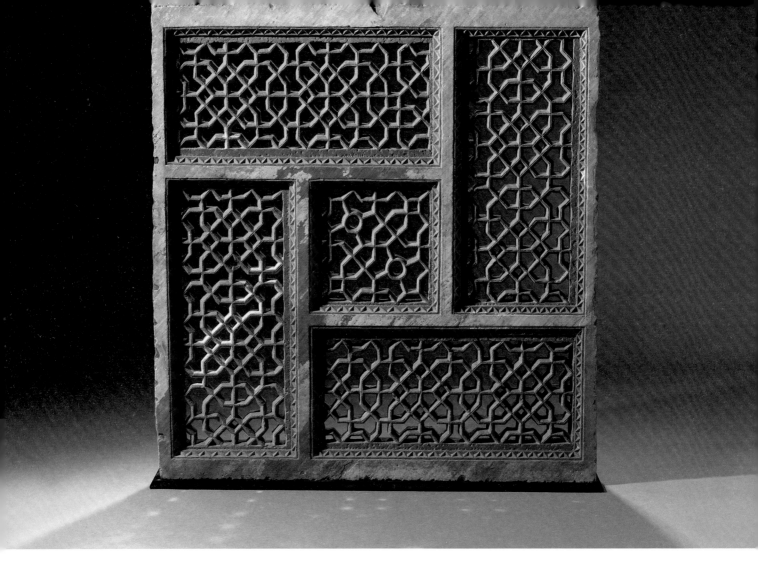

Unidentified artist
Indian, Mughal, Jahangir period
Perforated Screen, c. 1605–27
sandstone
42⅛ × 40⁹⁄₁₆ × 3¾ in. (107 × 103 × 9.5 cm)
Special Acquisition Fund, 2019.16.3

Mughal Indian windows in all types of stone buildings were filled with carved stone *jalis*, the ideal environmental solution for sunny climes, as they were perforated to allow for ventilation and control of light. Importantly, they could be seen through only from the inside, ensuring privacy from the world outside.

Jalis differ greatly – some are vertical, others horizontal, and others square – according to the proportions of the windows they were made for. Although they were practical, jalis were never entirely utilitarian. They were used to reinforce the floral, geometric, and/or curvilinear designs of a building. Not only pleasing to the eye on the outside, they cast changing patterns of shadow inside buildings as the sun moved over the course of a day.

This example features rectangles rotating around a central square with two circles organizing the pattern. The square format of this jali reinforces the power of its overall geometry.

Unidentified artist
Turkish and Italian
An Italian Panel with Ottoman Embroidery, 16th century
velvet
47⅝ × 24⁷⁄₁₆ in. (121 × 62 cm)
Special Acquisition Fund, 2019.27

This early Italian velvet embellished with finely executed, complex Turkish embroidery was an imperial textile made for the Ottoman court. Its repeating decorative pattern includes ten groupings of the three balls nearly ubiquitous in Ottoman textiles. A motif that originated in Buddhist imagery, these "leopard spots" are called *chintamani*, a Sanskrit word meaning "auspicious jewel." Each ball is composed of two embroidered, nestled crescents. The crescent is the central Ottoman symbol, but it was not widely used in the sixteenth century except on imperial objects.

Occasionally chintamani were combined with floral elements, creating an alternating balance of two distinctive styles, as here with the addition of the four flowers in high profile.

Although the Ottomans made velvets that were widely sought after in the West and often given as diplomatic gifts, research has shown that the court sought the very finest velvets made in Italy for its own use.

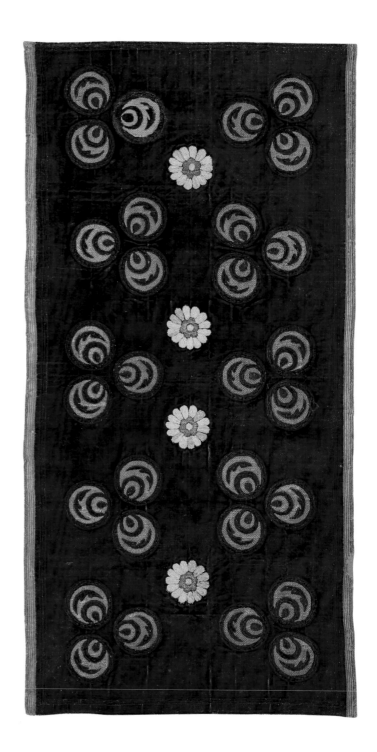

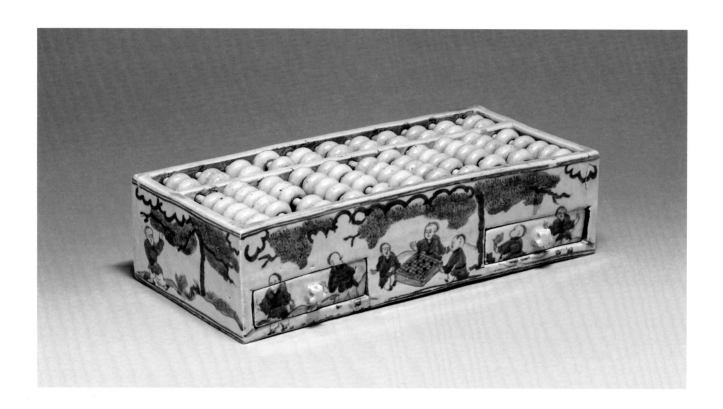

Unidentified artist
Chinese, Ming dynasty
Abacus, early 17th century
porcelain with underglaze cobalt blue
decoration
3 × 11¾ × 5½ in. (7.6 × 29.8 × 14 cm)
Gift of the William E. Shipp Estate, by
exchange, 2016.24ab

This porcelain abacus was probably less a functional device and more a desk object
symbolizing learned taste. While it does have two drawers and beads in two registers that
can be used for mathematical calculation, the tight structure does not allow much room for
movement. Its long sides picture two scenes of leisure within a landscape setting. In one,
boys are playing ball, while in the other they engage in playing the chess-like game *go*. In
the seventeenth century, both decorative motifs typifying cultured pursuits would often
adorn portable objects, usually made in China for the Japanese market.

Unidentified artist
Chinese, Qing dynasty, Kangxi period
Baluster Vase, late 17th century
porcelain with painted underglaze cobalt
blue decoration
height: 29¾ in. (75.6 cm); diameter:
9¹³⁄₁₆ in. (24.9 cm)
Gift of Beatrice Cummings Mayer, Class
of 1943, 2004.25.4

In the landscape painted in cobalt on this large
vase, scholars appear amid a vast scene that
includes cascading waterfalls, winding riverways,
and angular earth forms. Atmosphere and mist,
suggested by whorls of vaporous ether, weave
around the mountain peaks. The whiteness of
the porcelain contrasts with the vivid blue of the
painting, and the transparent glaze enhances the
smoothness and brilliance of the imagery. During
the Ming dynasty (1368–1644) most porcelain
designs featured court symbols and ornamental
patterns, but during the fifty-year period that
marked the transition between Ming and Qing
dynasties (c. 1620–70), styles diversified and
markets expanded. Landscapes like this one may
have appealed to patrons who were interested
in monochrome ink paintings but appreciated
seeing that format translated into a different
palette and media.

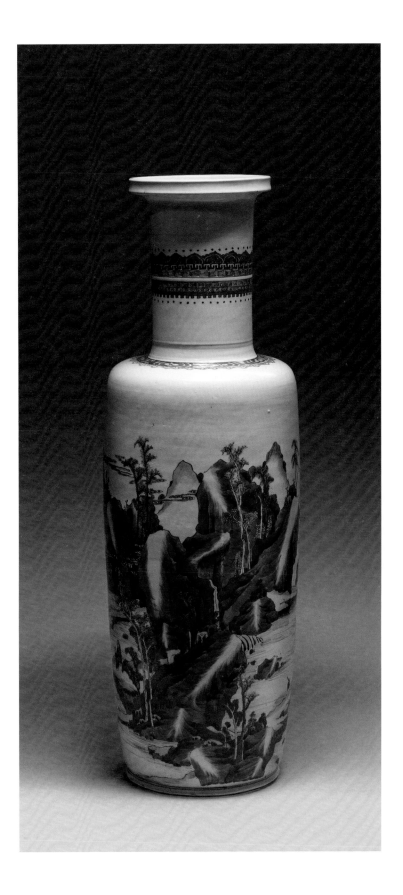

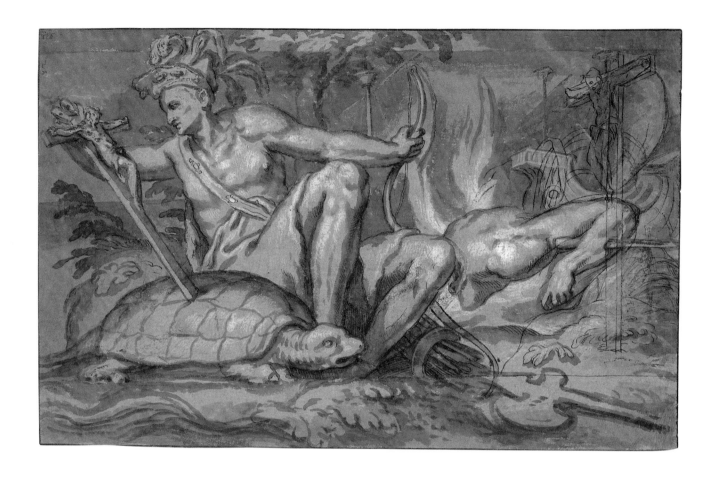

Paolo Farinati
Italian, 1524–1606
Allegory of America, 1595
pen and brown ink, brown wash and
gouache highlights (some of which have
darkened) over black chalk on blue paper
10⅝ × 16¹³⁄₁₆ in. (27 × 42.7 cm)
Ackland Fund, 77.55.2

Allegorical representations of the Four Continents gained popularity in Europe in the mid-sixteenth century, the great age of European exploration and colonization of new lands. Farinati's *Allegory of America* conforms to standard representations of the continent as primitive and savage, a place in need of the civilizing presence and spiritual guidance of a culturally and morally superior Europe. In his drawing, Farinati brings this European perspective on America to life. A New World Indian turns from the human shoulder roasting on a spit to cradle the cross. He has been converted from cannibalism to Christianity. The ships indicated in the background attest to the providential presence of Europeans (the Spanish) as the source of the "savage" man's salvation.

The *Allegory of America* was preparatory for a fresco cycle of the Four Continents at the Villa della Torre (now Villa Cordioli) in Mezzane, Italy. It is one of earliest-known representations of the evangelization of America.

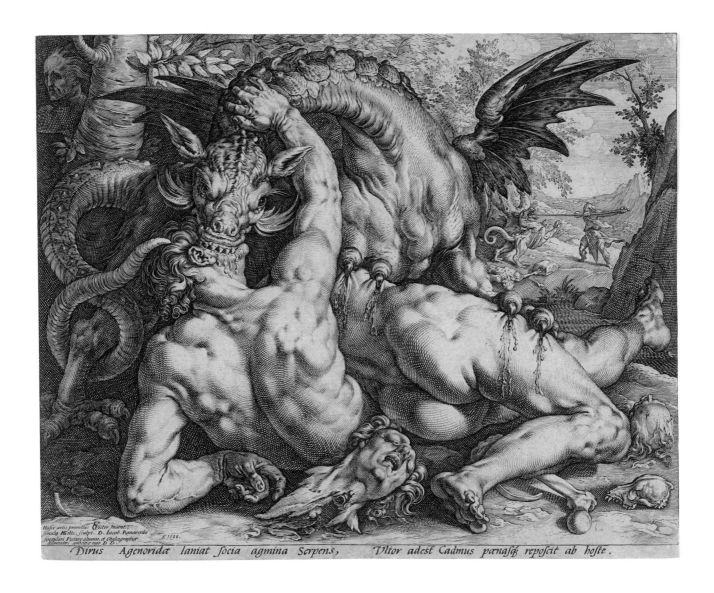

Háfee artis primitias Pictor Juvent;
jimula Melite, fculpt. D. Iacob Rauweerdo
Singularis Pictura alumno, et Chalagraphiæ
fautori; amititiæ ergo D.D. ℭ. 1588.

Dirus Agenoridæ laniat focia agmina Serpens, Vltor adeft Cadmus pænafꝗ repofcit ab hofte.

Hendrick Goltzius
Dutch, 1558–1617
The Followers of Cadmus Devoured by a Dragon, 1588
engraving
image: 9⁹⁄₁₆ × 12³⁄₈ in. (24.3 × 31.5 cm)
Burton Emmett Collection, 58.1.691

The grisly scene depicted by Goltzius in graphic detail barely merits a mention in the story of the founding of Thebes by Cadmus as told in Ovid's *Metamorphoses*. There, Cadmus's slaying of the dragon – seen in the distance in Goltzius's print – is described at length. Why relegate Cadmus's heroism to the background and bring such horror to the fore?

For Goltzius, the mangled bodies allowed him to display his mastery of human anatomy and his virtuosity in handling the engraver's burin. A close look reveals the subtle gradations from lights to darks that Goltzius creates with lines that wax and wane, giving three-dimensional lifelikeness to the dead and dying figures.

For Goltzius's Dutch viewers, who recently freed themselves from Spain after years of war, the bloodied bodies may well have evoked the horrors of battlefield slaughter, of Spain's tyranny and inhumanity, and of their victory over a monstrous enemy.

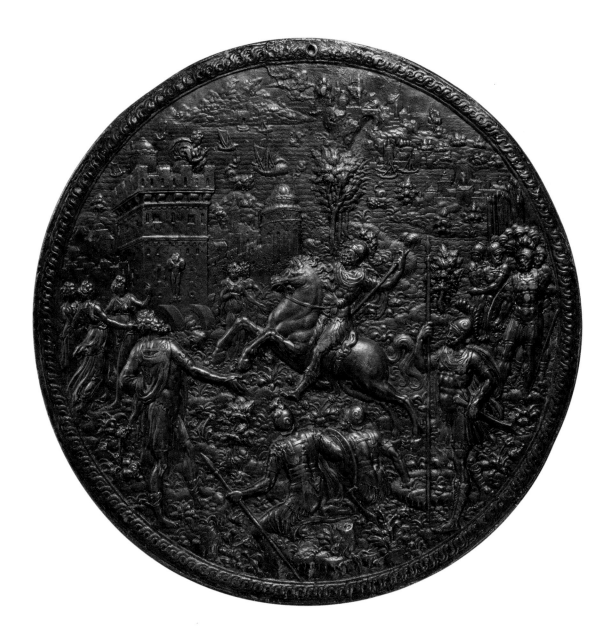

Hans Jamnitzer
German, 1538–1603
Minos and Scylla, 1569
lead
diameter: 7³⁄₁₆ in. (18.3 cm)
The William A. Whitaker Foundation
Fund, 81.17.1

The story of Scylla's fateful passion for her father's enemy, King Minos, comes from Ovid's *Metamorphoses*. Scylla betrays her father for Minos, only to be repudiated for her perfidy. The tale ends with Scylla's transformation into a seabird and her father into an osprey, who relentlessly pursues her. The Ackland's medallion shows Scylla watching and beckoning to Minos from a tower, as he approaches on horseback to besiege her father's city.

In the Renaissance, medallions and other small-scale relief sculptures flourished as independent art objects. They were avidly collected by connoisseurs. As they were easily transportable and existed in multiples, they contributed to the dissemination of Renaissance images and ideals across Europe. Medallions were produced by making relief molds in wood, stone, or wax, which were replicated in bronze or lead. Jamnitzer, a German goldsmith, designed the mold from which the Ackland's medallion was made.

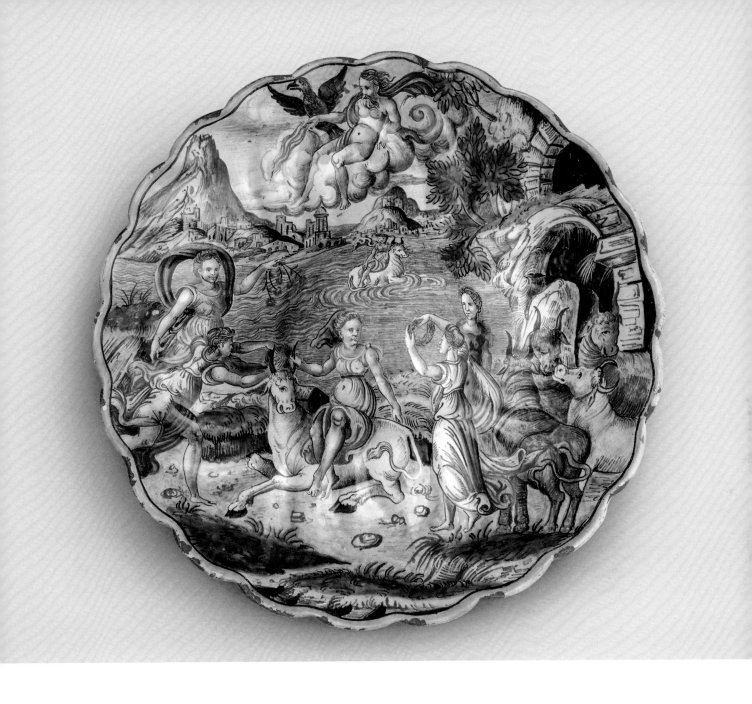

Unidentified artist
Italian
**Molded Dish (*Istoriato Crespina*)
with Europa and the Bull**, c. 1550
tin-glazed earthenware (*maiolica*)
2¾ × 11 × 11 in. (7 × 28 × 28 cm)
Gift of the William E. Shipp Estate,
by exchange, 2007.5

The term *maiolica* describes Italian tin-glazed pottery, known for vivid colors and complex painted designs. This earthenware was very common in the wealthy Italian home during the Renaissance. It was used, for example, for tiles, frames, plaques, and especially for dishes, often with narrative scenes. This dish displays two episodes from the story of Jupiter and Europa, as described in Ovid's poem *Metamorphoses*. Disguised as a bull, the Roman god Jupiter convinced the mortal princess Europa to sit on his back, and then carried her off to Crete. Jupiter appears three times: twice disguised as a bull, enticing and abducting Europa, and once as a god, with his traditional symbol, the eagle. In the sixteenth century, pottery with a scene representing an abduction of a young woman could have been presented as a wedding gift, a reminder of the expectation that a woman would submit to her husband's will.

Federico Barocci
Italian, 1528–1612
The Annunciation, c. 1585
etching and engraving
image: 17¹⁄₁₆ × 12 in. (43.3 × 30.5 cm)
The William A. Whitaker Foundation Art
Fund, 2011.22.1

Barocci's print combines the techniques of etching and engraving to reproduce the composition of a painting he made for his patron, the Duke of Urbino. With the needle and burin, Barocci represents an impressive array of visual and tactile effects. Light radiates from above, from Gabriel's head and from Mary's halo, and it glows in the landscape (of Urbino) visible through the window. In addition to the softness of flesh, hair, and drapery, Barocci shows us the textures of the feathers in Gabriel's wings, the delicate fringe at the hem of his gown, the sleeping cat in the corner. The toes of Gabriel's right foot peeking out from the drapery and the cat's paw draped over the cushion at the picture's edge further accentuate the sense of touch.

Giovanni Battista Naldini
Italian, c. 1537–1591
The Presentation in the Temple, 1577
oil on wood panel
16⅞ × 11¾ in. (42.8 × 29.9 cm)
The William A. Whitaker Foundation
Art Fund, 77.41.1

There are so many figures in this scene that it is not immediately evident who the protagonists are or what they are doing, but Naldini did provide clues. In the foreground and background, all the figures lean, point, and gesture toward the bald man (the priest Simeon), the kneeling woman (Mary), and the infant (Jesus) she hands to him. Before Simeon, Mary, and Jesus, the artist leaves enough open space to expose three steps leading up to them.

Naldini emphasizes turning poses, a crowded composition, and oblique angles of sight. The scene's complexity is both a way of underscoring its significance – everyone is excited about what's happening – and a way of linking it to the real space in which viewers would experience it. This painting is a *modello*, a model Naldini showed to his patron for approval. The finished altarpiece was for Santa Maria Novella in Florence, and Naldini's design took into account the angle from which worshippers approached the altar.

Unidentified artist
Italian
Judas and Saint Peter, after Leonardo da Vinci's *Last Supper*, c. 1510–20
colored chalks with later additions in black chalk by another hand
26¼ x 20 in. (66.6 x 50.8 cm)
Ackland Fund, 77.53.1

Scholarly dispute about the authorship and date of this drawing arises in part from its physical condition: its surface is worn, it was reworked at a later date, and the original paper support is concealed on the reverse by a heavy backing paper. It is difficult, therefore, to isolate the chalk marks made by the artist from those made later, or to assess whether the paper is from the sixteenth century or later.

Regardless, the drawing is clear testament to the allure of Leonardo da Vinci's famous *Last Supper* mural. The artist who made the Ackland's drawing explores the emotional power of Peter's reaction to Jesus's remark that one of his disciples would betray him: the tilt of Peter's head, his knit brow creating shadows over his eyes, and his open mouth – suggesting the sound of a gasp. Judas, in contrast to Peter but equally powerful, appears in stark profile and deep shadow.

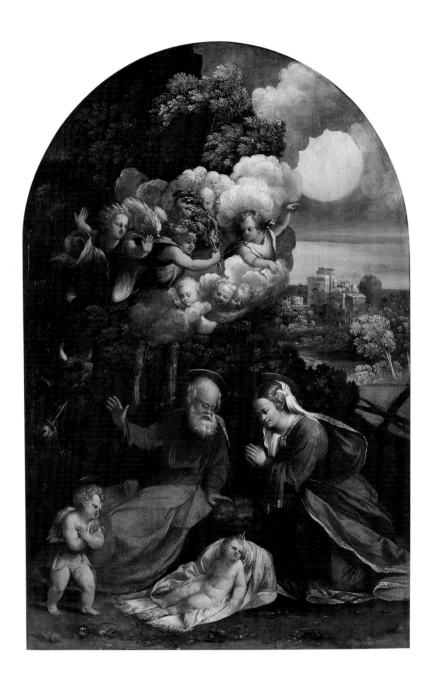

Battista Dossi
Italian, c. 1490–1548
The Holy Family with the Infant Saint John the Baptist, c. 1530
oil on wood panel
23³⁄₁₆ x 15⁵⁄₁₆ in. (58.9 x 38.9 cm)
Ackland Fund, 85.22.1

Battista Dossi and his better-known brother Dosso Dossi worked in the north Italian court city of Ferrara, governed by the d'Este family. Like many artists working in northern Italy in the sixteenth century, the Dossi brothers embraced the painting style practiced so brilliantly by Leonardo da Vinci and Titian. This style emphasized the textures and surfaces of the visible world. Battista depicts a wide variety of tactile surfaces, such as skin, hair, garments, animal fur, vegetation, stone, and water. He also shows us things that can be perceived but not touched, like wind, sun, clouds, angels, halos, and the radiant aura that surrounds Jesus's head. The choice to paint in this manner not only demonstrates Battista's proficiency with this new, fashionable style, but it also presents Jesus and his family in a way that activates the viewer's senses and encourages them to immerse themselves in the scene.

Marcantonio Raimondi
Italian, born c. 1470/1482–1527/1534
Standing Male Nude Seen from Behind,
c. 1500
pen and brown ink
10¹⁵⁄₁₆ × 5¹⁄₁₆ in. (27.8 × 12.8 cm)
The William A. Whitaker Foundation
Art Fund, 82.47.1

A muscular young man stands in a classical contrapposto pose – appearing alert but relaxed, leaning his weight on one leg while the other bends slightly. He looks to the picture's right, wearing a leafy crown and a fluttering cape, holding a bundle of branches and delicately fingering a halberd. His nudity and his attributes suggest that he is an allegorical figure rather than a real person.

Marcantonio is best known as an expert engraver, the printmaker responsible for reproducing paintings by Renaissance luminaries like Raphael so that artists and collectors across Europe had access to high-quality images of the inventions typical of his famous frescoes and oil paintings. Here, Marcantonio seems to apply some of his printmaking techniques to the medium of drawing, most notably in the crosshatched pen marks painstakingly applied to the background to make the figure stand out.

Giulio Romano
Italian, c. 1499–1546
Hercules Strangling Cerberus, 1527–32?
pen and iron gall ink
4½ × 7½ in. (11.4 x 19 cm)
Ackland Fund, 73.2.1

The subject of this drawing is the twelfth labor of the ancient Greek hero Hercules in which he had to capture Cerberus, the three-headed dog who guarded the entrance to the underworld. The triangular composition of the two figures accentuates their forceful struggle and Giulio's pen strokes convey the muscular power of both bodies. With only four dark marks on Hercules's brow, nose, and lips, Giulio indicates the hero's exertion. The three faces of Cerberus receive more attention, growling, gasping, and writhing.

This drawing is a type known as a *primo pensiero*, or first thought, though it is not clear what final product Giulio was planning. It is clear, however, that successive generations of artists valued it as a link to his creative process. In the eighteenth and nineteenth centuries, it was owned by three famous painters: Peter Lely, Benjamin West, and Thomas Lawrence.

Albrecht Dürer
German, 1471–1528
Nemesis, 1501–02
engraving
12½ × 9¹/₁₆ in. (31.8 × 23 cm)
Ackland Fund, 65.18.4

Dürer's virtuosity as a printmaker is striking in this engraving, which fuses fact and fiction into a visually compelling whole. A large female figure soars serenely above a valley landscape. The landscape is the village of Chiusa in the southern Tyrol. The female is a personification of the Greek goddess Nemesis and the Roman goddess Fortuna combined. She holds Nemesis's goblet of reward and bridle of restraint, while balancing on Fortuna's orb of unsteady fortune. Dürer describes real landscape and abstract figure with the same meticulous care.

Large engravings like *Nemesis* took Dürer months to complete. He had a ready market for them, however, among collectors who appreciated his prints as independent works of art. An astute businessman, Dürer used his prints to spread his fame and make his fortune, selling them to wealthy merchants to fund his travels through Europe. *Nemesis* was valued then, as today, for its originality and astonishing technical skill.

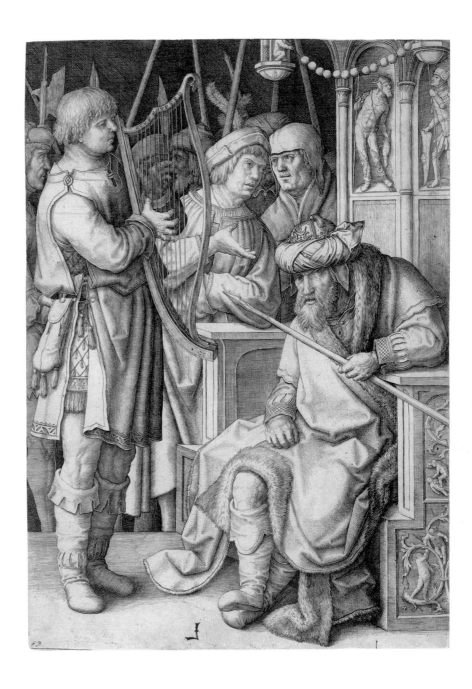

Lucas van Leyden
Netherlandish, c. 1494–1533
David Playing the Harp Before Saul,
c. 1508
engraving
$9^{15}/_{16} \times 7^{3}/_{16}$ in. (25.3 × 18.3 cm)
The William A. Whitaker Foundation
Art Fund, 92.27

David's ability as a warrior, who defeated Goliath with his sling, is familiar and frequently depicted. Less known and rarely represented is David's artistry as a harpist, whose music subdued the evil spirit that plagued King Saul (1 Samuel 18). This engraving dramatizes the tense moment when Saul is still afflicted. Saul's body hunches, his eyes shift, his feet convulse. David's soothing music has yet to heal him.

Lucas was one of the two greatest Northern European printmakers of his time, rivaled only by Dürer. He is particularly recognized for his unorthodox choice of subject matter. In *David Playing the Harp Before Saul*, Lucas not only chose an uncommon subject, but interpreted it in an extraordinary way. He was the first to depict Saul's affliction as an internal conflict, a mental or spiritual disease, rather than the work of a demon as the biblical text suggests.

Unidentified artist
German
**Frontispiece to *Das Buch genannt
der Seuse***, 1482
woodcut
9¹⁵⁄₁₆ × 7³⁄₁₆ in. (25.2 × 18.3 cm)
Burton Emmett Collection, 58.1.497

Heinrich Seuse (or Henry Suso) was a German Dominican monk and mystic, one of the
most popular writers of the fourteenth century. Seuse dedicated himself and his writings
to the divine, which he called Eternal Wisdom. Shortly before his death (1366), Seuse
produced a manuscript collection of his writings called *The Exemplar*, a spiritual guide that
draws on his pious practices and mystical experiences as the self-styled Servant of Eternal
Wisdom. The Ackland's page is the frontispiece of *Das Buch genannt der Seuse* (1482), the
first printed German edition of *The Exemplar*.

The frontispiece shows the Servant of Eternal Wisdom (left) dressed as a Dominican
monk and Eternal Wisdom in the form of a bearded king (right). The banners between them
bear instructive quotations from the Books of Wisdom and Ecclesiasticus, as for example:
"My son, if you wish for divine wisdom, maintain the virtue of justice" (second banner).

Unidentified artist
South German or Bohemian
**The Madonna and Child with the
Symbols of the Four Evangelists**,
1460–75
woodcut with hand coloring
sheet: 8½ × 5¾ in. (21.6 × 14.6 cm)
The William A. Whitaker Foundation
Art Fund, 2012.34

This single-sheet woodcut belongs among the very early European examples of printing pictures on paper. This practice emerged around 1400, enabling widespread distribution of compositions, most often for private devotion. This sheet presents a solemn and monumental image of the Virgin and Child, with the attributes of the "woman clothed with the sun and standing on the moon" of the Apocalypse. Occupying the corners are symbols of the four Evangelists, Angel (Matthew), Ox (Luke), Lion (Mark), and Eagle (John). The now faded colors would have enhanced the vivid immediacy of the image, though they were applied in the slapdash manner common to many such productions of the period, with, for example, green covering what iconographically should have been white lily blossoms in Mary's hand.

attributed to Sesshu Toyo
Japanese, 1420–1506
Birds and Flowers, 1485–1500
six-panel screen: ink and color on paper
screen: 63½ × 145½ in. (161.3 × 369.6 cm)
Ackland Fund, 98.9

A meditation on the seasons, this six-paneled folded screen illustrating birds and flowers formerly had a pendant, now presumed lost, that depicted the flora and fauna of spring and summer. Featuring vivid accents of red and green, the largely monochrome landscape once represented the passage of autumn (lost panel on the right) to winter at the left. It is attributed to Sesshu Toyo, a monk-painter celebrated for his original interpretations of Chinese models, which he studied while traveling in Ming China from 1467 to 1469. With finely rendered brushwork, the artist portrays numerous birds, including pairs of geese and small birds perched on branches, as well as peonies and a red cockscomb at the center. The bold outlines of the pine-tree roots and rocks contrast with the delicate execution of rippled water, misty mountains, and golden clouds, producing a dramatic, yet peaceful composition.

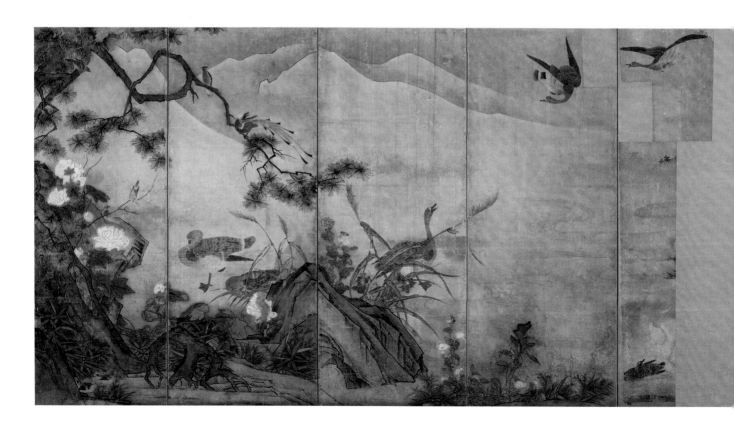

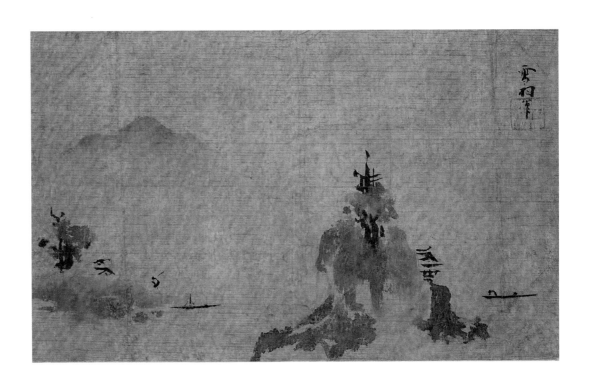

Sesson Shukei
Japanese, c. 1504–1589
Splashed-Ink Landscape, 16th century
hanging scroll: ink on paper
image: 11⅛ × 18⅝ (28.3 × 47.3 cm);
overall: 48¾ × 25¾ in. (123.8 × 65.4 cm)
Ackland Fund, 88.21

The artist of this landscape, devoid of outlines and contours, has flung the ink directly from the brush or hand, a technique referred to as "splashed ink." Wet and dry ink overlap to produce tones ranging from saturated black to spare grays. Both the execution and resulting image evoke immediacy and unmediated expression, as though form has emerged organically and spontaneously from fluid matter. Sustained looking offers a perplexing abstraction of a thatched-roof hut, mountains amid mist, boats, trees, and dense swaths of unrestrained ink vaguely suggesting precipitous cliffs. The spiritual practice of meditation in Zen Buddhist theories of enlightenment taught in fifteenth- and sixteenth-century Japan mirrors this painting's reliance on intuition over careful depiction. The signature of the famed sixteenth-century artist, the monk-painter Sesson Shukei, appears in bold strokes in the top right corner, paralleling the image's swiftly delivered vertical and horizontal lines.

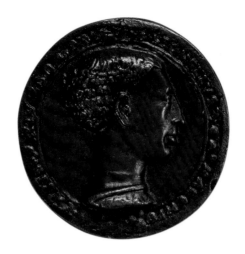

Amadeo da Milano
Italian, 1437–1482
**Portrait Medal of Leonello d'Este,
Duke of Ferrara**, c. 1440
bronze
diameter: 1⅞ in. (4.8 cm)
Gift of the Ackland Associates, 78.10.1

Two-sided commemorative portrait medals such as this one were a form developed by the famous medalist Pisanello (c. 1395– c. 1455), drawing inspiration from Roman coins that combined ruler portraits with allegorical scenes on the reverse. Leonello d'Este (1407–1450) was one of the first Renaissance rulers to embrace the form wholeheartedly, commissioning nine from Pisanello and additional medals from other artists, including this example by Amadeo da Milano. Given the inscription, this medal must date from just before 1441, when Leonello, although illegitimate, succeeded his father as Marquis of Ferrara. He gained a reputation as a highly cultivated prince, presiding over a court of intense intellectual activity. The reverse of this medal depicts Leda and the Swan. As Leda gave birth to four illegitimate children who achieved fame and renown, the emblem may have functioned as a subtle justification of Leonello's claim to succession.

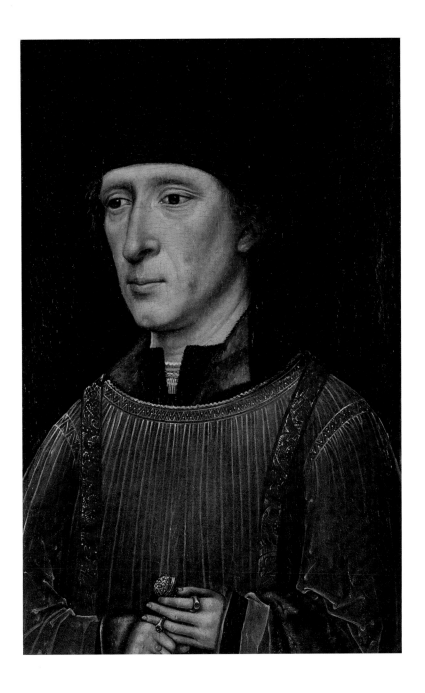

Master of the Legend of Saint Catherine
Netherlandish, active 1470–1500
Hugo De Groot, 1480s?
oil on panel
13⅛ × 8½ in. (33.3 × 21.6 cm)
Ackland Fund, 73.36.1

On the back of the wood panel on which this portrait appears, a Latin inscription identifies the man as Hugo, a priest from the city of Delft who was called "the great" (de Groot). The inscription, added after his death, also notes the date of his death: 8 May 1509. Hugo appears solemn and reverential, clasping a rosary bead in his left hand. The artist devoted the most space and attention to Hugo's face, describing the distinctive contours of his cheekbones, chin, nose, and mouth and suggesting the reflection of light on Hugo's skin, eyes, and hair. The meticulous detail with which the artist painted the head calls attention to the difference in proportion between the head and the hands, which are quite small. In fact, this striking feature helped scholars identify the artist: he is known as the Master of the Legend of Saint Catherine, whose figures typically have small hands.

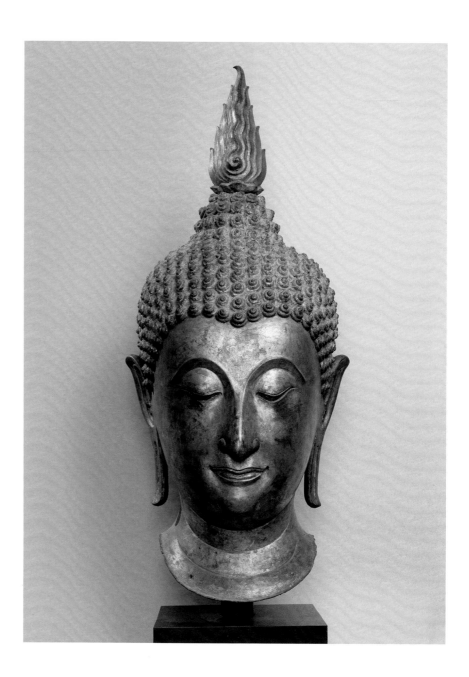

Unidentified artist
Thai, Ayutthaya period
Head of Buddha, 15th century
gilt bronze
38¼ × 16⅜ × 17⅝ in.
(97.2 × 41.6 × 44.8 cm)
Ackland Fund, 91.2

The style of this fifteenth-century bronze head is named for an earlier period in Thai history when its distinctive elements crystallized. Characteristics of this Sukhothai style include the symmetrical facial features – downcast eyes, stylized mouth, perfectly arched eyebrows, and prominent nose. The rules of design and proportion instructed sculptors to make the Buddha's nose resemble a parrot's beak. Also typical are the tightly curled locks of hair. According to some accounts, when the Buddha cut off his hair to take up an ascetic lifestyle, curls appeared all over his head.

Around the lower edge of the neck are holes with which the head was attached to a body, most likely in a seated position. The entire image, then, showed the Buddha meditating. The *ushnisha*, or protuberance on top of his head, symbolizes his expanded capacity for understanding after he attained enlightenment. The flame finial atop the ushnisha is another element typical of Sukhothai sculpture, and further emphasizes the Buddha's enlightenment.

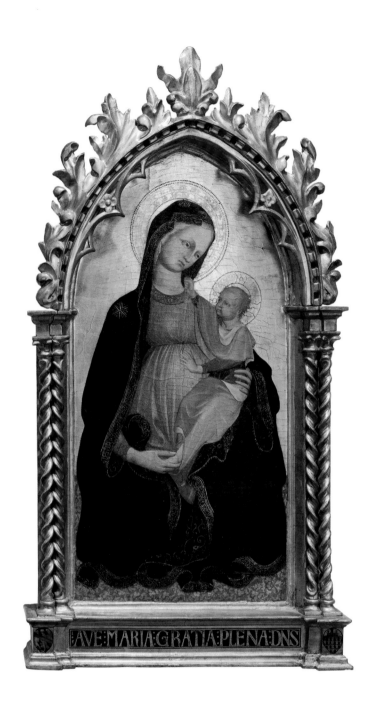

Master of 1419
Italian, active c. 1419–1430
The Virgin and Child, c. 1415
tempera and gold on wood panel
overall: 45¾ × 25 × 4½ in. (116.2 × 63.5 × 10.8 cm)
Ackland Fund, 80.34.1

A great deal of this painting appears stylized and abstract. The proportions of Mary's and Jesus's bodies emphasize long torsos and small heads. Mary is actually kneeling, but her voluminous mantle and its billowing hem make it difficult to perceive that posture. As a result, her torso seems even longer than it actually is. The painting's glittering gold background and the ornate halos create an immaterial, rather than an earthly setting for the two figures. These choices, however, are fitting. They emphasize the spiritual rather than the mortal aspect of the relationship between this mother and child. There is one detail that reminds viewers that these two were nevertheless a loving family. With his chubby right hand, Jesus reaches up to tug playfully at Mary's transparent veil. Judging by the subject and the size of this painting, it was likely made for a domestic setting for an Italian family to use in private devotion.

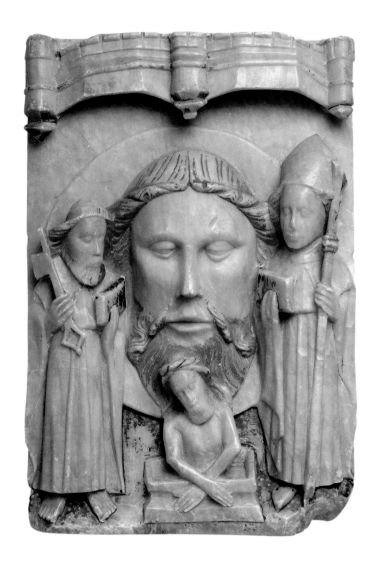

Unidentified artist
British, Nottingham
**The Head of Saint John the Baptist on
a Charger Flanked by Saint Peter and
Probably Saint Thomas of Canterbury**,
1420–50
alabaster with traces of paint
12⅝ × 8¾ × 1¾ in. (32.1 × 22.3 × 4.4 cm)
Ackland Fund, purchased in honor of
John M. Schnorrenberg, Professor of Art
(1959–1976), 76.44.1

Carved alabaster relief sculptures were made in London, Nottingham, and York in England. Reliefs depicting the head of Saint John the Baptist were a specialty of sculptors from Nottingham, so it is likely that the Ackland's comes from there. Traces of red, black, white, and gold paint remain in places such as the figures' beards, the edges of their clothing, and the crenellated canopy above them. In its original state, the Ackland's sculpture was probably set inside a painted wooden case with wings that could close over the image.

Surrounding the martyred Saint John's severed head are three figures: at left is Saint Peter, recognizable by the keys of heaven in his hands; at right is a bishop, who is most likely the English martyr Thomas à Becket; below is Jesus emerging from the tomb, a representation also known as "the man of sorrows."

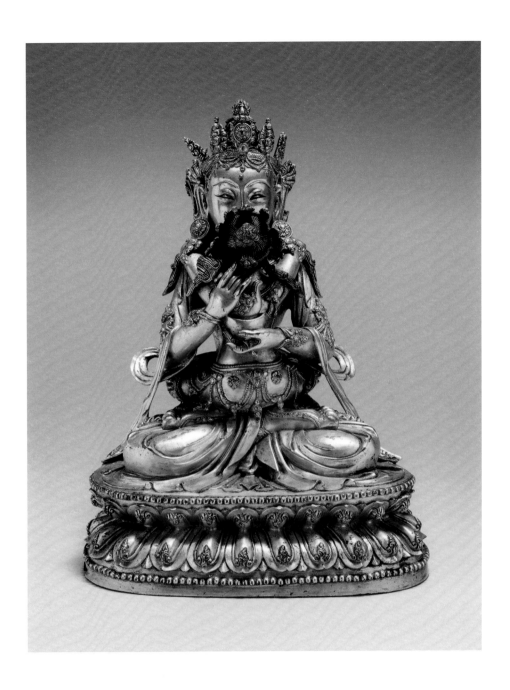

Unidentified artist
Sino-Tibetan
White Chakrasamvara and Vajravarahi,
15th century
gilt bronze
11¼ × 8¹¹⁄₁₆ × 6⅜ in. (28.6 × 22.1 × 16.2 cm)
The William A. Whitaker Foundation
Art Fund, 2004.9

Two lavishly adorned figures sit in full embrace. The male deity, sitting cross-legged on an elaborate lotus throne, is Chakrasamvara. Enveloped within his arms is the female goddess Vajravarahi, who emanates wisdom. Together, their union symbolizes the enjoining of compassion and wisdom. In Tibetan Buddhism, meditating upon such physical intimacy brings about perfect enlightenment.

Exquisitely sculpted accoutrements ornament their bodies. Flowing fabric drapes gracefully from Chakrasamvara's forearms and thighs. Bejeweled multitiered crowns sit regally on their heads, while both wear sumptuous clothing from which chains of precious materials hang. Even their throne bears lotus petals flowering into swirling tips, in both upward and downward directions. Not all their exquisite details are mere embellishments: Vajravarahi holds a bell, a symbol of wisdom, in her hands and Chakrasamvara grasps a diamond-shaped thunderbolt trident representing powerful clarity.

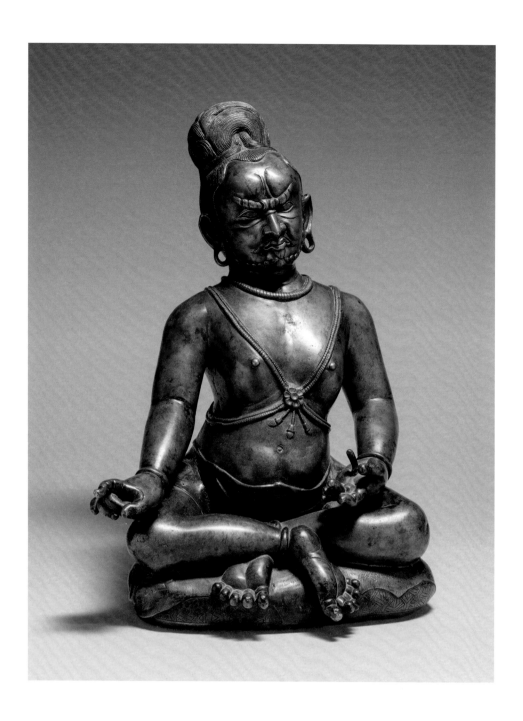

Unidentified artist
Tibetan
Dhamarupa, c. 15th century
bronze
14¼ × 10⅜ × 8⅝ in. (36.2 × 26.4 × 21.9 cm)
Gift of Ruth and Sherman Lee, 2004.1.1

Dhamarupa was a man who lived in India during the ninth and tenth centuries. In Tibetan Buddhism, he is known as one of the great adepts, men and women who have reached the highest degree of enlightenment. In body type, pose, and attributes, this bronze figure is typical of images of Dhamarupa. He sits in meditation, with the exposed torso and scanty garb with which Tibetan artists portrayed Indian ascetics. He originally held a skull cup in his right hand and a drum in his left – the name Dhamarupa means "the drummer." An inscription in Tibetan on the cushion just under his left leg confirms his identity. Sculptures such as this one appeared on altars in Buddhist temples and were used as aids in meditation.

Unidentified artist
Thai, Ayutthaya period
**Roof Decoration: A Sea Monster
(Makara)**, 15th century
terracotta
16⁵⁄₁₆ × 7¹¹⁄₁₆ × 11 in. (41.5 × 19.6 × 27.9 cm)
Ackland Fund, 87.50

The makara is a sea monster with both fish- and dragon-like features. Its image is widely used as an architectural decoration throughout South and Southeast Asia. This Thai example probably decorated the roof of a temple or other public building. It was once even fiercer-looking, as it has probably lost a tall crest on its forehead, a rising elephant-like trunk on its nose, and a beard beneath its chin. The significance of the spherical object in its mouth is not clear. Being water-monsters, makaras may have served to ward off fire.

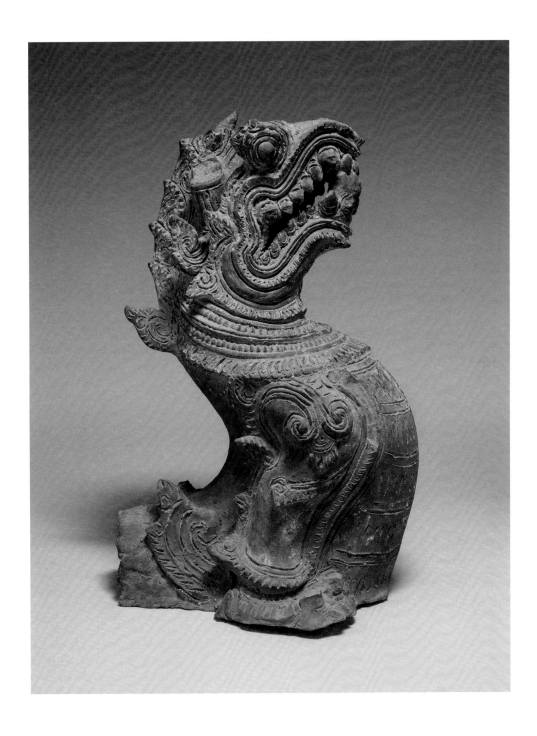

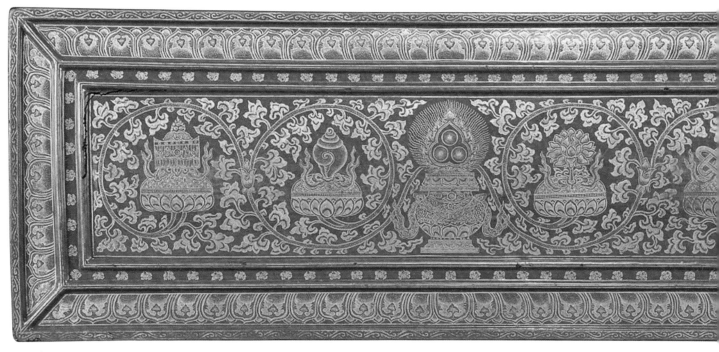

2005.17b

Unidentified artist
Chinese, Ming dynasty
Pair of Sutra Covers, c. 1410
qianjin lacquer
each: 28½ × 10½ × 1¼ in.
(72.4 × 26.7 × 3.2 cm)
The William A. Whitaker Foundation
Art Fund, 2005.17ab

These sutra covers were designed to enclose the pages of a religious text, written on horizontal sheets, unbound. The exterior sides of the covers are lavishly decorated with rich red lacquer and engraved with shimmering gold imagery. Featured throughout are Buddhist symbols, including at the center of each side the Three Precious Jewels, a motif representing the Buddha, his teachings, and the Buddhist community. On the inside of the top cover, the table of contents for this volume is engraved in gold, in both Chinese and Tibetan.

In 1410, the Chinese emperor Yongle commissioned a 108-volume compendium of sacred texts, the covers for which were produced in an imperial workshop with materials and techniques commonly used in the early Ming dynasty (1368–1644). The emperor gave these texts as gifts to religious leaders in Tibet.

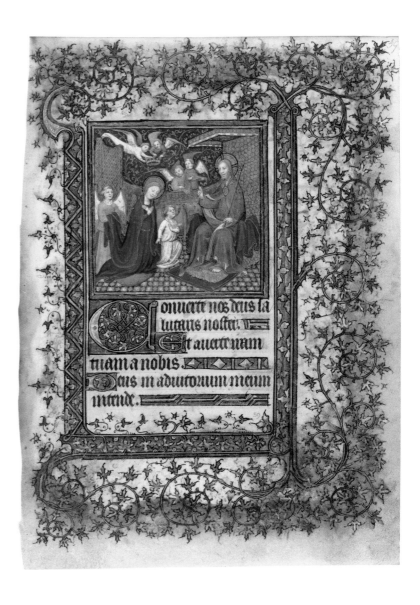

attributed to the Mazarine Master
French, active c. 1400–1420
The Coronation of the Virgin (Illustration for the Penitential Psalms), 1408
ink, tempera, and brushed gold on vellum
7 × 5¼ in. (17.8 × 13.3 cm)
Ackland Fund, 69.7.1

Early fifteenth-century Paris was a major center for the production of lavish illuminated manuscripts, prompted by the patronage of Jean, duc de Berry (1340–1416). This sheet is one of twenty-eight miniatures from a richly illustrated book of hours, a popular devotional text containing prayers and meditations focused on the Virgin Mary. This image depicts the non-biblical Coronation of the Virgin, as God the Father blesses the kneeling Mary, who receives a crown from the attendant angels. The Latin text cites verses from Psalms 84 and 69, with line-fillers in geometric patterns or jewel shapes. Elaborate curling foliage sprouts from the decorative border. The artist of this leaf is now identified as the Mazarine Master (named for the French library that holds a book attributed to him), one of the leading figures in manuscript illumination of the period.

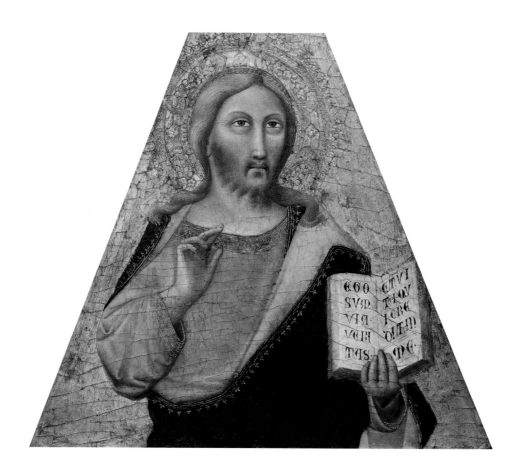

Francesco Traini
Italian, active 1321–45
Christ Blessing, c. 1335
tempera and gold on wood panel
13⁷⁄₁₆ × 15 ¾ in. (34.2 × 40 cm)
The William A. Whitaker Foundation
Art Fund, 61.12.1

Francesco Traini made this tempera and gold painting on a wood panel, covered with cloth, then prepared with gesso to make a smooth surface for the paint. Tempera paint – pigments mixed with egg yolk – dries quickly, so, rather than blending colors on the painting's surface, artists carefully laid parallel strokes of varying colors next to each other. This technique is visible in the strands of Jesus's hair, for example, and on his right cheekbone. The borders of Jesus's clothing are decorated with gold, and the painting's background and Jesus's halo are made with gold leaf. The artist used a compass to delineate the halo. The mark made by the compass point is visible at the center of Jesus's lower right eyelid. The shape of the painting suggests that it was originally part of a large, multi-panel altarpiece, probably placed at the top of the central panel.

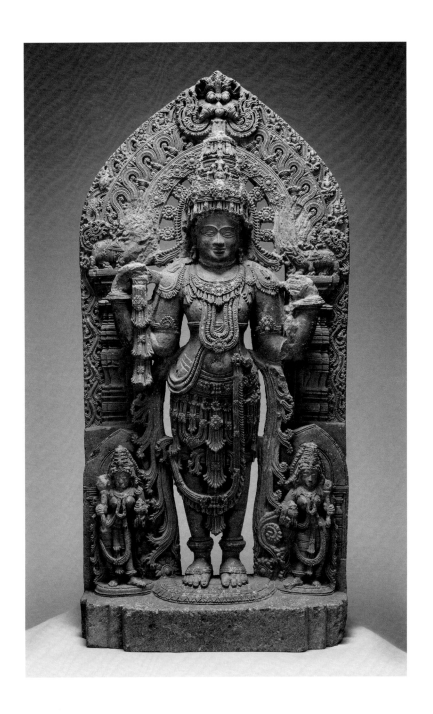

Unidentified artist
Indian, Mysore, Hoyshala period
Vishnu, 14th century
chloritic schist
39½ × 29⅝ × 3¹¹⁄₁₆ in.
(100.4 × 75.3 × 9.3 cm)
Gift of Harry Lenart, 71.22.1

The Hindu god Vishnu's frontal stance, bent arms, and direct forward gaze reinforce the sculpture's symmetrical composition. He is adorned with and surrounded by an intricately carved array of figures and ornaments. At his feet stand two female attendants in mirrored poses and at his shoulders two crocodile-like creatures face each other. At the outer edges of the pointed arch behind his head and tall crown, viewers who look closely will see tiny representations of Vishnu's ten incarnations.

Specialists and careful observers may notice that the figure's face does not quite match the texture and style of the rest of the sculpture. In fact, the original head was destroyed — perhaps by the ruler of a rival state? Afterward, the head was recut and has possibly been restored with clay, accounting for the discrepancy in appearance.

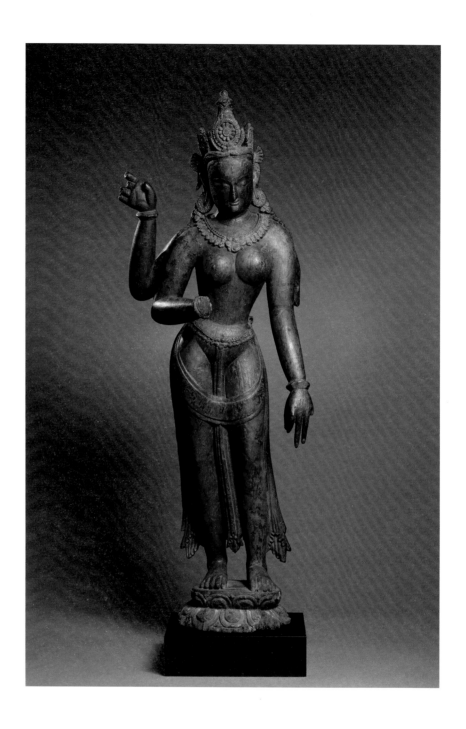

Unidentified artist
Nepalese
**Bhrikuti, the Female Companion of
the White Avalokiteshvara, Lord of
Compassion**, 14th century
wood with polychrome
41⁹⁄₁₆ × 15³⁄₈ × 9¹³⁄₁₆ in.
(105.5 × 39 × 25 cm)
Gift of the Tyche Foundation, 2010.9

This sinuous and elegant figure would have originally formed part of a group in a Buddhist temple, standing to the left of the bodhisattva of compassion, the White Avalokiteshvara. Tara, another female companion, would have stood to the right. Two further, smaller figures may have flanked this trio. The White Avalokiteshvara (literally, "The Lord Who Looks Down from on High") is considered one of the guardian deities of the Kathmandu Valley of the Himalayan kingdom of Nepal and numerous temples have been dedicated to him. This figure of Bhrikuti would have had a fourth arm; two of her missing hands would have held symbols (probably a coral and a rosary), while the two other hands formed gestures, including the gesture of reassurance. The sculpture was originally covered with gesso and painted; some of this decoration has survived in remarkably good condition.

Look Close
Think Far
Art at the
Ackland

Unidentified artist
Japanese, Kamakura period
Bishamonten, c. 1300
painted wood with additions in metal
and crystal
26⁹⁄₁₆ × 10 ½ × 8 ½ in.
(67.5 × 26.7 × 21.6 cm)
The William A. Whitaker Foundation
Art Fund, Purchased in memory of
Chancellor Michael K. Hooker, 2000.7

Fierce guardian figures appear in many varieties of Buddhism. Four guardian kings protect
the four quarters of the cosmos, and their images, trampling on vanquished demons,
may be stationed at the four corners of an altar. Bishamonten is the Japanese name for
the king of the north, the chief of the four guardians. He is also considered the protector
of warriors and the state. With a ferocious frown, swirling draperies, and a flaming halo
around his head, this image of Bishamonten has a lively, fiery appearance. Though standing
motionless, the figure seems to contain reserves of stored energy. Bishamonten carries
a stupa, a symbol of the Buddhist faith, in his left hand and in his right hand he originally
carried a lance (which is now missing).

Unidentified artist
Chinese, Yuan dynasty
Covered Box with Mouse, c. 1300
porcelaneous stoneware with celadon
glaze
height: 3¹¹⁄₁₆ in. (9.3 cm); diameter:
4⁵⁄₁₆ in. (11 cm)
Ackland Fund, 91.140ab

This covered box was probably made in the early years of the Yuan dynasty (1279–1368), when Kublai Khan united all of China under Mongol rule. Khan chose to establish the Yuan imperial kiln at the Jingdezhen porcelain center, which long had been famous for its bluish-white (*yingqing*) wares. Yingqing vessels, with their subtle blue undertones, were the precursors to the coveted blue and white wares of the Ming dynasty (1368–1644). They were made from kaolin clay combined with petuntse, a variety of feldspar, and covered with a translucent blue glaze. The mouse on top of this box may refer to the first of the twelve animal signs of the Chinese zodiac, the mouse or rat.

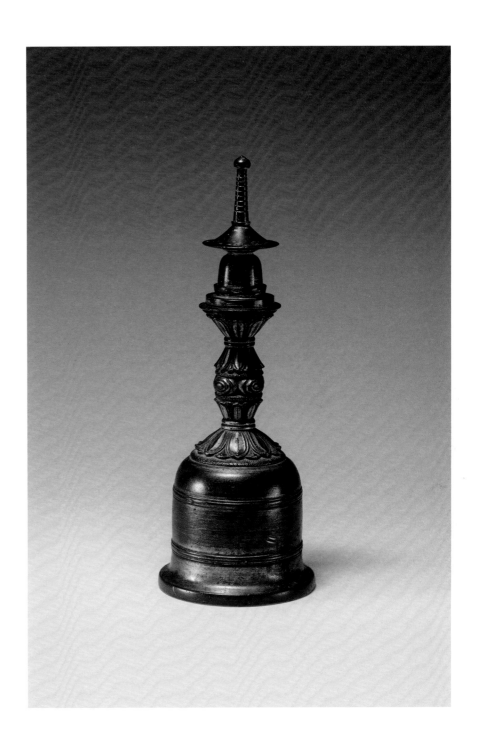

Unidentified artist
Japanese, Kamakura period
Pagoda-Handled Bell, 1185–1333
gilt bronze
6⅝ × 2⁷⁄₁₆ × 2⁷⁄₁₆ in. (16.8 × 6.2 × 6.2 cm)
The William A. Whitaker Foundation
Art Fund, 2014.17

This vigorously shaped bell would have played a role in ceremonies of Esoteric Buddhism in Japan. Although it does still have its clapper, it would not actually have been sounded. Rather, it would have been placed at the center of the ritual altar (symbolizing Buddha Dainichi, the most important deity of the Esoteric Buddhist pantheon), as part of a symbolic set of five bells. The pagoda shape of the upper handle alludes to the architectural form of the stupa, a structure for preserving relics of the Buddha. Appropriately, this part can be removed, revealing a space for relics. The form of the bell also incorporates designs representing bound lotus leaves.

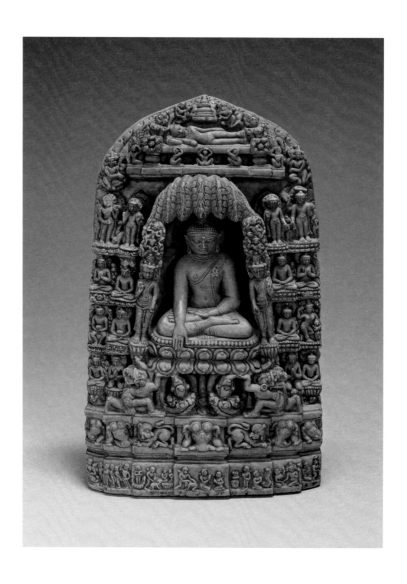

Unidentified artist
possibly Burmese
Buddha Calling the Earth to Witness,
c. 13th century
stone (yellow pyrophyllite)
6 ½ × 4⅛ × 1⅝ in. (16.5 × 10.4 × 4.1 cm)
Ackland Fund, 97.14.1

Finely carved Buddhist imagery covers the entire front surface of this small sculpture, and a small cavity at its base contains small scrolls – presumably Buddhist texts. Buddha is the largest figure on the sculpture, represented at the moment of his enlightenment. The gesture he makes with his right hand is associated with this moment and is known as Calling the Earth to Witness. The tiny narrative scenes surrounding him depict important events from his life. This combination of stories reinforced Buddhist teaching and history, making the sculpture useful as a compact, portable, devotional object. Religious pilgrims could carry objects like this on their travels, and merchants too could transport them easily. Many objects like this have been found in Burma, but they may have been made in India.

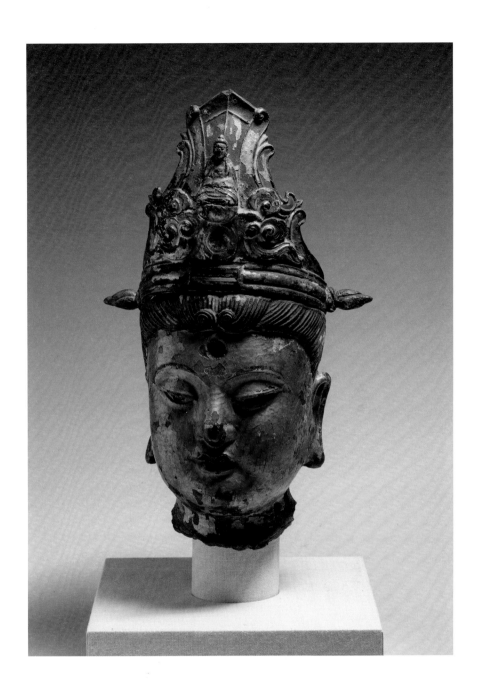

Unidentified artist
Head of Guanyin, Bodhisattva of Mercy,
12th to 15th century
gilded and painted cast iron
15¾ × 10 × 9⅜ in. (40 × 25.4 × 23.8 cm)
Ackland Fund, 88.29

Guanyin is one of the most frequently depicted deities in Chinese Buddhist art. In this sculpture, the identification derives from the image of the Amitabha Buddha on the impressive high crown, seated among the swirling clouds of a heavenly abode. In one particular sect of Buddhism, Guanyin was believed to escort the souls of the deceased to Amitabha's western paradise for peaceful rebirth. The slightly smiling, full lips and downcast eyes elegantly suggest the compassion closely associated with this Bodhisattva. With its original gilding and color paint unusually well preserved, this cast-iron head would have been part of a life-size standing or seated figure, probably displayed in a sumptuous temple setting suggestive of the perfected universe. A now missing jewel in the circular depression on Guanyin's forehead would have represented the auspicious "third eye" that offered insight into the divine world.

Unidentified artist
Chinese, Song dynasty
Tea Bowl, 12th or 13th century
Jian stoneware with "hare's fur" glaze
height: 2 in. (5.1 cm); diameter: 5½ in. (13.9 cm)
Gift of F. Eunice and Herbert F. Shatzman, 2003.28.17

Made in the mountainous Jian kilns located in present-day Fujian province in southwest China, this conical bowl is made of high-fired dark-colored clay, visible in its carved, unglazed foot. The mysterious brown streaks in the black glaze resemble rabbit or hare's fur. The streaks, becoming matte toward the outer edges of the bowl, are the result of a high concentration of iron oxide in a thickly applied glaze. During firing, the iron oxide changes its crystalline structure, freeing oxygen molecules that bubble upward, attaching to metallic iron that gets deposited on the surface in distinctive patterns. The Chinese came to appreciate the visual effect of frothy white tea contained in these dark vessels. Japanese Buddhist priests brought such bowls back to Japan, where they became widely admired and imitated. In Japan, these bowls were called "tenmoku," after Tianmu, the Chinese name for a mountain where the Japanese priests practiced meditation.

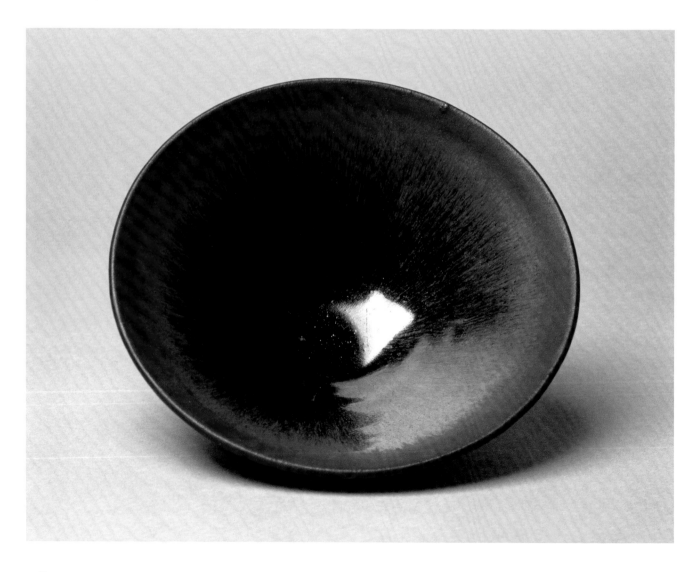

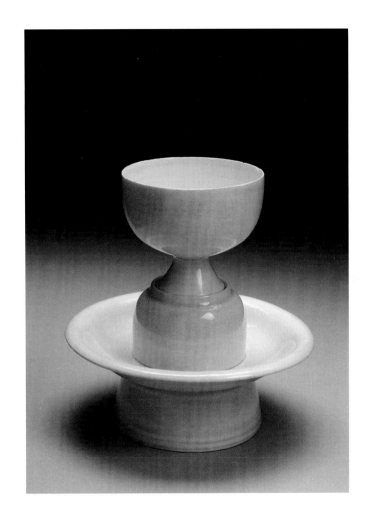

Unidentified artist
Chinese, Southern Song dynasty
Stem Cup and Stand, late 12th to late
13th century
porcelain with bluish-white glaze
cup: 2¼ × 2⅞ × 2⅞ in. (5.7 × 7.3 × 7.3 cm)
stand: 2⅞ × 5 × 5 in. (7.3 × 12.7 × 12.7 cm)
Gift of Smith Freeman and Austin
Scarlett, 2009.26.2

Cups with matching stands were used for drinking tea, often in social gatherings known for composing poetry, painting, and writing calligraphy. They were made in metal, lacquer, and high-fired ceramics, such as this elegant set made by porcelain artists at the Jingdezhen kilns. This harmonious vessel, combining strength and delicacy, has been crafted from individual parts thrown on a wheel, shaved, and luted together. The glaze's subtle color variations range from white with blue tint to colorless.

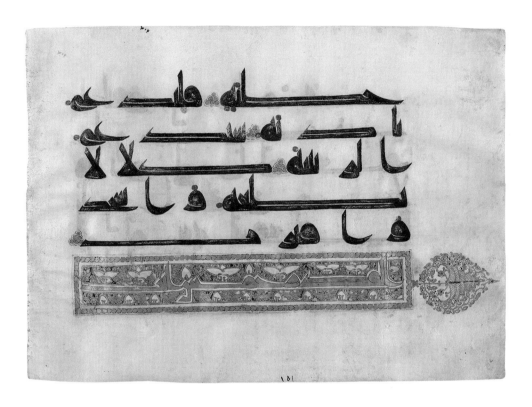

Unidentified artist
North African or Near Eastern
**A Qur'an Leaf in Kufic Script with Surah
Heading**, 9th to 10th century
ink and gold on vellum
sheet: 9 × 12⅞ in. (22.9 × 32.7 cm)
The William A. Whitaker Foundation
Art Fund, 2019.46

This leaf is from one of the earliest Qur'ans produced in the Islamic world, probably in North Africa. On a horizontal piece of vellum is the beautifully simple, horizontal Kufic script of ninth- to tenth-century Arabic. Black ink was applied with a reed pen by a well-trained and confident, but now unknown, calligrapher.

In stark contrast to the sparely written text that glides across the page in five lines with vocalization markings in red and pyramids of six gold dots outlined in black at the end of verses, a luxurious thick band near the bottom of this page is composed of elaborate illuminated decoration in burnished gold, indicating the end of the *surah* or chapter. Likely produced by an artist other than the calligrapher, the band contains gold writing in reserve that terminates in an elaborate, lacy, split palmette. Its outline shaped by vines, its interior is defined by sets of parallel lines in different directions.

Unidentified artist
Iranian, Hamadan
**Architectural Fragment with Arabesque
and Animal Decorations**, c. 1100–1350
sandstone
26¼ × 32⅞ × 5¹¹⁄₁₆ in.
(66.7 × 83.5 × 14.4 cm)
Gift of Mr. and Mrs. Osborne Hauge,
98.11ab

For most of the time this work has been in the Ackland's collection, it has been called a balustrade. Recent research, however, indicates that the term "balustrade" is not appropriate; such forms rarely if ever occur in the history of Iranian architecture, making "architectural fragment" a better choice until a more specific function can be determined.

 The sculpture is extensively carved. On both sides, on the part that projects upward, a lion stands in profile. On one side, the rest of the panel is decorated with lions attacking other animals; the other side's panel has principally geometric and floral motifs, with two animals at one lower corner. A similar architectural fragment in the Metropolitan Museum of Art in New York bears an inscription that dates it to the years 1303–04. The Ackland's sculpture may come from that same period.

98.11b

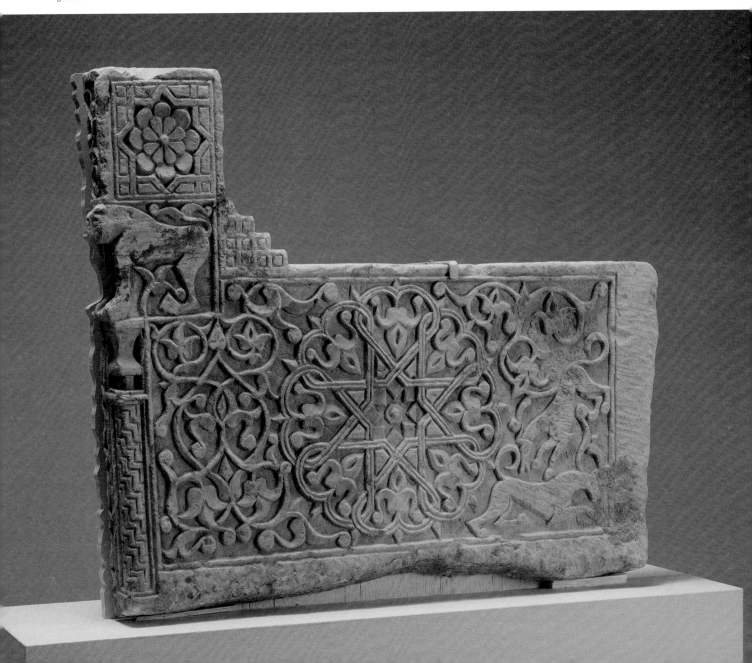

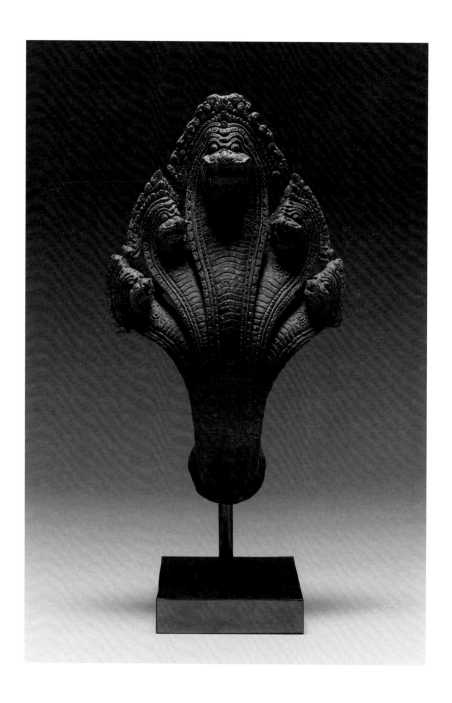

Unidentified artist
Cambodian
Naga Finial, c. 1000–1200
bronze
11¾ × 5⅜ × 5⅛ in. (29.8 × 13.6 × 13 cm)
Ackland Fund, 89.16

Five fearsome heads, crested and with fangs exposed, rise from a single shaft. This is a naga, a serpent divinity of the underworld usually represented by multiple cobra hoods. In Buddhist and Hindu traditions, nagas can, when properly worshipped, guarantee fertility, abundance, and good health. If they are slighted, they can withdraw their gift of rain and spread famine and disease. The motif appears in a wide variety of contexts, including as monumental adornments on temples. This small example in bronze, from the Khmer period of Cambodian art, was probably designed to adorn a piece of furniture. Circular lotus flowers, the opening and closing of which symbolize the rising and setting sun, adorn the naga's body and reflect its regenerative powers.

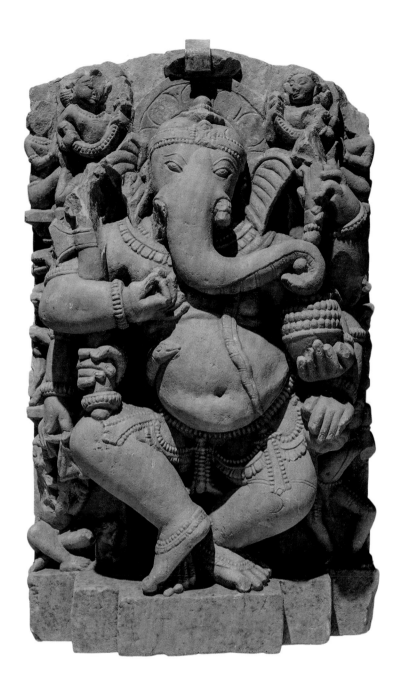

Unidentified artist
Indian, possibly Madhya Pradesh
Dancing Ganesha, mid-10th to
mid-11th century
sandstone
23 1/16 × 13 11/16 × 7 1/4 in.
(58.5 × 34.8 × 18.4 cm)
Gift of Clara T. and Gilbert J. Yager
in honor of Dr. Charles Morrow and
his wife, Mary Morrow, for their many
contributions to the University and to
The Ackland Art Museum during his term
as Provost, 85.2.1

This sculpture is likely from the exterior of a temple in northern India, placed at the point where devotees begin circumambulating the temple. Ganesha is known as the Lord of Auspicious Beginnings. When praying, worshippers offer him thanks and praise first.

Ganesha's elephant head is his most recognizable feature. By one account, his mother Parvati created him to guard her while she bathed. When her husband Shiva returned home, he saw Ganesha emerging from Parvati's doorway and, not knowing he was her son, decapitated him. He then vowed to give Ganesha the first head he saw, which was that of an elephant. A lover of music, Ganesha is often shown dancing with his leaning torso and jauntily placed leg. He is also a lover of sweets; from the heaping bowl in one of his left hands he has already taken two – one in a right hand and one in his trunk.

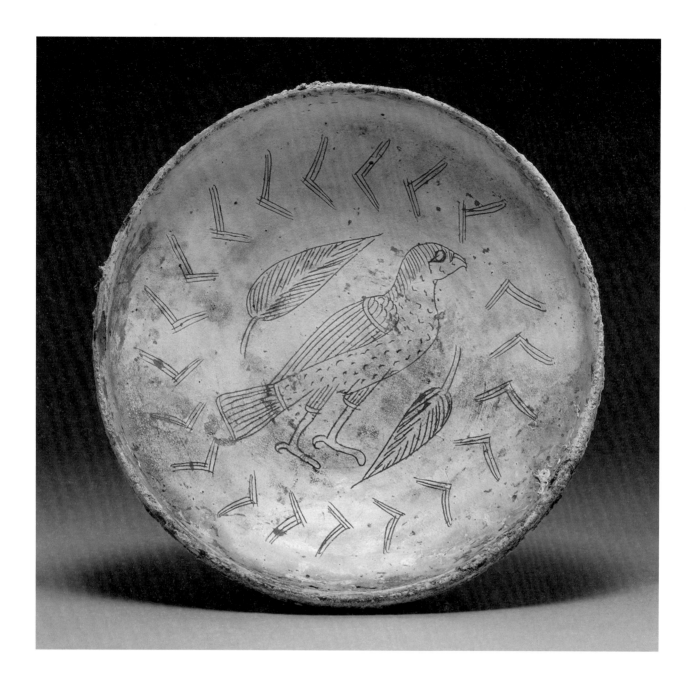

Unidentified artist
Byzantine
Sgraffito Bowl with Raptor, 12th century
earthenware and glaze
height: 3 in. (7.6 cm); diameter:
10¹⁄₁₆ in. (25.6 cm)
Gift of Charles Millard, 2018.46.3

The bird's hooked beak indicates that it is a raptor, maybe a falcon. Such birds were trained by European elites of the period for hunting, and depicting one on a bowl may have been a reference to the owner's power and status. This lively image of the bird is complemented by the leaves and chevrons, implicitly rotating in opposite directions. Such sgraffito or "scratched" decoration is created by applying a contrasting color of slip (clay thinned with water) to the surface of a vessel, and then engraving a design into the surface, revealing the color of the clay beneath. The interior surface of this bowl has been covered with a transparent glaze. The losses of glaze and slip, along with the remnants of incrustations, indicate that this bowl probably comes from a shipwreck.

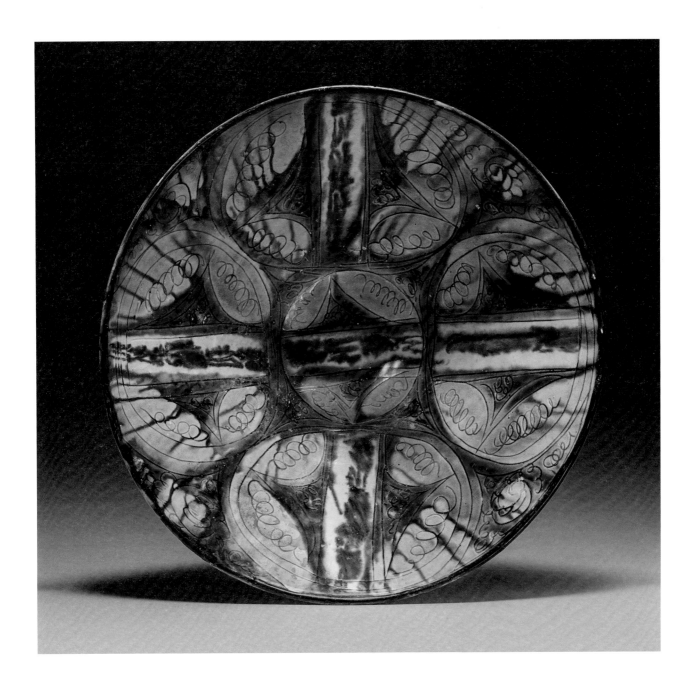

Unidentified artist
Uzbekistani, 10th to 11th century
Splashware Bowl with Sgraffito
Decoration, late 10th century
glazed earthenware with incised
decoration and colored glazes of yellow,
green, and manganese on a cream slip
ground
height: 4½ in. (11.5 cm); diameter: 14 in.
(35.5 cm)
Gift of the Estate of William S. Shipp,
by exchange, 2020.12

This large conical bowl with a vigorous incised design and vibrant decoration of glazes
bleeding into one another is a striking example of a type of tenth-century Central Asian
ceramic that connects to the splashware technique popular in Tang dynasty (618–907)
China. Although the direction of influence, probably along the Silk Road, has not been
definitively determined, both traditions share the love for loosely applied yellow, green, and
brown glazes so effectively deployed here. The expansive energy of the design is reinforced
by the rivulets of green glaze running from the center toward the rim, indicating the bowl
was fired upside down in the kiln. The springlike spirals of the incised lines are largely
focused on the yellow parts of the roundels.

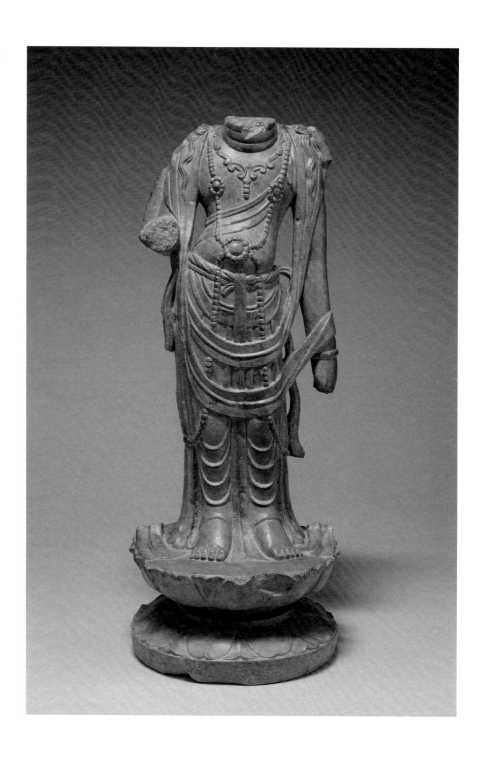

Unidentified artist
Chinese, Tang dynasty
Bodhisattva, 7th century
limestone
17⁹⁄₁₆ × 7¼ × 6¾ in. (44.6 × 18.4 × 17.1 cm)
The William A. Whitaker Foundation
Art Fund, 97.17

This sinuous and sensuous figure, lavishly attired in flowing scarves, graceful drapery, and strands of beads and jewels, represents a bodhisattva, according to Buddhist doctrine one who has stopped one step short of Buddha-hood in order to help others reach enlightenment. The style of the sculpture reflects influence from Indian traditions, which helped to move Chinese sculpture away from its earlier columnar stiffness. Probably damaged in the very extensive persecution of Buddhism and its monasteries in China during the mid-840s, the figure was likely making the "Abhaya mudra," a pose of reassurance with the right hand raised, palm facing outward.

Unidentified artist
Mexican, Veracruz
Smiling Figure ("Sonriente"), 600–800
terracotta with traces of polychrome
15¾ × 10 × 4½ in. (40 × 25.4 × 11.4 cm)
Gift of Gordon and Copey Hanes in honor
of Dr. Joseph C. Sloane, 90.95

This engaging work was probably excavated in Las Remojadas in Veracruz, on the south-central Gulf Coast of Mexico, produced by a culture that seems to have flourished between about 100 BCE and 800 CE. Many such hollow, mostly mold-made terracotta figurines have been found in burial sites and rubbish heaps. Childlike figures with triangular heads and ecstatic, open-mouthed expressions have become known as "sonrientes" (smiling faces), an uncharacteristic genre in pre-Columbian art, which tends not to reflect emotions. Their function remains unclear, though they may have represented performers or spiritual entities attending the dead. In this case, the figure holds gourd rattles in both hands, an unusual circumstance which may be explained by scientific evidence that the right arm is a later restoration. Many, such as this one, wear headdresses, pectoral bands, and loincloths decorated with geometric designs. Traces of color may indicate body paint, tattoos, and textile decoration.

Unidentified artist
Mexican, Colima
Dog Effigy Vessel, 200 BCE–300 CE
polished earthenware with red paint
8½ × 6¾ × 11¾ in. (21.6 × 17.1 × 29.9 cm)
Ackland Fund, 65.15.1

Colima, a state in modern northwest Mexico, is also the designation for a culture that flourished there some two thousand years ago. Especially numerous in Colima tombs are lively and charming figures of a breed of hairless dog, probably intended to serve as guides for the dead on their journey. Additionally, their plump bellies reflect the fact that such dogs were raised for food among the living. In a further allusion to nourishment, the corncob in this example's mouth may refer to a local myth about a dog helping the first humans to find food. These highly burnished redware figures with incised decoration always have an opening, here the tail-as-spout, to aid in the firing process. The popularity of these figures with collectors led to a proliferation of inauthentic pieces. This example may be a pastiche, made up of fragments of genuine objects, or indeed a modern imitation.

Unidentified artist
Chinese, probably Eastern Jin dynasty
Chicken-Headed Ewer, 4th century
Deqing-glazed stoneware
height: 8⅞ in. (22.5 cm); diameter: 7¼ in.
(18.4 cm)
Gift of F. Eunice and Herbert F.
Shatzman, 2003.28.1

This vessel was used for holding and pouring liquids like water and wine. It could be used to dilute wine for drinking, or to pour liquids in ceremonies. The imagery of a bird's head likely derives from bronze ewers of the Zhou period, which are often decorated with bird imagery. This might be related to the ancient Han Chinese practice of sealing a pledge by drinking wine mixed with rooster's blood. Over time, the chicken-head imagery on these ewers was replaced with more exotic birds like pheasants and phoenixes. This ewer comes from the Deqing kilns, located in modern Zhejiang province. Potters working at the Deqing kilns were the earliest to develop brown and black glazed pottery.

Unidentified artist
Roman
Fragment of a Horse and Rider (from a Lion Hunt Sarcophagus), c. 270–80
marble
31¹⁵⁄₁₆ × 14¹⁵⁄₁₆ × 3³⁄₁₆ in.
(81.1 × 38 × 8.1 cm)
The William A. Whitaker Foundation
Art Fund, 77.66.1

Although we see only the horse's head, chest, and foreleg in this marble fragment, they convey enough movement and emotion to imply that they are part of an action-packed scene. The dramatic turning pose of the horse, wide eyes, open mouth, and the wrinkles in the neck accentuate the sense of motion. With drill holes in the eye, nostrils, and curls of the mane, the sculptor created pockets of shadow that, when they contrast with the projecting areas and the polished sheen of the marble, heighten the dramatic effect.

Scholars have identified other fragments from the same sarcophagus in the collection of the Munich Glyptothek, including the Ackland horse's rider, whose eagle-headed weapon we see at the left edge. The horse and rider are part of a lion hunt, a subject ancient Romans considered fitting for sarcophagi, where it suggested the deceased's bravery, whether facing ferocious animals or the afterlife.

Unidentified artist
Roman
Lion-Footed Cauldron Leg, c. 1–100
bronze
20⁹⁄₁₆ × 6⅝ × 7⅞ in. (52.2 × 16.9 × 20 cm)
The William A. Whitaker Foundation
Art Fund, 80.33.1

This leg would have been one of three supporting an ancient Roman cauldron. The others are now in a private collection and in the Walters Art Museum in Baltimore. The curved structure of the leg makes it difficult to see its interior, but it is likely that its many components were cast separately, then put together. At the top of the leg, where it once joined the bowl of the cauldron, there is a tall palmette motif. Beneath the palmette, the upper portion of the leg curves outward. Just below the next joint, a rope binds an acanthus leaf to the leg so that folds of the leaf fan out slightly above and below the rope. The sculptor carefully represented the tendons, hair, claws, and toe pads of the foot. With three ornate legs like this one, the cauldron was surely an impressive household object.

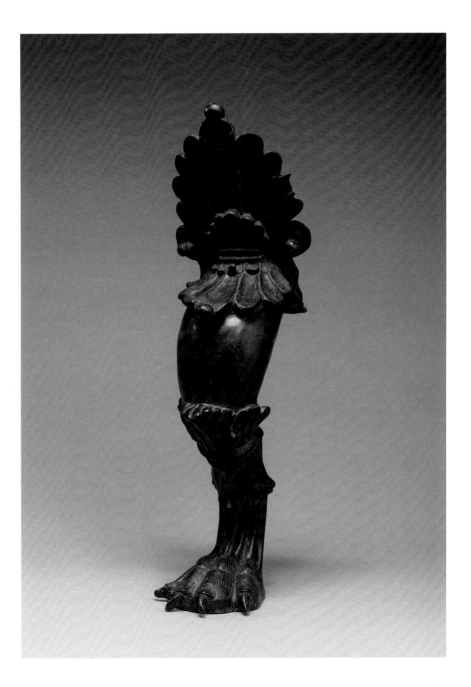

Unidentified artist
Roman, Imperial Period
**Jupiter, on a Denarius from the Reign
of Septimius Severus**, 210
silver
diameter: $^{13}/_{16}$ in. (2 cm)
Gift of William H. Race, 2012.37.2.62

This denarius, a standard silver coin from ancient Rome, was made late in the reign of
Emperor Septimius Severus (reigned 193–211), who is depicted on the front (or obverse).
The reverse, shown here, represents the god Jupiter, naked but for a cloak over his shoulder.
Appropriately, he holds attributes referring to his power and authority as ruler of the gods: a
thunderbolt in his right hand and a scepter in his left. Two smaller figures, perhaps children,
stand at his feet. This symbolic scene glorifies the emperor, whose abbreviated titles
encircle the image, ranging from PM (*Pontifex Maximus* or "Greatest Priest") to PP (*Pater
Patriae*, or "Father of the Country"). Septimius Severus was known for creating a larger,
better-paid army and improving the administration of the empire. These expenses led him
to debase the currency, reducing the silver content of coins such as this one.

Unidentified artist
Roman
Torso of Dionysos or Apollo, 2nd century
marble
20 × 12½ × 5½ in. (50.8 × 31.8 × 14 cm)
Ackland Fund, 62.14.1

It is a straightforward matter to determine that this figure represents a god. In Greek and
Roman antiquity, the only figures represented nude were athletes, soldiers, and gods.
Athletes and warriors did not wear their hair long and loose (note the curly locks falling on
the figure's shoulders), and both would have been represented with a more powerful body
type. Male gods, however, could be shown in varied body types – youthful through mature,
lithe, fleshy, muscular.

It is more difficult to determine which god this figure depicts. The most likely choices
are Dionysos and Apollo, both of whom were often shown as young men in relaxed poses,
with unbound long hair. Since the head is missing, however, it is impossible to see whether
the god wore Apollo's crown of laurel leaves or Dionysos's grape leaves.

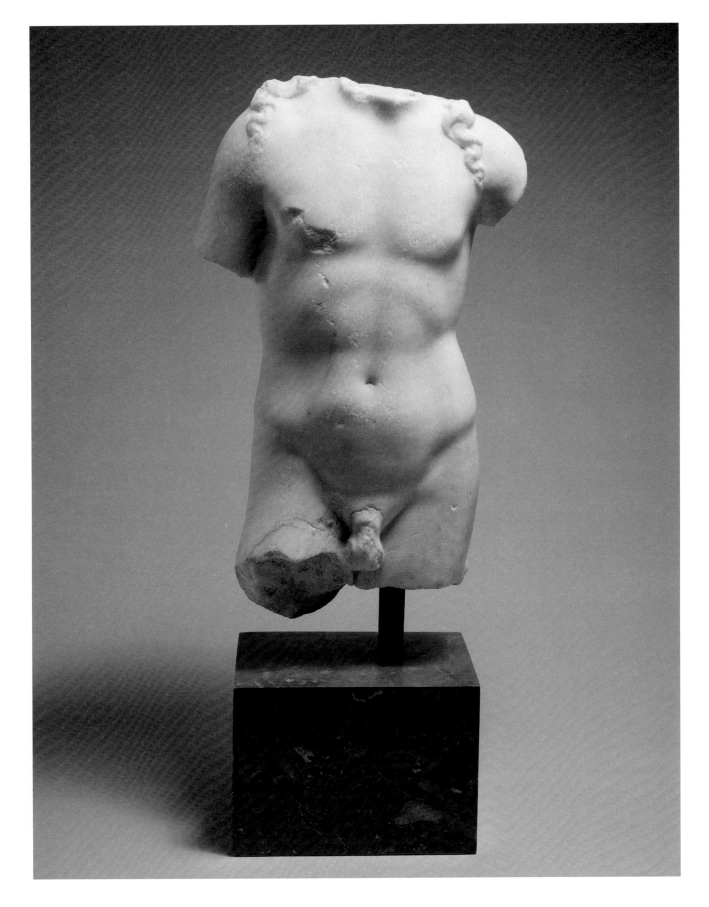

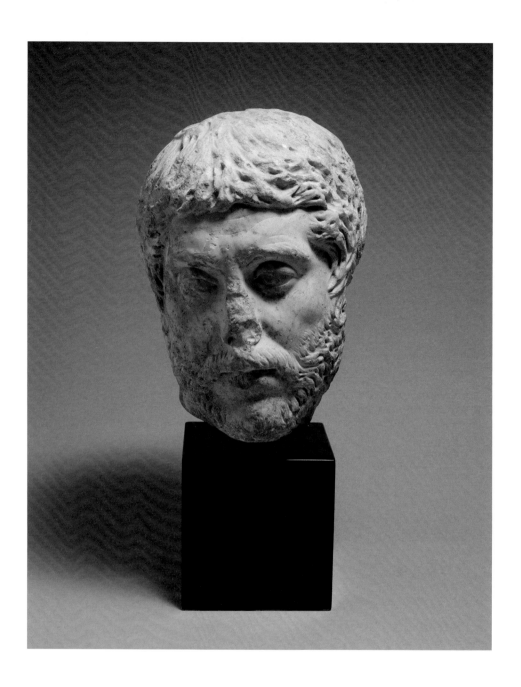

Unidentified artist
Roman
Head of a Roman Notable, c. 200
(recarved c. 250)
marble
12⁵⁄₁₆ × 8¹¹⁄₁₆ × 9¹¹⁄₁₆ in.
(31.3 × 22.1 × 24.6 cm)
Ackland Fund, 69.9.1

This marble head has much to say about style in ancient Roman art. The hairstyle, beard, and the expressive, heavy-lidded eyes resemble the appearance of portraits of the emperor Marcus Aurelius (ruled 161–80), but the Ackland head does not represent Marcus Aurelius. Instead, it imitates his portraits, attempting by doing so to evoke the admirable qualities of his character and his reign. This head was most likely carved around 200, in one of two imperial periods in which portraits imitated those of earlier reigns, making it difficult to use style to distinguish between the two periods. Fifty or sixty years later, the head was modified. It seems that a later patron also wanted to imitate the appearance of earlier portrait styles, but wanted an updated hairstyle. At some point later in the Roman Imperial period, the portrait finally looked outdated and – as cement encrustations in the hair indicate – it was used as construction fill.

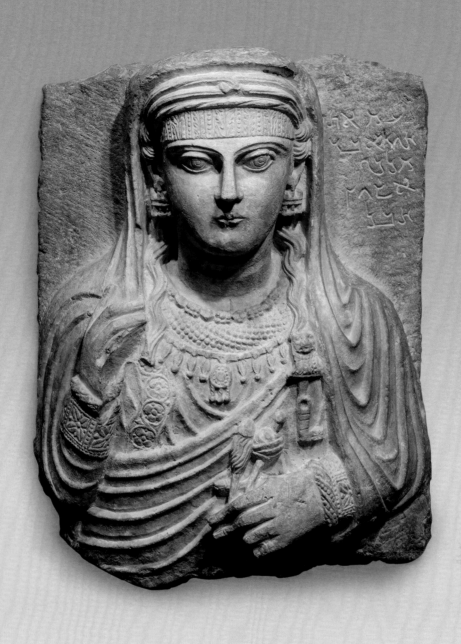

Unidentified artist
Syrian, Roman
Funeral Relief of No'om(?), Wife of Haira, Son of Maliku, c. 170
sandstone
19¾ × 15⅝ × 7⅜ in. (50.2 × 39.7 × 18.7 cm)
The William A. Whitaker Foundation
Art Fund, 79.29.1

In its original setting, this sculpture sealed the end of a tomb in Tadmor (also known by its Greco-Roman name, Palmyra) in Syria. The Aramaic inscription at the sculpture's upper right specifies the woman's name, marital status, and her husband's lineage. As is the case with other funerary relief sculptures from Palmyra, her clothing and the objects she holds confirm her position as a married woman of means. The spindle and distaff in her left hand and the key attached to her garments indicate her domestic responsibilities. The gesture of touching her mantle is one associated with brides. And her earrings, bracelets, necklaces, and the ornate patterns on her dress attest to both her social station and the artist's skill in carving sandstone.

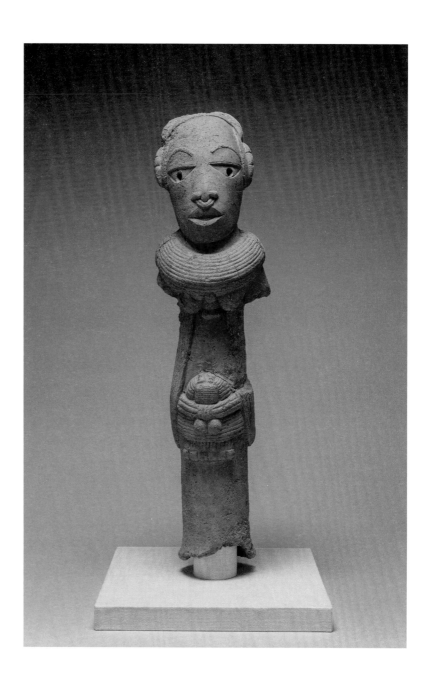

Unidentified artist
Nigerian, Nok culture
Female Figure, c. 100 BCE–200 CE
terracotta
19½ × 5 × 5 in. (49.5 × 12.7 × 12.7 cm)
Ackland Fund, 97.15

Little is known about the Nok culture, named for a village in Nigeria where terracotta sculptures such as this were first discovered in the 1920s. All the figurative pieces share stylistic traits, including relatively large heads, triangular eyes with perforated pupils, and elaborate adornment. The function of these expressive works remains unclear, though some may have been intended as portraits of individuals. The rough surface of the clay would probably have originally been covered by a smooth slip.

Given the appealingly sophisticated refinement of Nok sculptures, fakes and pastiches quickly emerged. The authenticity of the Ackland's work has been underscored by a thermoluminescence test verifying that it was last subjected to firing during the Iron Age, and by a computed tomography scan showing that it is not a composite of mismatched ancient fragments. Although missing its arms, this female figure retains an imposing presence, with its columnar form and dignified expression.

Unidentified artist
Roman
Statuette of Juno, c. 150–200
bronze
6¼ × 4⁹⁄₁₆ × 1¼ in. (15.9 × 11.6 × 3.2 cm)
The William A. Whitaker Foundation
Art Fund, 87.4

The small size of this sculpture suggests that it may have belonged in a Roman household, perhaps as part of a shrine in a wealthy home. It once had inlaid eyes that enlivened the appearance of the small face, and earrings attached to the small holes visible in the ears, while each hand once held an object. The dress and mantle that the figure wears are characteristic of Roman matrons' clothing. The mantle covers the head, as it would when a woman performed a religious ritual, in which case the outstretched hand might hold an offering. The prominent diadem or crown suggest that it is a deity, most likely Juno, who was associated with marriage and motherhood.

The figure's body is made of hollow-cast bronze. Since the arms extend so far outward from the body, they were probably made separately and then attached.

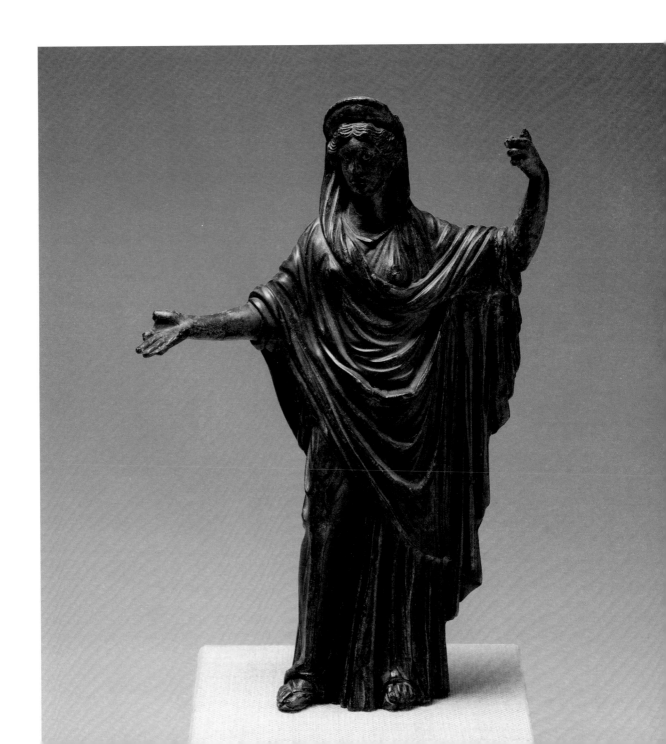

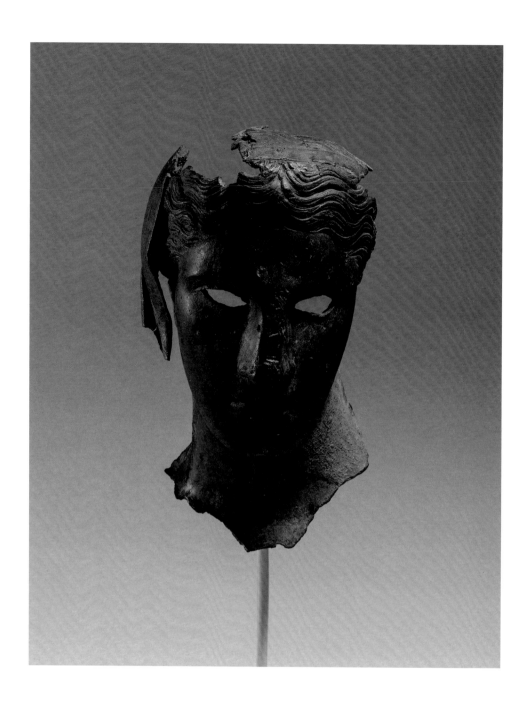

Unidentified artist
Greek
Head of a Woman, 2nd century BCE
bronze
11⅝ × 6 1/16 × 8 in. (28.7 × 15.4 × 20.3 cm)
Ackland Fund, 67.24.1

Because this head is fragmentary, it has been difficult to determine whom it represents. It has been interpreted as an image of the Greek goddess of agriculture, Demeter, and as a portrait of a mortal woman – perhaps a mourner or a queen. Sculptures of goddesses usually had idealized facial features, and the nose and mouth of this bronze do not conform to those seen in other second-century deities. Whereas goddesses might be represented over-life-size, the Ackland's sculpture is not, making it possible that it is a mortal. Attached to the head is a piece of what was a mantle, pulled up over the head as an ancient Greek woman in mourning might do. Across the woman's wavy hair there is a band, interrupted in two places where bronze is missing. If this band is a diadem, as some scholars believe, the woman represented would be a queen.

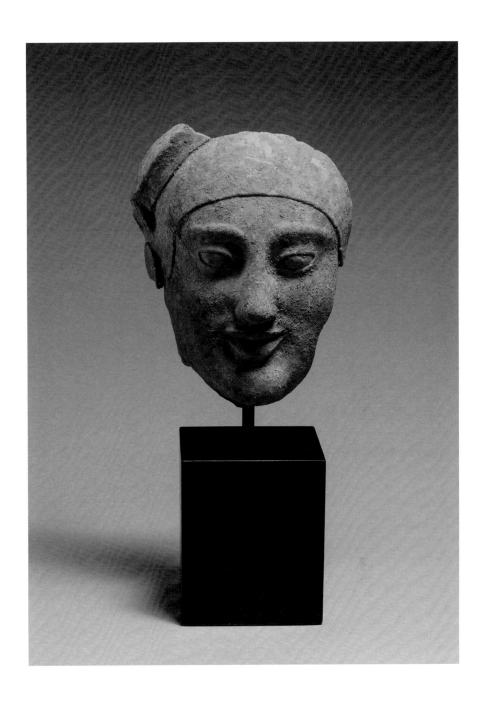

Unidentified artist
Greek, East Greek, Archaic period
Head of a Goddess, c. 500 BCE
terracotta
8½ × 6¹³⁄₁₆ × 5³⁄₁₆ in. (21.6 × 17.3 × 13.2 cm)
Gift of the Tyche Foundation, 2010.8

This finely crafted, mold-made female figure with a veil covering her crown and hair would have been part of a votive plaque, presented as a gift to a deity or perhaps buried with the deceased. Holes would have facilitated hanging on the walls of a religious precinct. Such plaques would have been brightly painted, and faint traces of color remain on the veil (red) and on the earring (blue). The face's stylized, almond-shaped, slightly tilted eyes, as well as the set of her bow-shaped lips, are hallmarks of the Late Archaic style of ancient Greek sculpture. While a definitive identification of the figure is not possible, Demeter, the ancient Greek deity of the harvest and agriculture, has been suggested, based on the reputed find-site of Knidos, a Greek city on the west coast of Asia Minor and home to an important cult of that deity.

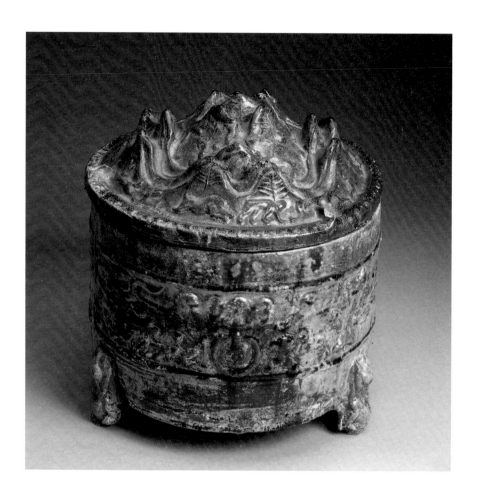

Unidentified artist
Chinese, Han dynasty
Hill Jar, c. 206 BCE–220 CE
red earthenware with green lead-based
glaze
jar: 2½ × 7¾ × 7¾ in. (6.4 × 19.7 × 19.7 cm)
base: 5⅝ × 7¾ × 7¾ in. (14.3 × 19.7 × 19.7 cm)
Gift of Smith Freeman and Austin Scarlett,
2009.26.14

Cylindrical earthenware jars with conical lids are common finds in Han dynasty tombs.
The green glaze has in areas corroded to a grayish silver. The shape of the body imitates
archaic bronze ring-handled containers for warming wine, while the unperforated lid
evokes incense burners in the shape of mountains. The molded decoration on such vessels
evokes a Taoist paradise, an otherworldly, immortal realm that was the hoped-for goal of
the deceased. Three auspicious and protective bears support the jar. In the central band,
the figurative imagery shows an array of wild beasts and mythological animals, which also
appear with crawling humans and stylized trees in the misty mountain landscape above.

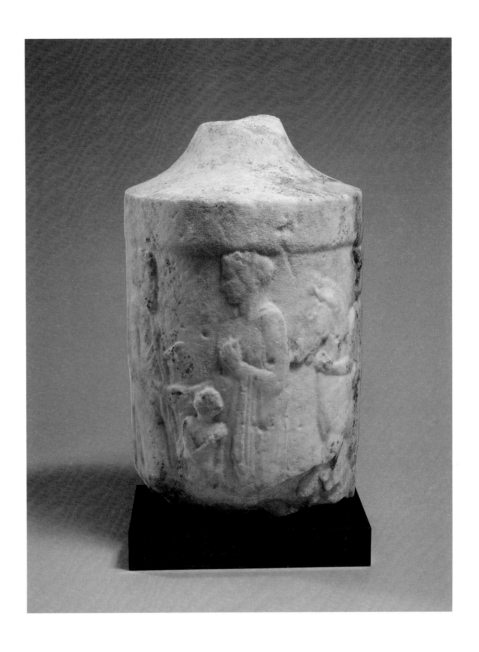

Unidentified artist
Greek, Attic
Fragment of a Funeral Urn (Lekythos)
with Leave-Taking Scene, c. 420–410 BCE
marble
15⁷⁄₁₆ × 9¹⁵⁄₁₆ × 4¾ in. (39.2 × 25.3 × 12.1 cm)
Ackland Fund, 76.24.1

The carving on this funerary vessel depicts what is probably a family group. A bearded older man stands at the left, a father who has died. A woman and boy face him, perhaps his daughter and grandson. Beside them are a horse and another bearded man, younger than the deceased and likely the woman's husband.

The father and daughter look soberly at each other and clasp hands (a gesture associated with parting in ancient Greek art), suggesting a connection that endures beyond death. The child tilts his head to look at his grandfather, leaning slightly against his mother in an understated yet poignant expression of their closeness.

This sculpture was made after a period when, due to war and disease, proper burial practices were sometimes suspended. When they were resumed, many people devoted renewed attention to their family burial plots, often commissioning objects like this one to mark the boundaries of those family plots.

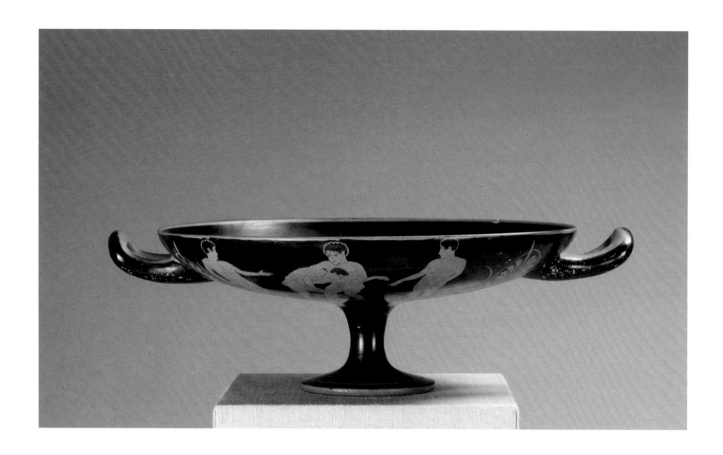

Workshop of the Codrus Painter
Greek, Attic, active c. 450–420 BCE
Cup (Kylix), with Athletes, c. 430 BCE
red-figured terracotta
$3^{15}/_{16} \times 8^{7}/_{8} \times 11$ in. (10 × 22.5 × 27.9 cm)
Ackland Fund, 66.27

Several details in the paintings on this cup associate it with the style of an artist known as the Codrus Painter. The Codrus Painter often depicted sturdy athletic figures and faces seen in three-quarter view. Lines painted in the figures' ears, elbows, and wrists are also typical of his style. He composed the scenes on the cup's sides and in its center with the Classical period's graceful balance. The profile figure about to practice the long jump on one side and the pair of wrestlers on the other (shown here) are flanked by two standing men who frame the scene and point us toward the action. Inside the cup, the long archer is centered within a circular border, with the same amount of empty space above his head as there is below his feet. A cup with handles on the sides and a shallow interior is known as a kylix, a cup for drinking wine.

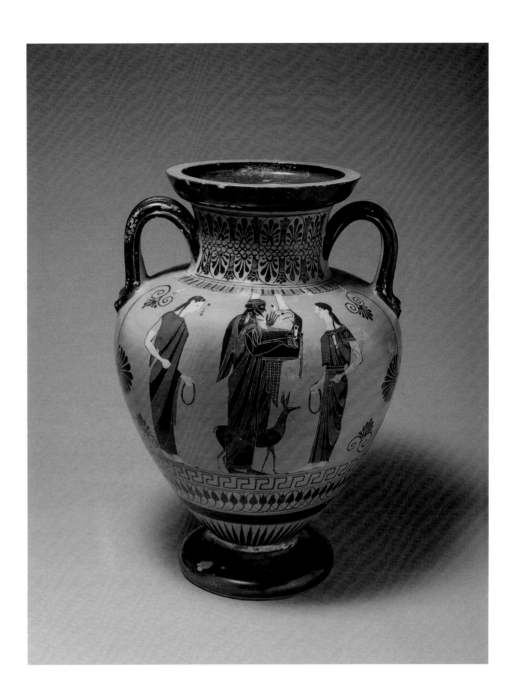

attributed to the Bucci Painter
Greek, Attic, 6th century BCE
**Neck Amphora, with Apollo, Leto,
and Artemis, and a Departure Scene**,
c. 540–530 BCE
terracotta, black-figure ware
height: 15¹⁵⁄₁₆ in. (40.5 cm); diameter:
11⁷⁄₁₆ in. (29.1 cm)
Ackland Fund, 88.15

Although this amphora had an everyday purpose – storing wine, oil, or grains – it was also
a beautiful and treasured object. The entire exterior is decorated with black, red, and white
paint. Around the neck and the base are ornate patterns. On the broadest area of the vase,
or its "belly," are two figural scenes. On one side, the god Apollo holds a lyre, one of his
common attributes, and is flanked by his mother and sister, Leto and Artemis. The deer at
Apollo's feet, looking at Artemis, is one of her common attributes. The amphora's other side
shows a warrior bidding farewell to his wife as he and his companions depart for battle.
The lavish decoration is one sign of the value that the ancient Greek owners placed on this
object. Another is the presence of twenty small holes in the vase's surface, indicators of
ancient repairs – the vase was too precious to discard when it broke.

Unidentified artist
Iranian, Nihavand region
Painted Jar, c. 2200–1800 BCE
terracotta
height: 12¹¹⁄₁₆ in. (32.3 cm); diameter:
14³⁄₁₆ in. (36 cm)
Gift of Osborne and Gratia B. Hauge in
honor of Dr. and Mrs. Sherman E. Lee,
91.20

The majority of this jar's decoration is painted in lines: the combination of straight and undulating lines that form the lower and upper portions of the painting, the diagonal strokes organized in shapes that resemble hourglasses, and the curved contours that indicate the heads, necks, and feathers of waterbirds. Within this complex linear pattern, the artist who painted it also managed to evoke a sense of the momentary. Two of the birds seem to have just dived down below the water's surface, revealing only their tail feathers.

The jar's decoration, its shape, and the texture and color of the clay associate it with a group of similar storage vessels, all made on pottery wheels, from a region in western Iran.

Unidentified artist
Egyptian, New Kingdom, Nineteenth
Dynasty
Stele of Prince Ankh-Nef-Nebu,
c. 1350–1100 BCE
limestone with some polychrome paint
12 × 8 × 3 in. (30.5 × 20.3 × 7.6 cm)
Ackland Fund, 62.19.1

The upper three-quarters of this limestone stele are decorated with a scene of a prince, Ankh-Nef-Nebu, presenting gifts to three deities. Hieroglyphics identify each of the figures, as well as the name of the prince's mother. The deities are Isis, Horus, and Min. The lower quarter, now without decoration, once had three additional registers of carving that may have been erased to prepare the stele for another use. At the left and right edges, the boundaries between registers and a few elements of the incised forms are still visible.

All of the carving is in very shallow relief. Originally, the forms were painted, which would have more clearly distinguished each figure, object, and hieroglyph. Traces of paint are still visible, for example in the red color on Isis's headdress or in the blue in the incised stars near the stele's curved upper edge.

Unidentified artist
Sudanese, Classic Kerma phase
Tulip Beaker, c. 1650–1550 BCE
clay with red and black slip
height: 4⅝ in. (11.8 cm); diameter: 6³⁄₁₆ in.
(15.7 cm)
Ackland Fund, 62.19.6

Kerma was the capital of the ancient Sudanese kingdom of the same name, located in Upper Nubia (modern southern Egypt and northern Sudan). It is famous for its extremely fine handmade ceramics, particularly the thin-walled and elegantly shaped vessels of the so-called Classic period, such as this one, characterized by a distinctive black top and highly polished reddish-brown body, which is divided by an irregular and almost iridescent gray band. The bell shape has led to the designation "tulip beaker." Many vessels like this have been found in the massive royal and subsidiary tomb chambers buried beneath huge earth mounds. This example was found in 1914 in a grave in Tumulus III, the largest in the Kerma cemetery, during excavations conducted by a joint expedition of Harvard University and the Museum of Fine Arts, Boston.

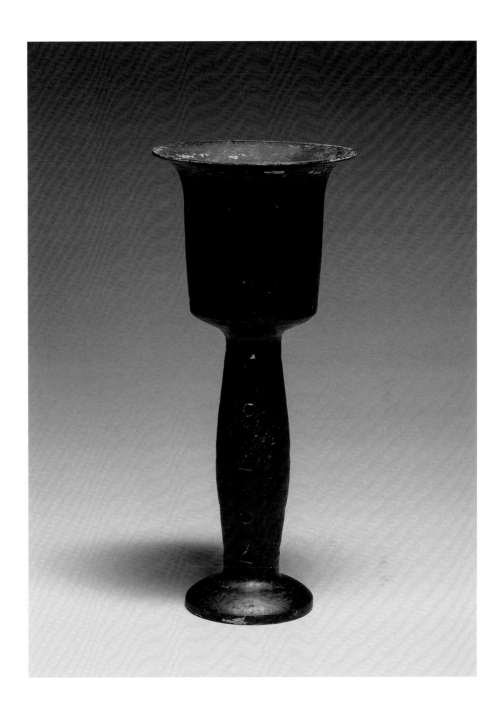

Unidentified artist
Chinese, Neolithic, Longshan culture
Long-Stemmed Goblet, C. 2500–2000 BCE
black "eggshell" earthenware
7¹³⁄₁₆ × 3 ½ × 3 ½ in. (19.9 × 8.9 × 8.9 cm)
Gift of the Rubin-Ladd Foundation,
2013.3.1

Black goblets of this form are characteristic of the Longshan culture of Neolithic China. This type of pottery, called "eggshell" because of its very thin walls, demonstrates masterful use of the potter's wheel. Without this technology, which appeared around 3000 BCE in China, such delicate pottery would not have been possible. Before firing, the pot was burnished to create a glossy surface. The rich black hue was produced by sealing the kiln near the end of the firing process to reduce the levels of oxygen, causing the clay to darken. These goblets are usually found in graves, and discoloration on this vessel suggests it was buried for millennia in an elite tomb. Goblets were likely used in rituals, perhaps for feasting at a funeral or pouring out libations for the deceased.

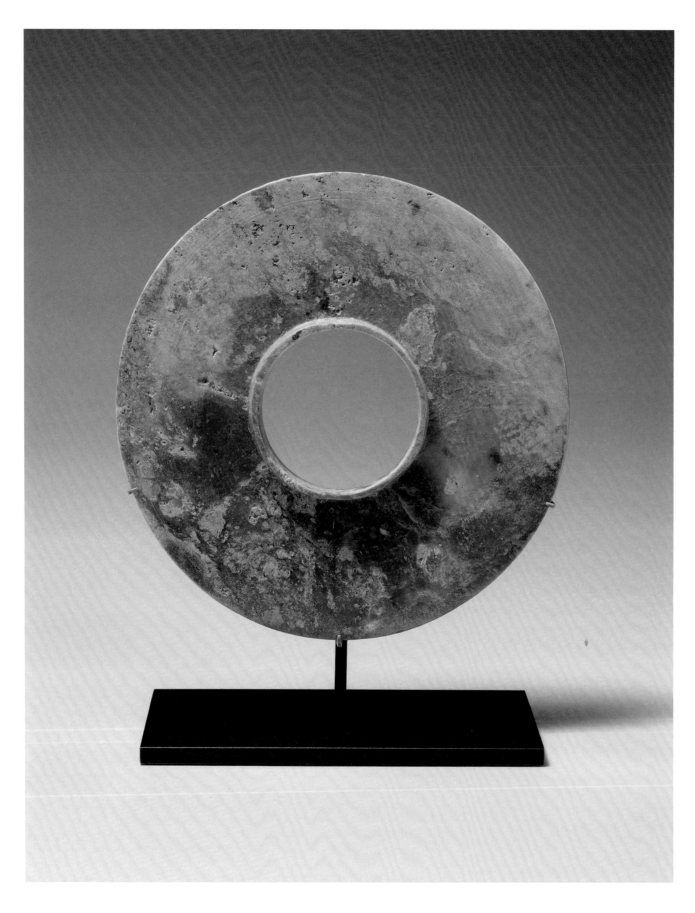

Unidentified artist
Chinese, Shang dynasty
Bi Disc with Collared Central Aperture,
13th century BCE
incised, ground, and polished nephrite
jade
diameter: 6⅞ in. (17.5 cm); depth: ⁹⁄₁₆ in.
(1.4 cm)
Spain Purchase Fund and The William A.
Whitaker Foundation Art Fund, 2016.9

Bi discs were made in China as early as the Neolithic Liangzhu culture (c. 3300–2250 BCE) and continued to be produced for thousands of years into the Han dynasty (206 BCE–220 CE). They are usually found in graves and are thought to convey wealth or social status due to their prized material (jade) and the expenditure of effort for their production. The shape and decoration of bi discs are thought to reflect the cosmos and the circular rotation of the heavens, and they might have functioned to help the dead transition to the cosmos. This bi is decorated sparsely with concentric circles, while later discs were more elaborately decorated with cosmological iconography.

Unidentified artist
Mesopotamian, Sumerian, Ur
Frog, c. 2000–1800 BCE
hematite
⅞ × ⁷⁄₁₆ × ⁵⁄₁₆ in. (2.2 × 1.1 × 0.8 cm)
Gift of Miss Emily L. Pollard, 69.3.1

This tiny sculpture is among the oldest objects in the Ackland's collection. There are only a few features carved into the stone – two protruding eyes and two hind legs folded tightly at the creature's sides – but they are enough for us to recognize a crouching frog. At the tips of its toes, a small hole was drilled through the stone. Four millennia ago, in Mesopotamia (now Iraq), this little frog was a protective amulet. A string or chain threaded through the hole allowed the owner to wear or carry the amulet. A frog amulet like this one might also have adorned the dead, buried with the deceased in a tomb, intended to protect the soul in its travels in the underworld.

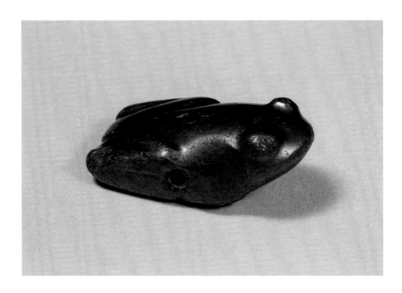

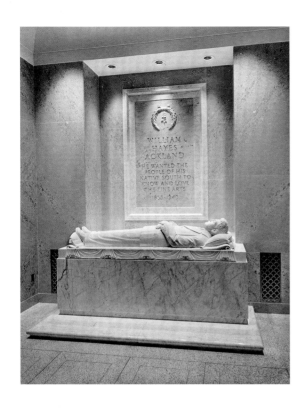

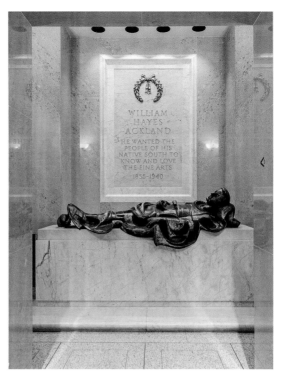

3 Unidentified artist, Italian, mid-20th century, *Recumbent Effigy of William Hayes Ackland (First Version)*, 1958, marble, dimensions unknown. No longer extant. Photo: University Archives.

4 Milton Elting Hebald, American, 1917–2015, *Recumbent Effigy of William Hayes Ackland*, 1961, bronze, partially gilded, 20 x 92 x 35 in. (50.8 x 233.7 x 88.9 cm). Ackland Fund, 61.28.1.

5 The Joseph Palmer Knapp Room, the Gift of Margaret Rutledge Knapp. As installed at the Ackland, c. 1960. Photo: Ackland Art Museum Archives.

6 Randolph Rogers, American, 1825–1892, *Ruth Gleaning Wheat*, 1853, carved 1866, marble, 46 x 26 inches (116.8 x 66 cm), Belmont Mansion Association, Nashville, TN.

7 Robert O. Skemp, American, 1910–1984, *William Hayes Ackland*, c. 1950, oil on canvas, 48 x 36 in. (121.9 x 91.4 cm). William Hayes Ackland Estate Collection, 58.9.1.

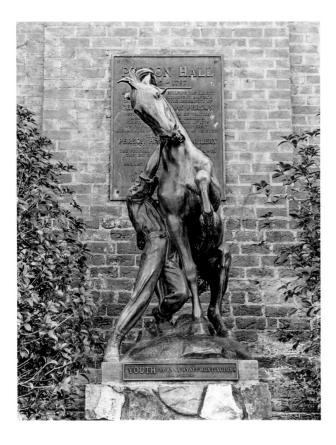

1 Frederick Waugh, American, 1861–1940, *Moonlight*, date unknown, oil on canvas, 30¼ x 40 in. (76.8 x 101.6 cm). Gift of Katherine Pendleton Arrington. Deaccessioned in 1961.

2 Anna Hyatt Huntington, American, 1876–1973, *Youth Taming the Wild*, c. 1927, bronze, 61⅝ x 29 x 45⅜ in. (156.5 x 73.7 x 115.3 cm). Gift of the Artist, 39.1.1. As installed in front of Person Hall.

3 Although donated by early 1937, this painting was assigned a retrospective 1955 accession number by the Ackland, along with other paintings (mainly eighteenth- and nineteenth-century British and American paintings with uncertain attributions) bequeathed by Arrington at her death.

4 In October 1937, she had already donated the aluminum sculpture *Swan with Outstretched Wing*, the work that now has the earliest accession number in the Ackland's records.

5 This account does not cover either the various portraits in the collections of the Dialectical and Philosophical Societies, student debating societies at the University active since the nineteenth century, or the paintings donated as the Genevieve B. Morehead Memorial Art Gallery by John Motley Morehead to the University's eponymous Planetarium, which opened in 1949. Information about these collections may conveniently be found in the *Ackland Newsletter*, no. 15 (Autumn 1983).

6 See, for example, a letter from John V. Alcott, chair of the Art Department since 1939, to House, by then chancellor of the University, recommending a working advisory board to "work towards… starting the collection now in good time" (November 6, 1951). Unpublished documents cited in this essay are in the collections of the University Archives or the Ackland's files.

7 At least some modern European prints and four pieces of African sculpture were acquired from Person Hall Art Gallery exhibitions as late as the first quarter of 1958, on the initiative of artist Kenneth Ness, the acting chair of the Art Department since 1957. Such purchases may have been made possible with the proceeds of the rental fee (25 cents a month) that the Department had been charging for the loan of facsimile color reproductions of famous paintings to students and townspeople since 1937. *Ackland Newsletter*, no. 14 (Summer 1983).

8 Although this essay is concerned with the art collection rather than the building history, it may be noted that 1951 also saw the finalization of a building program that included not only museum functions, but also the teaching, studio, library, and office requirements of the Art Department. The case for this rather expansive reading of Mr. Ackland's intentions had first been made by the Art Department within two weeks of the final court decision in 1949.

I: The Ackland before the Ackland

In the mid-1940s, the University reversed its rather diffident initial response to Mr. Ackland's idea and began very aggressively pursuing the bequest through the courts. By then, Person Hall Art Gallery and the Art Department could already point to some notable holdings in contemporary American art. They were proudly listed in a court filing of April 1946, related to the litigation over Mr. Ackland's bequest. By 1937, Katherine Pendleton Arrington (1876–1955), a major force in the North Carolina art world and one of the prime movers behind the initiative to establish an art gallery at UNC-Chapel Hill, had donated a moonlit seascape by the contemporary painter Frederick Waugh (fig. 1),[3] and the prominent sculptor Anna Hyatt Huntington had donated two sculptures, one of which, given in late 1938, was a dynamic representation of a *Youth Taming the Wild*, deemed symbolically appropriate enough to be placed in front of Person Hall (fig. 2).[4]

In 1943, the Federal Art Project of the Works Projects Administration, part of the massive relief program undertaken by the government during the Depression, distributed the art it had accumulated, and the University received four oils, seven watercolors, two sculptures, 215 prints, and thirty-three photographs (the last mentioned constituting an entire exhibition of the work of Berenice Abbott). To that could be added a smattering of other works and well over one hundred American prints on indefinite loan from the collector W. P. Jacocks, a University alumnus, public health professional, and early supporter of Associated American Artists in New York. By 1948, the collection had expanded into European paintings and sculpture, with the anonymous donation of thirteen works, primarily European paintings, given as the "W.W. Fuller Collection" (p. 125).[5]

The future of this respectable foundation was of course transformed by the court's final decision in early 1949 that allowed the campus of the University of North Carolina at Chapel Hill to be the site for Mr. Ackland's memorial building—with the marble sarcophagus and recumbent effigy stipulated in his will (both in its initial version and in the 1961 replacement, figs. 3 and 4)—and to be the recipient of income from a generous trust, set up to build the museum, support its activities, and enable purchases of art. But the University did not pause its activity in acquisitions until the completion of the building, the construction of which was delayed by debates on the appropriate architectural style. On the contrary, the prospect of a custom-built museum and professional staff may well have energized the collection-building project.[6]

Although records are scarce, the Art Department probably acquired additional works for teaching purposes in the 1950s. Art Department collections later officially transferred to the Ackland's care include African sculpture, numerous Japanese prints, nineteenth-century photographs, European prints (p. 112), and other works (p. 163).[7]

Nineteen fifty-one was a key year.[8] W. P. Jacocks donated a major portion of his very extensive print collection late that year (p. 69). It was also in 1951 that Mrs. Joseph Palmer Knapp, the widow of a major patron of the University, lent a large and eclectic collection of decorative art and other furnishings for display at the University's Morehead Planetarium, with the intent, finalized the next year,

Trove

PETER NISBET

1 The best account of the legal maneuverings and the Museum's subsequent development remains the essays in Innis Shoemaker, ed., *The Ackland Art Museum: A Handbook* (Chapel Hill, NC, 1983).

2 The story is here traced with reference to the preceding 283 illustrations. The contents of this volume can be supplemented by judicious searching on the Ackland's richly illustrated online collection database, which offers detailed cataloging information on every work in the collection: ackland.emuseum.com. Aspects of the history of collecting can be traced there by noting the year and circumstances of acquisition indicated by the first digits of the object's accession number and credit line. The full holdings in many categories can also be surveyed.

"We are, of course, deeply interested in permanent collections." So wrote R. B. House, then the dean of administration for the University of North Carolina at Chapel Hill, on December 17, 1936, replying to a letter from William Hayes Ackland of two days previous. Ackland had written to UNC-Chapel Hill, Duke University, and Rollins College in Winter Park, Florida, in virtually identical terms, informing them that he was "the owner of some valuable paintings and pieces of statuary" and thinking "of building and endowing a gallery in connection with some Southern college or university." As House pointed out, UNC-Chapel Hill had just recently established a department of art and was on the verge of opening a renovated building on campus, Person Hall, as "a modest art gallery." This brief exchange between the University and Mr. Ackland initially came to nothing, as the benefactor went on to decide on Duke as his preferred location and wrote his will accordingly; however, a convoluted and extended legal process after his death in 1940 would end up allocating Mr. Ackland's munificence to Chapel Hill, even though that decision was not finally reached until February 3, 1949. It then took almost ten more years before the Museum opened on September 20, 1958, as the William Hayes Ackland Memorial Art Center—a name it kept until October 1979.[1]

Over the twenty-one years between the openings of Person Hall in early 1937 and its successor, the University, following House's sentiment, started to build the significant art collections that came to anchor the Ackland Art Museum. Its ambitious acquisitions program has brought the institution to the prominence it enjoys today as one of the finest public university art museums in the country. Now with more than twenty thousand works of art covering well over five thousand years and many of the world's cultures, the Ackland collection is indeed a trove, a store of valuable and delightful things to be rediscovered by individuals in every generation. The word "trove" does bring along the association of "treasure" (and the Ackland has its fair share of those), but it also resonates with its French source, *trouvé*—something found, full of surprises. Successive administrations of Museum directors and curators have found what their predecessors laid up and then added to it, so that the future could in turn discover these riches.

These concluding pages recount some of the history of building this trove, with an emphasis on the early stages and the less obvious, more idiosyncratic moments that have contributed to the Museum's personality and individuality.[2]

Trove

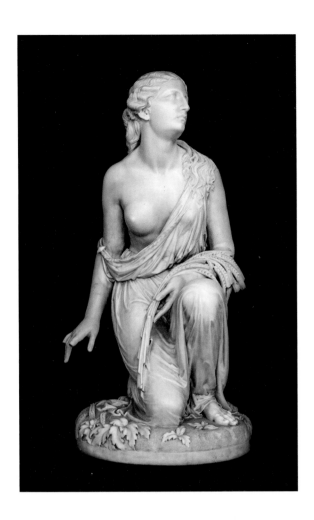

9 The Joseph Palmer Knapp Room existed in various locations and configurations within the Ackland building until the early 2000s, when they were dismantled. Most of the remaining collection (various pieces had been periodically disposed of since as early as 1960), along with similar collections of silver, ceramics, and furniture donated by the Estate of William Shipp in 1962 and a set of nine eighteenth-century chairs and a Flemish tapestry donated by Stephen Lynch in 1968, was sold in 2005. The substantial proceeds made possible an impressive series of acquisitions over the next fifteen years (pp. 76, 84, 122, 192, 201, 220, 225, 263).

that these objects and a range of other items should be donated for the future Ackland and largely housed in a reconstruction of the living room and foyer of her New York apartment, incorporating the original pine paneling (fig. 5).[9]

Perhaps the most consequential decision of 1951 was the University's purchase, for a nominal sum, of the collection of New York advertising executive Burton Emmett, a trove in its own right, comprising not only a large and significant collection of books, but also some 2,800 prints, drawings, and paintings. Transferred from the library's graphic arts collection to the Ackland in 1958 and later, this massive collection of European and American prints in all techniques put the Museum decisively on track to have a special strength in works on paper (pp. 223, 234). Other large print holdings transferred from the library at the same time, such as the Pickens Collection and the Howard Diers Collection, together amounting to over 500 works and both overwhelmingly portrait prints, reinforced the point.

Conspicuously absent from this ingathering of available art were any "valuable paintings and pieces of statuary," as mentioned in Mr. Ackland's initial letter to the University. In fact, Mr. Ackland was no collector. There is no record of

his having purchased a work of art in his lifetime, and what art he did own was inherited from his mother. Pieces that might have been of interest to the Ackland, such as a version of Thomas Sully's portrait of Queen Victoria and the mid-nineteenth-century sculpture *Ruth Gleaning Wheat* by Randolph Rogers (fig. 6), were explicitly declined by the University on November 12, 1957, at the request of the Trustees of Ackland Estate, who wanted them to stay with the institutions to which they had long been lent. Some portraits of Mr. Ackland did come, as did two nineteenth-century copies of busts of Roman emperors, a selection of Mr. Ackland's jewelry, a wide variety of European and other coins, and a bullet.

Mr. Ackland's estate had commissioned a posthumous portrait in oils (fig. 7), and this representation nicely reveals to us how much Mr. Ackland considered himself a writer rather than an art collector or enthusiast. He is shown at a writing table, with a manuscript, in a well-stocked library. He was a published author, known to his friends for his deep and extensive knowledge of European and American poetry (and his ability to quote it copiously). His bequest included his unpublished literary manuscripts, as well as an autobiography written in the last years of his life, to be kept in the Museum.[10]

The first version of the will, in 1936, had set goals for certain individuals to publish or at least distribute his writings, but there was no such obligation on either individuals or the Museum in the final version. The absence of any requirement to promote Mr. Ackland's writings was surely a welcome one, as he was steeped in the cultural attitudes and prejudices predictable for a man of his time and background. Born in 1855 in Nashville, Tennessee, he grew up in the luxury afforded by membership of a family whose extraordinary affluence derived largely from the firm of Franklin & Armfield, the largest business in antebellum America engaged in the particularly brutal and lucrative enterprise of slave trading. Ackland's views on society, race, and politics align with the "Lost Cause" and "Redemption" ideology of the post–Civil War decades. These attitudes seem not to have been translated into public or political action but saw only private and literary expression.[11]

The foundation for Mr. Ackland's own wealth was laid through a substantial inheritance deeply imbricated in an economy based on ownership of enslaved people.[12] This seems to have been nurtured and grown through shrewd investments in real estate and the stock market. It is nevertheless notable, given Mr. Ackland's own tastes and views, that the monetary bequest that forms the Museum's primary acquisition fund contains no restrictions, stipulations, or recommendations whatsoever on the nature of the art to be purchased. The Ackland Fund is in fact the Museum's least constrained source of acquisition money and as such has been used over the decades both for conventional and for experimental art, from traditions based in European heritage to cultures from across the globe. Half of the works illustrated in this volume owe their presence in the Museum to this fund.

10 By 1961, the papers had already been transferred to the University's library for safekeeping.

11 His one major publication was the melodramatic novel *Sterope: The Veiled Pleiad* (Washington, DC, 1892). Set in New Orleans and on the fictional Cypresmort Plantation on the banks of the Mississippi, this novel tells the story of Sterope de Bienville and her family in the years immediately before the Civil War. The novel is shot through with sentimentalized depictions of plantation life, and race and slavery are prominent themes. It is not hard to find racist caricatures of African American speech, viciously condescending portrayals of enslaved persons, and extended passages of debates about the institution of slavery. Sterope's main love interest is actually an abolitionist Northerner, who conjures a utopian vision that love can overcome all divisions, especially over what Sterope describes as "an institution which I have been reared to look upon as of divine authority, and which you have been taught to hold as iniquitous." Sterope agrees to the match, but the story ends in tragedy.

12 This background was certainly not overlooked at the time of the building's dedication. A banner headline in the *Daily News* in neighboring Greensboro, North Carolina, on September 28, 1958, declared "Slave Trade Fortune Builds UNC New Gallery But Rich Man's Art Is Not Worth Hanging." The official University news release on August 23, 1958, was more circumspect, describing Mr. Ackland as "a native of Nashville, Tennessee, who amassed a fortune as a Washington attorney."

13 Sloane was actually appointed director of the Museum and chair of the Art Department in 1958. He attended the dedication of the building in September that year. This essay uses the names of the Ackland's directors as convenient markers for the narrative, though of course the many curators who have served the Ackland over the decades have decisively guided and influenced acquisitions. A list of these essential staff members appears on the Acknowledgments page of this publication.

14 Although these accumulated holdings were not insignificant, Sloane may perhaps be forgiven his exaggerations on that occasion in saying that "we have an elegant building and nothing to put in it. The University owns some paintings, yes, but it does not have a collection per se." *News and Observer* (Raleigh), September 20, 1958.

15 Other acquisition endowments have been important too. In 1960, the Ackland received the very substantial William A. Whitaker Art Acquisition Endowment, restricted only to art that was not, in the terms of the gift, "faddish," but otherwise as open as the Ackland Fund. Forty works purchased with this Fund are included in this book. (Whitaker himself personally made significant donations, such as a large collection of works by the British caricaturist George Cruikshank and a number of Japanese woodblock prints [p. 96].) Equally important for the goal of improving the collection was another early event: the 1961 permission from the North Carolina State Legislature to sell works of art and use the proceeds to acquire other works. Sloane made immediate use of this new authority, exchanging two paintings acquired before 1958, including the Waugh seascape that had been the University's first art acquisition (fig. 1), for an early nineteenth-century American landscape by Thomas Birch. In 2019, the Ackland received another seascape by Waugh as part of The Hugh A. McAllister, Jr., M.D. Collection.

16 In his letter to the dealer agreeing to buy the amphora, Sloane did write (October 21, 1959): "You may be interested to know that this vase was the most popular by far. The Greeks haven't lost their charm, it would seem." It is perhaps indicative of prevailing taste that neither the twentieth-century European painting (a 1930 Fernand Léger) nor the American painting (by Ralph Albert Blakelock) was selected.

17 This initiative may have had its roots in a new program announced by Sloane in a July 1964 chairman's report to the Art Department: "the start of an acquisition program for contemporary paintings, sculpture, etc. which will complement the studio instruction in various useful ways." He actively solicited "definite nominations" from the staff. "The cooperation of the whole department is earnestly solicited to make this program effective." Another example was the $3,000 donated by the Kistler siblings of Fayetteville, North Carolina, in 1960, given to UNC-Chapel Hill art history professor Clemens Sommer to select and buy works of art during a sabbatical year in Europe.

18 One exceptional, and exceptionally large, instance was the 1962 donation of the entire visual archive (almost 2,000 works) of the illustrator, Art Department faculty member, and Chapel Hill resident William Meade Prince (p. 94). The challenge and wisdom of retaining such vast holdings by just one artist of limited significance have been the subject of debate since then.

II: The First Quarter Century

Such then was the collection, the trove, that greeted Joseph P. Sloane, the founding director of the Ackland when he arrived in Chapel Hill in February 1959.[13] He set to work on expanding it immediately.[14]

The first works of art purchased with the Ackland Fund, after it became available in 1959, were in fact modern, stylistically advanced, and varied European prints (p. 91). In this, Sloane was extending one existing focus of the UNC-Chapel Hill Art Department collection and the Burton Emmett Collection. When he quickly moved, later in 1959, to make full use of the new resources by searching out major paintings and sculptures, he again built on an established foundation, which by then included some European paintings acquired by gift and purchase in 1956 and in mid-1959 from Dr. Lunsford W. Long (1890–1964), a business executive and legislator, and his wife.[15]

In fall 1959, Sloane organized a two-week exhibition of thirteen paintings and sculptures lent by major dealers, "from which a selection for purchase will be made." It is perhaps not surprising that two of the four works purchased, a still life by Antoine Vollon and Eugène Delacroix's *Cleopatra and the Peasant* (p. 161), reflect Sloane's own scholarly concentration on French art of the nineteenth century. The two others, a Greek amphora and a polychrome German wood carving of the Virgin, are also firmly within the story of European art from the ancient Mediterranean to the present day that still forms a central pillar of the Ackland collection.

Interestingly, however, Sloane staged his exhibition with a fresh twist: he invited visitors to vote for their recommendations among the works on offer. While no evidence has yet emerged that would indicate in detail how people voted and whether those votes were taken into account, this welcome openness to external input surfaces explicitly from time to time in the Ackland's collecting history.[16] Between 1977 and 1999, supporters of the Museum called the Ackland Associates hosted annual "purchase parties" to vote on proposed acquisitions their contributions would finance (pp. 80, 81, 123, 238). Sloane also extended some decision-making authority to faculty, for example with the formation of an advisory group of studio art professors in the early 1970s to decide on significant purchases of contemporary art (pp. 33, 40, 44).[17] This multivocal chorus of stimulating advice and guidance has surely been for the good, especially in an institution that has never been able to support a broad-based curatorial staff with expertise in the full range of collection areas. A similar effect of healthy pluralism can also be achieved by adding large, often very heterogeneous collections. The example set in the early years (Emmett, Knapp, Jacocks) has reemerged in recent decades, with extensive donations and bequests from (to name only a few) Charles and Isabel Eaton in 2009, Joseph P. McCrindle in 2015, Robert Myers in 2015 (p. 63), Hugh A. McAllister in 2019 (p. 148) and Charles Millard in 2018–19 and previously (pp. 49, 130, 153, 181, 262).[18]

All in all, the forty-seven works of art acquired in 1959 set the tone for a central thread in much of the subsequent art collecting by the Ackland: the Western tradition. Continuing throughout the Ackland's history have been ongoing efforts to broaden and deepen this story, with the moment and the

19 More details on the history of collecting in two fundamental areas within this tradition are now available. See Carol C. Gillham and Carolyn H. Wood, *European Drawings from the Collection of the Ackland Art Museum* (Chapel Hill, NC, 2001); and Mary C. Sturgeon, *Ancient Mediterranean Art in the Ackland Art Museum* (Chapel Hill, NC, 2015). The latter points out the notable number of acquisitions of antiquities deaccessioned at various times by American museums, such as from the Museum of Fine Arts, Boston (a large group of Egyptian and Nubian art in 1962 [pp. 283, 284]), the Metropolitan Museum of Art (Cypriot pieces from the Cesnola Collection), and the Yale University Art Gallery (a Palmyrene portrait [p. 273]).

20 Evan H. Turner in *Ackland Newsletter* nos. 12/13 (Summer/Autumn 1982).

21 No trace has yet been found of the "five oriental paintings" given in 1953 by a Nina W. Troy of Greensboro, North Carolina.

22 Another purchase around this time of an object somewhat outside the then conventional parameters of the Western tradition was also a mistake: the authenticity of a Greek figurine in the Cycladic style acquired in 1966 has not survived expert scrutiny.

23 This single-digit percentage proportion is in effect not too different from the ratio to be found in the Ackland's 1958 inaugural exhibition, one that explicitly showcased the kind of art and collection to which the Ackland aspired. This presented 116 works lent by nineteen college and university museums, with five non-Western works (Japanese, African, and Indonesian).

24 *Ackland Newsletter*, no. 11 (Autumn 1981).

25 In his annual report for 1981–82, Turner himself gave the example of a twelfth-century Indian stone carving of Vishnu "costing 20% of what a comparable European sculpture would have cost."

curators favoring, say, sometimes drawings, sometimes sculpture, sometimes this time period, sometimes that.[19] Sloane's overall "goal of suggesting the evolution of the arts of the Western world" (in the words of a later director)[20] has led to a collection of Mediterranean, European, and American art that stretches over five thousand years, from an Elamite seal to contemporary video.

III: Beyond the Western Tradition

With this powerful emphasis on Europe and North America, what of art from other world traditions, so-called non-Western art? Importantly, from the very beginning, the Ackland welcomed—even if it did not prioritize—such works, primarily the arts of the Asian and African continents. The founding collections certainly included powerful examples, from Burton Emmett's Dan mask, Indian miniatures (p. 134), and Islamic calligraphy to the Art Department's collections already mentioned. A handful of minor Asian scrolls had been donated already in 1956, to which were added a group of Persian ceramics and glass in 1960, and twenty-five nineteenth- and twentieth-century Japanese sake cups in 1963.[21] The decade of the 1960s saw a trickle of scattered purchases and gifts. The lack of curatorial expertise was surely reflected in several missteps, such as the purchases of objects that later turned out not to be of the period assumed (such as figs. 8 and 9).[22]

The status of these collecting areas was neatly summarized in the 1969 exhibition of *A Decade of Collecting*, which presented 168 works of art, of which thirteen were of "non-Western" (in this instance, exclusively Asian) origin.[23]

The Ackland became more serious and more successful with art outside the Euro-American tradition beginning in the late 1970s. This turn for the better was initiated by the Ackland's second director, Evan H. Turner (in office, 1978–83), who had previously served as director of the Philadelphia Museum of Art. The project initially focused on Asian art, long a widespread enthusiasm within the American museum landscape.

Already by early 1982, a small exhibition of *Far Eastern Art in the Collection of the Ackland Art Museum* could be introduced by Turner in this way:

Although the emphasis in museum acquisitions has been concentrated on the western tradition, a few Chinese, Japanese, Indian, and Southeast Asian works have come to the collection, often as gifts. An effort is now being made to acquire a few further works of some quality which will give an indication of the range of pleasures and possibilities attendant to the study of Far Eastern art and, it is hoped, will present, in this small Museum, a more balanced view of man's visual explorations.

Turner's decisive initiative was grounded, as he said, in the institution's paramount priority of maintaining a "mobility of outlook" to seize "unexpected yet tempting opportunities."[24] It also had a practical underpinning in the financial incentive to forego expensive European and American art in favor of the more affordable Asian art.[25]

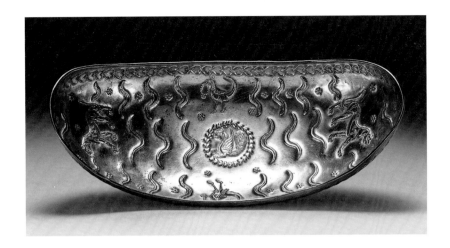

8 Unidentified artist, *Elongated Bowl in Sasanian Style*, probably 20th century, silver, 2½ x 12 x 5⅜ in. (6.4 x 30.5 x 13.7 cm). The William A. Whitaker Foundation Art Fund, 66.10.1.

9 Unidentified artist, *Ancestor Tablet in an Aedicula, in the Style of the Wei Dynasty*, perhaps 20th century, stone, 25½ x 11 x 5½ in. (64.8 x 27.9 x 14 cm). Ackland Fund, 68.16.1.

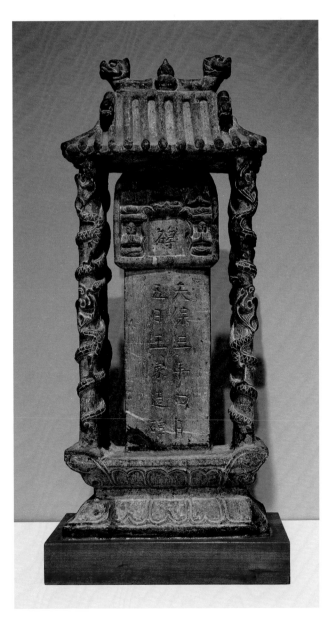

26 *Newsletter*, no. 29 (Summer 1991). More information specifically on the Indian sculptures acquired may be found in Pika Ghosh, ed., *Fashioning the Divine: South Asian Sculpture at the Ackland Art Museum* (Chapel Hill, NC, 2006).

27 *Ackland Newsletter*, no. 7 (Fall 1979).

Turner began with the 1980 purchase of two Chinese scroll paintings of the Ming dynasty, on which he consulted with Sherman E. Lee, then director of the Cleveland Museum of Art and an acknowledged expert in Asian art. This direction was then immeasurably strengthened in 1983 when Lee retired to Chapel Hill and contributed much advice and guidance. Lee also encouraged other collectors, such as Clara T. and Gilbert J. Yager (pp. 164, 170, 171, 194, 261) and Herbert and Eunice Shatzman (pp. 182, 256. 267), either to focus on Asian art or to become affiliated with the Ackland or both. Lee and his wife Ruth also went on to donate significant parts of their own collection (pp. 133, 216, 244).

The momentum in the field of Asian art certainly continued and indeed accelerated after Turner's departure in 1983. The remainder of that decade saw important purchases (such as the first major Chinese ceramic, a Northern Song bowl) and Indian objects selected by the Ackland Associates in 1989. Other major enhancements came through gifts and transfers (pp. 142, 145) such that, by summer 1991, Lee could praise the Ackland's Asian collections as "the finest, best-balanced collection of Japanese, Chinese, and Indian art between Richmond and New Orleans."[26]

It took the Museum longer to find its footing with the second major area of non-Western collecting: African art. A large gift from five individual donors of some seventy-five pieces of wood sculpture from West and Central Africa in 1972 was something of a miscalculation. The vast majority of these, along with other acquisitions and the Art Department's small collection of African sculpture that had been transferred in 1958, were deaccessioned in 2008.

Better informed and more targeted acquisitions began very gradually in the 1980s, though only two works were added in that decade and only three in the following. Art of the Yoruba culture of southwestern Nigeria was the primary focus (p. 86), and figural wood carvings and masks from Central and West Africa continued to attract the most attention for several decades. One major exception was the more ancient terracotta sculpture from the Nok culture (p. 274).

With his acquisitions of Asian art, Turner had established a precedent, and his innovative and decisive attention to two further collecting areas also influenced the agenda for the future. Both areas could be seen as lying outside the traditional canon of "high art" and their prominence within the collection to this day contributes importantly to the open-minded vitality across all the Ackland's work. He announced a policy of "aggressive growth" in the collecting of photographs ("given the great undergraduate enthusiasm for photographs," as he wrote),[27] methodically adding masterworks by a limited number of the great names of modernist photography in the twentieth century (p. 100). With the welcome prompting of faculty specialists in folklore, he selected a small but very distinguished group of folk art and nineteenth-century pottery from North Carolina (pp. 75, 143).

When Turner resigned his post to take on the directorship of the Cleveland Museum of Art, he published some thoughts about the Ackland's collecting policies. In summary, Turner explained that the Museum had "sought works to enrich and extend every part of the collection" and to "move into new areas" (he highlighted Far Eastern and Indian art); the Ackland had "again and again…

28 Turner described this philosophy in his final director's report, as also published in the *Ackland Newsletter*, no. 14 (Summer 1983).

29 Millard continued to have a tremendous effect on Ackland collection long after his retirement in 1993. He not only donated his large personal collection, as mentioned above, but also used the proceeds of the very remunerative sale of one eighteenth-century Austrian sculpture to establish a foundation for the primary purpose of acquiring major works of art for the Museum (pp. 64, 129, 179, 180, 206, 210, 250, 277). On the latter, see Peter Nisbet, ed., *Fortune Smiles: The Tyche Foundation Gift* (Chapel Hill, NC, 2010).

30 This group of seventeen works provided the foundation for the recent addition of a growing collection of Inuit drawings, the gifts of Rebecca and Bernard Herman. This activity with one tradition of Indigenous arts on the American continent is now helping to inform consideration of one on another continent, as the Ackland staff currently weighs adding works by Australian Aboriginal artists to the collection, complementing one print acquired in 2005.

purchased fine works which are not studied in the art history courses" as "collections should play a significant role in opening up the students' horizons in new directions." Works chosen "should raise the…level of quality in its particular area." The Museum "has continued to avoid objects in those areas notably favored by affluent private collectors" (largely for reasons of cost). Works by North Carolina painters and sculptors were not acquired, as they are readily viewable elsewhere; and "[p]erhaps most important of all, we do not view ourselves as building up a 'teaching collection'…too often the material thus collected is second rate or fragmentary and we firmly believe that the lesson to be garnered from such objects in poor condition is much overrated."[28]

In many ways, these guiding principles underpin and animate the Ackland's collecting program to this day. The subsequent decades have certainly seen some expanded initiatives and new emphases, but the core commitment remains the same: openness to great art of any time or place, especially that which can surprise and stimulate. The Ackland may now make more of an effort in popular areas (such as contemporary art) and be open to art of North Carolina that is also available elsewhere, but all this is done with the clear conviction that the best experiences (within an educational framework or beyond it) are to be had from work of the highest possible quality.

IV: Recent Decades

The spirit of Evan H. Turner was certainly at work under the Ackland's fourth director, Charles Millard, who came to Chapel Hill from his position as chief curator at the Hirshhorn Museum and Sculpture Garden in Washington, DC[29]

Turner's ventures into new collecting areas were echoed in the late 1980s with the establishment of a significant group of Inuit sculptures (p. 74) and of prints, with the generosity of H. G. Jones, a prominent archivist, historian, and public intellectual in North Carolina.[30]

Other "underrepresented" cultures have not yet received similar attention, though the Ackland does have a small selection of examples of Oceanic art and pre-Columbian art (pp. 265, 266), acquired mainly in the 1960s and early 1970s, on which future directors and curators could certainly build, if the opportunity and desire arose.

Beyond this, already established areas of focus have experienced increases in depth and breadth, building on existing strengths.

The growth of the collection of Asian art was for a period inflected by the programmatic goals of the Ackland's Five Faiths Project in the mid-1990s, especially during the directorship of Gerald Bolas (1994–2005). This multifaceted approach on "sacred objects and communities of faith" resulted in the addition of works primarily reflecting the beliefs and practices of some of the world's leading religions. This project brought in, for example, many objects of Islamic art (p. 123) which are now complemented by a more recent initiative under the current director, Katie Ziglar (director since 2016), to expand this area with works of higher aesthetic ambition and historical resonance (pp. 218, 219, 258, 263).

31 The still growing collection of Meiji-era
 Japanese prints donated by Gene and
 Susan Roberts currently numbers some
 500 works, while Carol and Jeffrey Horvitz
 have donated and placed on long-term
 loan numerous modern and contemporary
 Japanese ceramics.

32 With the exception of the pieces in
 the Knapp, Shipp, and Lynch gifts (all
 subsequently deaccessioned), furniture
 has not been acquired by the Ackland.

Other new accents within the Asian collection in recent times have included a broad-based expansion of attention to the arts of modern Japan, from woodblock prints engaging with the historical upheavals of the country's rapid modernization (pp. 120, 121) to contemporary and older ceramics (pp. 52, 107), as well as textiles (p. 85), painting (pp. 76, 84), metalwork, and other media (p. 122).[31] The holdings of Chinese ceramics have been greatly strengthened by donations from Smith Freeman and Austin Scarlett (pp. 257, 278), while a well-rounded collection of Asian porcelains made primarily in the eighteenth century for export to Europe and other markets has been added through the generosity of Richard D. Pardue (pp. 183, 185).

The Ackland's African collection has also seen shifts in emphasis, with particular attention now to the art of southern Africa. Colorful beadwork for decoration and daily life (p. 108) provides a counterpoint to the more traditional emphasis on religious and ceremonial carved wood objects from western and central Africa.

New areas in photography have included a conscious effort to expand the representation of photography's manifold functions in modern society—science, bureaucratic administration (p. 111), illustration, and even snapshots and other vernacular modes (pp. 110, 128, 144). Forays have also been made into video and time-based art (pp. 19, 20, 21), and these genres will certainly gain in weight as collecting priorities over the coming years.

The foundational commitment to painting, sculpture, prints, and drawings of the European and American tradition rooted in art of the ancient Mediterranean has not flagged, and important works from this area continue to be added with regularity and enthusiasm. The print collection has been continually expanded, and the drawing collection received a magnificent enrichment with the 2017 donation from Sheldon and Leena Peck of The Peck Collection of over 130 Dutch and Flemish seventeenth-century and eighteenth-century drawings (pp. 208, 209), including several by the greatest artist of the period, Rembrandt van Rijn. The Ackland is currently the only state university art museum with such holdings.

A collection with this "high art" profile in the Western tradition, however, has understandably had a tense relationship to the so-called "decorative arts," traditionally seen as minor. This area has never quite come into focus as a coherent collecting field for the Ackland, though the potential is surely present.

An institution consciously collecting ancient pottery as well as functional pieces from Asia and then also nineteenth- and twentieth-century North Carolina pots already has a latent capacity to be open to broader collection of vessels of various cultures. There is also the precedent of the early Joseph Palmer Knapp Gift, which brought many hundreds of pieces of ceramic, glass, and wood into the collection, reinforced by gifts from the William E. Shipp Estate a few years later, which added over two hundred pieces of silver and porcelain.[32]

Interestingly, when taken together, scattered gifts and purchases over longer periods have the potential to coalesce into a coherent collecting focus. Take, for example, the case of glassware. By 1975, thirty-two pieces of Roman glass had been acquired, almost all by gift. Some two hundred pieces of nineteenth-

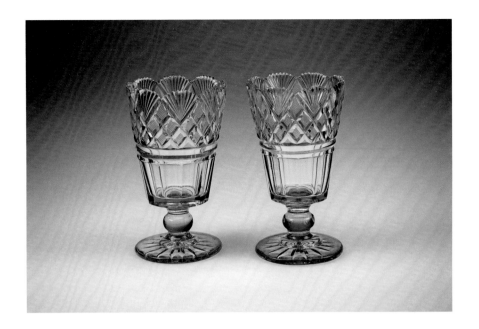

10 Unidentified artist, American, early to mid-19th century, *Pair of Celery Vases*, c. 1820–40, pressed glass, each 8⅜ x 5 in. (21.3 x 12.7 cm). Transfer from the Louis Round Wilson Library, Jacocks Collection, 84.16.23–24.

century American pressed glass were bequeathed to the Ackland in 1966. Only seventeen were kept, with the proceeds from the sale of the remainder enabling the purchase of significant European glass of the period. Some twenty years later, the University library transferred to the Ackland part of another, rather unexpected portion of the collections of W. P. Jacocks, whose name has featured prominently in the earlier account of the early print collections of the Museum—twenty-six celery vases, those glass fixtures of the bourgeois table in nineteenth-century America, selected from Jacocks's total collection of over 650 (fig. 10). And, beginning a decade later, a major collection of over fifty pieces of European and American glassware of the art nouveau and art deco periods was acquired by gift and purchase (pp. 92, 106), extending the depth of holdings in this medium and prompting the question whether a future effort can or should be made to refine and fill out a focused glass collection. The Ackland's few examples of modern and contemporary studio glass might contribute to such a project.

In each of the areas covered in the preceding paragraphs, contemporary art has featured prominently in recent decades. As with most other areas of collecting, the Ackland's engagement with contemporary art can be traced to the beginning. One of the works acquired in 1959 was a painting made the previous year. This continuing engagement has been punctuated by more focused moments, whether the purchase of winners in the eight National Student Printmakers exhibitions organized by the Ackland between 1967 and 1978 (fig. 11)—the faculty-led program mentioned above—or the dedication of a generous monetary bequest to the purchase of a group of important drawings in the early 1980s (pp. 32, 35), purchases made under the guidance and then directorship of Innis Shoemaker, who led the Ackland from 1983 to 1986. Although this engagement with contemporary creativity was limited for a while

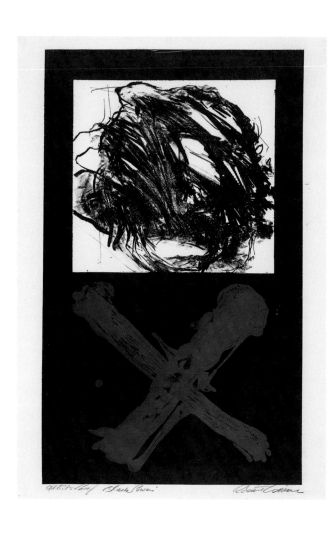

11 Robert William Conine, American, born 1947, *Black Power*, 1967–68, lithograph, 21¹⁵⁄₁₆ x 13⅝ in. (55.8 x 34.6 cm). Ackland Fund, 68.7.2.

12 Richard Howard Hunt, American, born 1935, *Untitled #1*, 1969, lithograph, 22¹⁄₁₆ x 30¹³⁄₁₆ in. (56.1 x 78.2 cm). Ackland Fund, 70.24.7.

13 Rephotographed photomontage showing Antoni Milkowski's *Diamond* in front of the Ackland Art Museum, May 1978. Photo: Ackland Art Museum Archives.

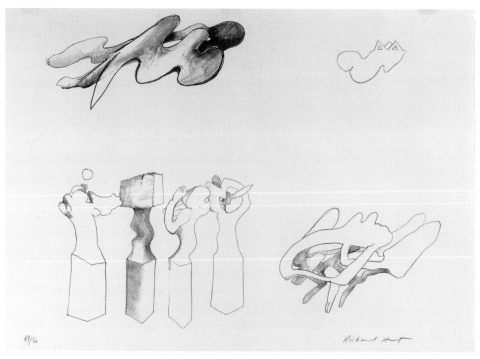

primarily to Euro-American art, recent decades have seen an increasingly global emphasis, with a conscious move to search out examples of contemporary art from many regions, sometimes with an explicit goal of connecting recent work to the historical cultures that form such an important part of the Ackland's collection. For example, additions of recent African (pp. 12, 13) and Asian (pp. 7, 9) art can be seen in this light. More broadly, the Ackland has paid attention to art from Central and South America (pp. 8, 24, 71).

The Ackland has also begun to establish a collection of outdoor sculpture placed around the campus (p. 30), an initiative that picks up both on a very early precedent set by the Ackland's precursor institution (fig. 2) and on a 1978 decision (for some reason never implemented) to acquire and place a large geometric abstract metal sculpture by Antoni Milkowski (1935–2001) in front of the Ackland (fig. 13).

Art from the United States has certainly not been neglected, and one area in particular has received special attention, as it has in recent times from so many art museums across the country: art by African American artists. As with so many other art traditions, genres, and media, the Ackland's first acquisition of work by a Black artist actually predates its founding. The 1943 distribution of works from the Works Progress Administration program included two powerful etchings by the Philadelphia-based printmaker Dox Thrash (1893–1965). Such an acquisition, however welcome in retrospect, can seem almost inadvertent, as can other such works, acquired as small parts of much larger accessions over the years, however much they are now famous and beloved (p. 95). It was not until 1970 that the Ackland spent money specifically on purchasing a work by a Black artist—a lithograph by the Chicago-based sculptor Richard Howard Hunt (fig. 12). In the wake of the civil rights movement of the 1960s, the 1970s seem

to have seen a more conscious effort in the field, one that continues to this day. The directorship of Emily Kass (2006–14) saw notable activity here (pp. 10, 36, 68), also marked by the beginning of an ongoing multiyear initiative to build a substantial collection of art of the African American South that was until recently considered "outsider" (pp. 16, 17, 26).

V: Encyclopedic

Such then is the trove that, toward the end of the first quarter of the twenty-first century, is being passed along to the next generation. Formed over many decades by choice and by chance, by serendipity and by strategy, the trove embodies what for a number of years was the tagline of the Ackland: "A World of Art." The Museum understands itself as, at least in principle, "encyclopedic." Unique among museums in the state, whether public or private, academic or municipal, the Ackland not only seeks to deepen and broaden its holdings of global art of all periods, but also makes that commitment a key part of its institutional identity.

Of course, adjectives like "encyclopedic" or "universal" are not only problematic because they are always aspirational; they may also be thought by some to be euphemisms for a collection that simply offers a little bit of everything, a patchwork and eclectic jumble. Does the Ackland collection, however good in parts, escape that stricture?

All users of the Ackland will have to answer that for themselves. The challenge for all those who have nurtured the collection in the past, for those who tend to it now, and for those who will take over these responsibilities in the future was, is, and will be to continually improve the quality of the collection so that it can sustain multiple demands from the widest possible range of visitors— for aesthetic pleasure, for historical inquiry, for emotional and moral uplift, and, importantly in this context, for cross-cultural connections, narratives, and comparisons. In essential ways, all the works in the collection are in some sense hybrids, the products of exchange, influence, and interaction. An encyclopedic collection is well placed to draw out this interconnectedness, sometimes just by the visual and intellectual stimulation offered by juxtapositions and groupings. These are made possible by the ongoing obligation to explore and expand the trove.

Acknowledgments

Perhaps more than most, a publication such as this draws on many generations of colleagues. When I thank those who, over the past few years, have joined me in contributing drafts of the commentaries on the "Selection from the Collection," I want also to acknowledge the extent to which we have all benefited from a multitude of interpretive and descriptive texts written for various occasions by past colleagues, often unnamed in the files, over many decades.

Draft commentaries were written by Carolyn Allmendinger, Bradley Bailey, Dana Cowen, Carlee Forbes, Rob Fucci, Ellen Huang, Bryanna Lloyd, Timothy Riggs, Amy Swartz, Carolyn Wood, and Katie Ziglar. Along with mine, these have been reworked, often extensively, and all are now published without authorship, though any errors remain, of course, my responsibility.

A wide variety of curators at the Ackland since our founding in 1958 not only conducted much of the research that informs these commentaries, but also had decisive influence on the development of the Ackland collection. To complement the naming of Ackland directors in this volume's essay, the names of all Ackland curators (and curatorial fellows) are listed here in recognition of this role: Bradley Bailey, Dana Cowen, Carol Gillham, Gay Hertzman, May Davis Hill, Ellen Huang, Christine Huber, Katharine Keefe (now Reid), Barbara Matilsky, Peter Nisbet, Kendal Parker, Chang Qing, Gil Ravenal, Timothy Riggs, Charlotte Robl, Sarah Schroth, Lauren Turner, Dean Walker, and John Minor Wisdom.

Throughout the long gestation of this publication, I have incurred many debts. I thank Tom Kenan for his early and enthusiastic endorsement of the project, directors Emily Kass and Katie Ziglar who have supported it as it evolved, and my many Ackland friends and colleagues who have done so much to improve the product, from carefully reading my essay drafts to generously offering words of encouragement at key moments. Much of the photography of the works of art in this volume was undertaken by Diane Davis and Brian Quimby, under the able supervision of registrar Scott Hankins. Business managers Suzanne Rucker (more than once!), Michelle Cordero, Erin Kernen, and Herleesha Anderson, together with Christy Baldridge of the University's purchasing office, kept their eyes on the financial and contractual aspects. Administrative underpinnings, including securing reproduction permissions where necessary, were contributed by curatorial assistants Amy Swartz and Megan Goble. Lauren Turner, first as assistant curator for the collection and then as associate curator for contemporary art and special projects, ably managed yet another of my publication projects, keeping meticulous track of texts and images. I am tremendously grateful to her for reassurance, advice, and bedrock competence. Colleagues at University Archives in the Louis Round Wilson Library greatly facilitated my research on institutional history.

We have been most fortunate in our partners, Paul Holberton Publishing, in London. Their flexibility, enthusiasm, and great design sense have been essential. We thank Paul Holberton, Laura Parker, Kristen Wenger, and Katherine Bogden Bayard.

And finally, I thank my family, Cecily, Cornelia, and Graham, who accompanied me on this journey, with all its doubts, detours, and delays. May this book be some small recompense for their patience.

PN

Reproduction Credits

pp. ii, iii: Alex Maness Photography

p. 5: © 2004 Marc Swanson

p. 6: © 2022 Rachel Howard / Artists Rights Society (ARS), New York / DACS, London

p. 7: © Hiroshi Sugimoto

p. 8: © Vik Muniz

p. 9: ©2005 Chiho Aoshima/Kaikai Kiki Co., Ltd. All Rights Reserved.

p. 10: © 2007 Kehinde Wiley

p. 11: © 2002 Hung Liu

p. 12: © 2014, Oghobase Onoriode Abraham

p. 13: © Sammy Baloji

p. 14: © 2001 Calhoun Thomas

p. 15: © 2002 Mohamed Zakariya

p. 16: © 2022 Estate of Irene Williams / Artists Rights Society (ARS), New York

p. 17: © 2022 Estate of Thornton Dial / Artists Rights Society (ARS), New York

p. 18: Courtesy of the artist and Jack Shainman Gallery, New York

p. 20: © 1997 Metro Pictures

p. 21: © 1996 Nam June Paik

p. 22: © 1995 Ken Price

p. 23: © 1995 Renée Stout

p. 24: © 1995 Sebastião Salgado

p. 25: © 1991 Sue Coe

p. 26: © 2022 Estate of Ronald Lockett / Artists Rights Society (ARS), New York

p. 27: © Sean Scully

p. 28: © 1990 Carl Chiarenza

p. 29: © 2022 The Kenneth Noland Foundation / Licensed by VAGA at Artists Rights Society (ARS), NY

p. 30: © Chiinde LLC (a Houser/Haozous family corporation)

p. 31: © Estate of Richard Nonas

p. 32: © 2022 Bruce Nauman / Artists Rights Society (ARS), New York

p. 33: © 2022 Dumbarton Arts, LLC / Licensed by VAGA at Artists Rights Society (ARS), NY

p. 34: © John Wesley

p. 35: © Donald K. Sultan

Cover, p. 36: © 1975 Barkley L. Hendricks

p. 37: © 1978 Chuck Close

p. 39: © The Estate of Ralph Eugene Meatyard, courtesy Fraenkel Gallery, San Francisco

p. 40: © 2022 Philip Pearlstein / Artists Rights Society (ARS), New York

p. 41: © Burk Uzzle

p. 42: © 2022 The Estate of Robert Morris / Artists Rights Society (ARS), New York

p. 43: © Gerhard Richter

p. 44: © Julian Stanczak

p. 46: © 2022 Artists Rights Society (ARS), New York / ADAGP, Paris

p. 47: © Association Marcel Duchamp / ADAGP, Paris / Artists Rights Society (ARS), New York 2022

p. 48: © 2022 Dedalus Foundation, Inc. / Artists Rights Society (ARS), NY

p. 49: © 2022 The Andy Warhol Foundation for the Visual Arts, Inc. / Licensed by Artists Rights Society (ARS), New York

p. 50: © 2022 Frank Stella / Artists Rights Society (ARS), New York

p. 51: © Agnes Martin Foundation, New York / Artists Rights Society (ARS), New York

p. 53: © Reproduced with permission of the Minor White Archive, Princeton University Art Museum by the Trustees of Princeton University

p. 54: © The Estate of Harry Callahan, courtesy Pace Gallery

p. 56: Courtesy of Michael Rosenfeld Gallery, New York, NY

p. 57: © 2022 The George and Helen Segal Foundation/ Licensed by VAGA at Artists Rights Society (ARS), NY

p. 58: © 2022 Maryland Institute College of Art (MICA), Rights Administered by Artist Rights Society (ARS), New York, All Rights Reserved.

p. 59: With permission of the Renate, Hans & Maria Hofmann Trust / Artists Rights Society (ARS), New York

p. 60: © 2022 Artists Rights Society (ARS), New York / ADAGP, Paris

p. 62: © The Josef and Anni Albers Foundation / Artists Rights Society (ARS), New York, 2022

p. 63: © The Oli Sihvonen Trust

p. 65: © 2022 Estate of Ad Reinhardt / Artists Rights Society (ARS), New York

p. 66: © 1946 Rose Piper

p. 67: © 2022 Estate of John Wilson / Licensed by VAGA at Artists Rights Society (ARS), NY

p. 68: © 2022 Estate of Hale Woodruff / Licensed by VAGA at Artists Rights Society (ARS), NY

p. 69: © 2022 T.H. and R.p. Benton Trusts / Licensed by Artists Rights Society (ARS), New York

p. 71: © 2022 Artists Rights Society (ARS), New York / SOMAAP, Mexico City

p. 72: © Successió Miró / Artists Rights Society (ARS), New York / ADAGP, Paris 2022

p. 73: © 2022 Estate of Pablo Picasso / Artists Rights Society (ARS), New York

p. 77: © Estate of Arthur Dove

p. 81: © 2022 The Estate of Edward Steichen / Artists Rights Society (ARS), New York

p. 82: © 2022 Artists Rights Society (ARS), New York / VG Bild-Kunst, Bonn

p. 83: © ESTATE BRASSAÏ – RMN-Grand Palais

p. 87: © The Raymond Jonson Collection, University of New Mexico Art Museum, Albuquerque

p. 88: © 1979 Amon Carter Museum of American Art, Fort Worth, Texas

p. 89: © The Ansel Adams Publishing Rights Trust

p. 92: © 2022 Artists Rights Society (ARS), New York / ADAGP, Paris

p. 95: © 2003 Valerie Gerrard Browne

p. 97: © 2022 Artists Rights Society (ARS), New York / ADAGP, Paris

p. 99: © 2022 Artists Rights Society (ARS), New York

p. 102: © Pechstein Hamburg/Tökendorf / Artists Rights Society (ARS), New York 2022

p. 104: © 2022 Artists Rights Society (ARS), New York / ADAGP, Paris

p. 105: © 2022 Artists Rights Society (ARS), New York

Fig. 4: © Milton Elting Hebald Trust

Fig. 6: Courtesy of the Belmont Mansion Association

Fig. 11: © March 10, 2022 Robert W. Conine

Museum Board Members